MW00800914

Giorgio de Chirico

Giorgio de Chirico
Life and Paintings
Fabio Benzi

Foreword by Paolo Picozza

Translated by Christopher Adams and David Smith

The publication of this work was realized with the collaboration
of Fondazione Giorgio e Isa de Chirico, Roma.

First published in the United States of America in 2023 by

Rizzoli Electa, a Division of
Rizzoli International Publications, Inc.
300 Park Avenue South
New York, NY 10010
www.rizzoliusa.com

Originally published in Italian in 2019 by La nave di Teseo editore, Milano.

© 2019 La nave di Teseo editore

All rights reserved. No part of this publication may be reproduced, stored in a retrieval system, or
transmitted in any form or by any means, electronic, mechanical, photocopying, recording, or otherwise,
without prior consent of the publishers.

For Rizzoli Electa
Publisher: Charles Miers
Associate Publisher: Margaret Rennolds Chace
Editor: Klaus Kirschbaum
Assistant Editor: Meredith Johnson
Managing Editor: Lynn Scrabis

ISBN-13: 978-0-8478-7238-1
Library of Congress Control Number: 2022944311

2023 2024 2025 2026 / 10 9 8 7 6 5 4 3 2 1

Printed and bound in Italy by Sincromia s.r.l., Roveredo in Piano (PN)

Visit us online:
Facebook.com/RizzoliNewYork
Twitter: @Rizzoli_Books
Instagram.com/RizzoliBooks
Pinterest.com/RizzoliBooks
Youtube.com/user/RizzoliNY
Issuu.com/Rizzoli

A labyrinth is a structure built to confuse men;
its architecture, rich in symmetries,
is subordinated to that end.
—Jorge Luis Borges

The enigma of art holds within itself the enigma
of the world, yet makes it formally practicable.
—Fabio Mauri

Contents

Abbreviations

Lettere	GIORGIO DE CHIRICO, *Giorgio de Chirico. Lettere 1909-1929*, a cura di Elena Pontiggia, Silvana, Cinisello Balsamo 2018.
Metafisica	*Metafisica. Quaderni della Fondazione Giorgio e Isa de Chirico*
Metaphysical Art	*Metaphysical Art. The de Chirico Journal. Fondazione Giorgio e Isa de Chirico*
Scritti/1	GIORGIO DE CHIRICO, *Scritti/1 [1911-1945]. Romanzi e scritti critici e teorici*, a cura di Andrea Cortellessa, edizione diretta da Achille Bonito Oliva, Bompiani, Milano 2008.

Foreword

"... I resume writing my memoirs, that is, narrating what I have seen, heard, and read over nearly three lustrums and expressing my opinion with clarity, sincerity, and courage on people and facts that ... I have had the opportunity to know and observe."

It may seem strange that after nearly forty years since the death of one of the greatest members of the twentieth century art scene, no informed, thorough publication has yet chronicled the life of Giorgio de Chirico in its kaleidoscopic entirety, from metaphysics to neometaphysics, from birth to demise.

Until now, the artist himself in *The Memoirs of Giorgio de Chirico* has been the only one to provide an account about his exciting and prolific journey without including scholarly discussion of his artistic phases. In his memoirs, as much as in his life, his career as an artist is depicted as a seamless thread that begins with his birth and evolves in numerous directions, all nourished by the same sap – a monographic account unifying a diverse artistic matter.

Gathering Giorgio de Chirico's life and work into a monographic study is a challenging task, and I believe Fabio Benzi has completed it with meticulousness, clarity, and scholarly rigor. This "essential," "clear," and "verified" account is the result of a lengthy examination of de Chirico's correspondence, sources, and works and is now ready to serve as an organizational matrix for the vast artistic and poetic-literary output of the *Pictor Optimus*, which will ultimately shed new light on the pressing *duel à mort* with André Breton which was continued by critics up to and beyond de Chirico's death. An exasperating swarm of prejudices, partisanship, and false truths kept alive, in part, by a lack of or insufficient knowledge of the artist as well as the man. A man whose difficult personality, sometimes gruff and often ironic, frequently elicited a negative response from critics who targeted their livid rage at the de Chirico's work, disdained the fruits of his "return to order," and distorted its meaning.

It is precisely thanks to this epiphanic monograph that Giorgio de Chirico's work is brought to life before our eyes and can be absorbed not only through words but also through the numerous images that enrich the pages of the present book.

Following the thread of metaphysical research, Fabio Benzi demonstrates how the artist's genius, unaffected by time and space, expressed itself through Nietzsche's theory of the eternal return of the same, explaining and redeeming de Chirico's practice of making copies and versions of his metaphysical subjects, and clarifying his habit of backdating.

"The metaphysical work of art is rather serene in its aspect, yet it gives the impression that something new must happen in this very serenity and that other signs, beyond those already manifest, must find place within the frame of the canvas. This is the revealing symptom of the inhabited depth. The flat surface of a perfectly calm ocean, for example, disturbs us not so much by the idea of the miles that extend between us and the bottom, but rather by all that is unknown and hidden within its depths. If this were not our idea of space we would experience only a feeling of vertigo as when we are at a great height."*

As vast as the ocean, the Giorgio de Chirico's career is returned to us at the end as it was at the beginning: a ceaseless exploration of a "continuous metaphysics" that pushes the *Pictor classicus* to navigate the waves of modernity and become a precursor and pioneer of future artistic trends. In this context, and in accordance with the ethics of a non-dogmatic truth supported and verified by historical documents, the Fondazione Giorgio e Isa de Chirico serves as a moderator of an ongoing dialogue between old and new generations of scholars. The goal of this ongoing investigation is to foster a virtuous and dialectical discussion of de Chirico's oeuvre that is devoid of narcissism, approximation, and resentment.

A first, long chapter of this story has just been written.

PAOLO PICOZZA
President of Fondazione Giorgio e Isa de Chirico

* Giorgio de Chirico, "Sull'arte metafisica," in *Valori plastici* I, 4–5 (1919): 18, English translation Joshua C. Taylor.

Preface to the English edition

This book was published in its first Italian edition in 2019. The English edition was scheduled to be released shortly thereafter, in 2020, but COVID-related complications delayed its publication.

Now, in 2022, it can finally see the light. Nevertheless, despite the pandemic and the fact that the two editions are chronologically close, many important studies on de Chirico have been published in the interim, the majority of which, I can proudly say, have been actively supported by the Fondazione Giorgio e Isa de Chirico, of which I am a member.

Therefore, it is important to summarize, albeit briefly, the new philological discoveries about an artist who never ceases to reveal new facets. Not that the book is outdated or outmoded in any of its parts, quite the contrary. Many recent publications have corroborated the overall interpretation advanced in it.

Firstly, a fact of paramount importance for the early history of de Chirico's art and the birth of metaphysical art must be noted. In 2020, the Fondazione Isa e Giorgio de Chirico acquired some of the artist's most relevant correspondence, that with his Munich friend Fritz Gartz, which precisely concerns the pivotal moment of the birth of metaphysical painting. As a matter of fact, these letters have been known for almost twenty years, but only through mediocre photocopy reproductions. No scholar had access to the originals. Unfortunately, this left room for ambiguity concerning the interpretation and even the date of many letters, leading some scoop-chasing "historians" to cause confusion about the beginning date of Dechirican Metaphysics and, therefore, of its natural context. The possibility of a different chronological ordering of the Fritz Gartz correspondence has given rise to long-standing disputes, which, in my opinion, were specious from the very beginning, born only because those who had promoted and misinterpreted them refused to acknowledge their initial, grave mistake. Now that important details have come to light, such as envelopes bearing exact postmarks, various inks employed, and other paleographic details, the sequence of the correspondence

has been completely and objectively established. While some dates could be misinterpreted due to mediocre xerography—together with the misleading antiquated dating system de Chirico used—there is no more ambiguity. All of this is conclusively and unequivocally demonstrated in the article that announced the acquisition of the correspondence and provided the correct chronological arrangement of the letters and the facts and ideas contained therein (see Paolo Picozza, "A Final Word on the Birth of Metaphysics," in *Metaphysical Art*, 21–22 [2022]: 9–14).

Meanwhile, important books conducting an in-depth analysis of two lesser-known moments of de Chirico's artistic career were published: Lorenzo Canova, *Il grande ritorno. Giorgio de Chirico e la Neometafisica* (Milan: La nave di Teseo, 2021), on the artist's final years, and Elena Pontiggia, *Giorgio de Chirico. Gli anni quaranta. La metafisica della natura, il teatro della pittura* (Milan: La nave di Teseo, 2021). In this way, once again under the aegis of the Fondazione, the most evident gaps in the study of the artist are being filled.

In two short essays conducting a preliminary investigation which I believe will open new avenues of research, I have presented several new documents and cultural findings concerning two different aspects of de Chirico's career: the first deals with one of the most formative moment of his life, that is the Florentine period (Fabio Benzi, "The de Chirico Brothers in Florence (1910–1911). The Musical, Pictorial, Literary, and Philosophical Context," in *Metaphysical Art*, 21–22 [2022]: 15–30); the second is an in-depth reading of de Chirico's famous novel *Hebdomeros*, its many labyrinthine allusions, and its international literary influence, which was much stronger than previously understood (Id., "Un'introduzione a Ebdòmero," in G. de Chirico, *Ebdòmero*, Milan: La nave di Teseo, 2019, IX–XLIX).

In addition, new research has been conducted on the journal *Metafisica/Metaphysical Art* concerning specific documents (single paintings or historical exhibitions) and unpublished correspondence (in this regard, de Chirico's letter exchanges with his mother, as well as with Gregorio Sciltian and others are especially important).

Despite the pandemic, several recent exhibitions have been dedicated to de Chirico. Although some of them were interesting, it must be said that they have not added to our understanding of the artist but have contributed to making his character more familiar to the public and disseminating his ideas—something that is extremely beneficial.

Despite the foundation's extensive activity, which not only promotes research on the artist but also protects the reliability of his works' authenticity, there are art dealers who, although convicted of peddling forgeries, act to

regain public credibility and, alongside art historians of dubious reputation, continue to pursue their own interests. In this regard, it's painful to mention that a self-styled *Catalogue Raisonné of the Work of Giorgio de Chirico* is being published in batches (Turin: Allemandi, 2019 and 2020). Its reliability is almost nonexistent, since it mixes established facts and unverifiable claims; features no bibliographical references later than 1955 (!); invents untraceable paintings accompanying them with specific descriptive essays; attributes dates (even specifying the month) without the basis of documentation; and states the provenance and date of a work of art without documentary support.

If it is not appropriate to speak of such miseries, which unfortunately appear to perpetuate a negative attitude against which de Chirico fought in his final years (as reconstructed in the book), it is unavoidable to mention them while sketching a panorama of studies oriented in a more positive and productive direction.

We hope that the English edition of this book will foster a more detailed understanding of all phases of de Chirico's art, which in anglophone scholarship has unfortunately been restricted primarily (though with notable exceptions) to the best-known Metaphysical phase (1910–18). This is due mainly to a prejudice spread immediately before the outbreak of World War II and fueled by a resentment against de Chirico harbored by André Breton, who was able to propagate an aversion towards the artist in the contemporary art world. Although many of de Chirico's fellow artists and friends (including Marcel Duchamp, Max Ernst, René Magritte, Francis Picabia, Jean Cocteau, and others) opposed Breton's position, his sentiment prevailed, overshadowing the later stages of research into de Chirico's life and work, which was based on a remarkable consistency of thoughts and objectives—although imbued, especially in the last years, with a corrosive and occasionally misleading caustic spirit. Perhaps, this did not help foster a better understanding of de Chirico or his work. In this sense, we hope to have removed many of the obstacles preventing an in-depth knowledge of one of the greatest and certainly most influential artists of the twentieth century.

Introduction

Why publish a monograph on Giorgio de Chirico today? The reasons are many and varied—first, to represent his entire artistic journey in greater detail than has been attempted for some time, beyond the scope of an exhibition catalogue where the thread of continuity is lost in the variety of individual essays. No other modern artist has suffered more from the fragmentary treatment of the different phases of his work, the consequence of which has been a loss of perspective.

Though de Chirico was initially appreciated only for his metaphysical period (1910–18), his art of the second half of the 1920s in Paris was later reevaluated in a positive light. Phases such as the classicism (*rappel à l'ordre*) of the *Valori Plastici* (1919–22) period have been neglected, as has been his subsequent "romantic" period (1922–24). The themes of his work from the 1930s have received attention in the wider context of those years, but the imagery of the 1940s continues to be almost unknown. De Chirico's work of the following decade (that of neo-baroque inspiration) has been more or less tolerated, which brings us to his final, neometaphysical phase, which has generated, on the contrary, a certain amount of interest. In short, repeatedly thrown on the Procrustean bed of twentieth-century art criticism, de Chirico's practice as a whole—which has benefited from significant in-depth sectoral studies—has only received piecemeal attention and has never been treated in a thorough monograph: that is, a unified and all-encompassing analysis of the development of his art over the course of its seventy years (perhaps a somewhat démodé undertaking today, given the tendency toward increasingly compartmentalized studies of single periods in artists' careers). Such a schizophrenic treatment of de Chirico's work was actually unjustified, for despite his character flaws, the artist himself was certainly not schizophrenic.

Hence, as a corrective impulse, we must start from a unified principle—something that will surely have a positive effect on future research, by virtue of the fact that it provides a global and uninterrupted vision. Certainly, the

complexity of his labyrinthine personality poses many difficult questions, and his favored themes—mystery, dreams, and the irrational—make a methodical approach difficult. But an obstacle represents something to be overcome in historical investigation, not something that is taken as a given and reinforced.

De Chirico's markedly polemical attitude, which sometimes led him to reject positions he had previously endorsed, has caused his changes of taste and perspective to be considered unhinged (whereas those of other artists have been seen as normal). Similarly, the controversy surrounding the forgery of his work has generated rumors about him that have been used for personal gain by people of questionable intentions as well as others above suspicion, resulting in a distorted image of his personality and introducing a twisted and contradictory historical-critical outline that has formed the basis of the principal considerations of his art for years, even decades. Deforming and partial (albeit not without brilliance at times), this warped outline has become incomprehensible over time and with critical distance. Certainly, much of the bitter criticism—incompatible with the deontological honesty required of the art critic—that we will encounter and analyze over the course of these pages can only be explained by de Chirico's difficult character; otherwise it would be impossible to account for the many significant attacks against, and misrepresentations of, one of the most important artists of the twentieth century (certainly, the most important Italian artist). But as we shall see external factors also come into play—for example, in regard to the falsification of de Chirico's works, which his astonishing cosmopolitan mobility facilitated: working in locations he would later leave behind undoubtedly enabled the proliferation of forgeries.

Another determining aspect concerns a number of commentaries with clear philological shortcomings that have appeared over the years, which, due to editorial workings that every historian is familiar with, have contaminated the interpretation of the artist's work. Errors, repeated ad infinitum, presenting distorted readings that are reiterated as if by parthenogenesis, have hindered an accurate reading of the artist's work. These errors, mixed with an infinite quantity of original documentation, have created a tangled mess that requires unraveling for the sake of the historical record.

In its fundamental form, the present monograph refers to documentary material while avoiding the cumbersome reproduction of the material consulted. Intended as a basic system of reference from which errors and distortions have been filtered out, it constitutes a framework that is essential—clear and verified. The institutional responsibility of the Fondazione Giorgio e Isa de Chirico, of which I am a member, is to present an accurate

interpretation of the artist and his oeuvre. I do not claim that the present volume represents the only possible reading, as scholars are naturally free to offer their interpretations, something de Chirico's personality fortunately allows for with unlimited amplitude. But a historical reading must be based on objective data, not that which has been distorted.

The present volume is not simply a collection of established historical facts presented and examined in a chronological order. It also offers much that is new, especially in the examination of de Chirico's art, such as the ordering and dating of his early Arnold Böcklin–inspired production, as well as an objective analysis of the genesis of metaphysical art and its many phases, which, instead of providing a mere summary, brings to light its constant evolution. A thorough consideration of the Return to Order (*rappel à l'ordre*) period has been undertaken, as well as an accurate and documented account of de Chirico's relationship with the surrealists, which is astonishing to say the least. The historical and intellectual climate of the period following the Second World War and the question of replicated metaphysical paintings are also examined, including aspects of art history criticism that are extremely significant in relation to the artist's story. Some thorny interpretive aspects have not been overlooked, instead receiving deserved attention when particularly advantageous, including analyses of metaphysical art's original masterpieces, not least *The Disquieting Muses*. Also provided are reasoned hypotheses concerning the issue of forgery, along with a new reading of the artist's "baroque" period, in light of previously unknown material, as well as a discussion of numerous baseless interpretations. One might object that certain arguments have not been adequately addressed, that some aspects of de Chirico's life or work have not been dissected as closely as they might merit or that some bibliographies have not been discussed. However, the scope of the book did not allow for this, and every effort was made to avoid the sterile polemics on which some recent bibliographies have been based. A decision to favor linear clarity was made in order to avoid being diverted by discussions that would have required dozens of pages distracting unnecessarily from the primary exegesis, the text's most important aspect. The path laid down, in the final analysis, is much more coherent and logical than one might think thanks to reference to verifiable and incontrovertible information. This has resulted in an unequal amount of attention being given to the various periods. Historical-critical requirements and the relative in-depth analyses caused me to choose an organic narrative for topics and new developments in regard to their historical relevance, rather than an abstract, parataxis symmetry. By such means, it was possible, even amid the contradictions of a complex personality, to present an image

of this great artist and his true intellectual journey according to documentation that is clear, concrete, and "cleansed" of both ancient and more recent encrustations.

The bibliography concerning Giorgio de Chirico is truly immense. During the many years I have dedicated to studying the artist's work, I believe I have examined all of the available sources, and I refer to those contributions that have provided the most useful information and interpretations in my notes to the text. I deemed a bibliography unnecessary, as it would have required a separate volume in order to be anything other than a summary. There seemed to be no justification for this and, as stated, the notes provide details on the most significant and enlightening texts, as well as those whose errors and misinterpretations—which de Chirico scholarship is riddled with—necessitated further discussion. As we shall see, while contributions of an extraordinarily high standard were made during the artist's lifetime, others were marked by aggression and cynicism, negatively influencing the evaluation of his work. Yet even prior to his death, attempts were made to restore a less biased reading. For example, Austrian scholar Wieland Schmied presented the first major de Chirico retrospective at Milan's Palazzo Reale in 1970, chronicling the artist's entire artistic and intellectual journey without prejudice. In 1971, Claudio Bruni Sakraischik began to publish the fundamental *Giorgio de Chirico: Catalogo generale* (which ran to seven volumes up to 1983), initially in collaboration with the artist himself and, following his death, with the advice of de Chirico's wife Isabella (Pakszwer) Far and art historian Giuliano Briganti. In 1986, Isabella, together with Bruni Sakraischik, established the Fondazione Giorgio e Isa de Chirico, which has remained the cornerstone of research and of safeguarding the artist's legacy. The following year saw the publication of volume VIII of the *Catalogo generale*, which, like the earlier volumes, was organized along the lines of the model established by Christian Zervos's catalogue of Pablo Picasso's work and conceived as a *liber veritatis* intended to gather information concerning works belonging to both private collections and those of museums. In recent years the foundation has continued this work, publishing fundamental bibliographical research for artworks not included in Bruni Sakraischik's eight volumes that have come to light during the ongoing study of de Chirico's oeuvre and have been authenticated by the foundation over the years.[1]

Sometime around 1978–80, a number of young Italian critics, such as Maurizio Calvesi and Maurizio Fagiolo dell'Arco, began examining and verifying existing interpretations of de Chirico's work, which they pursued despite being aligned with critic Lionello Venturi's school of thought and the teachings of artist André Breton and scholar James Thrall Soby. Their

research initially focused on the metaphysical art, de Chirico's important and innovative nucleus of work, and expanded over the years to include subsequent periods. Their reexamination of phases of the artist's career that had been neglected, minimized, or even ignored, was carried out using a document-based method free of bias.

In 1982, Calvesi published *La Metafisica schiarita*,[2] which remains a fundamental contribution to the analysis and interpretation of that period (preceded in 1981 by *La Metafisica. Museo documentario*,[3] a prologue to the later text). Subsequently, other publications explored later phases of de Chirico's work, including his final neometaphysical period.

For his part, Fagiolo dell'Arco began to reexamine both the metaphysical period and the period that followed the First World War, up to the time of de Chirico's encounter with surrealism. His research was published in three small volumes: *Giorgio de Chirico: Il tempo di* Valori Plastici *1918–1922*,[4] *"Le rêve de Tobie" 1917—Un interno ferrarese e le origini del Surrealismo*,[5] and *Giorgio di Chirico: Il tempo di Apollinaire. Paris 1911–1915*.[6] These were followed by focused studies of later periods: *Giorgio de Chirico: Parigi 1924–1929*[7] and *De Chirico: Gli anni Trenta*.[8]

In light of important new documentary evidence, certain aspects of Calvesi's studies require slight amendment and modification (in terms of detail rather than substance). Fagiolo dell'Arco's studies also contain numerous inaccuracies and misinterpretations. However, both scholars have shown a willingness to examine afresh the artist's towering figure in a manner uncontaminated by precedent and somewhat negative polemics. Some of Fagiolo dell'Arco's contributions, especially those made in collaboration with the art dealer Paolo Baldacci, have given rise to very serious controversies concerning the forgeries they include.[9]

In more recent years I have contributed to the reevaluation of the different phases of de Chirico's work. An exhibition in 1992 at the Palazzo delle Esposizioni in Rome[10] presented, for the first time since the Milan retrospective of 1970 (when the artist was still alive), every period of his career with equal dignity and approximately the same number of works, allowing an objective and linear overview of his oeuvre.[11]

From 2002 onward, the foundation has published important contributions to the study of the artist's oeuvre in its periodical *Metaphysical Art— The de Chirico Journals*, including de Chirico's letters to André Breton and Paul Éluard, edited by Jole de Sanna, which brought greater clarity to the question of the artist's complex relationship with surrealism. Throughout the pages of this journal, many aspects of de Chirico's infinitely faceted personality and art have been discussed and studied, together with the publi-

cation of fundamental, previously unknown epistolary material and documents.[12] Such documentation has helped provide a clearer picture of the artist's relationships in the context of contemporary events and the ongoing and complex evolution of his ideas, which has often resulted in the resolution of historical uncertainties and misattributions. The foundation has also underwritten a series of studies of significant documentary and technical interest.[13]

In short, the obscure reasons for which de Chirico's work was considered to have been of fundamental importance for a period of just eight years (those corresponding to the metaphysical phase of 1910–18) have been gradually dismissed. However, the absurdity of such attitudes—which have no equivalent in twentieth-century art history—is astonishing. Artists such as Kandinsky, Miró, Malevich, Braque, Léger, Grosz, Dix, and countless others, whose work underwent radical stylistic changes and even sharp declines in quality following their initial innovative achievements, have never been subjected to the kind of vociferous criticism directed at de Chirico.

Nevertheless, even in recent times *l'affaire de Chirico* has been revived with methods reflecting the conflicts that took place in the 1920s. A high-profile publication by Paolo Baldacci reopened questions that, once again, have much more to do with the art market and the mindset of its author than they do with art history. However, the volume is not without merit due to the amount of information it contains.[14] Substantially tracing and expanding on *La Metafisica. Museo documentario* (1981)[15] and on Fagiolo dell'Arco's 1984 volume, *L'opera completa di de Chirico 1908–1924*,[16] Baldacci summed up the numerous biographical and documentary acquisitions that had been made over the course of previous years. But in basing his study on recently rediscovered correspondence between de Chirico and his German friend Fritz Gartz, a fellow student at the Munich Academy, which he interpreted incorrectly—due to an inability to navigate its chronological and paleographic trappings—Baldacci claimed that the invention of metaphysical art occurred in 1909, in Milan, rather than in 1910, in Florence, where it actually took place (accusing de Chirico of methodically lying from the beginning). As a consequence of this, he even stated that the metaphysical art was the joint invention of de Chirico and his brother, Andrea (known in artistic circles as Alberto Savinio). In so doing, he paradoxically repurposed an assertion that, as we shall see, constituted Breton's final attempt to smear de Chirico, his sworn enemy, in 1938: a point of view that even James Thrall Soby, although completely taken with Breton's vision, scornfully rejected as completely untenable.[17] This alteration of historical truth—despite being contradicted by serious studies—has been taken up in a rather haphaz-

ard manner by a number of authors associated with Baldacci, either out of naiveté or for other incomprehensible reasons.[18] Although Baldacci has recently been forced to retract his erroneous dating of one of the artist's letters to Gartz—the only "philological" data he had in support of the improbable backdating of the birth of metaphysical art to 1909[19]—his anger toward those who had defended de Chirico's reputation at the time (first and foremost, the foundation) has seen him continue to uphold his doubtful backdating of metaphysical art, as well as his assertion regarding the dual formulation of its aesthetic principles, something that Savinio himself had never dreamed of putting forth. Following his expulsion from the foundation, with which he was associated for a time, Baldacci has pursued—*toute proportion gardée*—the aforementioned Breton–de Chirico scheme, which will be discussed in detail in this book. Breton's discrediting of de Chirico's judgment concerning his own paintings, subsequently upheld by Baldacci, created a climate favorable to the authentication of forgeries. It was a trap into which the latter dramatically fell and has been convicted for having knowingly placed a significant number of fake paintings on the market.[20] Furthermore, his book's reconstructions of individual paintings are also unreliable in their blending of real and supposed data, thereby preparing the ground for further dubious authentications in the future. Yet the credit gained from the publication of this book, which contains a fair amount of interest in regard to de Chirico's Ferrara years, made it possible for the author to introduce disconcerting forgeries in the various exhibitions on which he collaborated, even managing to keep the principal curators in the dark.[21]

The relationship with his brother Savinio has often, for convenience's sake, been interpreted as being an intellectual course that is perfectly parallel and overlapping to that of Giorgio. As they lived for many years together with their mother, it seemed easy and fitting to use Savinio's writings and memoirs as a basis for explaining Giorgio's works, creative phases, and encounters. This arbitrary approach has led to them being thought of as interchangeable twins, yet this was never the case. The absence of the letters de Chirico received (which were evidently lost in his frequent relocations, or not saved for other reasons) has also left historical gaps that cannot always be filled. However, if analyzed carefully, de Chirico's handwritten letters—preserved in archives around the world—are of a quality and accuracy that is manifestly verifiable: not only did he not lie, he indeed wrote with enviable mnemonic precision.[22] Savinio, three years younger than de Chirico and of a different temperament, was in fact greatly indebted to the guidance of his older brother, who lovingly introduced his philosophical references (Nietzsche, Schopenhauer, et al.) to his adolescent brother. No

tangible collaboration has ever come to light: the sense of pride, and perhaps self-esteem, of both men always prevented this, except in the difficult stages of Savinio's musical endeavors, when Giorgio generously assisted his brother. The only thing that can be discerned in Savinio's much later pictorial activity (from the second half of the 1920s on) is his frequent and literal revisiting of many themes from the work of de Chirico, who never ceased to encourage his brother. Resisting the temptation to interpret one brother with the words and experiences of the other is more than a necessity—it is a duty. However, it can sometimes prove useful to consider thematic overlaps when attempting to clarify certain details.

My own relationship with de Chirico began when I was four or five years old: his cousin, Fernanda Floquet, gave me my first lessons in painting and art history. She lived in a house by the sea next to one that belonged to my family, where I spent part of my holidays and where de Chirico was a frequent guest of my parents. It is in this context that I met the artist. Since then, many people have assisted me in the study and in-depth analysis of his art. It would be truly impossible to mention them all individually, so I thank them collectively. But I would like to give a special thank you to Paolo Picozza, who over the course of the years of writing this book has constantly encouraged me, and to Katherine Robinson, who reread the text in detail while reviewing the English translation, and to all the friends of the foundation who have assisted me in this long endeavor.

Preface:
"Eternal Return" / "Eternal Avant-Garde"

Considering de Chirico's seventy-year-long artistic journey, one of the thoughts that comes most insistently to the scholar concerns the amazing variety of his styles and the synchronicity that often characterizes them. One could make a similar observation looking through Picasso's catalogue, noting how the multifaceted activity of a genius can bridge an epoch like the twentieth century and be in no way comparable to the work of artists of earlier ages. The "brief century" with its contradictions, its two world wars, the dizzying progress in thought, technology, and science is in no way analogous to anything that came before. It is therefore logical that those figures who best reflect this century and who felt its perturbations more than others, cannot be measured against figures of the past (or, indeed, many contemporary figures) with their wholly compact and homogeneous styles.

Nevertheless, for de Chirico, several fundamental questions persist and are burdened, even recently, by a prejudice that only the new century seems able to take on. Now that the monolithic, progressivist, and evolutionist vision of modern art is long surpassed, fallen down like a dilapidated Berlin Wall, fixed ideologies that appeared untouchable only a short time ago are being challenged. Above all, de Chirico, whose behavior apparently seemed out of line with his contemporaries, no longer appears as a unicum. Historical distance allows for an understanding of the similarities to be found among apparently differing positions and how these actually draw on analogous stimuli and insights that only time can bring into focus.

Among the foremost artists of the twentieth-century avant-garde, in 1910 de Chirico fine-tuned a vision, "metaphysical art," which, together with those of his contemporaries Picasso, Matisse, Kandinsky, Balla, and Malevich, constitute the great pillars of contemporary art. In particular, de Chirico, while avoiding formalist and abstract research such as the chromatic and expressionistic exaggerations of his great colleagues, projected his own quest into the theretofore unexplored territories of the dream, the mys-

tery of the world and of memory, thus tracing a high road that would lead to surrealism and to all artistic expression that refers to the unconscious.

De Chirico's journey, full of side steps and revolutions, was extremely varied in its devotion to the full freedom of artistic research. His tenacious autonomy was a luxury that cost him dearly, with hostility shown by companions who felt betrayed by his disdainful capacity for research. Apart from appearances, it was a path of research that was always one of absolute modernity, even when he seemed to be inspired by the past. His references to classical eras, to the antique, which was indeed a central aspect of metaphysical art, seemed increasingly aimed at the avant-garde, which he had helped create but went on to consider dated and obsolete. The bitter pill of polemic also gave each of his actions the nodal, semantic chrism of the avant-garde. Thus, with ingenious disdain, he showed that modernity is a way of being, not an immobile formula or a mere stylistic goal, and that, in the absolute relativity of the world, to return to the past could be more modern and avant-garde than pursuing already exhausted avenues. The invention of metaphysical painting harked back to an ancestral time of human dawn; it was a sounding line cast before historical time, and therefore somehow outside of time. De Chirico found a way, through Nietzsche's philosophy of the Eternal Return, of expressing his genius as if he were outside time, something he did while looking with profound interest and curiosity (sometimes polemic) to the events of his day. This balancing act produced one of twentieth-century art's most modern and disquieting bodies of work. As Maurizio Calvesi has written:

> The artist carried out a true revolution of the subject; of the explicit, narrative subject which painting is called upon to illustrate. Indeed, de Chirico replaced this subject with one that was unreachable and enigmatic, as if suspended above the painting, or rather, he identified the subject within the enigma itself. Nevertheless, it is not an enigma—a problem that is subject to a solution—but an enigma-spirit state which is irreducible to a determined state. Even though the pictorial image is not abstract and purely formalist (and thus an end in itself), but is, in fact, "representative" of something and does present a "subject," it does so without putting forward a definable meaning. In the final analysis, what it expresses is a "non-sense" and as such raises the doubt whether "non-sense" is the foundation of reality. Instead of a subject which "explains" the painting or a subject that is absent and insignificant—which is the case of the Cubists—the subject causes the painting to become a mirror of mystery, one that hangs a question over painting itself, folding it into incongruent spatial solutions, alarming combinations of color, voids and shadows of silent resonance. Universal non-sense is the great suspicion that dwells within

the young de Chirico's soul; it hides profound meaning, the unreachable or nothingness. As a devoted Nietzschean, de Chirico verges on gratuitous nihilism but redeems it with a taste of great poetry.[1]

It appears difficult today to undertake a monograph on de Chirico without taking into account the historical-critical issues of his time that not only relate to him in a general sense, but that also directly involved him, drawing him into intense controversy throughout much of his life. These also lead to an exhausting struggle with falsehoods, prejudices, personal dislikes, and bias that was unusual if not unprecedented in the twentieth century. Understandably, no study of an artist can disregard an artist's critical and philological history, but in de Chirico's case this aspect assumes dimensions that are as gigantic as they are paradoxical. Such critique began in 1926 when he found himself in opposition to André Breton and a number of surrealist artists, a conflict that would see him both acclaimed and denounced, insulted and imitated. In truth, almost a century after its spark, this ideological war speaks to us, more than anything else, of the truly colossal stature of the artist rather than the validity of the reasons behind this polemic. Moreover, would the subsequent attacks to which de Chirico was subjected have been so malicious if he had truly been so insignificant in his later years? Nevertheless, as we shall see, the ambiguities arising from this attack did not die with its protagonists: even in more recent research, the climate created by a process of systematic denigration has proved to be fertile ground for the deployment of insidious arguments that some have taken to be true, thereby continuing the defamation of one of the most important figures of twentieth-century art.

It is also true that the very sense of mystery and enigma that characterizes de Chirico's art and thought has been used to foster ambiguity about his work, even though there was no reason to use this quality of his personality and art—which appeared in the form of a heraldic motto inscribed in his first self-portrait of 1911 ("*Et quid amabo nisi quod aenigma est?*" [And what shall I love, if not that which is enigma?])[2]—for other purposes. Therefore, the aim of this monograph is also—indeed, above all—to represent de Chirico's figure in linguistically correct terms, while remaining aware that the enigma is a Gordian knot so complex that no one will ever succeed in unraveling it completely, and it is in this that the enormous value of his work consists.

The de Chirico family, ca. 1900.

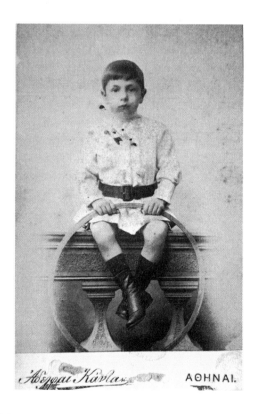

Giorgio de Chirico with hoop, ca. 1894.

1. Education in Greece

Giorgio de Chirico was born in Volos, Thessaly, in northeastern Greece, on July 10, 1888. His birthplace was not a chance occurrence since his family, although Italian, had been deeply rooted in the cosmopolitan Middle Eastern milieu for generations. His father, Evaristo, was born in Istanbul, where the family chapel is situated in the Katolik Mezarliği cemetery. His mother, Gemma Cervetto, was probably born in Smyrna, although her family was of Genoese origins.[1] His grandfather was a dragoman (an official translator) for the Russian czars of the Sublime Porte, as well as representative of the kingdom of Sardinia.[2]

The family was well off, although not immune to the occasional economic instabilities of life. In a book written by Savinio, *Infanzia di Nivasio Dolcemare*,[3] he gives an extensive account of the cosmopolitan atmosphere of their childhood among bizarre characters living as expatriates amid uncertain wealth, artistic expedients, and consolidated fortunes. Several languages besides Italian were spoken at home, which represented their ever-present origins, including Greek[4] (of which traces could be heard in interviews with the artist even late in life); French, the language of study and conversation; and German.[5] In Greece of the time, German was linked to the first king, Otto, born into the Bavarian royal family, and to the continuation of the European cultural bonds instituted and consolidated in that initial period, which were not phased out by the arrival of King George I (1863) who was Danish by birth. A few words of Turkish and English were surely also spoken at home, making for an extraordinary summary of Europe.

Giorgio's father was a civil engineer, who studied in Italy and was accredited in London and who built railways, first in Italy, Bulgaria, and Turkey, and then in Greece. Had Giorgio not been born in Volos, where his father was working at the time, he would probably have been born in Athens, like his brother, Savinio. The fortuitousness of his birth was decidedly relevant. In addition to his Italian origins, as a young man de Chirico felt deep cosmopolitan, Anatolian, Middle Eastern, and Mediterranean roots, not as oc-

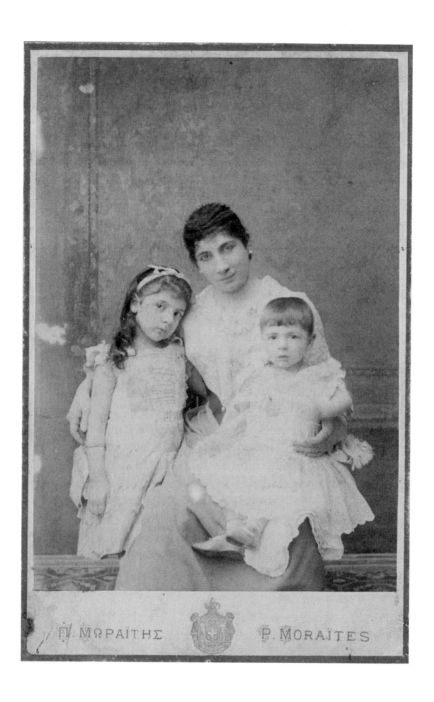

Gemma Cervetto de Chirico with daughter Adelaide (who died in 1891) and little Giorgio.

casional expatriate events, but rather as decisive and experience-oriented necessities with a hereditary quality to them.

To understand the thread running through the whole of de Chirico's art we must always keep this international upbringing in mind: his ability to feel at ease in different cultures allowed him to move freely not only in Europe and the United States but also in the most disparate territories of art. From his Greek childhood he drew the unifying sense of Greek myth that certainly constitutes the most continuous, determining, and ideal fulcrum of de Chirico's aesthetic vision and which more than any other aspect succeeds in binding the artist's different works and periods, the intentions and manifestations of which can appear very distant at times. Among the multiple elements simultaneously present in the oeuvre of the artist, it is perhaps myth that bears the most outstanding significance: like one of those Freudian complexes which, in their most intense forms, seem to be able to steer an entire existence in a univocal set of choices.

For de Chirico, however, myth is not mythology, a grouping of complex tales and fables, but rather all that mythology represents as symbol and metaphor, archetype and philosophical allusion. Before gaining direct knowledge of Freud (in a more or less contemporaneous period), de Chirico drew up a system of symbolic, psychic, and archetypal references that summarize the meaning (always mysterious and inexplicable) of human existence by actually drawing upon the same primordial insight that led to the birth of the Homeric fables and Greek tragedies. These impressions were soon consolidated by his reading of, and passionate adherence to, the philosophy of Friedrich Nietzsche, who considered Hellenism to be one of the foundations of contemporary European thought. The influence of neo-Greek thinking and literature on the young artist has always escaped scholars of de Chirico's work, who have tended to focus on the analysis of Greek figurative culture of the time (of little importance in terms of his development). This influence, impossible to establish through documentation or testimonies that are totally lacking, can only be presumed by reference to the environmental context and what one might term circumstantial evidence. For instance, one of the great twentieth-century Greek poets, Kostìs Palamàs (at that time already considered to be the greatest living Hellenic poet), was not only associated with that highly cultured and specialized milieu to which de Chirico himself belonged but had come to be considered a symbolic public figure by many young people—above all, university students like the young Giorgio—around the turn of the century. Indeed, his writings in favor of the "vulgar" *dimotikì* rather than the nobler *katharèvusa* language led to street battles in 1903 (resulting in a number of deaths) between progressive

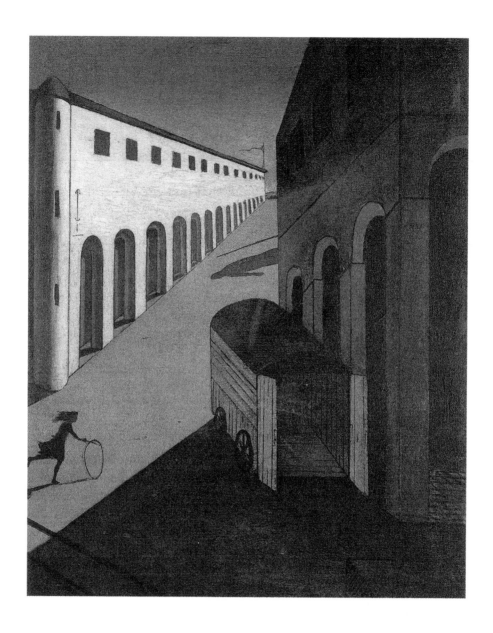

Mystery and Melancholy of a Street, first half of 1914,
private collection.

The shadow of the girl with the hoop recalls the premature death of his sister.

and conservative students at the University of Athens, of which Palamàs was secretary-general. It is not known whether Giorgio de Chirico participated in these clashes—in 1903 he was enrolled at the Polytechnic—or, if he did, to which side he was sympathetic. Nevertheless, the poet Lorèntzos Mavìlis[6]—a cousin and close friend of de Chirico's father (the son of his mother's brother)—was firmly in agreement with Palamàs; accordingly, we can presume a certain sharing of opinions on this point. As a young man participating in the capital's cultural life, and who attended the Polytechnic, he could not have been unaware of the greatest Greek writer and polemicist of the day, whose ideas inflamed the minds of his fellow students and much of Greece's intelligentsia.[7] The thought and poetry of Palamàs, deeply nourished by the ideas of Nietzsche, modernized ancient Greek culture and gave it contemporary relevance, creating a strong sense of identity. Both this possibility of a synthesis between modern and ancient Greek culture, and the references to Nietzschean philosophy, would have had an impact on the young artist's sensitive soul during the early years of his education, enabling his later exploration of these themes in great depth.

The meaning of childhood, understood as a whole and filtered through the philosophy of Schopenhauer and Nietzsche, as the infancy of the world, of humanity, and of the artist himself, governed his poetics transversally: childhood as the crucible of archetypes, as the sense of a primordial discovery, as initial form of knowledge without prejudice, as a pure and ancestral state of consciousness—a childhood that had its spatial and temporal location in Greece at the turn of the twentieth century. Like Freud, de Chirico understood that the meaning of a life is indissolubly linked to childhood by powerful and unbreakable bonds. The images of Athens and Volos, of Olympia and Delphi would stir de Chirico's imagination over the course of his life.

Athens and Greece were impressed on his mind in a complex and indelible way and were recalled by the artist with enthusiasm throughout his life, including the later period: "Then again, the landscape of Athens (that magnificent city) strongly contributed to orienting his spirit to the romantic, enigmatic and obscure side that was the truly vital source of Greek classicism";[8] "It is certain that all these spectacles of exceptional beauty that I saw in Greece as a boy, and that were the most beautiful I have seen in all my life, made a very deep impression on me and remained powerfully impressed on my mind and thoughts."[9] The contrast between ancient ruins and modern industrial buildings, bristling with chimneys, was characteristic of the Gazi district,[10] whose industrial complex—adjacent to the monumental cemetery of Keramikòs (not yet excavated at that time) and in view of the Acropolis—first provided public electricity to the city. This caught de Chirico's imagination as

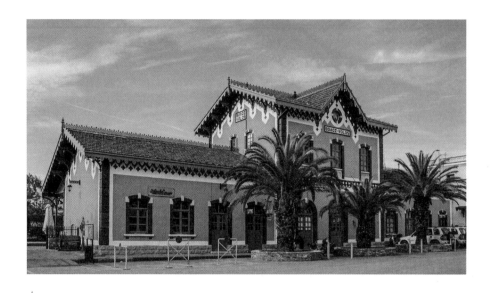

The Volos train station, designed and built by Evaristo de Chirico in 1882.

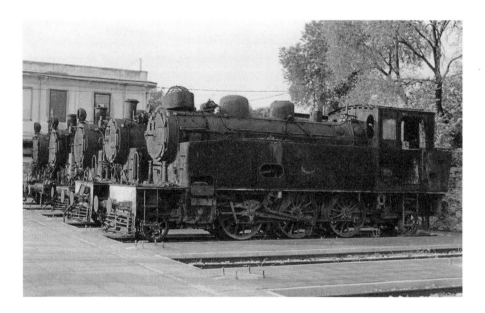

Trains in the Railway Museum in Volos.

ATHÈNES. Place de la Constitution.

13970.

Syntagma Square with a view of Mount Lycabettus in a photograph of 1910. De Chirico lived for a while in one of the houses on the left during his stay in Athens.

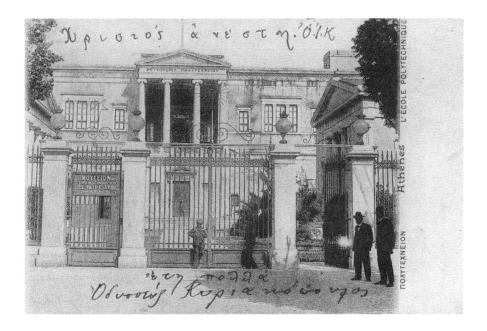

The Polytechnic of Athens in a photograph of 1910.

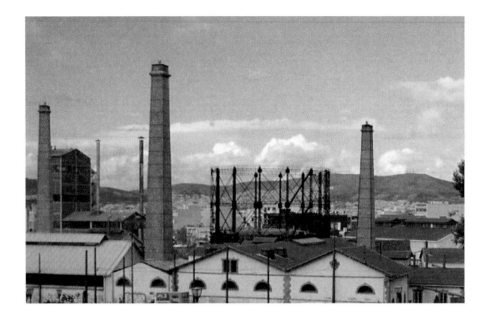

View of the Gazi factories of Athens.

much as his father's locomotives and railways along with other details of the city: a neoclassical architectural hybrid rendered contemporary through daily life taking place among constant reminders of antiquity, where the streets were (and still are) named after the ancient gods (Hermes/Ερμού, the main shopping street; Athena/Αθηνάς, etc.) and where the houses bore effigies in stone or terracotta, in a forest of antefixes, acroteria, tympana, and columns.

So, de Chirico's early studies, immediately directed toward drawing and art, occurred between Volos and Athens:[11] he took lessons from the Greek painter Mavrùdis, the Italian Carlo Barbieri, and the Swiss Jules-Louis Gilliéron, teachers of an honest yet amateurish and academic value who are today long forgotten. After studying privately and at the Leonino High School of Athens, he enrolled at the Polytechnic's Fine Arts School, initially intent on becoming an engineer like his father, but painting gained the upper hand, and his parents indulged his inclinations.[12] His teachers at the academy had all been educated at the Academy of Fine Arts in Munich, a city in which they had spent long periods, and represented a link between modern Greek painting and the new expressive modes of the Continent. In other words, they embodied the idea of modernization of the Greek state of arts into a language that ideally laid the way, through a chiefly Central European connection, for a renewal of Greek art, which until that time had been connected with the painting of sacred icons.

Solitude, 1917,
Museum of Modern Art, New York.

Konstantínos Volanákis, Geòrgios Roilòs, and Geòrgios Jakobìdis were de Chirico's three main teachers at the academy. We would search in vain, however, for influences of these artists on de Chirico's mature painting, although certainly in his first efforts (now completely lost) he must have been a devoted follower of the academic realism expressed in Volanákis's landscape paintings, Roilòs's more refined and intellectual scenes animated by a familiarity with Parisian impressionism, and Jakobìdis's portraiture and genre scenes (of an obsolete bourgeois style). As we shall see, elements of traditional icon painting, which the young de Chirico must have experimented with, would enjoy a more intriguing reprise in the Return to Order period of the early 1920s and are to be understood as the final manifestation of a Greek origin in his painting. The painting of icons was moreover practiced by one of his closest friends and colleagues from Athens, Stàvros Kantzìkis. Other friends from those days, whom he met, perhaps not coincidentally, in Munich and Paris on his subsequent travels, were Dimìtris Pikiònis, a leading twentieth-century Greek architect and one of Europe's greatest, and Geòrgios Bouziànis, who moved to Munich and became a secessionist and expressionist.

The many documents still emerging regarding de Chirico's adolescence and youth reconstruct a biographical outline that is more meticulous than substantial: the academic stimuli were in fact limited to a scarcely experimental routine, but the young de Chirico was already distinguishing himself, and not only for his spontaneous approach to some of the future exponents of the best avant-garde Greek art of the twentieth century. In fact, an area that deserves greater investigation, as mentioned, is the link with Greece's vibrant literary and philosophical milieu.[13]

It was above all the atmosphere one breathed in Greece, among immanent myth, memory, and contemporary culture (a concentration of which was seen in Palamàs, as previously discussed), that formed a strange and unprecedented blend in de Chirico, which, together with a predisposition for cosmopolitanism, set him on the road to a restless search for newness and for cultural roots to interweave, an attitude he would share with other great contemporary artists. From the cultured outskirts of Europe, the greatest wind of innovation of the new century was arriving at its major centers: Picasso from Spain, Kandinsky from Russia, Marinetti from Egypt.

2. Munich: Between Academic Restrictions and Intellectual Development

When de Chirico's father, Evaristo, passed away in May 1905, the family was left deeply shaken, their finances stagnant, though they were certainly well enough off. Evaristo had been directing the construction of the railway between Athens and Thessalonica, and his work, together with what he had already undertaken in Thessaly, Turkey, Bulgaria, and earlier in Italy, must have left a small inheritance. It was costly to maintain life at an appropriate social level for widow Gemma and her two sons. Without savings to rely on, their income lasted until the 1920s,[1] so that they were comfortable but without luxuries. At the time of their father's death, Giorgio was not yet seventeen and his brother was thirteen and a half. There being no evident reason for staying in Greece, their mother decided to move to Munich in September 1906, where they arrived in October, after freeing the family of its commitments and property in Greece.

The decision was undoubtedly taken to further young Giorgio's career.[2] By enrolling at the Academy of Fine Arts, de Chirico followed upon the crucial and almost obligatory path of his polytechnic teachers. Munich was, in fact, culturally more influential than Paris for Eastern Europe: Kandinsky himself, arriving from Russia, had undertaken his early training as a painter in the German city. This landing was however of no concern to de Chirico's brother, who continued to study music privately, first with Max Reger and then with other musicians. He could easily have studied composition in Italy, the ancient land not only of the de Chirico family, but also of *bel canto* and music, which Gemma and her sons had visited with stops in Rome, Milan, and Venice on their way from Athens to Munich.

De Chirico's stay in Munich constitutes the second touchstone of his artistic culture. Little is known about the period except biographical data, addresses, and some acquaintances, of which there were certainly others, as only a few emerge from the artist's *Memoirs* and from documentary sources. The salient points are the following: de Chirico became familiar with Ar-

nold Böcklin's painting and Max Klinger's visionary engravings and gained a sharper perception of the philosophy of Schopenhauer and Nietzsche. Otto Weininger's influence, usually believed to pertain to this early period, must have instead taken place several years later in Paris.[3] It was undoubtedly in Munich that de Chirico achieved a fuller reading of Nietzsche's work and thought, from which the idea of metaphysical painting would subsequently develop.[4] The artist had certainly already gathered a general knowledge and was predisposed toward Nietzsche's vision in Greece (thanks to the Athens literary milieu, especially Palamàs, as spoken of in the previous chapter). De Chirico also spoke and read German fluently, and his philosophical and literary passion for Nietzsche at this point in time is borne out not only by his autobiographical testimony but by his correspondence with Fritz Gartz.[5] Even if it would not lead to a turning point in his painting until 1910, nonetheless, as his art historian friend Giorgio Castelfranco later pointed out, "what is perhaps not widely known today is that the spreading of Nietzsche's writings, the effectiveness of their infiltration, was enormous; for many, many years, with his caustic, incisive, exciting words he was actually a master of minds, an overwhelming influence such as few have been in the history of European literatures"[6]—an influence whose voice must already have been perceived in the cultural circles of Athens youth.

The art of painting taught at the Academy of Fine Arts in Munich was not so different from what the artist had learned in Athens: one of his teachers, Gabriel von Hackl, was immersed in that realistic and bourgeois narrative sketching that de Chirico had already experienced with Jakobìdis. However, the general artistic spirit of the city was oriented toward a secessionist, late symbolist fashion (Franz von Stuck), which also partially inspired Carl von Marr, one of de Chirico's professors. These international novelties, starting with impressionism and Les Nabis synthetism, were well known and shown at the Secession exhibitions.

De Chirico's friends were lively and intelligent Greeks, often expatriates like himself (Pikiònis, Bouziànis) studying in Munich, but also Germans: in particular, he befriended Gartz, a fellow student at the academy, with whom he would remain in touch after moving to Italy.

Not much is known about what he painted at the time, since his Munich works have apparently all disappeared, except for a small and insignificant portrait of a classmate. However, a photo of de Chirico in an atelier (possibly at the academy) shows a faded image of one of his paintings on an easel: an academic female nude seen from behind that echoes Jugendstil elements. The photograph, preserved at the artist's home in Rome (held today in the

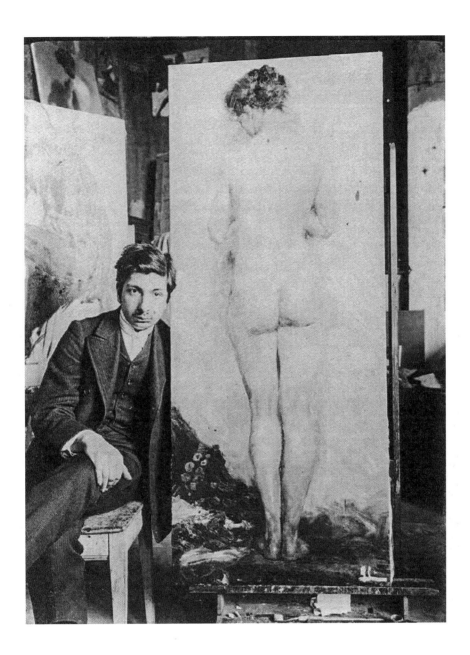

Giorgio de Chirico in the atelier in Munich beside one of his paintings in 1907.

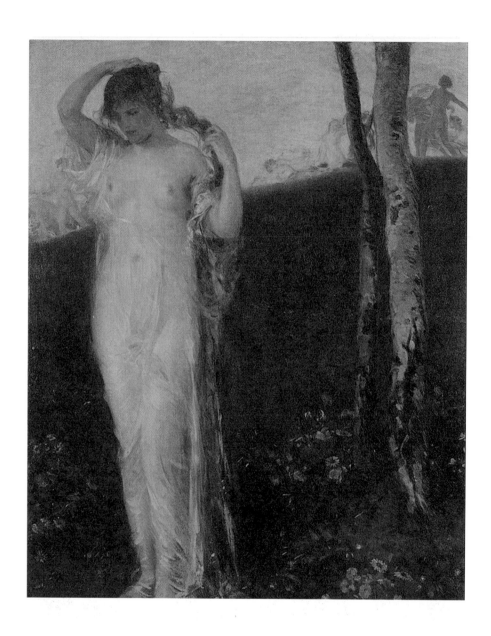

Carl von Marr, *The Flagellated*, ca. 1900,
private collection.

Hans Thoma, *Apollo and Marsia*, 1886,
private collection.

foundation's archives), had been cut and the image of the painting eliminat-
ed: an evident sign of a *damnatio memoriae* regarding the works the artist
painted in Munich. The date 1907 written on the back of a copy of the photo-
graph his friend Gartz preserved shows that his discovery of Böcklin (which
certainly took place early on arrival in Munich, and we know he poured
over the painter's images in Max Reger's waiting room while his brother
took music lessons),[7] at this time, however, had yet to bear visible fruits:
it was rather his disciple, Hans Thoma,[8] and his academic professor von
Marr who influenced and guided the young man's still-academic taste. This
is not surprising, since the rigidity of the academy's professors impeded any
modern or "eclectic" deviations of taste, meaning that even the artist's per-
sonal interest in Böcklin and his followers (such as Max Klinger) could not
have been expressed in a pictorial practice conducted under the control of
the teaching staff, who were inflexible and severely inclined to an academic

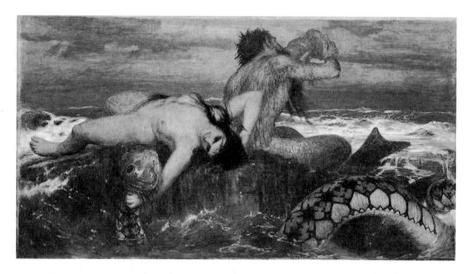

Arnold Böcklin, *Triton and Nereid*, 1873–74,
Schack-Galerie, Munich.

realism, which, although veined with symbolism, was decidedly antagonistic
to Böcklin.[9]

Although Munich provided de Chirico with new literary and philosoph-
ical stimuli (Nietzsche and Schopenhauer), as well as figurative sources
(not only Böcklin and Klinger, the champion of the secessionists, but also
Anselm Feuerbach and Hans von Marées,[10] whose work de Chirico would
certainly have seen and studied at the Schack Collection in Munich), his
"classical-romantic syncretism" (as said Castelfranco) had to lie hidden and
dormant beneath the heavy hood of academicism. His years of academic
study were therefore divided between personal research and the school's
approach, which severely limited the scope of experimentation. Confirma-
tion of this is found in a text the artist wrote in Paris a few years later,[11]
which is therefore reliable and free of possible later mnemonic adjustments:
"When I became aware that the route I was following *after* [*author's italics*]
leaving the Munich Academy was not the one I was supposed to follow, I
ventured upon tortuous paths; I was initially captivated by a number of
modern artists, especially Max Klinger and Böcklin." Despite the many in-
correct attempts to reconstruct his early Böcklinesque period,[12] the above
words make it clear that this practical purpose did not begin in Munich, but
rather during the subsequent Milanese period, immediately *after* he left the
academy. His clearly conflicted and tense relationship with the institution
gave rise to a certain hostility toward academic studies, which resulted in

Max Klinger, from the *A Glove* series, 1878–81,
private collection.

de Chirico's leaving the Academy of Fine Arts before the completion of his
course.

In March 1907, after only a few months in Germany, de Chirico's broth-
er, Andrea, moved with his mother to Italy, where he was not only better
equipped linguistically (unlike his brother, he didn't speak German), but also
certainly had greater opportunities in terms of his music. Giorgio stayed in
Germany alone until the end of the third year of his course, which represent-
ed his last full term before he left the academy. In the two and a half years or
so that he spent in Germany without his family[13] de Chirico clearly engaged
deeply with German culture and developed his literary and philosophical
interests, eagerly reading Nietzsche (certainly, *Thus Spoke Zarathustra*),[14]
engaging in discussions with his German friends (first and foremost, Fritz
Gartz and his brother Kurt, who "was obsessed with the philosophical ideas
of Nietzsche"),[15] and slowly building an inner world on the foundations of
which he would later arrive at the invention of metaphysical art.

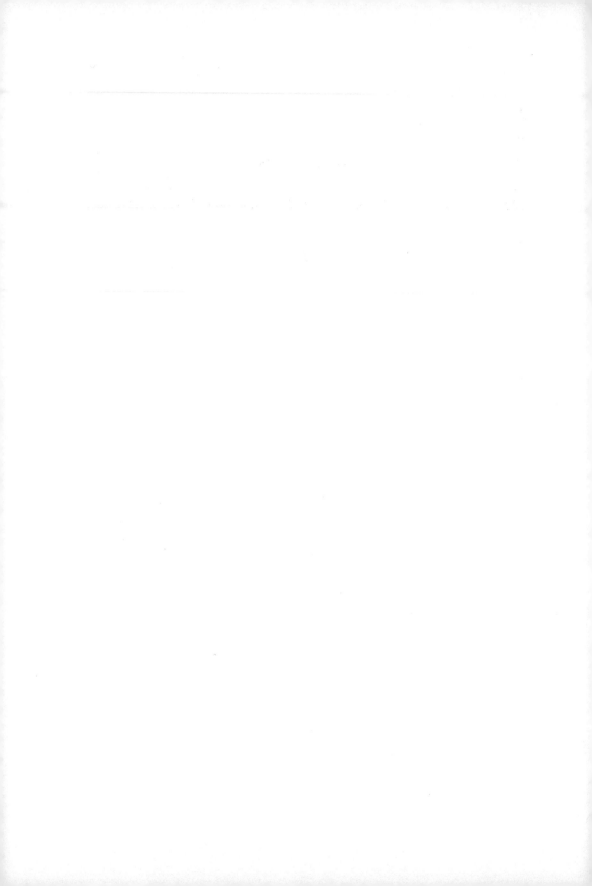

3. Milan and the "Böcklinesque" Paintings

We do not know the dates of de Chirico's first "Böcklinesque" paintings. Only two are dated. *The Departure of the Argonauts*, dated 1909, shows distinctly Italian Quattrocento-style clouds in the sky. The artist must have seen similar clouds in numerous paintings during his trip to Florence, with visits to the Uffizi, and to Rome in October that year, while he was living in Lombardy. The painting was therefore certainly executed after de Chirico left the academy in Munich and moved to Milan in the second half of 1909. The other painting, a portrait of his brother, is dated 1910 and is known to have been painted in Milan. "Mediolano M.CM.X" appears as an epigraph on the painting, thus dating it to the end of the artist's stay in the Lombardy capital (the painting was completed in March at the latest).

De Chirico must certainly have left behind all his previous production in Munich or probably destroyed it, considering it trite and inadequate at that point.[1] It is not possible to adduce concrete evidence to support the theory that de Chirico's new experiments in the style of Böcklin can be dated to the final period of his time in Munich;[2] at any rate, it seems decidedly improbable that this was the case given the artist's own clear autobiographical statement made in Paris no more than two to five years after the events in question, in which he noted that these Böcklinesque experiments only began following his departure from the academy and coincided with his return to his family in Milan in the summer. A letter sent from Milan to Fritz Gartz on December 27, 1909, gives even more support to this hypothesis, with de Chirico clearly stating: "I have been working and studying a lot and I now have very different goals than before."[3] Naturally, Gartz was perfectly familiar with what de Chirico was painting during his time in Munich; since his Böcklin-based inspiration occurred in Milan, it would have made no sense to alert Gartz to a radical change of approach of which his friend was already well aware.[4] The new, Böcklin-inspired phase therefore undoubtedly developed following his departure from Munich. One cannot completely exclude

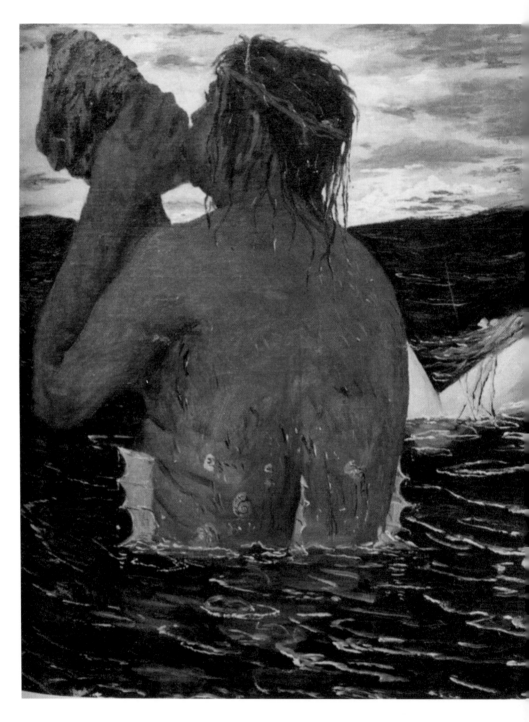

Triton and Siren, summer–autumn 1909,
private collection.

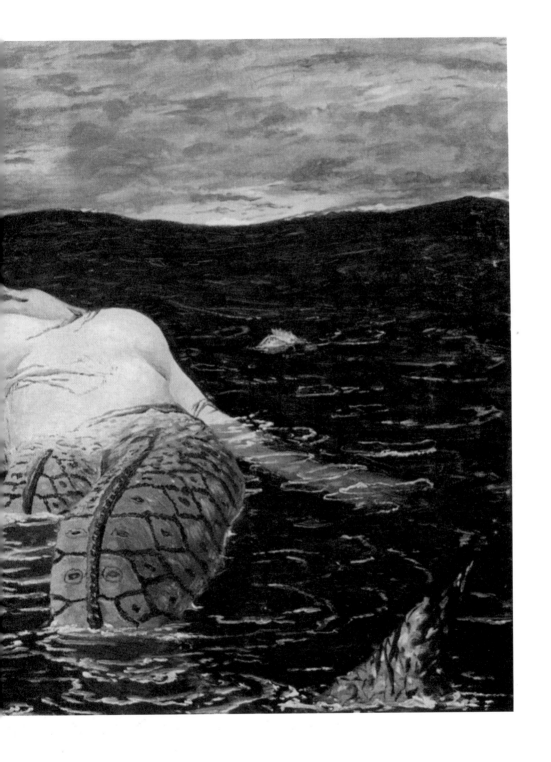

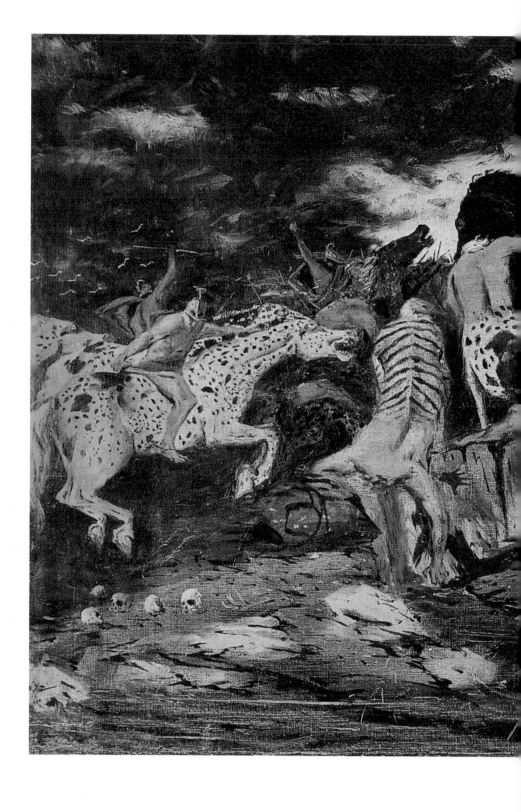

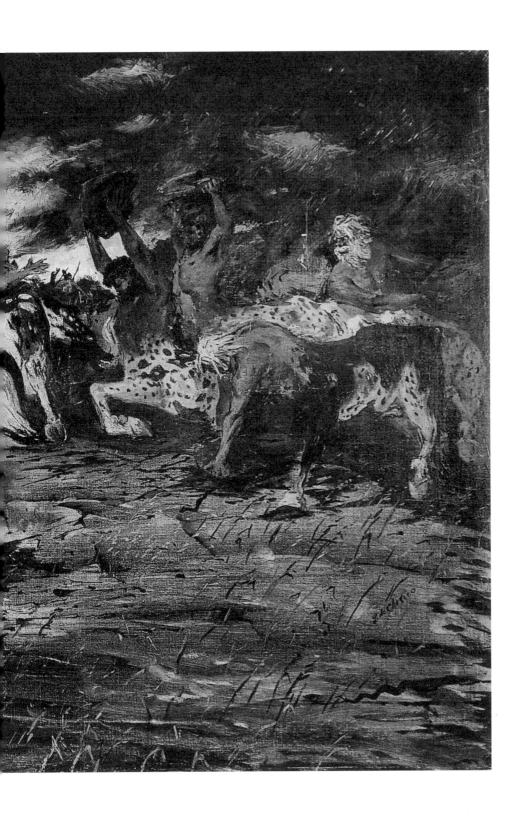

the possibility that some independent experiments, unrelated to his academic training, may have led to the decision to abandon his studies; but the clarity and consistency of his statements leads us to believe that the change occurred as a consequence of his sense of liberation from academic practice.

The quantity of so-called Böcklin-like paintings (eight works survive in total) tallies with what he would have been able to paint in Milan during those few months, beginning in the summer of 1909 (about ten months, a brief period that also included trips to Venice, Rome,[5] and Florence). However, he certainly also painted during the early months of 1910 in Florence—albeit very little, as we shall see. The most "Florentine" painting in this group is *Serenade*, which probably dates between April and the summer of 1910, with its Böcklinesque landscape that also contains elements of Tuscan naturalism (it is a view of Fiesole), suggesting execution in situ. From the summer of 1909, it seems certain that the artist had embarked on a completely new path—the result of mature and autonomous choices, free from academic influences—along which he continued unwaveringly until the autumn of 1910: scenes of centaurs, landscapes animated by monumental presences hidden within features such as rocks, sparkling skies, and Hellenistic landscapes with Argonauts. If the debt to Böcklin's painting is very strong (Tritons and Nereids, seaside villas, mythical landscapes), and certainly bears witness to Nietzsche's idea of the artist as a searcher of "new paths," the filamentous and flat painting style reveals a closer connection with that of Klinger, which various iconographies hark back to. It is a lofty, synthetic approach to painting, which in a broader sense also suggests an adhesion to certain veins of modernist secessionism.

Hence, de Chirico left Munich and followed his mother and brother to Italy, abandoning the studies that evidently no longer satisfied him. He lived for a few months in Milan, roughly between July 1909 and the early months of 1910 (in April we find him settled permanently in Florence, possibly since March).[6] Milan held no further attraction for him; indeed, he began to suffer from a long and painful gastrointestinal ailment, possibly of psychosomatic origin.[7] Milan was only a temporary base while he decided where to live permanently. However, de Chirico produced around six or seven of the eight Böcklinesque paintings that remain known to us today during these months (and those later, less active ones in Florence) in an evident attempt to apply

Previous pages:
Battle of Centaurs, summer–autumn 1909,
La Galleria Nazionale, Rome.

Dying Centaur, summer–autumn 1909,
INA Assitalia collection.

Nietzschean methods to his new painting, something that de Chirico himself suggests in the passage from the Éluard-Picasso manuscripts cited above. Having spoken of Nietzsche and his profound impact that resulted in a primordial world opening up generating an almost childlike sense of wonder in him, he spoke of Böcklin and Poussin, who "reached extreme limits in [the art of] painting; one final effort and painting will have *the* painting that takes us *beyond all paintings.*"[8] Evidently, de Chirico alludes to himself in this passage and to the propaedeutic role that Böcklin had played in his painting, which, after a final effort, would lead him to the absolute concept of metaphysical art.

In Böcklin's mythical context he had glimpsed the possibility of expressing an ancestral world suspended between primordial nature (centaurs, Tritons) and ancient mythology, the source of humanity—the dawn of mankind, in which everything amazes and time is still, circular, a present as yet without history, where Nietzsche's Eternal Return is possible. Certainly, the eight or so paintings that he would have painted in Milan and the early part of his time in Florence touched on subjects suspended in that Zarathustran atmosphere that had so deeply captivated him during his Munich years. The only one with a date, "Milan 1910," was evidently painted in the early months of that year (January–March) as an affectionate tribute to his brother, in view of their departure for Florence. There is no reason to doubt this date, which is freshly inscribed on the painting in a more than evident and structural manner in the architrave of the window in the background,[9] which opens onto a mythical Hellenistic world inhabited by a centaur and dotted with altars and temples: Giorgio introduces his brother, who was then just eighteen years of age, into his personal, mythical, and Nietzschean world. Far from representing a period of collaboration between the two brothers, the months de Chirico spent in Milan would have seen him engaged in teaching and informing the very young Andrea: the centaur in the background of the portrait, inspired by a classical model seen in Rome (Capitoline Museums, although widely reproduced), is probably Chiron. Accordingly, it would seem to allude to that exemplary relationship of master and pupil that is among the most classical mythological and iconographic *topoi.*[10] A glimpse into the role he played as cultural tutor to his younger brother would come to light shortly after, when de Chirico wrote to Gartz telling him that he had helped Andrea write his musical pieces.[11] Indeed, proof of this assistance was given in the program of the concert that the young Andrea gave in Munich in January 1911, where a section of the passages was signed by Giorgio himself. The form of the "Fantastical Poem" and the explicit allusion to Nietzsche in the title (*Revelations on the "Enigma of the Eternal Return"*) reveals that

Prometheus, winter 1909–10,
private collection.

The Departure of the Argonauts,
winter 1909–10,
private collection.

de Chirico had introduced his brother to Nietzschean philosophy, having discovered and studied it in Athens, and clearly read in German (a language that Andrea did not speak) during his long and solitary stay in Munich. The overall structure of the work also echoes that of Richard Strauss's "symphonic poem," *Also sprach Zarathustra*, an illustrious example of musical translations of Nietzschean philosophy.

Portrait of the Artist's Brother, January–March 1910,
Staatliche Museen zu Berlin – Stiftung Preußischer Kulturbesitz, Berlin.

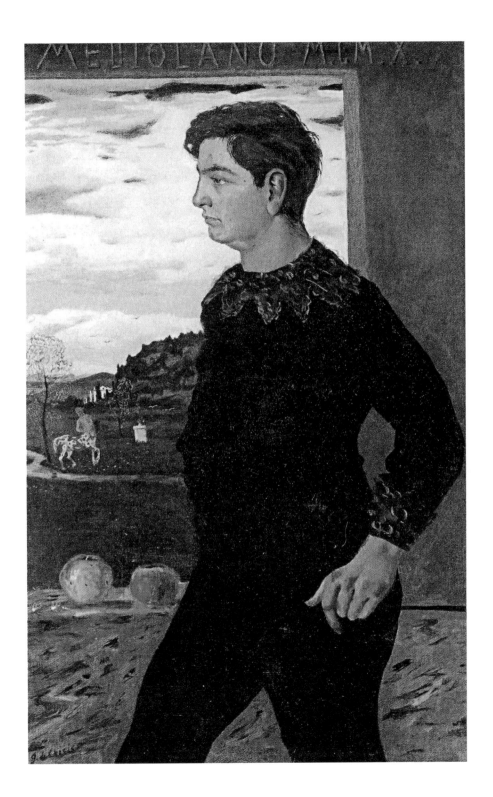

4. The Florentine Period
and the Birth of the Metaphysical Aesthetic

De Chirico spent the year 1910 in Florence where he continued to suffer from an intestinal illness that no doctor could cure, during which time he painted very little (perhaps even not at all). Instead, he spent his time reading.[1] He certainly would have broadened his study of Nietzsche as can be seen from the first book he read at Florence's National Library on April 23, 1910 (*L'origine de la tragédie ou Hellénisme et pessimisme*). He also consulted a variety of books on philosophy (Kant, Schopenhauer, Plato), archaeology and ancient history, and some modern literature as well (as can be deduced from his request for a *Revue*, which can perhaps be identified as the *Nouvelle Revue Française*). He indeed would also have been aware of what was going on in Florence, one of the most active cities in the literary and artistic debate taking place in Italy at that time. Without doubt he saw the *Prima mostra italiana dell'Impressionismo* at the Florence Lyceum, a show organized by Ardengo Soffici that opened in April 1910.[2] It cannot have been uncharted territory for de Chirico, who had already had the chance to see impressionist works at the Munich Secession. The exhibition represented an avant-garde moment for Florence that put Soffici at the forefront of avant-gardism, which one of the leading Italian cultural publications, *La Voce*, had already helped establish. At the cutting edge of Florentine intellectualism, the publication saw the trio of Giuseppe Prezzolini, Giovanni Papini, and Ardengo Soffici defined as the cultural leaders of Italy, bolstered by an irrefutable cosmopolitanism that had overtaken other emerging Florentine publications such as *Hermes*, *Leonardo* (a predecessor of *La Voce*), and *Il Marzocco*. The publication also significantly broadened the predominantly literary range of *Il Marzocco* by taking on an artistic and philosophical slant. There is no doubt that de Chirico was aware of all of this: Maurizio Calvesi has clearly shown the complex interweaving of Papini's ideas with the beginning of de Chirico's metaphysical art,[3] even though Calvesi had attributed the emergence of the metaphysical art to an earlier stay in Florence prior to discovering further

Serenade, spring–summer 1910,
Staatliche Museen zu Berlin – Stiftung Preußischer Kulturbesitz, Berlin.

documentation. Papini's dialectic must have made its mark, and deeply, on the artist's restless development in the course of 1910 that led to the elaboration of the first paintings of this new "vision." The influence of Nietzsche, Schopenhauer, Weininger (to a lesser degree), and even Papini is discernible in de Chirico's many writings and acted as a counterbalance based on analogies of intuition for him. In addition to this, we can see how *La Voce* played host to these reflections by quoting an essay by Giulio A. Levi that is in effect a long review dedicated to the philosopher Oskar Ewald with a highly significant date (September 22, 1910). It was published in *La Voce* together with an important article by Soffici on the use of perspective (which opens up fundamental reflections on the eccentric use of perspective in de Chirico's metaphysical art, a topic already remarked on by Calvesi).[4] The article examines Ewald's philosophical critical essays on Nietzsche and his analogies with Weininger's thought, in line with de Chirico's reflections of that time.

Calvesi's predominant, or rather, unique treatise regarding a potential as well as evident relationship between Papini and de Chirico focused specifically on a philosophical, literary, and poetic vision, and did not examine the

stylistic and painterly elements that led to the tangible development of de Chirico's new figurative style. An aspect that has not been looked into concerns Soffici's pragmatic, critical, and specifically artistic thought, which just might constitute the great missing piece of the complex puzzle of concentric reflections that led to the definition of metaphysical art's *painterly* poetics in the autumn of 1910.[5]

The crucial point of de Chirico's metaphysical innovation resides not only in the development of a new poetic and aesthetic system, fruit of his philosophical reflections of previous years, but in the development of a completely new system of representation in a clear break from his former Böcklinesque (i.e. Milanese) production, compared to the "nouvelle vague" that started with the paintings produced in the autumn of 1910: *The Enigma of an Autumn Afternoon* and *The Enigma of the Oracle*. This innovation is not only about content, but it also owes its original expressive force to the adoption of a new and original painting technique, which, in contrast with that previously used, succeeded in condensing an objective sense of symbols devoid of meaning, of a figurative and bare evidence that makes up the essential basis of the new *Stimmung* ("atmosphere in a moral sense," as de Chirico himself would translate it) that he finally succeeded in fully bringing to life in the fall of 1910.

The change in his painterly style between his early, more simply Böcklinesque paintings and the new metaphysical works is remarkably clear. In the latter, his style undertook a radical evolution in which he substantially changed his use of linguistic and expressive values. This difference was not so much that of a distancing from Böcklinesque iconographies, references of which continue to emerge in the new paintings, but rather, a total and radical abandonment of his earlier representational style and painting technique that he had derived from Böcklin's and Klinger's realism. The soft and trembling thin-lined brushstrokes manner used in his Milanese paintings was similar to the painterly language of nineteenth-century realism (which he had learned at the academy) and Mitteleuropa symbolism. This technique was surpassed in the new paintings, in an "à plat" laying down of paint area by area in the composition in an almost total abandonment of the painterly vibrations of the brushstrokes in his earlier works that had conferred a phenomenal and realist value to wholly fantastic subjects such as centaurs or figures submerged in a mythical antiquity.

It is crystal clear that such a radical transition of style set the pace and extent of the innovation of his new metaphysical paintings. And yet one has difficulty finding an explanation, or even a suggestion, in critical investigations (even recent ones) in reference to a technical and, as a consequence,

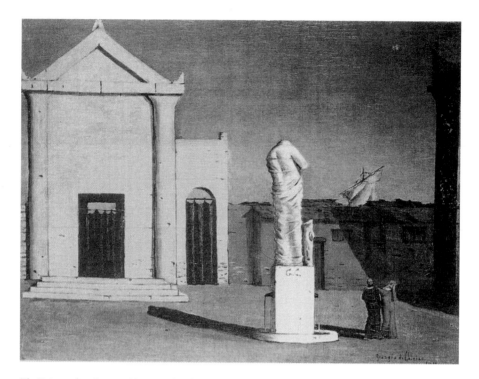

The Enigma of an Autumn Afternoon, October–November 1910,
private collection.

linguistic transformation of such great importance. In fact, the sudden de-
velopment of a metaphysical painterly and stylistic language is the result of
the evolution and the fine-tuning of thought that was essentially philosoph-
ical, developed and defined in the two aforementioned paintings. This is es-
sentially the interpretation that de Chirico also gives, with no allusion made
to "visual" elements but only to theoretical and philosophical elements in
regard to their realization. However, there are two points that induce us to
look for specific suggestions of a highly "figurative" essence. The first re-
gards an aesthetic reflection that, although attaining new depth, continued
along the lines of the artist's Böcklin-Nietzsche reflection dating back to de
Chirico's sojourn in Munich.[6] This, however, cannot have been the cause of
the discontinuity seen in the new paintings. The second point focuses on the
fact that there *must* have been an influence or more concrete visual reference
that determined such an extensive "linguistic" change. In reality, given that
the theoretical direction remained substantially unchanged, the spark that
inspired the artist to change his representational style so radically is a histor-
ically important event. *Natura non facit saltus.*

Leaving aside the specific Florentine reference to Papini (which in all events is a philosophical-literary one) and looking instead at the then current Tuscan context, it is possible to identify the event responsible for the technical "leap" that led to the full application of a feeling of metaphysical estrangement. Attempts to pinpoint de Chirico's metaphysical stylistic references relative to this chronological period have been made very effectively by Calvesi.[7] These include Giotto's painting and that of Paolo Uccello, supported by a critical reading regarding "primitive" perspective, on which Soffici placed emphasis at that very moment in *La Voce*[8] (this is, in fact, more evident in works that followed immediately after these two initial paintings). Calvesi includes Gauguin as an influence, a reference made in relation to a later Parisian phase of the painter, as was that of Van Gogh and Picasso. The influence of Titian has also been noted, which is certainly less evident and substantial when compared with the "chromatic planes, imbued with a certain gloom, such as those extraordinary greens and reds which, even when in the light, do not shine."[9] The influence of Matisse, which was critically highlighted in the late 1990s in an exhibition at the Museum of Modern Art (MoMA) in New York and taken up again by Baldacci[10] cannot date to the 1910 period (the one Matisse painting exhibited in Florence in the impressionist show that de Chirico might have seen is far from his own monochrome and uniform planes). The reference pertains to a linearity with chromatically contrasting silhouettes set side by side and a formal synthetism present above all in later nudes such as the 1913 *Study* and *Nude (with black hair)*, which, in its dark lines, is reminiscent of certain Matisse nudes.

In addition to his important article on the use of perspective by Italian primitive painters, which must have affected de Chirico's subsequent Parisian work (where the perspectives seem to contradict each other, creating scenes that are objective and at the same time emanate a feeling of displacement, something not yet evident in the Florentine works), Soffici dedicated an article to Rousseau Le Douanier in the September 15, 1910, issue of *La Voce*. The article, drafted some time earlier by Soffici who at the beginning of the year had purchased two paintings by the French painter (a still life and a landscape), was completed and published after the news of the painter's death. From the time of the article's publication and de Chirico's vision and execution of his first metaphysical painting in October–November 1910,[11] we can just imagine his significant and attentive reflections. In the introduction to his article, Soffici talks about popular painting, which he maintains is one of the most meaningful revelations for a tired intellect.[12] It should be noted how de Chirico felt metaphysical innovation to be a re-

Benedetto Croce.

HENRY ROUSSEAU

H. ROUSSEAU. — La musa che ispira il poeta G. Apollinaire.

H. ROUSSEAU. — Lotta fra tigre e bufalo.

A page from *La Voce*, September 15, 1910, with an article by Ardengo Soffici on Henri Rousseau Le Douanier.

spite from his tired and excited sensitivity:[13] "I don't know if you are like me . . . but I adore that kind of painting that intelligent people call stupid," concludes Soffici. In the second part he speaks more precisely about Henri Rousseau, of the modernity of his painting, of his cultural references (Paolo Uccello), and even of his original painting technique.

In the first part we find statements that will be largely echoed by de Chirico, as well as descriptions of scenes that seem to be premonitions of what de Chirico will shortly bring into being in his new metaphysical painting. These can be seen as poetic and thematic suggestions for de Chirico. Even the visionary language, of almost Rimbaudian or Nietzschean enlightenment, corresponds to the language of de Chirico's first theoretical writings dating to 1911–15.[14]

Soffici writes:

> I am talking about a different kind of painting: more naive, more candid, more virginal, so to speak. . . . But oh! The intensity of expression increased by the awkwardness of the forms and the color! . . . The irreparable tragedy of dark and subordinate souls! All cosmic life . . . the day after a cataclysm. Now that I think about it, I would also say this—putting aside commercial value—Raphael's *Marriage of the Virgin* on the same playbill! . . . And it is precisely this power of sentiment, despite everything (conscious or casual, what does it matter?) that counts for me. In works such as these, I find the nude and crude expression of an unadorned but sincere soul, lacking in harmony but penetrated by reality.[15]

We find an echo of this in de Chirico: "This is what the artist of the future will be; someone who gives something up every day; whose personality becomes ever more pure and innocent with every passing day";[16] "The artwork has a strangeness to it that comes close to the strangeness a child may feel."[17]

Furthermore, the objects mentioned by Soffici (barber and storefront signs, funfair booths) seem to foresee the poetic interpretation that will take place in de Chirico's metaphysical art in Paris (hanging gloves, barber's busts, etc.): "They are the tarpaulins of acrobats, old fire screens, signs for dairies, hotels, barber shops and herbalist shops, village tabernacles, ex votos, funfair ballet dancers and soldiers, still lifes above doors and frescoes on the walls of countryside inns."

The childish and primordial scenes evoked by Soffici have all the metaphysical and solitary gravitas of de Chirico's compositions, including even the Parisian mannequins, heavy with a sense of melancholy:

> Around them a gray and brooding square opened up like a desert. At the very end, down at the bottom stands a straight white wall along which a yellow dog runs. No proportion, no balance between the various parts of the painting.

Monstrous drawing and color. . . . The soldier as hard as wood and shiny as a saucepan, the bundled-up servant . . . alone, in that immense square; the watermelon seller, the dog and the white wall at the back! A Sunday-like feeling of desolation in strange neighborhoods, areas near barracks, silent and solitary leisurely walks threatened by the fate of the captain and the butler! . . . A canary-yellow streetcar . . . arrives scraping the black edges of the bend, traced with architectural instruments. In the background, a terrace of light brown houses, with hundreds of yawning windows in a row, unrelentingly square, open upon dark, empty rooms that—one senses—are uninhabited. The same drawing, the same color. But once again, here, as in thousands of paintings of this sort, the same sense of irreparable, routine, daytime melancholy.[18]

Sometime later de Chirico, now in France, wrote descriptions that are almost identical for their effect and tone, in which a sense of melancholy dominates: "And enigma of the school, the prison and the barracks; and the locomotive whistling away at night beneath the icy vault and the stars";[19] "All of a sudden I found myself in a large square city. All the windows were closed, silence and meditation were everywhere";[20] "the conqueror's square city, the tall towers and huge sunny squares, the train rolled along broiling in the summer heat. . . . There was no more joy. The soldier in the railway car and the sorrow of the families";[21] "It was solemn. It was melancholy. When the sun arrived at the top of the celestial curve, they inaugurated the new clock on the town's railway station. Everyone was crying. A train passed frantically whistling away";[22] "Behind the walls life rolls on like a catastrophe."[23]

Soffici's striking language that seems like a description of de Chirico's paintings, even before they had been painted, gives us the measure of how, just prior to his intuition, de Chirico must have read these pages and found them charged with an unrealized prophecy: descriptions of deserted piazzas, of heart-wrenching melancholy, and of objects devoid of meaning, lyricism disrobed of rationalism. Soffici speaks of "the childishness of the world," a concept that de Chirico also gleans from Schopenhauer, and above all from the study of Heraclitus, which was of great interest to de Chirico who also found validation in Nietzsche: "A truly immortal artwork can only be born of a revelation. It was possibly Schopenhauer who best defined this moment and indeed actually explained it";[24] "it is the hour of the enigma. It is also the hour of prehistory."[25]

Soffici's text continues with descriptions that must have resonated in de Chirico's soul like a premonition, a revelation:

How he knew how to render the dark sadness of an inhospitable square, of an empty lane, of an expanse of somber Parisian rooftops under the gloomy

clouds Immense compositions . . . where the grotesque marries the ten-
der, the absurd unites with the magnificent and the absolutely weird joins that
which is indisputably beautiful and poetical. . . . A new mix of geniality and
mental cross-eyedness. Now one must ask oneself: what does this overcrowd-
ing of heterogeneous things that are discordant among themselves, placed close
to the other without any plausibility. . . . What does it mean? Well, it does not
mean anything. . . . It is that Henri Rousseau, who does not reason but works,
rather, in his own special way of conceiving from first impulses, had understood
this truth: in art everything is allowed and legitimate if every element contrib-
utes to the sincere expression of a state of the soul. Both for their color and
for their structure, that divan, that nude body, that moon, those birds, those
beasts and flowers, represented for him many images which, independently of
any articulate logic, formed in his spirit a purely artistic unit, that he found
the most appropriate for expressing his personal vision. Conforming in this
way to the tendencies of the modern school of painting with its desire to expel
any rational element from art in order to abandon itself completely to a lyrical
exaltation emanating from colors and lines, seen and conceived independently
of their practical destination and their office of delimiting and differentiating
bodies and objects. Rather than asking oneself what these things mean, which
for the painter are nothing but images, it would be better to see if the poetic
sense that he wanted to bring out does indeed emerge through the respective
forms and colors and, if it does, to recognize its power and at the same time his
full right as a free creator.[26]

The comparison with the words, poetics, and concepts of de Chirico's
metaphysical art is striking: "To live in the world like in an immense museum
of oddities, full of bizarre, multicolored toys which change what they look
like and which like children we occasionally break to see what they are like
inside";[27] "I became aware that there is a multitude of strange, unknown
things that can be translated into painting";[28] "What is needed above all is
to free art of everything it contains of what is known today, all subjects, all
ideas and thoughts, all symbols must be put aside";[29] "one must have great
sensitivity above all. To represent everything in the world as an enigma, not
only the big questions that have always been asked, why the world was cre-
ated, why we are born, live and die, as after all it may possibly be, as I have
already said, that there is no reason in this";[30] "Divest art of everything that
it still may contain of routine, of rules, of a tendency toward a subject, of an
aesthetical synthesis; completely suppress man as a point of reference, as a
means of expressing a symbol, a sensation or a thought . . . to see everything,
even man, as a thing. It is the Nietzschean method."[31] Every one of these
elements leads to a direct correspondence in Soffici's words in regard to
Rousseau.

There is also significant consonance regarding the concept of "state of soul": "It is that Henri Rousseau, who does not reason but works, rather, in his own special way of conceiving from first impulses, had understood this truth: in art everything is allowed and legitimate if every element contributes to the sincere expression of a state of the soul." The word *Stimmung*, which de Chirico places at the foundation of his metaphysical perception, means "state of soul" and many years later, remembering that he had derived the concept from Nietzsche, de Chirico actually defined his aesthetic intuition in this way: "Such novelty is a strange and profound poetry, infinitely mysterious and solitary, which is based on *Stimmung* (I use this very effective German word which could be translated as atmosphere in the moral sense)."[32]

But what is perhaps even more interesting about this article on Rousseau, which describes his poetics and his dawnlike images of the world, is the passage in which Soffici "technically" describes Rousseau's painting process in terms that cannot fail to influence de Chirico, constituting a truly unique parallel: "And firstly his colors, even though they are achieved in a bizarre way (he spreads his colors on the canvas one at a time; for example, first all the greens, then all the reds, then all the blues, and so on), are refined and magnificent . . . they have nuances and hues of an unprecedented sweetness and richness."

There can be no doubt that this technical influence, which is one of painterly concreteness and not only of a poetic and philosophical kind, is exactly what de Chirico put into practice in his earliest metaphysical renderings. This influence is completely different from the painting technique he previously used: its layers become expansive and monochrome, heightened by gentle brushstrokes that are light or dark and give volume to the forms. This technique is completely different from the fizzling weaves of layered brushstrokes that build forms in the Böcklinesque paintings. The use of this new technique has double value for de Chirico. If, on one hand, he expresses himself through a "modern" technique that abandons the tiresome traditions in which the paint impasto struggles to adhere to reality and its forms, on the other, he succeeds in representing a world in which the abstraction of color gives a noumenal, abstract, and mental absoluteness that achieves

Facing page, top to bottom:
Henri Rousseau le Douanier, *The Muse Inspiring the Poet* (first version), 1909, Pushkin State Museum of Fine Arts, Moscow.

The Enigma of an Autumn Afternoon, 1910 (detail), private collection.

an interior and synthetic vision. If the two paintings appeared in black and white in the article on Rousseau and no true association with his themes can be seen in de Chirico's forms, a new "method" making color a wellspring of "primitive" preciousness did however emerge and constituted a practical suggestion for the decisive leap that occurred in the search for a language capable of expressing the intellectual and philosophical innovations he had developed at the time.

De Chirico applied the "Douanier method" diligently: spreading broad and monochrome areas upon which he intervened with light patinas and black outlines to give concrete substance to the elements. We see brick and stone walls achieved with a uniform background to which the painter added simple and schematic lines; uniform facades without contrasts but only sparse shadows; skies that are no longer rippling with reflections but are intact and monolithic like glazes. If we compare them with the paintings that came just before, the technical difference is truly profound: the new metaphysical method took form on indications revealed by Soffici about a painter who, like him, was above and beyond artistic modes and movements. De Chirico derived from these influences a method of transforming a reality that is still realistic and phenomenal into an archetypal, sound, and absolute form: he opened the way to the "total solidification of the universe"[33] he would achieve in a decisive manner in Paris.[34]

An element of direct iconographic reference to Rousseau does indeed exist, even if de Chirico carried on his own personal path, toning down any comparison to Le Douanier, a sort of elective brother he knew only through the words of Soffici (revealing scenes of deserted cities laden with a sense of inexplicable melancholy) and the two mediocre reproductions published in the periodical, seemingly not on his wavelength. The first painting depicts a tropical forest in which a wild beast devours a buffalo and the other, *The Muse Inspiring the Poet*, is quoted almost literally in *The Enigma of an Autumn Afternoon*: the two figures lost in the middle of the square are undoubtedly dressed in ancient robes, a man and a woman embraced one another. In the corresponding part of Rousseau's painting we see the poet and his muse in the same pose: a raised hand, the other resting on the poet's back. Incidentally, Rousseau's muse also wears an ancient tunic. It is difficult to imagine that de Chirico's figures do not represent the poet and his muse in such a programmatic painting and at the same time that they are not a silent homage to Rousseau.

A secondary, later confirmation of the close analogy between de Chirico and Rousseau is provided by Soffici who was the first in Italy to write about de Chirico, whom he had met at Apollinaire's studio in Paris in 1914. His ar-

ticle is interesting insofar as it indicates Paolo Uccello as a significant and ex-clusive basis for comparison to the metaphysical painting of de Chirico, the only painter he also believed had profound similarities with Le Douanier. Clearly Soffici had glimpsed a common denominator in the purity of the chromatic layers in both artists' works and found further evidence of a di-rect vision of the works of Le Douanier, Apollinaire's favorite artist, in de Chirico's Parisian production. Yet initially Apollinaire had also been struck by the perception of an analogy with Rousseau, only to dismiss it from his final appraisal of de Chirico's work. As we shall see, he considered the artist to be a figure who was totally and extraordinarily independent of the French avant-gardes: "I would not really know who to compare Giorgio de Chirico to. The first time I saw his paintings I instinctively thought of Le Douanier, above all because of the religious feeling he conveys in painting his skies. Today, however, I must confess that it was a rash comparison."[35] Apollinaire could not have suspected a knowledge of Rousseau on de Chirico's part, when still in Florence. And we can be sure that de Chirico would never have confessed to Apollinaire, or to anyone else, his fleeting yet decisive debt to Le Douanier.

We must ask ourselves a further question to which, admittedly, there may be no definite answer. In 1910–11, Florence was truly a small milieu, in which one could bump into anyone just by walking past the Giubbe Rosse café. The question is whether de Chirico may possibly have gained direct contact with the intellectuals of *La Voce*, which as we have seen had a clear influence on the developmental turning point in his painting—in particular Soffici. Neither of the two protagonists speaks of this nor seems to even hint at it. And yet we cannot rule out that a casual encounter may have taken place (but neither can we take it for granted based on current knowledge). If they did meet, de Chirico could have possibly seen the two Rousseau paintings in Soffici's home and in particular the *Still Life* with its green background that has the same resonance as certain metaphysical skies, the same disquieting, semiprecious stonelike solidity of the sky in *The Enigma of an Autumn Afternoon*, *The Enigma of the Hour*, and *Self-Portrait*, painted in Florence. Four years before de Chirico and Soffici's meeting in Paris in 1914, a fleeting encounter could have taken place between the two when de Chirico was still entirely unknown. Soffici would possibly have forgotten such an encounter (de Chirico certainly not); it is also possible that de Chirico would not have mentioned it to his new friend whom he now saw absorbed in Apollinaire's circle. And yet a passage of the review, in which the two de Chirico brothers are described as "Florentine" (based solely on a year's sojourn in Florence or on an uncle who lived there) by a

Pablo Picasso, Baroness Hélène d'Oettingen, Serge Férat and Léopold Survage at Dinner with Self-Portrait by Rousseau, 1914,
private collection.

Henri Rousseau le Douanier, *Still Life*, 1910,
previously owned by Ardengo Soffici.

"genuine" Florentine such as Soffici, leaves a wide margin of plausibility for this hypothesis. Here is Soffici's text, published in the July 1, 1914, issue of *Lacerba*:

> Imagine a painter at the very heart of the increasingly daring research burning up this city that is the crucible of the world's genius, who continues to paint calmly and with the application of an old, solitary master. A sort of Paolo Uccello, enamored with divine perspective and unaffected by anything outside its beautiful geometrics. I wrote Paolo Uccello's name with no intention of establishing an indispensable similarity. Giorgio de Chirico is first and foremost absolutely modern and his geometry and the effects of perspective are the principal elements of his art and methods of expression and emotion. It is also true that his work is not similar to that of anyone else, ancient or modern, developed on these same elements. De Chirico's painting is not painting in today's sense of the word. It could be defined as a writing of dreams. By means of almost infinite flights of arches and facades, long straight lines, gigantic masses of simple colors, lightness and almost funereal darkness, he expresses a sense of vastness, of solitude, of immobility, of stasis, which sometimes produce specta-

cles reflecting the state of memory in our soul that has almost fallen asleep. In a way that no-one else has ever done, Giorgio de Chirico expresses the poignant melancholy of the end of a beautiful day in an ancient Italian city, where at the far end of a solitary scene, beyond the background of loggias, porticoes and monuments from the past, a train puffs past, a lorry from a large warehouse waits or a tall industrial chimney stack smokes against a cloudless sky. The two brothers are Florentine.[36]

We can see that the terms Soffici uses about de Chirico are somewhat similar and sometimes identical to the ones used for Rousseau. While keeping de Chirico's originality clear, the reference made to Uccello in relation to Rousseau in 1910 becomes extremely significant:

Even good old Donatello laughed about the pictorial eccentricities of his shy friend Paolo Uccello; but those who know what art and beauty mean, know today that he was wrong, and that the madcap who did not know how to draw a horse's anatomy, was one of the freshest, most sincere and courageous, and thus one of the greatest painters of the 15th century and of all time, of Florence, of Italy, of the world. Remembering Paolo Uccello, I may have involuntarily mentioned the only European artist to whom Henri Rousseau can be compared. Like him, he lives in a strange world that is both fantastical and real at the same time, present and distant, sometimes laughable and sometimes tragic, like him he is gratified with the luxuriating abundance of vegetables, fruit and flowers, in the imaginary companionship of the animals, beasts and birds, like him he spends his life in work that is ignored, he is composed and patient, greeted by laughter and by mockery each time he comes out of his solitude to show the world the fruits of his labors.[37]

5. A Proto-Metaphysical Painting:
Procession on a Mountain, 1910

Some words should be dedicated to a painting that is unanimously considered to immediately precede the new metaphysical path, as a link between the strictly Böcklinesque paintings and the first *Enigmas*: *Procession on a Mountain*.[1] The composition is influenced by a painting by Camillo Innocenti that de Chirico most certainly saw at the Venice Biennale in 1909, as suggested by Calvesi,[2] or less likely by a composition by Charles Cottet present at the Venice Biennale in both 1903 and 1907, as Leo Lecci suggests.[3] This shows us de Chirico's ability to seize upon stimuli and impressions from very disparate and unpredictable elements, such as Innocenti's painting, which appears to have no point of contact with de Chirico's reflections or even his central models of that moment. It is a litmus test of the artist's omnivorous ability at using influences from images on various levels of consciousness, of his powerful ability to redevelop and metabolize casual and linguistically disparate influences. These reflections give a detailed account of the eccentric ways of taking on and transforming considerations that have intrigued him, as the article on Rousseau did, with its two photographs of works that were seemingly far from his sensibility (but with contents that were rather consistent with his own restless reflections about the search for a novel style to express new meaning). Beyond these reflections, what is striking about *Procession* is its technical achievement, which is totally different from Innocenti's model. It is instead much closer to that of the three *Enigmas* and to Rousseau's flat, monochrome application of color as Soffici described: colors painted "one at a time" in large areas, the absence of raised and quivering brushstrokes, the synthetic and "childlike" definition of the forms. There can be no doubt that Innocenti's Sardinian subject struck the artist and brought to his mind an image of Greece: a rugged countryside with a typical Byzantine church. The ghostly figures that move side by side, executed without luminous painterly vibrations, already belong to metaphysical transfiguration. The primordial and naive elements in the composition have a direct relationship with Le Douanier's simplifications, with his "bun-

Procession on a Mountain, September–October 1910,
Galleria Civica d'Arte Moderna, Brescia.

dled up" characters and the solitary desolation of his landscapes (and at the
same time he clearly removed himself from Camillo Innocenti's naturalistic
figures whose clothes move in the wind). Soffici describes Le Douanier's
work in this way: "You need only look at his portraits, his family groups,
his scenes of local life in the countryside and in the city, his weddings, still
lifes and landscapes, in order to feel with what acute even if good-natured
and almost kind perception he grasped the fright of the empty soul of his
models, the bundled misery of the bourgeois man, his equal and kin." The
distant similarity with Gauguin, aired by Calvesi and picked up by Lecci
through Cottet, is not likely at this time if one considers the impressionist
works de Chirico actually saw in Florence: his representational synthesis

Camillo Innocenti, *Al rosario*, 1908,
exhibited at the Venice Biennale of 1909.

Henri Rousseau le Douanier, *Pavillon*, 1901,
drawing, previously owned by Ardengo Soffici (detail).

instead closely resembles that of Le Douanier and Les Nabis synthesis. It is to be further noted that Rousseau's "bundled up" figures were known in Florence and, in addition to the reproductions published in *La Voce*, at least one drawing in Soffici's collection showed a strict resemblance to those in de Chirico's painting.[4]

An even greater similarity to Rousseau's paintings found in this painting, even in the subject and rendering, suggests that it was completed before the more mature, later ones, a fact that is clearly and unanimously accepted by art historians. However, given the evolution of a style of painting of flat, silhouetted areas, it was certainly completed after Soffici's article on Rousseau—thus after September 15, 1910. Not only does the clear debt the painting owes to Le Douanier confirm what was just illustrated, but the date of the painting is thus strictly connected to that of *The Enigma of an Autumn Afternoon*, namely the beginning of October, and it forms the first experiment, still unripe, but soon destined to take form in a new vision—the invention of metaphysical art.

6. The First Metaphysical Enigma:
The Enigma of an Autumn Afternoon

In various writings from the first Parisian period (1911–15) to the second postwar period, de Chirico recalls how the birth of his first metaphysical painting was linked to a moment (the autumn) and a specific place, namely Piazza Santa Croce in Florence, as well as a particular state of convalescence that put him "in a morbid state of sensitivity":

> On a clear autumn afternoon, I was sitting on a bench in the middle of Piazza Santa Croce in Florence. Indeed, it wasn't the first time I had seen this square. I had just recovered from a long and painful intestinal illness and found myself in a morbid state of sensitivity. All of Nature surrounding me, even the marble of the buildings and the fountains, seemed to me to be convalescing also. In the center of the square stands a statue of Dante cloaked in a long robe, hugging his oeuvre to his body, thoughtfully bowing his pensive laurel-crowned head toward the ground. The statue is of white marble, to which time has given a gray tinge that is very pleasing to the eye. The autumn sun, lukewarm and without love, lit the statue as well as the facade of the temple. I then had the strange impression that I was seeing everything for the first time. And the composition of my painting came to me and every time I look at it, I relive this moment once again. Still, the moment is for me an enigma, because it is inexplicable. And I also like to call the resulting work an enigma.[1]

The reason for frequent walks through Piazza Santa Croce ("Indeed, it wasn't the first time I had seen this square"), apart from the compactness of the city, is revealed in scholar Victoria Noel-Johnson's analysis, in which she indicates how the square was a somewhat compulsory point of passage on the frequent journeys that de Chirico made between his home and the National Library of Florence situated just behind it. This was a journey that he repeated at least forty-nine times between April 23 and November 9, 1910.[2]

Comparing (as Soby did) *The Enigma of an Autumn Afternoon* to a historical photo of the square in which the statue of Dante is still positioned in front of the church's facade,[3] the initial inspiration seems clear, as does de Chirico's

The Enigma of an Autumn Afternoon, October–November 1910,
private collection.

enormous ability for poetic and iconographic reconstruction. The "metaphysical" content of the painting is well known, thanks to the artist's own reference to Nietzsche and his poetics of *Stimmung* of the autumn afternoon, an atmosphere in which things appear to our eyes heavy with the inexplicable mystery of their nature, devoid of the common sense with which habit tends to dress them.

The uninhabited (somehow abandoned and ruined) houses in the background, however, are an echo and almost a copy of one of the backdrops described by Soffici in his article on Rousseau, in which he makes his most explicit reference to melancholy: "In the background, a terrace of light brown houses, with hundreds of yawning windows in a row, unrelentingly square, revealing dark, empty rooms that one senses are uninhabited. The same drawing, the same color. But once again here, as in thousands of paintings of this sort, the same sense of irreparable, routine, daytime melancholy."[4]

In a letter to his Munich friend and colleague Fritz Gartz, written at the end of December 1910[5] just after he had painted his first metaphysical paintings, de Chirico communicates with enthusiasm the principles of his new and profound stylistic and aesthetic innovation:

Piazza Santa Croce, Florence, in an early 20th century photograph.

What I have created here in Italy is neither very big nor profound (in the old sense of the word), but *formidable*. This summer [between the end of summer and early autumn, *author's note*] I painted paintings that are the most profound that exist in the absolute. . . . Do you know for example what the name of the most profound painter who ever painted on earth is? . . . his name is Arnold Böcklin, he is the only man who has painted profound paintings. Now, do you know who the most profound poet is? You will probably say right away Dante, or Goethe or yet others. This is totally misunderstood. The most profound poet is Friedrich Nietzsche. . . . Profoundness as I understand it, and as Nietzsche intended it, is elsewhere than where it has been searched for until now. My paintings are small (the biggest is 50×70 cm), but each of them is an enigma, each contains a poem, an atmosphere (*Stimmung*) and a promise that you cannot find in other paintings. It brings me immense joy to have painted them.

In a letter immediately after, the artist gave further indications regarding the themes of his "illumination" and what had struck him most about Nietzsche's work: the theme of Eternal Return, the lyrical flash of inspiration and the aspect of eternity:

A new air has entered my soul—a new song has reached my ears—and the whole world appears totally changed—the autumn afternoon has arrived, the long shadows, the clear air, the serene sky—in a word: Zarathustra has arrived, do you understand?? Do you understand the enigma this word holds—the great cantor has arrived, he who speaks of eternal return, he whose song has the sound of eternity.[6]

7. *The Enigma of the Oracle*

The Enigma of the Oracle was, in my opinion, the second painting executed by de Chirico in the new style. The identification of the site where the mantle-clad oracle is inspired by a god partially hidden behind a curtain is useful for the full understanding of the meanings and forms of visual inspiration of this very first metaphysical moment. The painting was executed in Florence in the second half of 1910, about the same time as *The Enigma of an Autumn Afternoon*,[1] two paintings that together represent a programmatic display of the painter's philosophical-poetic intentions.

The identification of this transfigured place dates back to a 1992 essay of mine.[2] Even in the radical transformation of its individual elements (which one can ascertain also in the portrayal of the Piazza Santa Croce), the small temple on a terrace recalls the Acropolis seen from the temple of Athena Nike in Athens with fitting clarity. The terrace overlooking the void, the continuous walls with no openings both of the temple and of the picture gallery (πινακοθήκη) in front of it, the narrowing of the shadow created by the open-air propylaea, but above all the white city in the distance at the foot of the hill, with the view in the background of the sea of Piraeus bounded to the left by Mount Egaleo, are elements that converge with extreme precision (and reinvention) in the iconography of the painting.

In *The Enigma of the Oracle* de Chirico seems to allude to Athens as an inevitable place of thought and his own youthful education, while in *The Enigma of an Autumn Afternoon*, to Florence as the "Italian Athens," the city where he deepened his philosophical interest thanks to Nietzsche and Schopenhauer and where he reached the "revelation" of his new metaphysical method of painting (simplified through Rousseau's childish and motionless technique). The two paintings can therefore be read as a diptych, a sort of manifesto dedicated to the enigma (found in both titles and that are the same size): the Greek enigma and the Florentine enigma as syntheses of a new system of thought, of a kind of painting that reveals previously unknown meaning. For this reason, we suggest a further influence in Charles

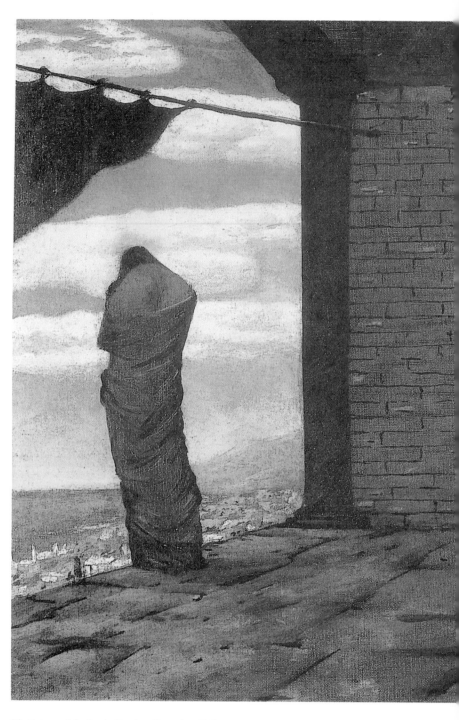

The Enigma of the Oracle, October–December 1910,
private collection.

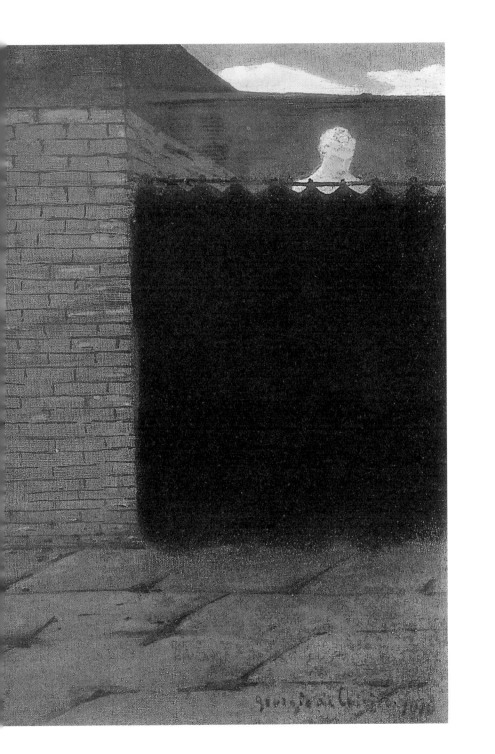

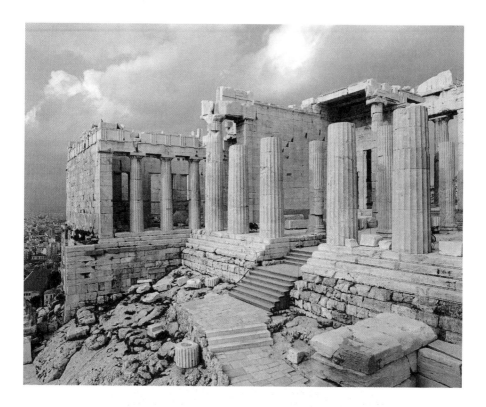

Propylaea in Athens seen from the temple of Athena Nike.

Maurras, a French writer and journalist, who certainly must have spent time with the de Chirico family during his lengthy stay in Athens (March–May 1896) for the first Olympic games: it would have been almost impossible to avoid him given the close cultured circle of Athens. In 1901 he published *Anthinéa: D'Athènes à Florence*, a book that had many print runs, in which he wrote widely about the parallels of Athens and Florence, a fact that cannot have escaped de Chirico's attention, and that of his mother and brother: an indication of a widespread European sentiment that saw Athens and Florence as the origins of classical and Renaissance modern civilization. The book contains many references echoed in de Chirico's vision of the first metaphysical painting.[3]

An element in *The Enigma of the Oracle* that alludes to the Greek experience is seen in the curtains hanging in the temple, which recur in *The Enigma of an Autumn Afternoon* where de Chirico also carries out a "Hellenization" of the neo-Gothic facade of the Santa Croce Church. If on one hand the figure of the cloaked man with his back to us is taken directly from

Böcklin's *Ulysses and Calypso* (as Soby noted), and represents the oracle, the poet-prophet invaded by the mysterious spirit of God, on the other hand, curtains do not recur in any of the Swiss painter's works and they are a curious addition of a wholly Dechirichian origin. We can find an explanation of this iconography, which would recur in the painter's work, in the de Chirico brothers' childhood experiences. It is Savinio who makes particular reference to this: "In the middle of the iconostasis the arch masked by a red cotton curtain opened up. The hieron was behind. Nivasio tiptoed closer, he stopped to listen, he heard the rasping breath, the thick sighs of He who was hiding in the sacred partition. . . . Nivasio *knew* that two steps away, behind the red cotton curtain, in the sacred and cold space . . . sat the Greek God. And a warm piety brought tears to the rim of his eyelashes."[4]

The curtains are those found in Greek Orthodox churches that divide the holy place from that of the worshippers, thus hiding the mysterious "presence" of the god. The reference is even clearer in *The Enigma of an Autumn Afternoon*, where they seem to be indeed part of the iconostasis. Savinio himself would later portray the god hidden behind the sacred curtain in disquieting mystery in a painting of 1930, *Le Père Eternel contemple la maquette du Paradis Terrestre* [*God the Father Gazing at the Model of the Earthly Paradise*], having also previously echoed his brother's painting in a famous drawing of 1917–18.[5]

It seems even more evident from this last element that the figure seen from behind the holy area cordoned off by a curtain blowing in the wind can be none other than the oracle (mentioned in the title) of the hidden god (whose head we can get a glimpse of behind the impenetrable curtain): he who puts divine thought in communication with the world of man. The meaning of the oracle is also related to Heraclitus, the philosopher upon whom Nietzsche founds the philosophy of Zarathustra (in *Ecce Homo*). De Chirico himself describes the sentiment of the oracle he intended to represent:

> One of the strangest and most profound sensations that prehistory has left us with is the sensation of premonition. It will always exist. It is like an eternal proof of the nonsense of the universe. The first man must have seen premonitions everywhere; he must have trembled with every step he took. . . . I have often imagined vaticinators attentive to the lament of the wave which in the evening withdraws from the Adamitic earth; I have imagined them with head and body enveloped in a chlamys, awaiting the mysterious and revelatory oracle. Thus I once also imagined the Ephesian [Heraclitus] meditating in the first light of dawn beneath the peristyle of the temple of Artemis of the hundred breasts.[6]

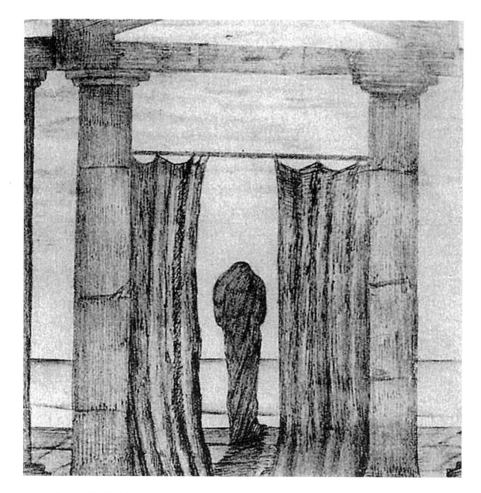

Alberto Savinio, *Untitled*, 1917–18,
artwork stolen (previously in the Angelo Signorelli collection, later in the Vera Signorelli Cacciatore
collection).

The hour of the day is dawn, in contrast with the afternoon represented
in the "founding" painting of metaphysical art: *The Enigma of an Autumn
Afternoon*. The lack of shadows in the painting also attests to this, appropri-
ately for the "frozen hour of dawn." In the same passage, which constitutes
a very accurate description of the painting under examination, de Chirico
perhaps also indicates to us the time of year (in addition to the time of day)
in which he imagined the painting, namely "toward the end of springtime":

> In a temple in ruins, a mutilated statue of a god spoke in a mysterious language.
> This vision always comes to me with a cold sensation as if a wintry wind had

touched me from a faraway, unknown land. The hour? It is the frozen hour of a luminous dawn at the end of spring when the glaucous profundity of the celestial vault causes dizziness in he who delves his gaze into it. Startled, he feels drawn to the abyss as if the sky was beneath him; he stares, like a trembling helmsman leaning from a prow bathed in the golden light of dawn, at the cerulean blue profundity of the withdrawn tide. It is the hour that has already been. Like the man who from the light of day finds himself in the shade of a temple and does not see the white-looking statue, which little by little reveals its form to him, a form ever purer; it is thus that the sentiment of the primitive artist is born in me again. The first to chisel out a god, the first to feel the desire to *create* a god. And then I thought that the idea of imagining God with a human face as the Greeks conceived in art could be an eternal pretext for the discovery of great sources and new sensations.[7]

In addition to noting the clear intention for "primitive" representation (which we have seen widely examined in Rousseau through Soffici's interpretation), we must observe how the painting is quite likely a representation of the spirit of springtime; even if painted in the last months of 1910, it was probably finished after the autumnal *Enigma*.

8. *The Enigma of the Hour*

Two works de Chirico painted prior to his departure for Paris in July 1911 (where his brother Andrea had moved in February), *The Enigma of the Hour* (dated 1910)[1] and *Self-Portrait*, constitute the culmination of the initial, in-depth exploration of de Chirico's new artistic path. As in previous works, the former presents a transfigured view of a real place: in this case, the cloister of the Chiesa del Carmine in Florence.[2] This subject—once again, an almost deserted square populated by enigmatic, solitary, and rather ghostly figures—amplified the breadth of the artist's reflections of this period even further. In a text of 1992[3] that had surprisingly received little attention from scholars and which has recently been afforded consideration,[4] scholar Federica Pirani has provided a very thorough and convincing reading of this early work of the metaphysical art: "In fact, in de Chirico's metaphysical paintings one can find a number of clocks marking the hottest and sunniest hours of the day: from *The Enigma of the Hour*, to *The Philosopher's Conquest*, *The Pleasures of the Poet*, and *The Enigma of Midday*; conceptually speaking, the title of the latter work contains a possible interpretative key." She recalls numerous Greek texts with which de Chirico was certainly familiar—the artist having quoted them on occasion—starting with those of Heraclitus.[5] In Greek tradition, and that of the wider Mediterranean context, midday is the hour of ghosts, of visions, of *deliqui vaticinatori* (prophetic madness), being the southern equivalent of the nordic midnight. De Chirico speaks specifically of this in an essay on Gaetano Previati of 1921: "In certain uniformly deep turquoise skies, without a glimmering of light on the horizon, he succeeded in rendering the nocturnal feeling of light, the sense of midnight at noon, which is the meaning the Greeks marvelously expressed in the myth of Pan, god of noontide, Pan, piper behind the crags and reeds at the hottest hours of the day; Pan who frightens shepherds and wayfarers by appearing suddenly before them."[6] It is at that time, dominated by Pan, that the chthonic mysteries present themselves to human minds: "Whoever exposed themselves to the heat of the sun during that magical hour was, in fact, always in danger of prophetic madness. Accordingly, it is no coincidence that Tiresias surprised Pallas naked at noon, losing his sight as a punishment but receiving the inner light of divination as a gift. However, the theme of clairvoyance, in terms of the poet-prophet-seer

The Enigma of the Hour,
October–December 1910,
private collection.

Cloisters of the Carmine Church, Florence.

equation, is common throughout all metaphysical painting."[7] Therefore, de
Chirico's work contains meditations on his ancestral Greek culture, an interest
that is clear from his reading of texts dealing with anthropology, mythology,
and the history of religion in Florence. Significantly, the theme of Pan and the
fatal hour of noon as a symbol of Greek revival also recurs many times in the
neo-Hellenic poetry of Palamàs, which the artist had read during his youth in
Athens. Therefore, the "paintings of Böcklin and the writings of Nietzsche do
not represent the extent of the artist's personal mythology; rather, these initial
experiences were deepened and investigated further in the mirror of the Ger-
manic world's interpretation of antiquity. If we search among the interstices
of thought, in marginal notes, in comments on the work of other artists, in
fragments of texts or in certain poetic compositions, de Chirico's meditation
on noontime and its demons emerges with lucid precision." And one can add
that, in addition to that of the Germanic world, there emerges a neo-Hellenic
interpretation that was certainly familiar to the artist during his adolescence.

In other words, the paradigmatic meditation represented by the first two
metaphysical canvases, based on locations in Florence and Athens, was ex-
tended to more broadly Mediterranean piazzas that would be further elab-
orated in Paris, grounded, as they are, in the sense of Greek primordial-

ism and the illumination provided by Nietzsche's philosophy and poetry, to which de Chirico added his own personal references. The enigma of time, adding itself to the other enigmas of the world of things and existence, is condensed into that fateful hour, which, by making the rational mind vacillate, enables the function of the Nietzschean Eternal Return to a present without history and to a consciousness where the future coincides with the past, and where man is a presence that can only be interrogated, without providing any answers regarding the meaning of the world.

De Chirico often returns to this aspect in passages of his Parisian writings:

> The clock on the bell tower marks half past twelve. The sun is high in the sky and broiling. . . . What an absence of storms, of hooting owls, of tempestuous seas. Homer would not have discovered any song. A hearse has been waiting forever. It is as black as hope, and this morning someone claimed it would still be waiting tonight. Somewhere there is a dead man whom we do not see. According to the clock it is thirty-two minutes after twelve, the sun is setting; it is time to leave.[8]

> Toward the middle of the day they assembled on the large square where a banquet had been prepared. . . . The sun possessed a terrible beauty. The regulated shadows. . . . Finally noon arrived. It was solemn. It was melancholy. When the sun arrived at the top of the celestial curve, they inaugurated the new clock on the town's railroad station. Everybody was crying. A train passed by frantically whistling away. The cannons thundered. Alas it was so beautiful.[9]

The meaning of high noon corresponds tightly with Greek mythology and with Hellenic classicism, in an enduring bond that years later the surrealists would be incapable of understanding: "And now the sun has halted high in the center of the sky; and with eternal happiness the statue bathes its soul in the contemplation of its shadow."[10]

During their journey from Florence to Paris, de Chirico and his mother stopped for a couple of days in Turin to visit an exhibition commemorating the unification of Italy. But the artist was again experiencing his recalcitrant intestinal disorder and saw the city with its squares deserted in the heat of July, its soaring and eclectic towers (the Mole Antonelliana), and its equestrian monuments flanked by arcades, as if in a trance that sharpened his perception of things as mysterious and alien, somewhere between presentiment and vision.

Italian squares (initially that of Santa Croce, subsequently incorporating impressions received in Turin and Rome, in an afflatus of nostalgic Italian memories), of a "Hellenic primordialism,"[11] the enigma, eternal return as an ultimate moment where everything lives in the eternal present: these elements, explored in the infinitely composed Florentine works, would give life to the first series of masterpieces created during de Chirico's Parisian period.

9. Paris, the Metaphysics of Nostalgia

De Chirico's new vision of metaphysical art, which came into being at a deep level during his stay in Italy and conspicuously in Florence, reached maturity in Paris, where he arrived on July 14, 1911, ready to encounter what was new in France and make his paintings known to the public. Through his reading of Soffici, he had already seized upon the pictorial crux of Rousseau who held a privileged place of honor on the Parisian intellectual scene: Picasso and Apollinaire were indeed great admirers of Le Douanier. The French novelties would touch de Chirico only marginally, since he was fully mature, established, and conscious of his own innovation. Apollinaire marveled at his language, an increasingly complex and abstract development (though he did not write his first article on de Chirico until 1913). Indeed, it was Apollinaire who stressed the almost inconceivable independence of de Chirico's art from the French avant-garde context, which drew all modern artists into its orbit (even the futurists): "[De Chirico's art] derives neither from Matisse nor from Picasso; and is not derived from the impressionists. This originality is so new that it deserves to be recognized."[1] The artist pointed out a completely novel and original path in the art of the European avant-gardes, preparing the way for the creation of oneiric, dreamlike, and surreal imagery.

Elevated into the eclectic Olympus of Apollinaire, the poet-prophet of the avant-garde (which ranged from Rousseau to the cubists, from Picasso to the orphists, and to de Chirico himself), from that moment onward de Chirico was no longer an Italian artist (or "Florentine," as Soffici wrote) but above all European, capable of uniting Germany, Italy, France, ancient and modern Greece—all the founding souls of the Continent—in a lasting synthesis. But on a personal level perhaps he felt like a spiritual brother to Apollinaire, an *apolide* torn from the native Greece of his origins that he would never stop loving and dreaming of: "He knew all about melancholy," wrote de Chirico of Apollinaire (maybe thinking to himself),[2] "first and foremost that of the stateless person. He was born in Rome to Polish parents; as a child he lived in Monaco; then, when he grew in spirit and in

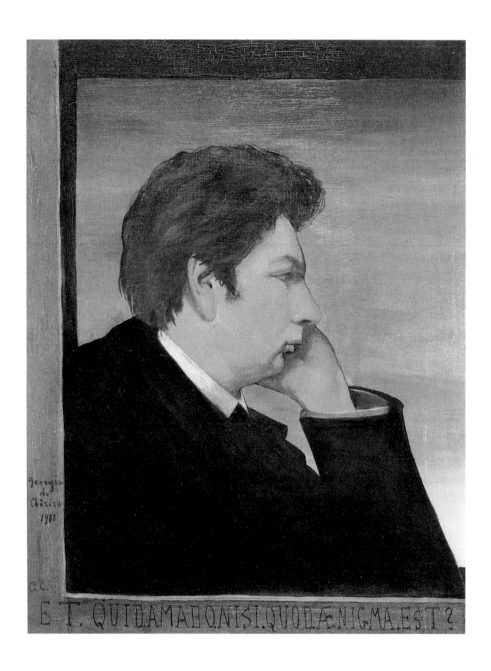

Self-Portrait, spring 1911,
private collection.

The original date of 1911 was later modified by the artist in 1908.

volume, for several years he dragged his 100 kilos of flesh through all the cities of our old mother Europe until he stopped in Paris." The "Greek-ish Chirico," as Carlo Carrà called him in a somewhat derogatory tone,[3] never lost, as previously mentioned, his Greek accent even in Italian (possibly also in French?), as a testimony to how deep his Greek roots were. *The Birth of Tragedy: Hellenism and Pessimism* was also the title of the first book by Nietzsche that he borrowed from the National Library of Florence upon his arrival in the city of metaphysical revelations. And it is in this book (chap. I) that de Chirico found (or rediscovered if he had already read it in Munich) the expression of the sublime nature of art, which derives from dream:

> In dreams, according to the conception of Lucretius, the glorious divine figures first appeared to the souls of men, in dreams the great shaper beheld the charming corporeal structure of superhuman beings, and the Hellenic poet, if consulted on the mysteries of poetic inspiration, would likewise have suggested dreamsand would have offered an explanation resembling . . . *illusion truths thrice sealed / In dream to man will be revealed. / All verse-craft and poetisation / Is but soothdream interpretation.* The beauteous appearance of dream-worlds . . . is the presupposition of all plastic art . . . and Schopenhauer actually designate the gift of occasionally regarding men and things as mere phantoms and dream-pictures as the criterion of philosophical ability. Accordingly, the man susceptible to art stands in the same relation to the reality of dreams as the philosopher to the reality of existence; he is a close and willing observer, for from these pictures he reads the meaning of life, and by these processes he trains himself to life.[4]

So in July 1911 de Chirico moved from Florence to Paris. The city of metaphysical illumination was left behind in order to reunite the small family nucleus, but also to find a wider platform for his artistic vision, which by then was ripe and colossal. His brother, Andrea, having attempted to further his musical career in Milan and having held a concert in Munich without the hoped-for success, had moved to Paris. Some months later his mother and Giorgio joined him, convinced that the French capital might be the most suitable springboard for the brothers' aspirations. For de Chirico it certainly would be.

After the summer months struggling with his persistent, possibly psychosomatic, ailment, de Chirico probably painted little in the autumn, possibly only *Portrait of the Artist's Mother*, which formed part of a kind of family triptych together with that of his brother (1910) and his own *Self-Portrait*.

In October 1912, he exhibited for the first time at the Salon d'Automne. The three paintings he showed were the "diptych" of "revelation": *The Enigma of an Autumn Afternoon* and *The Enigma of the Oracle*, together

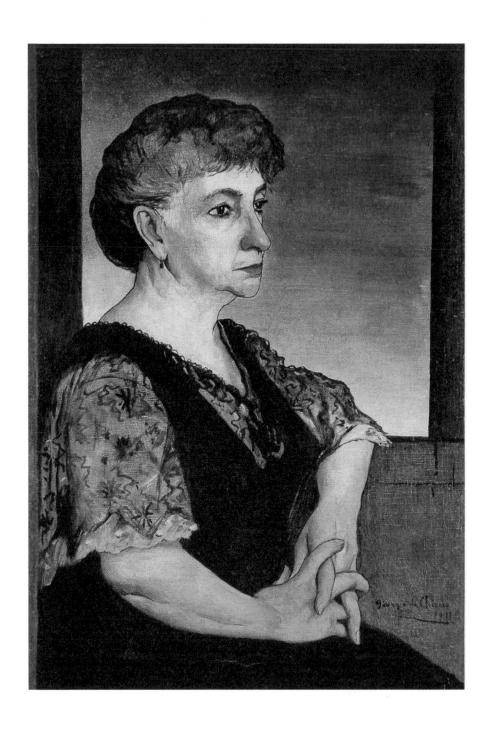

Portrait of the Artist's Mother, autumn 1911,
La Galleria Nazionale, Rome.

with his *Self-Portrait*, in which he depicted himself in the pose of a well-known photograph of Nietzsche, with a phrase that declares his poetics: "*Et quid amabo nisi quod aenigma est?*" [*What shall I love, if not what Enigma is?*]. He would be noticed by one of the period's most interesting critics who carefully followed the first steps of cubism and futurism, Roger Allard,[5] but also by Louis Vauxcelles.[6]

For his next public show, at the Salon des Indépendants in March 1913, he exhibited another three paintings[7] that were apparently noticed by Picasso as well as Apollinaire, who still hadn't written about him but would become his friend soon after.[8] These works presented piazzas inhabited by statuary presences that blend with human ones, lost in distant ancestral time, such as *The Enigma of the Arrival and of the Afternoon*, datable to early 1912, that follows along the Florentine series, represented in the exhibition by *The Enigma of the Hour* of 1910. In this period the architectonic elements compose spaces that mix Greek and Italian memories, giving rise to an immanent enigma that takes on the conflicting reality of dream.

Méditation Matinale [*Morning Meditation*], probably dating from the second half of the year, presents a more accentuated synthetic technique, a more fluid use of paint, a more agitated and gestural brushstroke, revealing a generic awareness of the synthetist novelties of French painting, which were to become more evident over the following years: Matisse, Picasso, Gauguin, even Van Gogh, although certainly perceived as echoes, and digested through an autonomously modern interpretation of the current pictorial style. The subject of the painting is once again derived from a childhood memory: the building on the left, in the open windows of which appear the silhouettes of ancient statues, evokes the memory of his visit to the Olympia Museum, where similar statues looked out mysteriously from low windows.[9] The coexistence of the statues of gods and of a human figure increases the sense of mystery that flows insolubly between the silent characters. Other Greek references can be identified in some of the first paintings he executed in Paris. In *The Melancholy of a Beautiful Day* (1913), the mountain in the background, whose slopes rise swiftly from the plain, recalls the hilly landscape around Athens where the city abruptly stopped, suggesting a view of Mount Lycabettus from the Zàppeion Gardens (where Savinio remembered the brothers playing as children), which stood just behind the family home in Syntagma Square. Dotted with a few houses, this area marked the city limits at the beginning of the century.

Various other places in de Chirico's metaphysical imagery have been identified by art historians or have been suggested by the artist himself. For example, the silhouette of the horse monument that we see in two paintings from the Parisian period derives from monuments in Turin (in particular

*The Enigma of the Arrival and of the
Afternoon*, early 1912,
private collection.

Morning Meditation,
second half of 1912,
private collection.

The original building housing the Olympia Museum.

Carlo Marocchetti's statue of Emanuele Filiberto, as Soby noted, at the end
of the road where Nietzsche lived in Turin, a city in which the philosopher
had a breakdown in 1888). De Chirico saw these monuments in Turin in
July 1911 on a brief visit during which he found himself once again in a
state of physical discomfort that intensified his sensations and perceptions.
The Montparnasse train station, which lent its name to a painting of his,
unites childhood memories (his father was an engineer who built railways in
Greece) and forms part of a nucleus of paintings featuring railway stations
and locomotives blowing steam ("peintre des gares" is how Picasso defined
him in 1913, as the artist later recalled in an autobiographical text).[10]

There are many other seemingly imaginary places in de Chirico paintings
that can be identified. These places always hold special significance in his
pictorial philosophy as locations of *Stimmung*. We could say that de Chi-
rico's inspiration is aimed toward decoding the mysterious aspect of places
and things: "You must find the demon in every thing," as he wrote in 1918.[11]
This aspect prevails in the initial definition of metaphysical art, when the art-
ist based his work on a precise recovery of real elements that he transformed

so greatly as to render them almost unrecognizable, as mysterious echoes of a dawning world.

As noted, Turin in particular struck him with an extraordinary mythopoeic force during his short stay of July 1911 and a subsequent yet more unsettled visit in 1912.[12] The impression he had in Piazza Santa Croce in Florence must have been replicated as a consequence of similar health problems, which kept him in a state of feverish uncertainty, and by the vision of those porticoed squares, standing out in the summer heat, where his philosophical mentor Nietzsche had experienced madness.[13]

Following his move to Paris, he began to reference other locations in his work—no longer only places in Greece or Florence, but Paris itself, as well as Rome and Turin. If the aforementioned literal reference to Turin's equestrian monument to Emanuele Filiberto is well known (the only such explicit depiction to be found in de Chirico's work), another of the city's landmarks also influenced his transfiguring visionary mechanism. In *The Nostalgia of the Infinite*, the large tower may represent the prototype of this highly effective motif in de Chirico's vocabulary (the painting is dated 1911 but is generally—and correctly—dated 1913; the earlier date may record the experience that generated the work during the artist's first visit to Turin). This seems to reference the vertical structure of the Mole Antonelliana that dominates the city: two colonnaded floors at the base with sloping roof upon which the trapezoidal structure rises up (in the original this is slightly inclined, but in de Chirico's version it is straight), at the top of which rises another colonnaded floor. Together, these features recall the Mole Antonelliana's form,[14] although where this culminates in a sharp spire, de Chirico's building is truncated, and crowned with four flag-bearing pinnacles.

Notwithstanding the continued inspiration of the fourteenth-century frescoed towers that the painter had studied in Florence,[15] this typological reference to Turin—subsequently elaborated in various ways—is very clear, although it had not been acknowledged prior to an essay of mine published in 1993.[16] Moreover, the painter himself explicitly alluded to it in a manuscript dated August 1911, written soon after his departure from Turin, a city of the "great towers": "Having left the conquerors' square city, the great towers and the huge sunny squares."[17]

A visit to Rome in October 1909 probably inspired his love for endless arcades (suggested by the interminable rhythm of the aqueducts in the Roman countryside), as the artist himself recalls in a passage dating from his first Parisian period: "The *Roman* arcade is a fatality. Its voice speaks in enigmas full of a strangely Roman poetry, of shadows on old walls and of strange music, of a deeply blue quality like lines from Horace: something of an afternoon

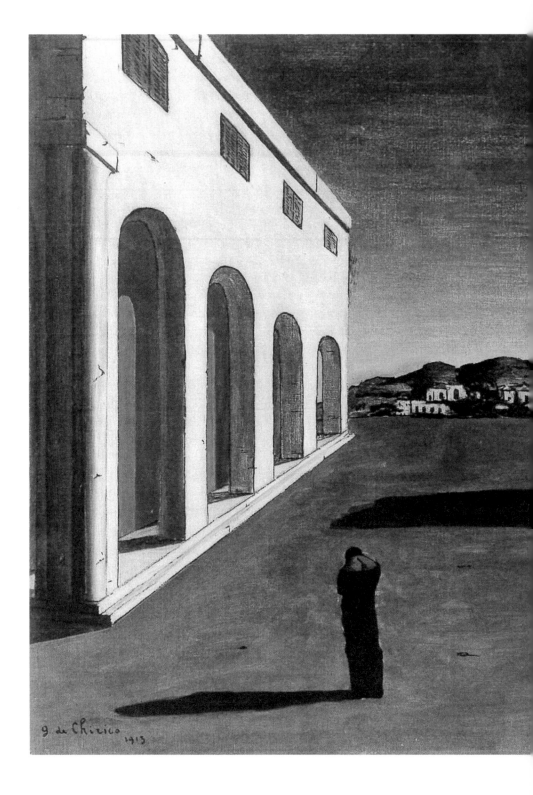

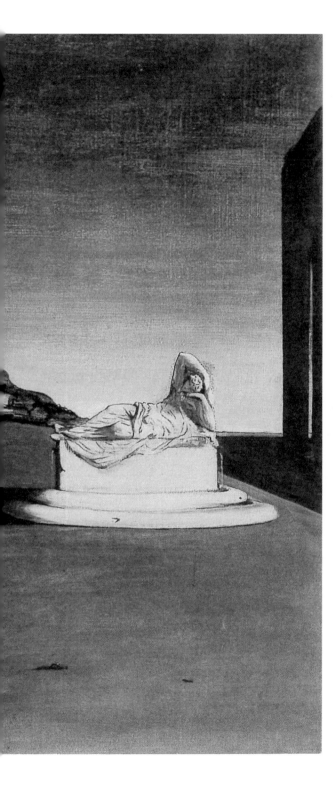

The Melancholy of a Beautiful Day,
1913, Musées Royaux des Beaux-Arts
de Belgique, Brussels.

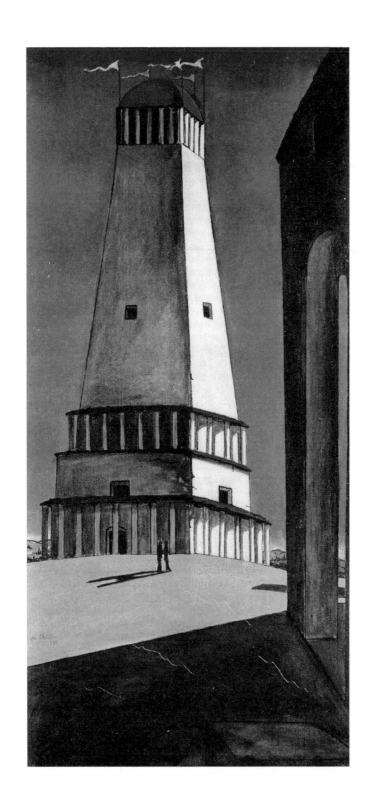

3680. TORINO. Ricordo Nazionale; architettura d'Antonelli. (Edizioni Brogi)

The Mole Antonelliana, Turin.

Previous page:
The Nostalgia of the Infinite, 1913,
private collection.

The Claudio aqueduct, Rome

Carlo Marocchetti, the Carlo Alberto Equestrian Monument, Turin.

The Red Tower, April–October 1913,
Peggy Guggenheim Collection, Venice.

at the seaside."[18] And: "In Rome the feeling of prophecy has something that makes it even more vast. A sensation of an infinite and far-off grandeur, the same sensation the Roman builder set in the sentiment of the arcade, reflects the spasm of the infinite that the celestial vault arouses in man at times."[19] The painting *La tour rouge* of 1913 is an almost literal re-elaboration of the isolated tomb of Cecilia Metella on the Via Appia Antica.[20]

As noted above, in Paris de Chirico took inspiration from stations and towering, monolithic chimneys (in 1918 he would describe the city's suburbs with their busy factories and "forests of red chimneys"), although these would also have caught his imagination during his childhood and adolescence in Athens: the railway stations constructed by his father, the chimneys of the Gàzi district—which stood out against the backdrop of the Acropolis, creating a strident and enigmatic contrast between mythical antiquity and industrial modernity—or those of Piraeus, with ships departing in the background, as in *Ariadne's Afternoon* (1913). Until 1913–14 de Chirico therefore drew on elements of reality, both present and past, that he associated with the nature and meaning of specific places, isolating and transforming them

The Cecilia Metella Tomb, Rome, photograph James Anderson, second half of the 19th century.

in the process. It is the *Stimmung*, the visionary sensibility he had developed by appropriating the philosophical system of Nietzsche (and Schopenhauer) that led him to discover new and disquieting aspects of reality, ones that were revelatory yet simultaneously enigmatic and inexplicable.

The first reference to the theme of Ariadne dates to 1912, with the painting *Solitude (Melancholy)*, a work that is stylistically congruent with other paintings of that year (although its date has been questioned),[21] and which recalls the Nietzschean theme of a poem in the *Dithyrambs of Dionysus*, published in 1889. The last book approved by the philosopher immediately before his descent into madness, it would certainly have attracted the attention of de Chirico, who considered Nietzsche to be "the most profound poet"[22] and saw his work predominantly as an expression of vertiginous poetry. The theme of Ariadne was specifically developed in a poem titled *Klage der Ariadne* (*Ariadne's Lament*) that seems to find an echo in the tone of some of the artist's Parisian writings dating from the period 1912 to 1913. Nietzsche's lyrics contain various elements that can be identified in what may be considered a small "cycle" of paintings created between 1912 and 1913, based on the motif of a statue of Ariadne. These reveal an ever-deeper investigation of and meditation on the work of the German philosopher, with the use of elements ranging from melancholia,[23] explicitly referenced in the aforementioned painting, to the exotic and almost unique (at that time) motif of curving palm trees, which appear in the background of *The Soothsayer's Recompense* (dated 1913)[24] and in at least two passages from the book,[25] as well as the explicit theme of Ariadne herself: "Struck down by your lightning, / your scornful eye, glaring at me out of the dark! / thus I lie, / writhing, twisted, tormented / by all the eternal afflictions, / struck / by you, cruellest hunter, / you unknown—*god*. . . . " The hidden eye that looks at Ariadne seems to be perfectly represented by the shadow in the foreground, which reveals an unknown, motionless, and disturbing presence before the reclining statue. The theme of Ariadne was also touched on by Apollinaire in a poem of 1913 titled "Le Musicien de Saint-Merry," but at that time the relations between the two were not so close as to suggest that de Chirico already knew of and was influenced by the poet's text in 1912, prior to its publication.[26]

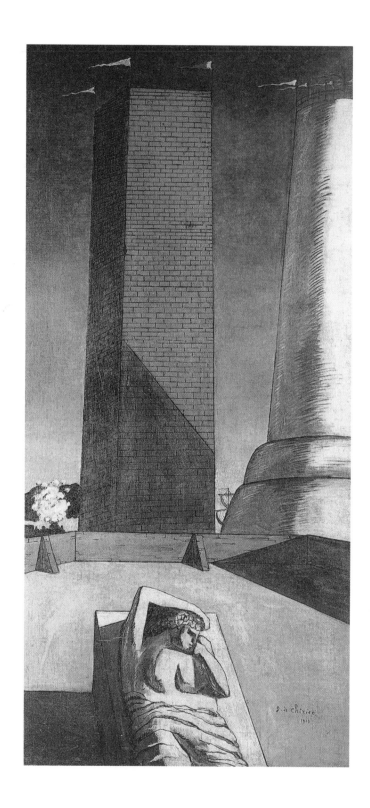

View of the Acropolis from Gazi, Athens.

Facing page:
Ariadne's Afternoon, April–October 1913,
private collection.

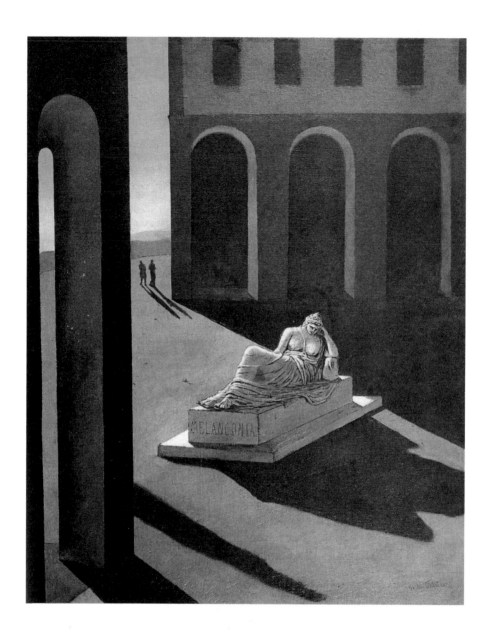

Solitude (Melancholy), first half of 1912,
private collection.

Previous pages:
The Soothsayer's Recompense, 1913,
Philadelphia Museum of Art, Arensberg Collection, Philadelphia.

10. The Evolution of the Metaphysical Aesthetic Between 1912 and 1913

Contrary to the chronology indicated by several scholars for works dating to 1912, that year would also seem to have been relatively unproductive for the artist: in fact, in March 1913 he exhibited a Florentine painting[1] at the Indépendants alongside another dating from the beginning of the previous year;[2] evidently, his new works were still in progress at that moment and were few in number, since he was forced to exhibit pieces executed some time previously. However, over the following six months or so he must have worked rapidly, and with formidable inspiration, given that in early October he presented around thirty paintings in his studio.[3] Since we know with certainty that the first painting sold by de Chirico, *La tour rouge*, was purchased shortly after the Salon d'Automne (November 15, 1913–January 15, 1914),[4] we can be sure that de Chirico exhibited practically all his metaphysical works on that occasion. From what we know, by March 1913 he had painted around fourteen or fifteen works of this kind,[5] meaning that the remaining fifteen would have been created during the intense period of work that took place over the following six months: around two new paintings each month, and in some cases even three. Apollinaire is the only critic that cited some of the paintings on display,[6] including some earlier pieces and two unidentified works, which may have been modified subsequently by the artist himself. The identification of fifteen more recent paintings is therefore hypothetical, although they would certainly have been similar to those shown several days later at the Salon d'Automne.[7] The selection comprised four paintings with carefully chosen subjects, each of which was different from the other: a portrait, a nude, a "piazza d'Italia" with a tower and an equestrian monument, and another piazza of Greek inspiration, which included the figure of a soothsayer/seer in the foreground.

In his studio exhibition, de Chirico would certainly have presented the Ariadne series and that of the towers, the new subjects (often combined) that were exhibited at the Salon d'Automne, in addition to the nudes and the recent portraits. In these works a clear dialogue with Parisian painting of the time begins to emerge: some of the Ariadne pieces exhibit formal simplifications in the manner of Picasso, while the nudes are characterized by the synthetic qualities typical of Matisse, as well as a technique using parallel brushstrokes to suggest volume that echoes the style of Van Gogh.[8] Certain

The Lassitude of the Infinite, first half of 1912,
private collection.

compositions incorporating exotic elements and increasingly strong mono-chromatic planes, *cloisonnés*, of expansive pure yellow and ocher tones, recall Gauguin,[9] not to mention the aforementioned debt to Rousseau. However, these references glide like mercury across de Chirico's absolutely autono-mous images, without ever leaving obvious traces, as Apollinaire noted:

> The art of this young painter is an inner and cerebral art that bears no relation to that of those painters who have come to the fore in recent years. It derives neither from Matisse nor from Picasso; and is not derived from the Impression-ists. This originality is new, and thus deserves to be recognized. De Chirico's very acute and very modern sensations tend to be expressed in an architectural context. There are stations adorned with clocks, towers, statues, large deserted squares; railway trains pass by on the horizon. Here are some singular titles for these strangely metaphysical paintings.[10]

Apollinaire describes de Chirico's paintings as "metaphysical," revealing that this term, which the artist had already employed in his writings, was habitually used to characterize his work.[11] Surprisingly, in the (very positive) evaluations of de Chirico's solo exhibition, both Apollinaire and Maurice Raynal commented on the artist's "sad" use of color (Apollinaire), or even that it lacked "an existence in itself" (Raynal). This is all the more remarkable given their close associations with cubism, which until 1913 had been defined by a very muted color scheme dominated by earthy, gray tones that were even less vibrant than those used by de Chirico. However, such observations probably encouraged de Chirico to strengthen his colors—and even to rework a few of his recent paintings.[12]

The evolution of the vocabulary and space explored by de Chirico over the course of these years is perfectly comprehensible if we examine the Italian

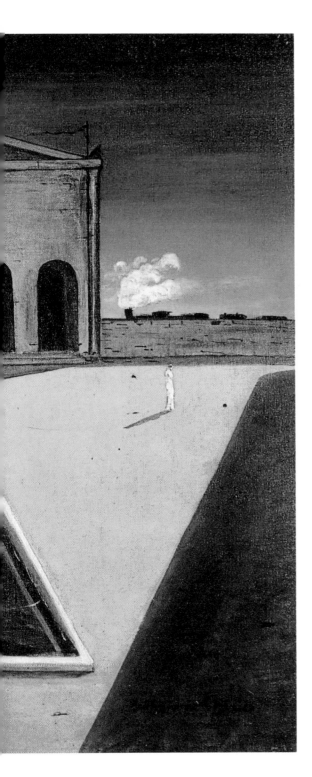

The Delights of the Poet, first half of 1912,
private collection.

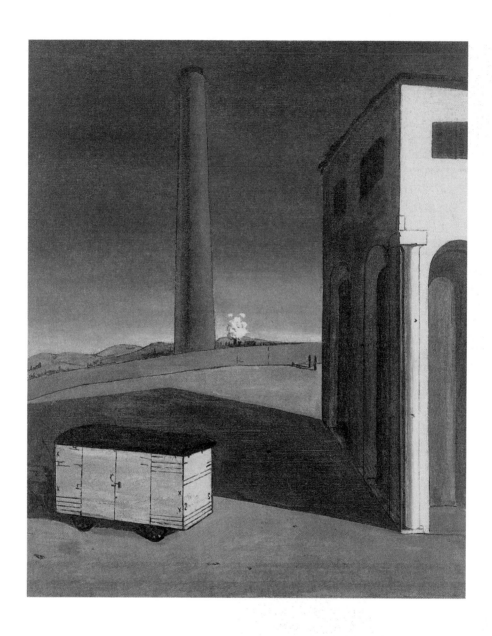

The Arrival (The Melancholy of Departure [?]*)*, second half of 1912,
Albert C. Barnes Foundation, Philadelphia.

Portrait of Madame L. Gartzen, April–October 1913,
private collection.

Nude (with Black Hair), April–October 1913,
private collection.

Henri Matisse, *Blue Nude (Memory of Biskra)*, 1907,
Baltimore Museum of Art, Baltimore.

Pablo Picasso, *Three Women*, 1907,
Hermitage, Saint Petersburg.

Piazza with Ariadne, mid-1913,
private collection.

The Silent Statue, second half of 1913,
Kunstsammlung Nordrhein-Westfalen,
Düsseldorf.

Paul Gauguin, *The Loss of Virginity*, 1891,
Chrysler Museum of Art, Norfolk.

Vincent Van Gogh, *Still Life with Statue*, 1887,
Kröller-Müller Museum, Otterlo, Netherlands.

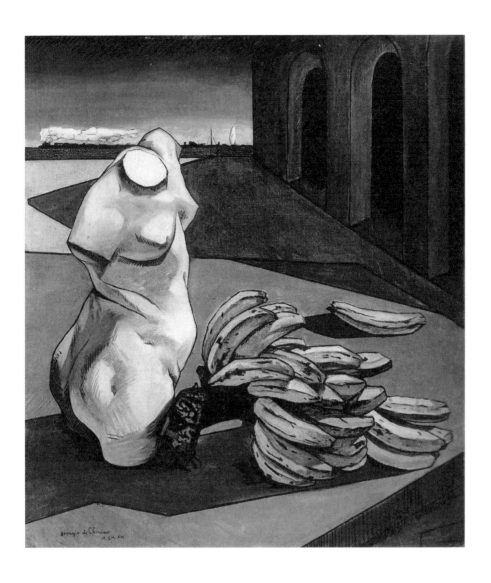

The Uncertainty of the Poet, second half of 1913,
Tate, London.

Piazza series. Those of 1910–11 continue to be constructed ostensibly in accordance with a traditional system of perspective that is essentially frontal, but which also incorporates lateral points of view. While initially appearing to be subjected to a centralized perspective, the architectural openings and arcades have their vanishing points away to the side, creating a subtle imbalance, a perceptual discrepancy, which endows the compositions with a sense of unease and strangeness in contrast with conventional vision. Evidently, de Chirico was already reflecting on how, in addition to using specific iconographic elements, he might suggest the sense of a disquieting world in which familiar scenarios—even those veiled by the reassuring veneer of classicism—could evoke an atmosphere of indecipherable mystery. Perhaps influenced by Soffici's observations concerning the art of the primitives,[13] he elaborated a diachronic system of perspective, which combined a reassuring centrality and even (in the early Florentine paintings) frontality, with jarringly eccentric and apparently incompatible points of view.

This system was initially applied in the context of details that were not immediately apparent, or even "embedded"—but nevertheless evident to psychological perception—then it was amplified in the paintings of 1912 to create more evident and alarming perspectival incongruities. De Chirico went on to multiply the vanishing points and place them in different zones and at different heights in order to accentuate the sense of a disjointed or inebriated perception of the world in which we are unable to orient ourselves, despite still being able to recognize it on an iconographic basis thanks to familiar reference points.

In his paintings of 1913, de Chirico employed this technical expedient in a yet more extreme manner, inventing ever-more daring and precipitous perspectives. His deconstruction of the perspective system—which by nature was intended to provide a credible representation of the world—became increasingly pronounced and disorienting. Manifestly incoherent and disorderly, this approach rendered his imagery even more unreal, resembling that of the dream, intended to bring to light from the depths of the psyche those associative nodes that would stand in a progressively more explicit manner as the equivalent of visionary disorientation, of the Nietzschean and Schopenhauerian "revelation."

This dialectical relationship with reality (albeit a reality distorted by inconsistent perspectives), changed considerably in the course of 1914: places become less and less recognizable, being transformed into "non-places" devoid of external references, emphatically identified as such by increasingly distorted perspectives and spatial forms. De Chirico further changed his vision but also his style; his paintings became more anti-naturalistic in terms of their colors and shapes: this was the era of his friendship with Apollinaire.

11. Apollinaire and the Avant-Garde

The relationship between Giorgio de Chirico and Guillaume Apollinaire,[1] well known and documented both by the poet, prophet of the Paris avant-gardes, and by the artist and his brother, Savinio, has often been seen as a deep though generic stimulus, as de facto proof of de Chirico's entry into the cultural milieu of the French avant-gardes. Although certainly true, this doesn't tell the whole story: the intellectual bond they enjoyed was extremely productive, especially for de Chirico, who in Apollinaire's poetic world found a vast range of fascinating impressions and images, as well as stimulus for a substantial evolution of the very language of his painting. We have no certain information regarding the beginning of their relationship, which seems to have oscillated between the winter of 1912–13, following the first exhibition of de Chirico's paintings in Paris[2] (Salon d'Automne, October 1912), and their definite meeting in the artist's studio in rue Notre-Dame-des-Champs, where he organized a presentation of about thirty paintings in October 1913 that Apollinaire reviewed in an extremely positive manner. The relationship between the two artists seems to have grown closer toward mid-1913. However, it is clear that while one or more informal meetings might have already occurred in 1912, Apollinaire's interest in de Chirico developed more strongly only in the autumn of the following year, when he published two reviews of the painter's work; by contrast, he completely neglected to mention de Chirico's participation (with three pictures) in the Salon des Artistes Indépendants in the spring of 1913. Further proof of this developing relationship is given by the beginning of their correspondence in January 1914,[3] which although initially formal, did not lack in intimacy and rapidly reflected an altogether closer friendship.

Following pages:
The Anxious Journey, late 1913,
Museum of Modern Art, New York.

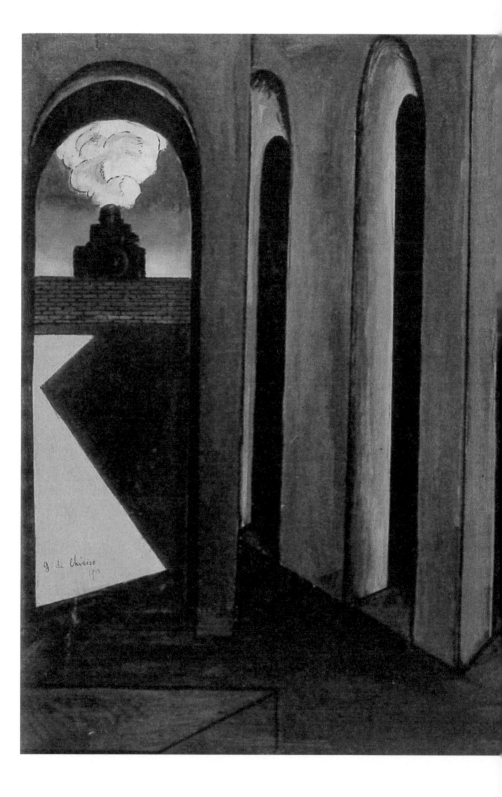

Between the end of 1913 and the start of 1914, while his relationship with Apollinaire was intensifying, we can see a significant evolution in de Chirico's work, even from a stylistic point of view. In the construction of space, all allusion to existing places (the "Italian Piazza"), dense with references from his youth, is left behind. The new spaces lose connection to reality during the final period in Paris (1914–15).

After encountering Apollinaire's ideas, de Chirico took on dizzying perspectives in the spaces of his paintings, and the settings become decidedly unnatural: the architectonic elements lose the reference value of memory and are arranged in animated groupings lacking specific connotations. The spaces and contexts being created increasingly reflect the irrational ones of dreams: this journey had already begun with the Florentine metaphysical art but now went deeper into more complex and multifaceted iconographies. Apollinaire's profound influence on de Chirico's style should be interpreted and evaluated in parallel with the development of their relationship. Even the celebrated theme of the "mannequin" has its origin in Apollinaire's literature, just as the *onirocritique*, that is, the dream method of Apollinaire's poetry, had a deep influence, "triumph of falsity, of error, of imagination," "nothing that resembles us and everything as our image": dream and psychological automatism as the motive and motor of a new poetic style, to which de Chirico applied his previous references (Nietzsche, Schopenhauer, Heraclitus, Papini, et al.), and which would constitute one of the departure points of surrealism[4] (which, let us be reminded, is a word coined by Apollinaire).

We must also ascribe to this period de Chirico's thorough study of Otto Weininger, according to the testimony of his friend Castelfranco—information certainly gleaned directly from the painter sometime around 1919:

> De Chirico had already given us his "Italian Piazzas" and his first spatial interpenetrations, such as *The Departure,* when he read in Otto Weininger's posthumous work *On Last Things* the brief and illuminating chapter "Metaphysics— Idea of a Universal Symbolism," a proposal to seek the meaning of each single element within the All: "A greater reality belongs to psychical phenomena," writes Weininger, "than to physical phenomena"; physical reality should be explored by the yardstick of our psyche; each of our psychical concepts is an avenue of connection, of the discovery of real analogies between things. . . . To give a very evocative example on the subject of de Chirico: "the midday calm, in which all sounds are lost, is the disturbing side of apparent perfection, of the absence of desire, of apparent satisfaction. To the disturbing side of noontide (Pan) corresponds perhaps the fear of total intellectual clairvoyance, of the solution to all problems. . . ." In a word, around 1914 de Chirico drew from

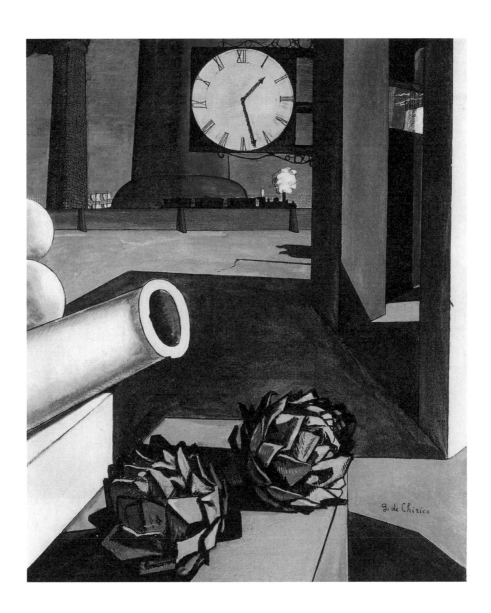

The Philosopher's Conquest, first half of 1914,
Chicago Art Institute, Chicago.

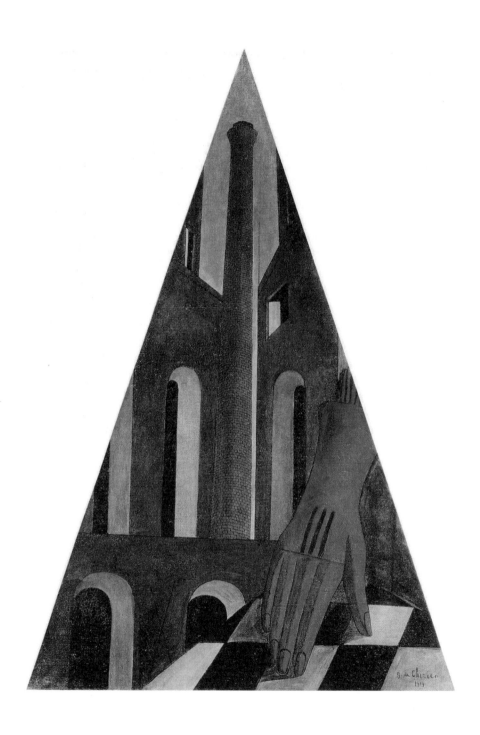

The Enigma of Fatality, first half of 1914,
Basel Kunstmuseum, Basel (on loan from Emanuel Hoffmann-Stiftung).

Weininger's book not only the use of this new meaning of "metaphysical" but also a confirmation of his imagination, mental means of definition and in a certain sense new impulses.[5]

As we have seen, the term *metaphysical* was in fact already being used by de Chirico and Apollinaire (and, naturally, by the other figures in their milieu) from at least October 1913. Accordingly, de Chirico's deeper investigation of Weininger probably dates from around the middle of 1913, and the new "psychic" perspectives that this opened up for him certainly led to an even greater alignment between his ideas and the analogous dreamlike and unconscious "automatic" research of Apollinaire.

The first half of 1914 was a period of innovative and astonishing paintings such as *The Philosopher's Conquest, The Enigma of Fatality, The Serenity of the Scholar, The Joy of Return, The Revenant (The Child's Brain), The Fatal Temple*, and *The Song of Love*, in which objects loom monumentally in incomprehensible and compressed spaces, and where even the works themselves could take on triangular or trapezoidal formats, completely novel with respect to the canons of art history. Even the Italian Piazzas, when they still appear, are shaken by inner, dreamlike tremors that seem deeper and more threatening, as in *The Enigma of a Day I, Mystery and Melancholy of a Street, Still Life—Turin Spring*, and *The Fête Day*.

It seems almost pointless to search for symbolic meaning in paintings that deny any logical connections. The links by now are only psychic in nature. We do indeed find the familiar *topoi* of de Chirico's vocabulary, but they conflict and jar with their intentionally unsettling contexts, as in our most intimate and mysterious dreams, which leave us anxious and unable to decipher their meaning upon awakening.

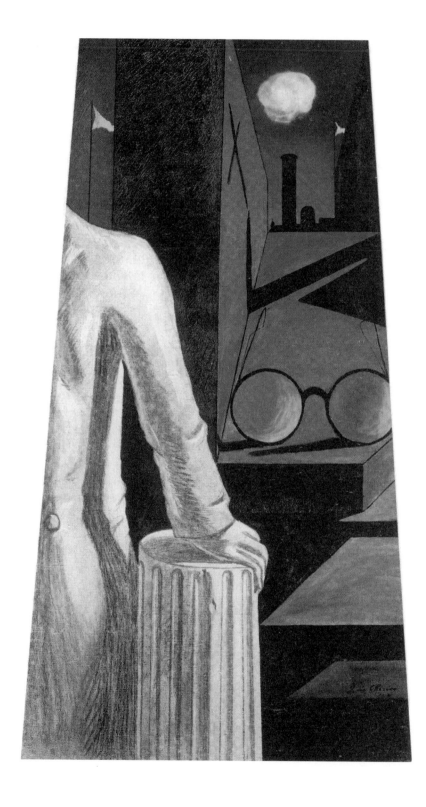

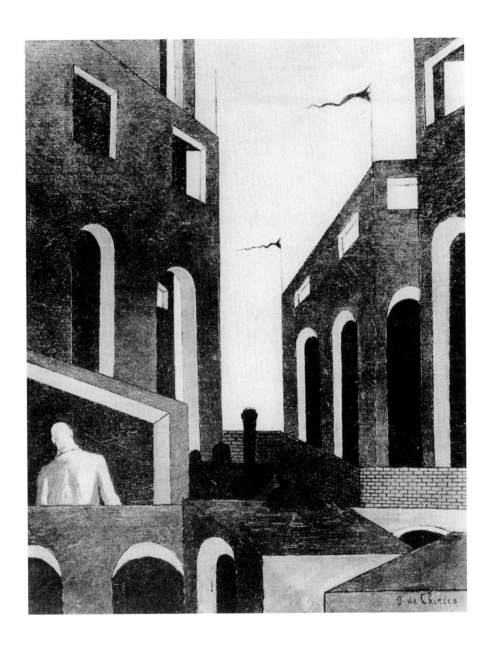

The Joy of Return, first half of 1914,
private collection.

Facing page:
The Serenity of the Scholar, first half of 1914,
Museum of Modern Art, New York.

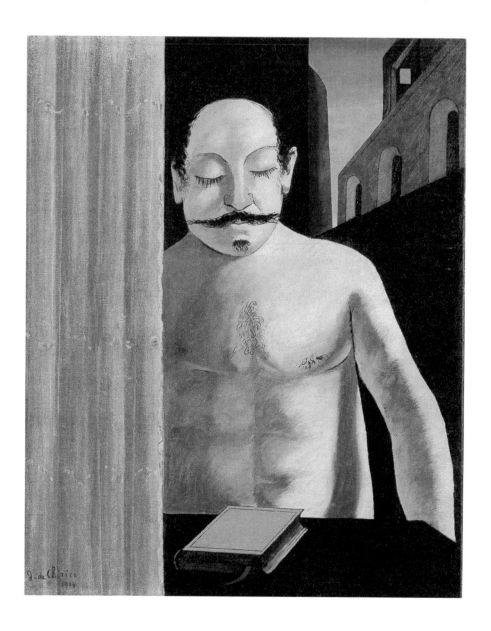

The Revenant (The Child's Brain), first half of 1914,
Moderna Museet, Stockholm.

The Fatal Temple, first half of 1914,
Philadelphia Museum of Art, Philadelphia.

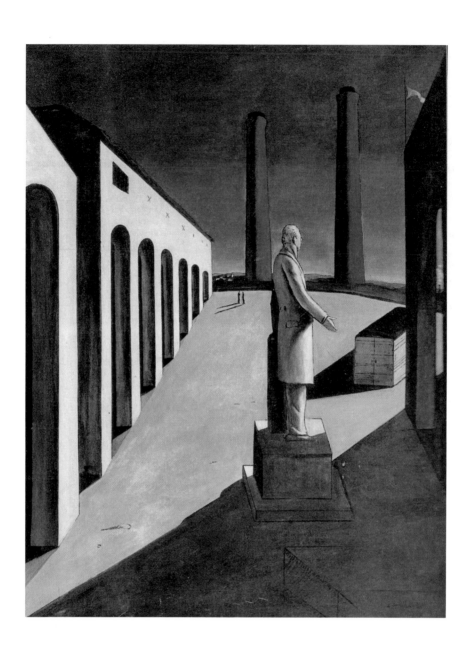

The Enigma of a Day I, first half of 1914,
Museum of Modern Art, New York.

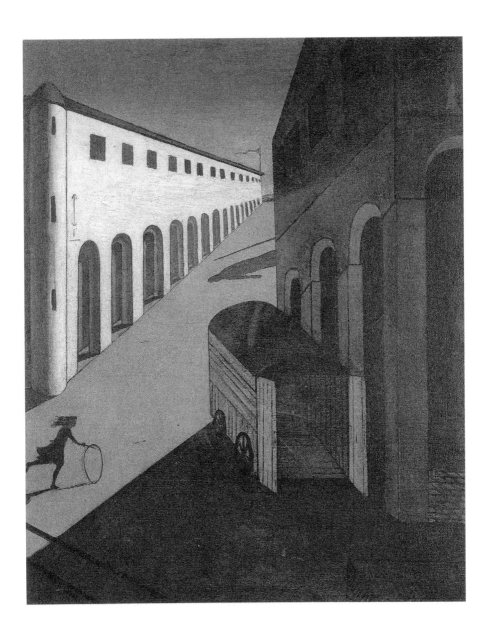

Mystery and Melancholy of a Street, first half of 1914,
private collection.

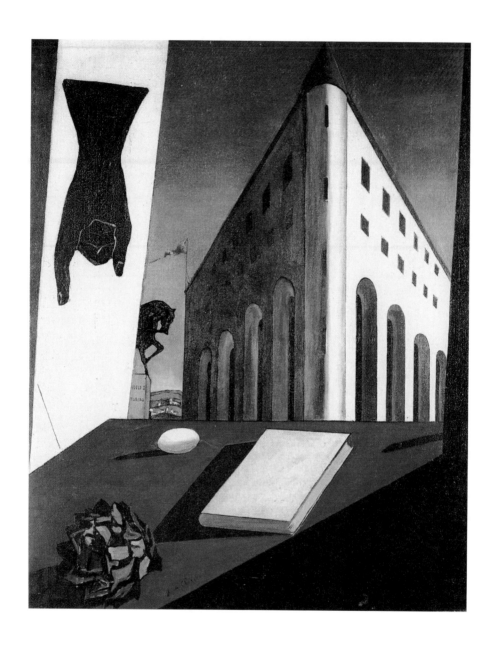

Still Life, Turin Spring, first half of 1914,
private collection.

The Fête Day, first half of 1914,
private collection.

The Song of Love, mid-1914,
Museum of Modern Art, New York.

12. The *Portrait of Apollinaire* and the Dreamlike Space of Metaphysical Art

To better focus on the fruitful reciprocal relationship between de Chirico and Apollinaire, it is instructive to examine a work that is emblematic in this respect, and which is in a certain sense unique: the portrait of the writer painted by de Chirico in 1914, which is perhaps the most representative of de Chirico's stylistic renewal of metaphysical art, and which in some senses can be seen as the "manifesto" of this new phase of research.[1] The painting's singularity stems from de Chirico's attempt to endow it with a meaning associated with a specific sitter, in contrast with other contemporaneous works.

Between the end of 1913 and the beginning of 1914 de Chirico began frequenting Apollinaire's home in Paris to study his writings. It wasn't until January 1914 that he introduced his brother to the French poet.[2] Among the various autobiographical writings of the two de Chirico brothers that refer to the many afternoons and evenings spent in Apollinaire's literary salon, two stand out as being particularly significant: "Apollinaire pontificated from the chair at his work-table; taciturn and consciously thoughtful individuals sat on the armchairs and divans . . . Later, two or three of my metaphysical paintings were also hung there, including a portrait of Apollinaire depicted as a target-figure which, apparently, prophesied the head wound Apollinaire received."[3] "At his desk, loaded with objects of indeterminate use that were nevertheless curious and pleasant in their own right, Apollinaire corrected the proofs of 'The Poet Assassinated' with a vigilant eye and a swift hand. Beneath his stately nose he sucked on one of those little clay pipes that feature as elegant and highly fragile targets in the shooting-booths at fairgrounds."[4]

Apollinaire must have shortly become very friendly with de Chirico, to the extent that he gave him manuscripts of his unpublished poetry and certainly asked him to read his freshly written works or works in progress. On this subject in fact Savinio, as we have seen above, recalls with precision that the poet was correcting the drafts of *The Poet Assassinated* while he

Portrait of Guillaume Apollinaire, summer 1914,
Centre National d'Art et de Culture Georges Pompidou, Paris.

Portrait of Apollinaire, summer 1914,
private collection.

to Guy Romain, to the man and benefactor, an homage of friendship and peaceful memories M.CMXIV.
Giorgio de Chirico. (Guy Romain is a pseudonym given to Paul Guillaume by de Chirico [A/n])

was at his house, in those short months before July 1914, when Apollinaire left as a volunteer (even though he managed to enroll only later due to his documents) for the Great War. It is well known that *The Poet Assassinated* consists largely of pieces written many years earlier but, due to the war, published only in 1916. The general composition of the work, however, was concentrated between 1913 and 1914,[5] exactly the period of Apollinaire's consolidated friendship with de Chirico.

The Poet Assassinated is a sort of symbolic autobiography of Apollinaire, the allegorical course of the life of Croniamantal (the protagonist, which literally means "the seer of time," the seer of eternity—almost the title of a de Chirico painting),[6] a clairvoyant poet whose story is outlined symbol-

ically, like that of the "Great Initiates," Christ and Orpheus, from procreation and gestation to final martyrdom and glorification. Many passages in the "poem-novel" are extremely significant for explaining the works of de Chirico and even of Savinio in that period (for example, the idea of the mannequin); in particular, it is, as I pointed out in 1993,[7] the precise inspiration from which de Chirico set out to construct his celebrated painting *Portrait of Apollinaire.*

The "premonitory" portrait of Apollinaire (the target marking the temple on the black silhouette was said to be a foretelling of the shell shrapnel that struck him in exactly the same spot in the war) was not generated by a metaphysical premonition of de Chirico's (which the painter harmlessly accepted credit for) but if anything was inspired by the Christological-Orphic allegory that Apollinaire had drawn of himself as poet, mortally wounded in the eye by a false poet (in the poem). So the wound was foretold by the autobiographical figure of Croniamantal,[8] a new Orpheus, prior to de Chirico's portrait in oil. From a reading of the poem one also understands how the black outline is not only that of a *homme-cible* (man-target) but also represents the monument to the poet himself, to Apollinaire-Orpheus. Croniamantal's followers, after his violent death, want to raise a monument to him, a statue of eternal memory; but a monument in marble, bronze, or wood would not be enough for him: "It's something too old," says one of his disciples, "I must sculpt a deep statue of nothingness, like poetry itself and glory." A statue of profound meaning, made "of nothingness."[9] So in the woods of Meudon a pit was dug whose interior was modeled in the image of Croniamantal in such a way that "the void was full of his ghost." Also in the portrait, the outline painted by de Chirico is a void, a shadow, a nothingness full of the ghost of Apollinaire.

The painting, which Apollinaire called a "singular and profound work," confirming the identification of his profile in the *homme-cible*, is therefore the pictorial transposition of Apollinaire's own literary self-portrait. And if the clay pipe typical of shooting ranges that Apollinaire used to smoke may have suggested the idea of the profile,[10] it is certain that he adopted this solution because it represented the fortunate coincidence of a formal setting with the "inner," premonitory, and mysterious content of the poet-seer Croniamantal and his destiny—of the "negative statue," made of emptiness.

Apollinaire is evoked in a moving passage by de Chirico in 1918, a portrait of his poet friend who had recently died in Paris.[11] In describing him in the brief article, the characteristic he most underlines and insists on almost obsessively is melancholy, which comes to light in various passages:

Carp, illustration, early 20th century.

> When I recall his numismatic profile that I imprinted on the green sky of one
> of my metaphysical paintings, I think of the grave melancholy of the Roman
> centurion . . . a man steeped in the hot bath of universal melancholy. He knew
> all about melancholy; first and foremost, that of the stateless person . . . verses
> printed in the melancholy of that fatal Avenue de l'Observatoire, situated
> almost at the city limits, there where the smoking port of industrious work-
> shops begins and the forests of red chimney stacks rise . . . the spirals of his
> chronic melancholy as an ill-fated poet.

 Certainly de Chirico saw the stigmata of melancholy in his poet friend, the
metaphysical muse he had celebrated in the homonymous painting of 1912
and which made him almost a spiritual brother. And the fish that stands
out in the foreground of the *Portrait*, a carp, is explicitly defined in Apolli-
naire's *Bestiaire* as a "fish of melancholy . . . which death has forgotten,"[12] in
addition to the Christological symbol used by the poet himself,[13] thus con-
firming the Orpheus-Christ-Apollinaire identification. For Apollinaire the
carp was symbol of melancholy, a disquieting muse of both de Chirico and
the poet himself, forgotten by death just as poetry escapes death through
glory. The "sacred" fish that stands out emblematically and mysteriously at
the center of the painting alongside the shadow of Apollinaire is likewise
represented as an "absence" rather than by its physical presence (suggested
by a tin mold used for cooking desserts, which triggered the painter's typical
surreal-metaphysical associative process), in exactly the same manner as the
commemorative monument to Croniamantal-Apollinaire. It's a sort of mod-
ern fossil—the memory of a primordial epoch—whose form is preserved by
the void it leaves behind.
 The shell that also appears in the foreground of the *Portrait of Apollinaire*
seems to be a symbol of pilgrimage, something to which Apollinaire refers

French cake mold in shape of carp (*left*). French "Madeleine" cake mold in shape of Saint Jacques shell (*right*).

in *The Poet Assassinated* ("girls dressed in the shoulder capes of St James of Compostela; their costume, as is fitting, studded with Saint-Jacques shells").[14] De Chirico also refers to the melancholy of the pilgrim wandering through Europe in his aforementioned article of 1918, citing it as the prime reason ("first and foremost, that of the stateless person") for his melancholy spirit. It has been argued that the Saint-Jacques shell may symbolize the lyre, the instrument of Apollo but also of Orpheus, since it originated from a shell. However, this is decidedly unlikely, as the lyre is associated with tortoiseshells, both in Greek mythology[15] and historically, as well as for Apollinaire.[16] As with the fish, de Chirico chose the "empty" scallop-shaped form of a cake tin, typically used in baking madeleine biscuits.

As for the meaning of the white bust in the foreground, it is possible that the earliest inspiration came to de Chirico from a barber's papier-mâché head, which he recalled in 1918 in *Zeusi l'esploratore*: "The papier-mâché skull in the middle of the hairdresser's window cut in the strident heroism of gloomy prehistory, burned my heart and mind like a recurring song."[17] The ambiguity of the head is accentuated by the fact that it is not a classical bust, despite the fact that its white marble appearance might initially suggest it. The balding figure has a decidedly modern hairstyle that one would never find in a classical work, confirming the reference to the barber's head. It

Facing page:
The Nostalgia of the Poet, summer–autumn 1914,
Peggy Guggenheim Collection, Venice.

therefore represents a contemporary man depicted as a classical bust, and it is this "modern" aspect that further endows the figure with a disorienting and metaphysical presence, something further accentuated by the dark lenses that hide his eyes, making him a sort of ideal effigy, a "modern" Homer or Orpheus, whose black glasses allude to clairvoyance.[18] Ultimately, however, its contextual meaning remains difficult to decipher. Perhaps it represents a further allusion to *The Poet Assassinated*, in particular the image of Croniamantal's father, who was unknown to him (like Apollinaire's own father).[19]

A further dimension to the theme of Orpheus, which represented an extremely interesting shared point of reference for Apollinaire, Paul Guillaume, and de Chirico (as well as having important consequences for the artist's painting during the 1920s), was a text by Salomon Reinach titled *Orpheus. Histoire générale des religions*,[20] a volume with which both de Chirico and Guillaume were certainly familiar, since both alluded to it (de Chirico referred to a phrase that appears in the epigraph to the text by Marcus Anneus Lucanus: *Veniet felicior aetas*). In Reinach's book, Orpheus is described as "the 'theologian' par excellence in the eyes of the ancients, the instigator of the mysteries that ensured the health of mankind and, crucially, the interpreter of the gods." The text must have been a topic of discussion among the three men, given de Chirico's reference to it in a letter to his distant friend Guillaume on June 3, 1915.[21]

In any case, an inner symbolic and psychic portrait of Apollinaire clearly emerges from de Chirico's painting. It is one of the artist's few metaphysical works to have a precise iconology and to contain literal references to a programmatic and implied source. Elsewhere, the absurdity of the world prevails.

13. De Chirico and Apollinaire: The Non-Places of the Final Parisian Metaphysical Years; the Mannequins

A more in-depth consideration of Apollinaire's written work allows us to understand in greater detail the relationship between the poet and the artist as well as the effect their friendship had on the evolution of de Chirico's metaphysical art. For example, a key question in studies of metaphysical art, one that has sometimes given rise to mistaken ideas concerning the inventive contiguity between the work of de Chirico and Savinio, leading to an emphasis on its reciprocal character, relates to the genealogy of the mannequin motif as well as certain other atmospheres and iconographic elements typical of de Chirico's work in 1913 and 1914. This matter, debated in the context of *Les Chants de la mi-mort* (The Songs of Half-Death; published by Savinio in Apollinaire's journal *Les Soirées de Paris* in August 1914) and the paintings that de Chirico produced during the same period, can be resolved with certainty by referencing the texts Apollinaire was working on at that time, in particular *The Poet Assassinated*. The images of Savinio that led to erroneous assumptions regarding his invention of the mannequin motif (Roberto Longhi was the first to suggest this—with calculated maliciousness, as we shall see)[1] are, in particular, the *homme-cible* (man-target), the "bald man," the "wrought iron men," and the statues (including an equestrian monument). However, we have already noted that the man-target motif consisted of de Chirico's transposition of an intensely symbolic episode described in *The Poet Assassinated*; accordingly, he did not borrow it from his brother Savinio who, in fact, in using figures of this kind merely made a double quotation (from both de Chirico and Apollinaire). Likewise, a bald man,[2] and a bronze statue that speaks and moves,[3] also appear in Apollinaire's "novel," while a man "without eyes without nose and without ears" features in a poem published in *Les Soirées des Paris* on February 15, 1914 ("Le musicien de Saint-Merry," subsequently republished in *Calligrammes*).

Evidently, then, the relationship was quite the other way around, and indeed, one can note many other points of contact between Savinio's *Les Chants de la mi-mort* and the writings of Apollinaire. For instance, a charac-

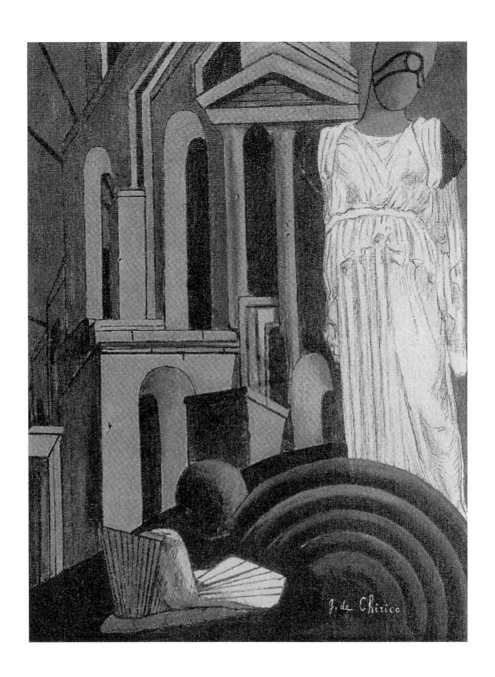

The Torment of the Poet, late 1914,
Yale University Art Gallery, New Haven.

ter in the former's "scenic poem" is named Onirocrite—a direct reference to one of Apollinaire's most important texts, *Onirocritique* (*Criticism of the Dream*, 1908). Above all, however, Apollinaire's example can be discerned in terms of certain stylistic techniques, of free verse and of unpredictable, visionary, and "surreal" scenes.

Accordingly, it is not possible to hypothesize an interdependent or reciprocal influence between the two brothers in the formulation of the metaphysical iconographic system (and in particular, the "mannequin" theme). If anything, both might be considered to have owed much to the example of the French poet: a circularity, a reciprocity of intentions, revolving around the poetic pivot of Apollinaire, the prophet of the Parisian avant-garde, notwithstanding their own undoubtedly original interpretations. We must instead establish the references Savinio made to his brother's previous work and the many atmospheres and images he used in his poem, such as the equestrian statue, and the yellow and greenish lights flashing on scenes cluttered with disparate objects and bizarre machinery. The mannequin was therefore born as a projection of the avant-garde "machine-man" of Apollinaire, but in de Chirico's work it assumed a defined and absolutely original form with a highly personal, autonomous meaning, with de Chirico's habitual capacity to mix inspirations from "low," banal levels, to create images of great evocative impact (such as the mannequin in *The Nostalgia of the Poet*, one of the earliest representations that clearly drew on the tailor dummy). In keeping with the Nietzschean ideas seen in the early metaphysical phase, the mannequin took on the aspect of man deprived of rational consciousness, an enigmatic presence in the midst of the world's other enigmatic presences: primordial man at the dawn of history. Its appearance in de Chirico's painting coincided exactly with the outbreak of the First World War (summer 1914) and his own first tragic experience (a bombardment he witnessed in Paris),[4] thus representing a sense of human alienation caused by conflict. What emerges at this point is a feeling of disorientation and probable incapacity to bring forth the explicit classical dimension of the marble statues or the sculptural casts painted during the preceding years and months. It is as if the Hellenic and Italian classicism that had consistently permeated his early metaphysical paintings had been thrown into crisis by the blind brutality of the war. However, even in the midst of this crisis, de Chirico's underlying vision remained intact. The mannequins take on the role of "muses": in one of the first depictions of this theme, *The Endless Voyage*, the mannequin wearing classical drapery delineated in charcoal pencil emerges in an almost ghostly fashion,[5] and in *The Seer*, as an oracle. This further detachment from "human" and classical psychological reality perhaps conveys even more effectively the "mysterious" role of the

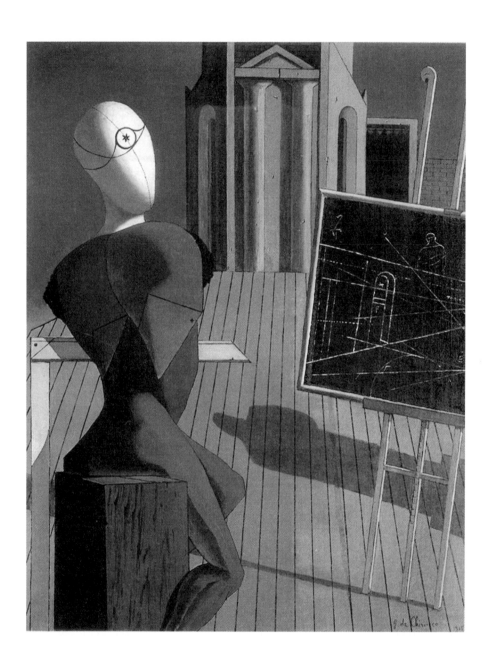

The Seer, early 1915,
Museum of Modern Art, New York.

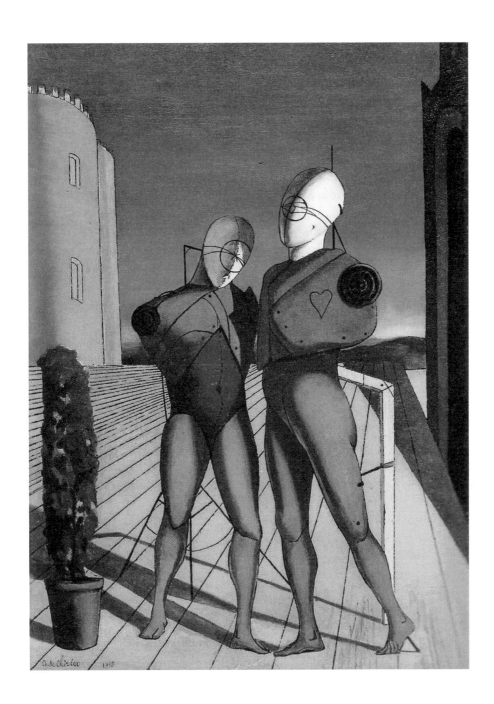

The Duo, early 1915,
Museum of Modern Art, New York.

oracle, overtaken by the power of clairvoyance. And yet, classical references continue to subtly inform the composition of these works. *The Duo* is clearly inspired by the ancient statue of *Orestes and Electra* that de Chirico had seen in Rome during his formative period, and which had evidently made a lasting impression on his unconscious. The proportions of the figures, the positions of their feet and legs, and their beautifully captured embrace, are all identical. If one considers how this would become one of de Chirico's most fruitful themes, inspiring such major paintings as *Hector and Andromache*, *The Return of the Prodigal Son*, and even *Orestes and Pylades*, it is clear how much a classical substratum informed his works from the metaphysical period onward and not just from the following *Valori Plastici* classicist phase.

Multiple references to Apollinaire's work can be found in de Chirico's paintings, in addition to the inspiration provided by the statue-man, or mannequin, and those more evident elements that have been identified in the *Portrait of Guillaume Apollinaire*. For example, Calvesi has suggested that the mysterious hieroglyphs that appear in de Chirico's paintings after 1914 may have been inspired by the treatises on divination and magic with which he would have been familiar through Apollinaire.[6] The poet certainly was familiar with such texts, and one can identify references to them in his own works. For instance, the first chapter of *The Three Don Juans* (dated 1914 but published in 1915) is titled "The Predictions of the Astrologer" and includes the character of *maître Max Jacobi*—a clear portrait of his friend and esotericist, Max Jacob—who practices chiromancy, sciomancy, neomancy, necromancy, and oneiromancy. These divinatory signs, associated with the hieroglyphs of ancient civilizations at the dawn of time,[7] were objects of curiosity and study for Apollinaire, and quickly came to interest de Chirico himself, given their relationship to themes that had already been dear to him for several years: the "prehistory" of humanity, the sensation of presentiment, the oracular, the mysterious, and the irrational, which can be expressed through signs whose precise meaning is unclear. However, it is possible that these incomprehensible signs were blended with examples of more modern stenography by de Chirico, according to his typical compositional process mixing, with no clear order or meaning, antiquity and modernity.

Likewise, the cannon that appears in *The Philosopher's Conquest*, in which art historian Jean Clair has perceived a provocative phallic significance, may derive from a passage in *The Poet Assassinated* (chap. VII)[8] where a "wise woman" exclaims that cannons are "vigorously priapic." Above all, howev-

Orestes and Electra (Ludovisi group, sculpture by Menelaos), Greek original I sec. A.D., Palazzo Altemps—Museo Nazionale Romano, Rome.

er, it was the assonance between the poetics of the two artists[9] that led to a relationship so intense as to bring about a clear change in de Chirico's style.

The relationship with Apollinaire was therefore extremely productive for de Chirico, insomuch as he derived a number of key symbols, signs, and themes from his poet friend, such as that of the mannequin, as well as an expressive form that was increasingly calibrated on oneiric images and on an out-of-joint representation of objects, spaces, architectures. From the Italian Piazzas of 1910 to early 1914, plausible notwithstanding their spatiality strained by subtle and alarming perspectival incongruities, rich in references to symbolic places or places of memory, he elaborated even greater unnatural spaces that lacked external references and were aimed instead at causing the emergence from within the psyche of associative cruxes that suggest the equivalent of visionary disorientation, of the "revelation" deriving from Nietzsche and Schopenhauer. These were no longer veiled in the melancholy of places but besieged by enigmas of disproportionate and indecipherable objects that were even more assertive.

In fact, the spaces become claustrophobic, objects become unrecognizable or are transfigured, architectural elements become backdrops crowded with pillars and tympana without constructive logic, grouped together in a manner that is often incongruous or even impossible. The few objects that remain identifiable are juxtaposed in an illogical fashion: a bust of Apollo beside an oversize rubber glove; artichokes and cannons; bunches of bananas abandoned in the middle of deserted streets; bizarre tools and toys; heads of dolls and cake molds in the shape of fish or used for baking madeleine biscuits; anatomical elements taken from medical encyclopedias; and paintings within paintings that further transport our perception of the world to earlier, more inscrutable eras. Elements that recall an experienced yet transformed reality progressively disappear, leaving the field to alien worlds that become increasingly dreamlike. The figures of soothsayers, disquieting travelers, shadows of living beings, or statues of men are deprived of their humanity, becoming merely mannequins—objects without purpose in a world without explanations.

Accordingly, from the beginning of 1914, the metaphysical works de Chirico created in Paris abruptly changed direction, adopting a poetic approach that united Nietzsche with both Weininger and Apollinaire, the influential friend who had brought him into the international avant-garde, his stateless and melancholic elective brother. Even after Apollinaire's departure from Paris the works of the time would continue to be consistent with this new direction. De Chirico would undersign a contract entrusting more or less all of his output to his dealer Paul Guillaume (also a friend of Apollinaire's) that would bring him critical success, and which also resulted in a relatively greater financial security and psychological solidity.

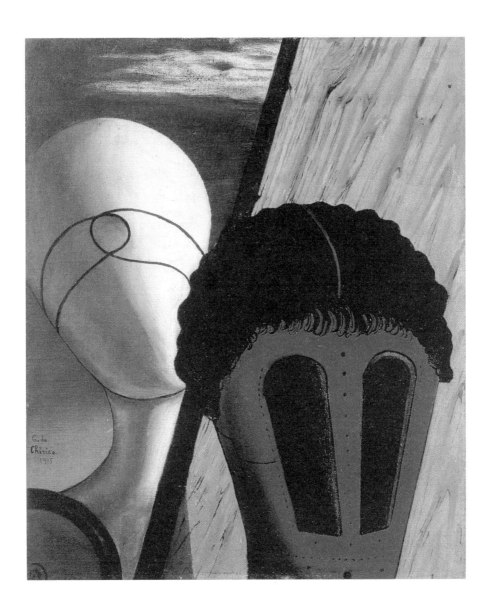

The Two Sisters, first half of 1915,
Kunstsammlung Nordrhein-Westfalen, Düsseldorf.

GREGG.

IsAAC PITMAN.

GRAHAM.

MUNSON.

LINDSLEY.

PERNIN.

CROSS-(ECLECTIC)

"Various stenographic methods compared" from a manual of 1897.

This visionary rupture would continue to manifest itself during the Ferrara period, albeit mediated by a progressive return to real reference points represented by "rooms" that, despite their disturbing claustrophobia, would constitute a newly realistic setting for the artist's inner, oneiric vision. The theoretical aversion of de Chirico—but above all of Savinio—to the emphasis placed on dreams, which has often led scholars to ignore or underestimate the oneiric component in the genesis of de Chirico's paintings,[10] should instead be afforded attention and discernment by the historian—and also from a psychological viewpoint. De Chirico was particularly assertive in his theoretical positions and, for the sake of polemics, would radically contradict affirmations he had made only a few months earlier. Such was the case with futurism, which up until April 1919 he considered an "unques-

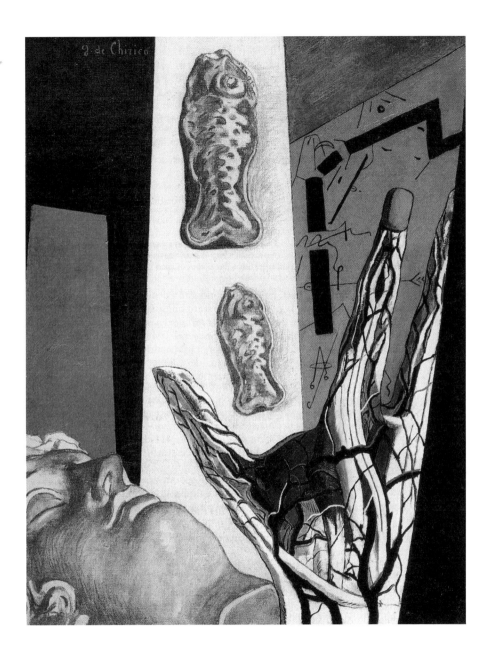

The Span of Black Ladders, summer–autumn 1914,
private collection.

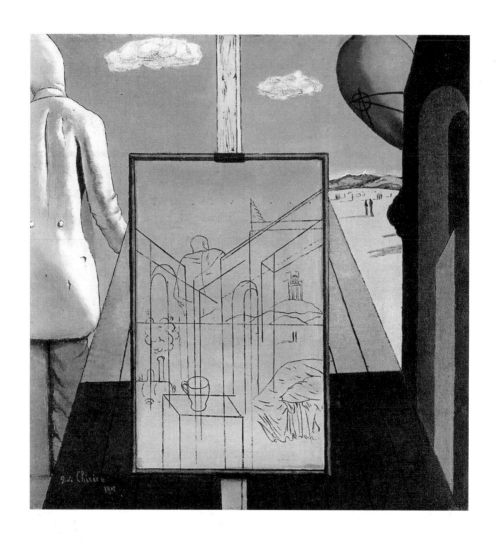

The Double Dream of Spring, first half of 1915,
Museum of Modern Art, New York.

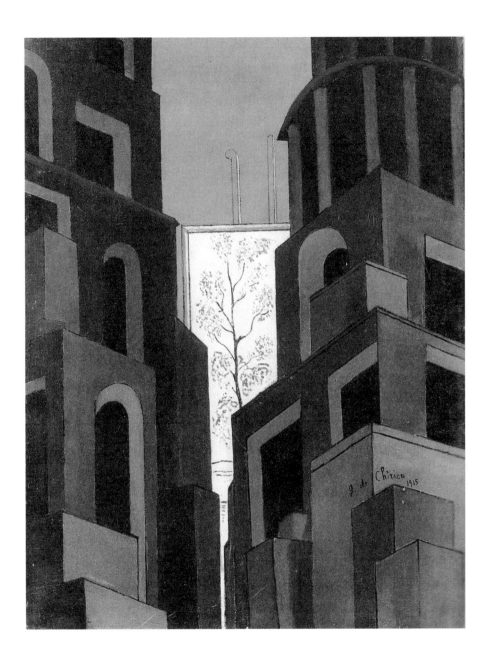

The Purity of a Dream, first half of 1915,
private collection.

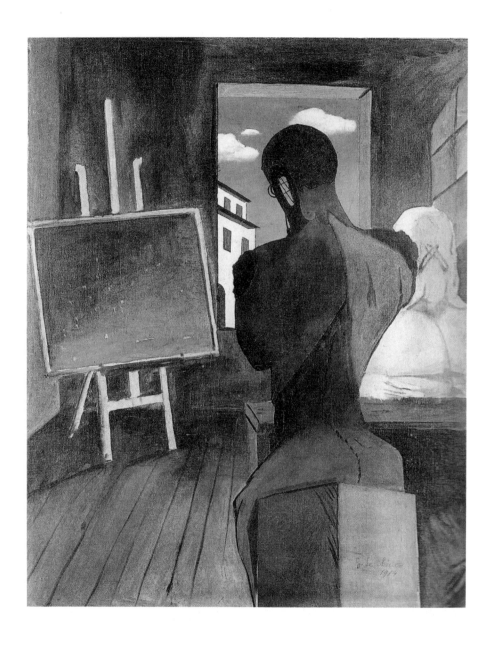

The Poet and the Philosopher, first half of 1915,
private collection.

tionable necessity,"[11] a movement that was doing "immense good" to the new modern art,[12] but which at the end of the year became an aberration that "has done no good whatsoever to Italian painting."[13] In this polemical game, which Savinio also participated in to a certain extent, his position vis-à-vis the importance of dreams underwent considerable changes over time. De Chirico speaks of dreams as a source of artistic inspiration in texts dating from the Parisian period, just as Savinio recalled that *Les Chants de la mi-mort* were nothing more than "songs of sleep" or of dream: "During sleep— which some call a half-death—I live, and in a more precipitous manner than I do in real life. Where will Hermes oneiropompos lead me . . . ?"[14] De Chirico himself expressed similar sentiments in a manuscript of 1914–15: "To be really immortal a work of art must go completely beyond the limits of the human: good sense and logic will be missing from it. In this way it will come close to the dream state, and also to the mentality of children."[15] In his first article on de Chirico, Soffici also remarked that his painting could be considered a kind of "dream writing."[16] Subsequently (and understandably) the philo-oneiric position was downplayed around the time of the return to classicism, eventually becoming a point of distinction that surfaced during the controversy with the surrealists, who identified the dream as one of their most important sources of inspiration.

The relationship with Apollinaire and the influence of his *onirocritique* ("criticism of dreams"), a method linked to poetry, therefore coincides with the development in de Chirico of increasingly unreal spaces (evident in the painting's almost abstract composition), close to the dreamlike state of non-places, or better, places of interior consciousness. Mannequins, in-explicable forms, and unintelligible writings would populate them thence-forth—signs of a consciousness in a primordial state, of a barely expressed vaticination. Instead of bringing more clarity to the world, it makes it all the more inscrutable.

14. The Early Metaphysical Art of Ferrara

When Italy entered the war in May 1915 de Chirico and his brother were summoned to Italy. Apollinaire had already joined the French armed forces in mid-1914. Before leaving, de Chirico entrusted some of his paintings to Paul Guillaume, while others were retrieved by his mother once he was in Italy[1] and, at the end of the war, still others were collected by his poet friend Ungaretti from his former atelier in Paris. The brothers were initially sent to the military district of Florence, the city where they had registered as Italian citizens, and sent on to Ferrara in June. The interruption of his fecund Parisian period and the initial impossibility of being able to paint while in the army triggered a moment of dismay and uncertainty in the artist. The fortunate circumstance of being assigned to noncombat service made it possible to return to work in the autumn of 1915 after settling in—thus beginning a new creative cycle. Thanks to Guillaume he made contact with Tristan Tzara and Zurich dadaism and sent drawings and photos of his paintings to dadaist magazines (*291*, *Dada II*). He kept in contact with Soffici, Apollinaire, and with his Parisian dealer Guillaume and made new friends in Ferrara, among them Filippo de Pisis, the poet Corrado Govoni, and, through Soffici, he entered into direct contact with Papini. As noted, the relationship with Guillaume continued to be very intense: evidently the artist hoped to return to Paris as soon as possible after the war and his letters convey heartfelt feelings for his dealer friend,[2] to whom he continued to send paintings in order to comply, as far as he was able, with the contract the two had established in France.

The works de Chirico painted in Ferrara during the second half of 1915 addressed a number of different subjects: portraits, such as that of his friend and fellow soldier Carlo Cirelli (in October) which can be put in relation to his earlier Parisian portraits such as that of Madame Gartzen; a decidedly eccentric, naturalistic *Still Life*—a unicum—but in which the subject is exposed to an unnatural electric light that makes the natural elements appear transformed to stone; and finally, scenes deriving from his metaphysical research of the end of his stay in Paris, created under Apollinaire's influence, in which the forefront dominates the background with a "zoom in" on details that, if possible, make the scenes appear even more claustrophobic. Appearing now at the top of the familiar precipitous perspectives suggesting the deck of a ship (*paccobotto*) or

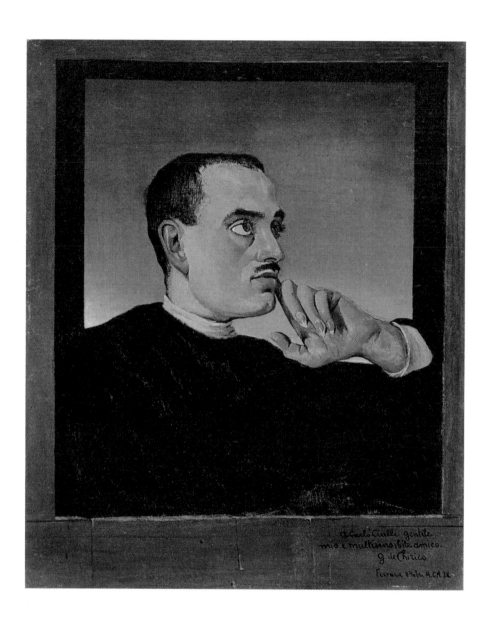

Portrait of Carlo Cirelli, October 1915,
private collection.

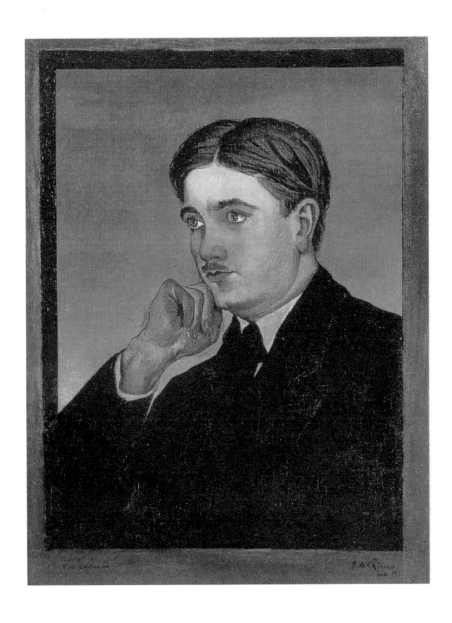

Portrait of Paul Guillaume, first half of 1915,
Musée de Grenoble, Grenoble.

Still Life, autumn 1915,
private collection.

Facing page:
The Playthings of the Prince, autumn 1915,
Museum of Modern Art, New York.

theatrical stages, are the buildings of Ferrara (facades of Renaissance church-es, the ducal castle). These take the place of the architecture seen in the earlier Italian Piazzas and renew the feeling of melancholic distance and of unsettling architectural nostalgia. But de Chirico's objects also begin to exhibit funda-mental changes: the indefinable and mysterious objects of the Parisian works are transformed into common items such as bobbins, biscuits, and colorful cardboard boxes. *The Amusements of a Young Girl* revisits and revises the theme of *The Song of Love*, but the orange rubber glove is now a more familiar leather glove; the architecture, with its mysterious arches, has been transmut-ed into the Estense Castle; the perfect green sphere has been replaced by cy-lindrical spools of thread. The effect is no less unsettling, but the elements are taken from a different *imagérie*, grounded in the empty streets of Ferrara and the window displays of somnolent shops full of simple objects jumbled togeth-er, waiting for somebody to give them a purpose (as with Klinger's *A Glove*, one of the matrices of the artist's metaphysical inspiration). In short, it seems that de Chirico was trying to pick up the threads of his aesthetic with fresh eyes and to introduce the new symbols Ferrara suggested to him into his unique "my-thology." Provincial shopwindows with disordered objects, perhaps forgotten for generations, almost like a window on a *Wunderkammer*, harboring the curiosities of distant lands—objects whose use is apparently unknown, and which seem to belong to other, remoter cultures. This is the context in which the artist's intense interest in Ferrara's Jewish ghetto emerges, where these el-ements were infused with an even greater sense of static timelessness. Anyone familiar with Greece, even at the end of the previous century, will find such images of dusty objects accumulated in shopwindows extremely familiar. De Chirico would have seen and recognized a distant echo of the impressions he had received as a child in Greece, in contrast with the brilliant Parisian window displays. The mercantile and Balkan character of Greece would have led him to perceive parallels in the commercial, and the simultaneously cosmopolitan and conservative, character of the ghetto's shops: "What struck me above all and inspired me from the metaphysical point of view in which I was working then, were certain aspects of Ferrara interiors, certain windows, shops, houses, and neighborhoods, such as the ancient ghetto, where one could find certain sweets and biscuits with remarkably metaphysical and strange shapes. To this period belong the so-called 'Metaphysical Interiors.'"[3] From this stimulus de Chirico, who had been deeply interested in "other" cultures—Middle East-ern, East Asian, historical, and religious—ever since his visits to Florence's Na-tional Library,[4] discovered fascinating analogies between a Jewish outlook and his own personal research. Even in recent texts[5] this interest has often been in-terpreted as having been of a purely aesthetic, and therefore "exotic," nature. However, I believe it was altogether more complex in character: comparative, structural, cultural, and philological. We know he read a broad range of texts

The Amusements of a Young Girl, winter 1915,
Museum of Modern Art, New York.

in Florence in 1910, which indicated a particular interest in Judaism, and he also read Reinach's works on the history of religions, in addition to his archaeology studies.[6] In Reinach's interpretation Judaism is the founding religion of Western civilization along with Greek paganism. Accordingly, de Chirico was interested in its "primitive" sense, its dry, image-based, original aspect that coincided, as did paganism, with the simplified essence of his own avant-garde vision, based on the divinatory figure of the oracle who creates a short-circuit between the superhuman and the human, just as the Hebrew prophets did between the divine and the human. *The Jewish Angel, Evangelical Still Life I,* and, above all, *The Dream of Tobias* are paradigms of this idea: in the latter, the link between the god Mercury, the "god of mysteries,"[7] represented by the thermometer, and the biblical angel of Tobias, who possessed the ability to restore sight, created a fusion between the two primogenial and foundational visions. In a similar although personal manner, Carrà would identify this primitive and ancestral world with ancient African and Oceanic art, characterized by its extreme formal and conceptual simplification.[8]

The paintings de Chirico produced initially in Ferrara between 1915 and 1916 were very small, suggesting that he found it difficult to paint in these new and unfamiliar circumstances. This naturally favored close-up perspectives, a lenticular depiction of objects and a focus on details. The period also gave rise to new meditations on the art of the moment, which in turn influenced his own painting with novel accents. De Chirico seems to have distanced himself from Parisian culture in a somewhat polemical fashion, having experienced a significant, although transient and brief, moment of experimentation with certain artistic vocabularies in 1913, when his work had echoed the stylistic approach of Picasso, Matisse, and others. In fact, in a letter to Guillaume he criticized his decision to support Amedeo Modigliani and Maurice Utrillo and decried the reliance of Francis Picabia's new works on his own and, while sparing the "demonic" Picasso, although harshly denounced "his general staff of hydrocephalic idiots."[9] On December 12, 1915, he offered a number of more substantial and significant reflections in a letter to Soffici, in which he reevaluated the futurists, whose work he had never concerned himself with until that point, describing them as more original and lyrical than French painters, including the cubists and the fauves:

> I would like to be associated more closely with them because in them I find more beauty, more fatality, and more of the future than in other modern creations, including those of Cubism; the latter, eminently French, is based on matters of aesthetics; on the palatable aspects of painting, on the *"joli"* in art . . . which is destined to decline. Of course, even in the Italian Futurist group there are many weaknesses . . . but that does not matter, and I believe that among them one can better maintain one's own personality than among the Cubists and the "Fauves" of Paris.[10]

Ardengo Soffici *Bif§zf+18. Simultaneità. Chimismi lirici*, 1915, cover.

This latter point is extremely significant and was elaborated in dialogue with Soffici, who had distanced himself from futurism the previous year, but who continued to feel the implications of its aesthetic. Nevertheless, de Chirico was genuinely interested in this expression of *italianità* and, as Calvesi has rightly pointed out,[11] from 1916 on one can begin to see allusions to futurist compositions in his depictions of geometric objects jumbled together (triangles, architect scale rulers, goniometers, and other curvilinear instruments).[12] Moreover, in these recent geometric and tightly packed compositions one can also perceive a reference to the cover of Soffici's book *Bif§zf + 18. Simultaneità—Chimismi lirici* that de Chirico bought in a bookshop in Ferrara in January 1916 and would leaf through constantly, as he indeed mentions in his letters to Soffici. De Chirico's relationship with Soffici quickly grew closer, to the extent that the latter suggested organizing a joint exhibition in Florence that would also display works by his friend Carrà, whose most recent paintings de Chirico was not yet familiar with.

The paintings of 1916 begin to reduce the spatial environments elaborated over the course of the previous year, depicting various objects in abstract spaces that are paradoxically devoid of architectural elements: technical

Metaphysical Composition, early 1916,
private collection.

The Nostalgia of the Engineer, first months of 1916,
Chrysler Museum of Art, Norfolk.

The Faithful Servant, mid-1916,
Museum of Modern Art, New York.

Greetings from a Distant Friend, mid-1916,
private collection.

The Gentle Afternoon, mid-1916,
Peggy Guggenheim Collection, Venice.

The Revolt of the Sage, mid-1916,
Estorick Collection of Modern Italian Art, London.

Metaphysical Interior with Large Factory, summer 1916,
Staatsgalerie, Stuttgart.

Facing page:
The Jewish Angel, summer 1916,
Metropolitan Museum of Art, New York.

Geographical map of Istria of 1916.

instruments (of the kind that he saw around him in the military offices), unexplained mechanical contrivances, biscuits and sweets from the shops of Ferrara, which, when seen out of context, resemble archaeological finds from past eras, arranged as if according to scientific classification, and military maps on which naval routes are marked. Significantly, in the four paintings we know of that incorporate military maps,[13] two depict Istria.[14] Carrà would take up the same theme the following year in his painting *The Metaphysical Muse*. This detail not only suggests de Chirico's sympathy for Italian irredentism—which called for the annexation of the (culturally Italian) Istrian peninsula—but also endowed his apparently hermetic and frequently indecipherable Ferrara compositions with a political charge. When not depicting such readily identifiable geographic locations, the maps appearing in other paintings allude more generally to journeys and departures.[15] De Chirico's position was entirely consistent with that appreciation of the futurists

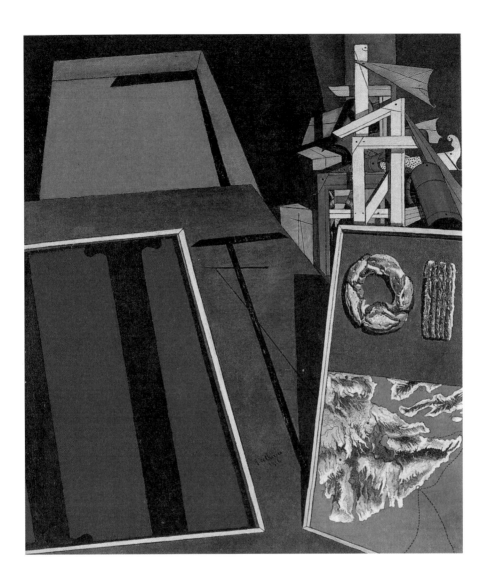

Evangelical Still Life I, September–December 1916,
Osaka City Museum of Modern Art, Osaka.

Locale Quadri Elettrici

Inside of a First World War submarine.

he expressed in his letter to Soffici in December 1915, where he described them as the only artists still to manifest "the Italian spirit expressed in politics by Cavour and Mazzini, and in war by Garibaldi and a 'Great King.'"[16]

In fact, the references to Istria allow us to date with greater precision to the year 1916, not only the two paintings that refer to it directly, but also the whole group of stylistically similar works containing maps. In fact, an episode occurred in 1916 that deeply moved the entire Italian population, abruptly bringing the issue of Istria to the fore. Nazario Sauro,[17] an Istrian irredentist enlisted in the Italian army, had undertaken a series of important military operations against the Austrians from the beginning of the war, but during his final raid in late July he was captured with his submarine that was stranded in the gulf of Quarnaro. Identified as an Istrian, he was tried for high treason and hanged on August 10. The news arrived in Italy on August 28 and caused a great uproar.[18] The creation of this group of paintings would therefore seem to have taken place toward the end of the year, in the months between September and December 1916, by way of an allusion to this episode. And it is not impossible that the jumble of planes and objects, of instruments and tubular segments, was intended to evoke the crowded interiors of the First World War submarines.[19]

Veronese green skies of a metallic consistency and ceilings whose beams mimic military formations constitute the few remaining references to recognizable spaces. A slender pennant also appears in several of the paintings from this period: "my heart flutters 'waving like a flag,'" de Chirico wrote to Soffici, citing one of his friend's verses.[20]

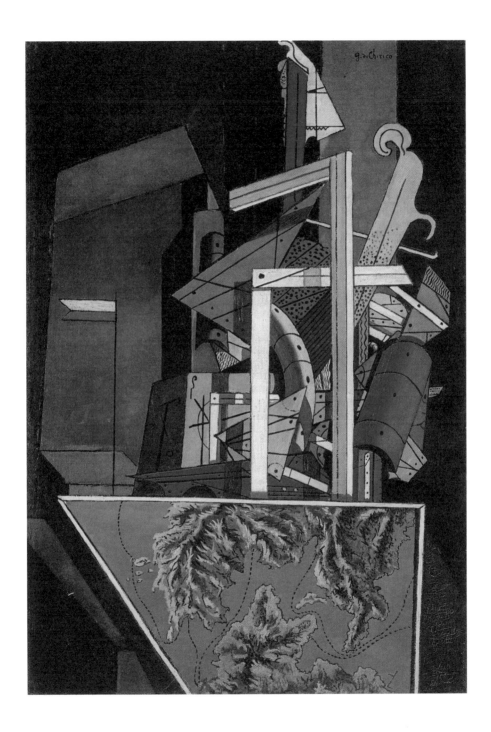

The Melancholy of Departure, September–December 1916,
Tate, London.

Top to bottom:
Politics, September–December 1916,
private collection.

Satellite view of the bay of Volos (detail).

The Pirate, September–December 1916,
Albert C. Barnes Foundation, Philadelphia.

15. From the Alliance with Carrà to the *Disquieting Muses*

It was Soffici who introduced de Chirico to his old futurist friend Carlo Carrà, who had likewise abandoned the movement some time previously. In 1916, Carrà was in a state of creative crisis and was seeking to recover a sense of solidity through the representation of a childlike world that also drew inspiration from Giotto, Paolo Uccello, and Picasso's proto-cubist, primitivist work.

Encouraged by Soffici, who considered the two de Chirico brothers to be among the few noteworthy figures of Italian culture (he was a great admirer of Savinio's *Hermaphrodito*),[1] Carrà initially showed reservations toward de Chirico, whose work he considered to be "cold literary rationalization". In truth, this judgment reflected a certain amount of personal resentment on Carrà's part, possibly owing to the praise lavished on de Chirico by Soffici, and the indifference shown by the latter toward Carrà's most recent paintings.[2] Nevertheless, after being transferred to Pieve di Cento, not far from Ferrara, he finally met de Chirico at the end of March, and moved to the city itself at the beginning of April 1917. Their relationship was to prove intense and fruitful; having both found refuge in the military hospital at Villa del Seminario, sheltered from military operations as well as from other official duties, the two artists worked alongside one another for just over four months, until Carrà's departure in mid-August. They were both profoundly affected by this encounter (Carrà to a much greater extent than de Chirico). De Pisis may have arranged this "special accommodation" in the hospital,[3] intended for soldiers suffering from psychological trauma caused by the war. The two painters did not fall into this category, but their quiet stay there certainly allowed them to work under the sympathetic eyes of the medical-military staff.

Soffici brought together Carrà and the two de Chirico brothers for the creation of a new journal and, ultimately, the nascent group relocated to Paris, where its activities would be promoted possibly with the help of their friend Apollinaire and the dealer Guillaume. However, the duration of the war, the subsequent economic situation, and, especially, the death of Apollinaire[4] upset these ambitious projects.

De Chirico continued to create his almost bas-relief compositions, but also revisited one of his Parisian themes, that of the mannequin, in a number of drawings, as well as in the painting *The Revelation of the Solitary*, simultaneously reintroducing the cubic spaces of rooms and interiors. Carrà enthusiastically adopted de Chirico's "revelatory" iconography, but with emphatically idealistic and explicitly Platonic motivations that had little to do with de Chirico's nihilism. He created a sort of "religion" of art, in which everything was determined by harmonic and philosophical rules[5] but used and abused de Chirico's imagery and motifs. Carrà's innate geometric and simplifying tendencies, which had already been evident in his futurist vocabulary, were perfected in the crucible of Ferrara. His employment of the mannequin, which he would develop at this time to a greater extent than de Chirico, who had invented it (from whom he took the motif), linked up with his earlier creation of mechanical futurist characters in works such as *Western Horseman*.

For de Chirico the encounter seems to have favored a slow and progressive detachment from the abstract and agitated spaces of his metaphysical art (of the end of the Parisian period) and the Ferrara period of 1916, when clusters of inexplicable objects appear in restricted and claustrophobic spaces like the storerooms of museums. This took place by means of an increasingly assured exploration that expressed itself in an irregular manner between 1915 (for example, *Holy Friday*, a painting that is nevertheless of an uncertain date and collocation)[6] and 1918, when arrangements of simplified cubic spaces that were plausible from both a formal and an iconographic point of view appeared. It was the period of "Metaphysical Interiors," rooms in which visionary apparitions of triangles, maps of nonexistent worlds and recollections of disturbing dreams, paintings within paintings, coagulated. De Chirico would create several paintings during the months he worked alongside Carrà: *The Scholar's Playthings* (May), *The Revelation of the Solitary*, *The Dream of Tobias*, *Metaphysical Interior with Villa*, and *Metaphysical Interior with Small Factory*.[7] It should be noted that de Chirico had already been elaborating on these interiors since 1916 (*Metaphysical Interior with Large Factory*). Carrà avidly grasped their sense of Giottesque, "primitive" perspective representation, which, reflected in his own work, marked his exit from futurism.[8] De Chirico's position remained markedly avant-garde, even finding common ground with the futurists.[9]

Facing page:
Holy Friday, winter 1915 [?],
private collection.

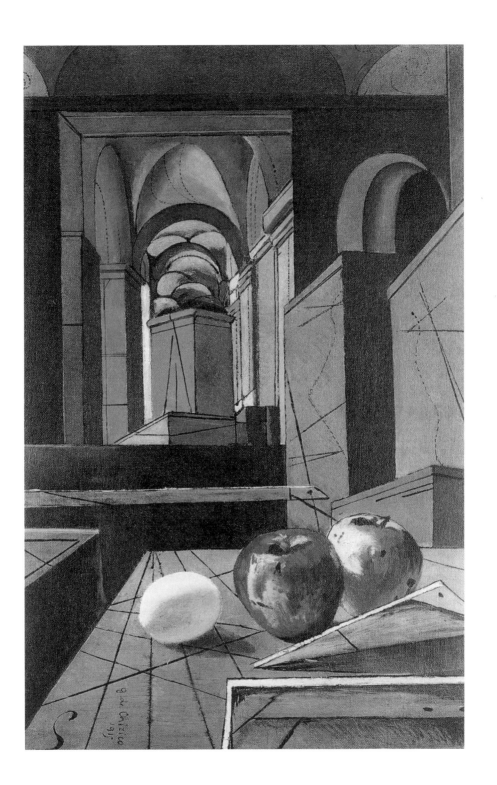

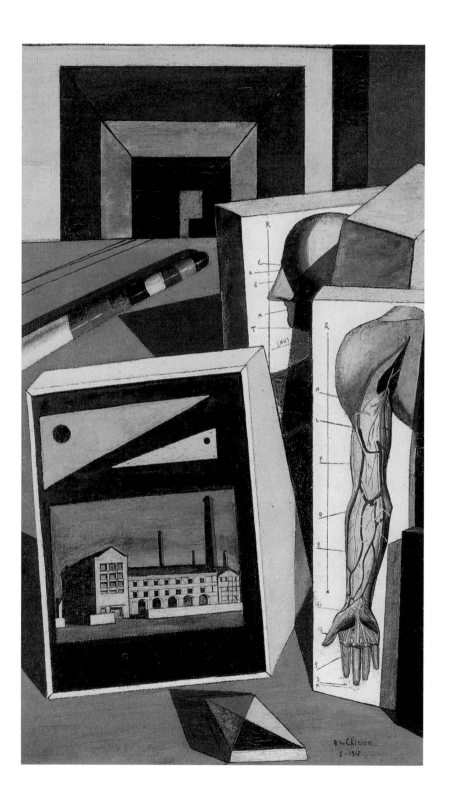

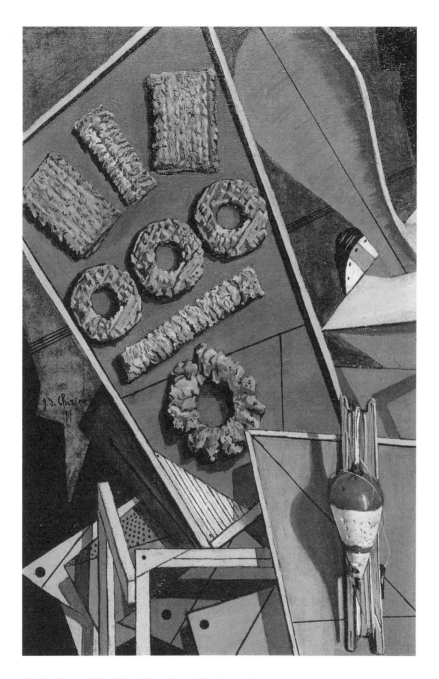

The Revelation of the Solitary (Metaphysical Composition), spring 1917,
Acquavella Collection, New York.

Facing page:
The Scholar's Playthings, May 1917,
Minneapolis Institute of Arts, Minneapolis.

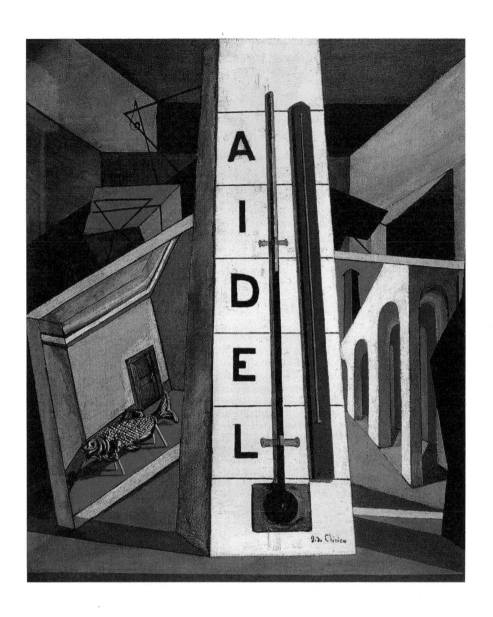

The Dream of Tobias, mid-1917,
private collection.

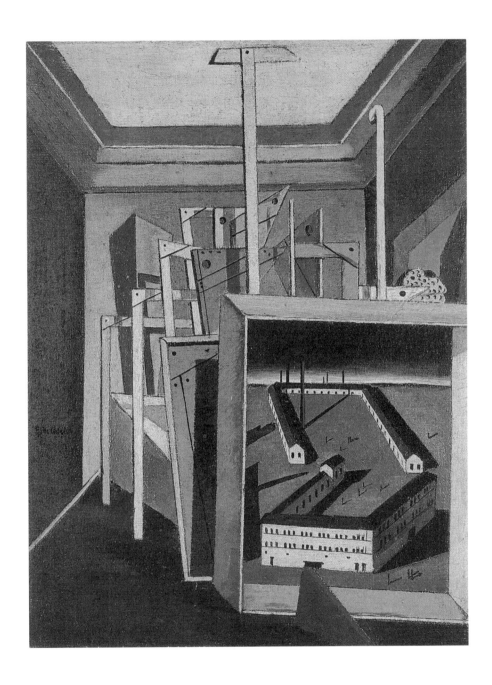

Metaphysical Interior with Small Factory, spring–summer 1917,
private collection.

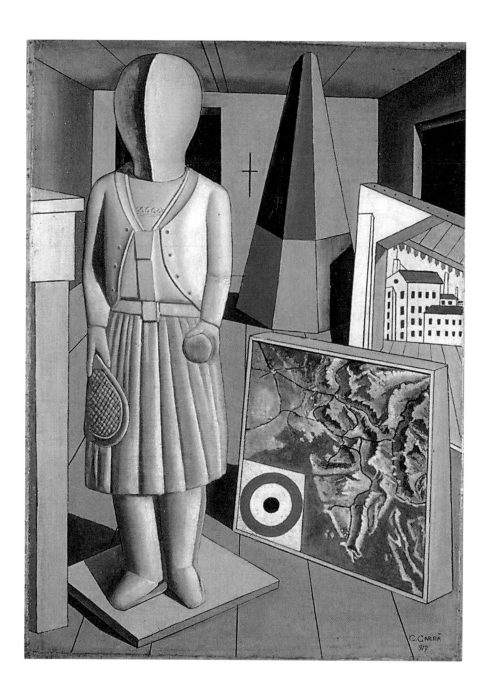

Carlo Carrà, *The Metaphysical Muse*, March–August 1917,
Pinacoteca di Brera, Jesi Collection, Milan.

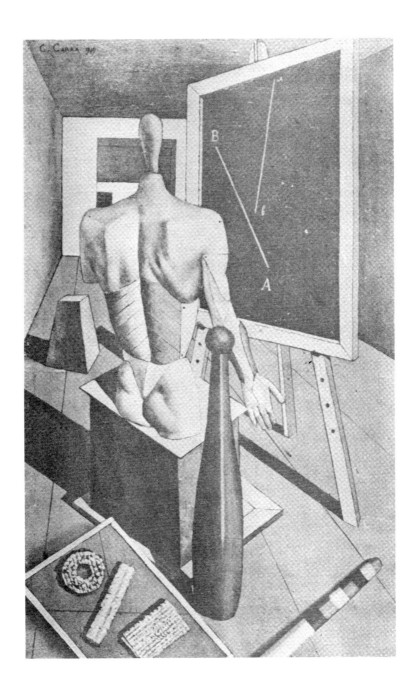

Carlo Carrà, *Solitude* (first version), March–August 1917,
in the periodical *Valori Plastici*.

In this crowding of triangles and frames, biscuits and anatomical tables (a reference to objects at the sanatorium, similarly to his use of the geographic maps, the triangles and curvilinear instruments he had seen in military offices), there began to appear with increasing evidence between late 1916 and 1918, some glimpses of nature, apparently hyperrealistic, set in one of the many frames that refer to de Chirico's own dream telling. In fact, the *Metaphysical Interior with Villa* of 1917 represents a dream so striking that he would remember it with extreme lucidity many years afterward in his *Memoirs*: a dream he had one night in 1912, prior to exhibiting for the first time at the Salon d'Automne:

> During the night before my visit to the painter Laprade I dreamt that I saw a landscape somewhat similar to the banks of the lakes in Lombardy and Lake Garda. In the foreground were a few trees and some pink blossoms; in the background was a stretch of water like a mirror. When I entered Laprade's studio the next day I saw, exactly opposite the door, standing on an easel, a painting which represented a landscape identical to the one I had seen in my dream. . . . I told him that during the night I had dreamt of the painting that was standing on the easel. Laprade smiled and said, "Oh, how funny." From which I deduced that the painter Pierre Laprade did not show the same interest in the metaphysics and mystery of dreams as someone like Pythagoras or Arthur Schopenhauer.[10]

The mysterious landscape on the easel harked directly back to de Chirico's dream: a landscape of Lake Garda, a garden in the foreground and a stretch of water in the background; the villa, typical of the Lombardy lakes, is not described in the dream, but the site is extremely fitting in terms of that dream memory of almost fifty years earlier (but only five or six prior to the painting).

The Estense Castle in Ferrara (together with simplified Renaissance architecture) is also depicted with a frozen realism in the paintings of this period starting with *The Amusements of a Young Girl* at the end of 1915 and reaching its apotheosis in 1918 with *The Disquieting Muses*. De Chirico completely abandoned the system of transfiguration he had applied in his early metaphysical phase (the transformation undergone by Piazza Santa Croce and the Acropolis in the paintings of 1910, for example) and greatly increased the sense of objective and estranging realism that is proper to dreams. The replacement of human figures with mannequins devised in the Paris period augmented the "dehumanization" and oneirism of the scenes. Two "technical" devices illustrate the subtlety with which de Chirico obtained a sense of profound disorientation in that striking and absolute image *The Disquieting Muses*. A number of horizontal drip marks in Prussian blue[11] on the base

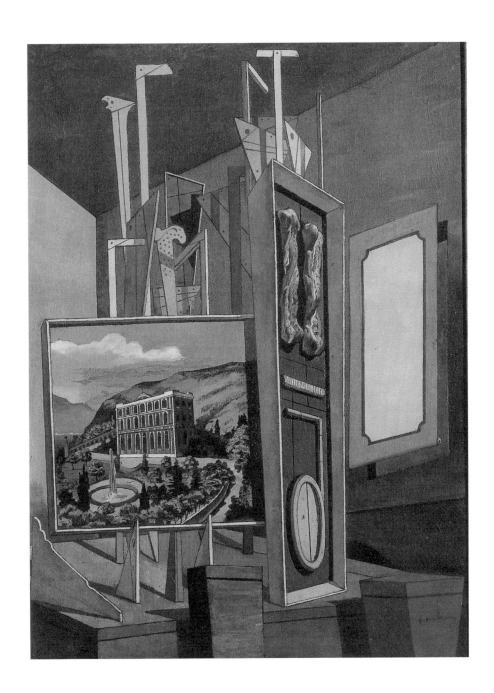

Metaphysical Interior with Villa, summer 1917,
Museum of Modern Art, New York.

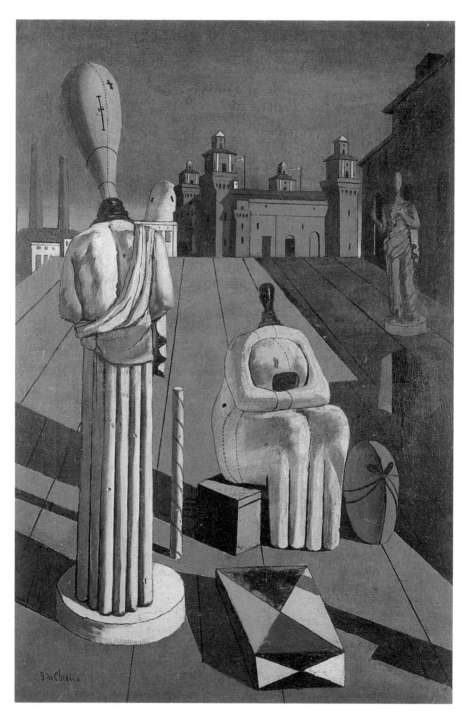

The Disquieting Muses, June 1918,
private collection.

Artemis, mid-VII century B.C.,
National Museum of Archaeology, Athens.

upon which one of the muses sits, which are barely perceptible, since they extend along her dark and seemingly infinite shadow, reveal that de Chirico painted the work turned horizontally, at least in part. This expedient evidently allowed the artist to paint the various elements of the work (and certainly not only this one) with a sense of objective detachment, thereby nullifying the image's overall compositional sense, as if observing an upside-down world. The perspective of the multicolored box in the foreground is likewise back-to-front. Castelfranco—the first owner of the painting and a friend of de Chirico's—revealed that this object was painted not according to the observer's point of view, but from that of the muse herself: "the spaces are dominated and interpenetrated fantastically, sometimes by means of the lyrical simultaneity of different systems of coordinates, as in the *Metaphysical Interior* and even in *The Disquieting Muses*, where the box in the foreground

A,6.

Artemis (in Stefanos Koumanoudis, "Trìa gliptà archaïkà," in *Archailogiké Ephémeris*, 1874, pl. 71) (*left*).

Kore, mid-VI century B.C.,
National Archaeological Museum, Athens (*right*).

is seen from the perspective of the seated Muse and therefore, for the viewer, in reverse perspective."[12] The painting was originally named *The Disquieting Virgins*,[13] a title evidently owed to the clear archaeological derivation of the three muses, the middle one in particular, the identification of which adds significant meaning to the painting. The headless sitting figure clearly derives from a famous and unique sculpture of a female deity that is among the most ancient and primitive sculptures preserved in the National Archaeological Museum in Athens. Of noteworthy interest is the fact that the Polytechnic Academy of Fine Arts de Chirico attended in Athens was situated only fifty meters from this museum and represented an important site of research for the students. At the time, this sculpture had already been interpreted as representing Artemis (goddess of chastity) based on a disquieting epigraph engraved on the base: the word *omega* to be read backward as *agemo* and

Facing page:
Evangelical Still Life II, September 1917,
private collection.

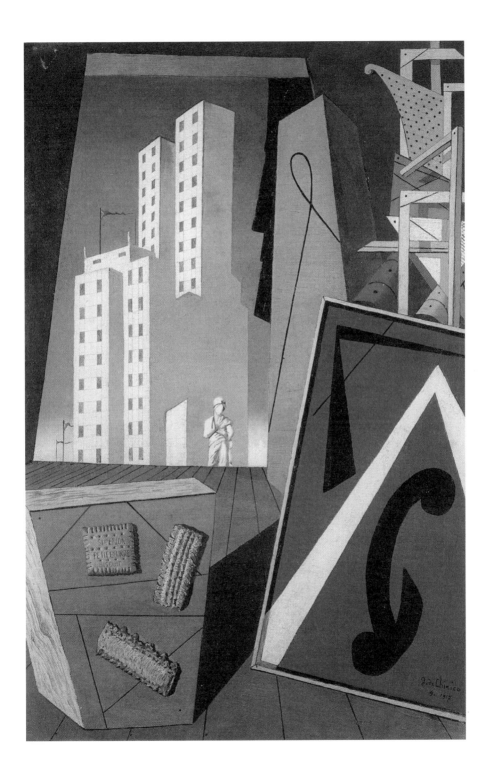

interpreted as "Hegemone" (ruler, hegemonic), as proof of its absolute and dominating power. However, when read normally, as a palindrome, it suggests that the goddess is a terrible mistress of the end of time (the omega), a mysterious eschatological figure. De Chirico was surely familiar with the statue's identity as the virgin Artemis, as established in a famous essay of 1874[14] and something he could bear witness to at the museum. In all probability he easily read the mysterious dominating *omega* (hegemonic) on the base, which may have blended in his memory with the idea of the Nietzschean Eternal Return: "The eternal sand-glass of existence will ever be turned once more, and you with it, you speck of dust" (Nietzsche, *The Gay Science*, aphorism 341). Heraclitus of Ephesus is perhaps of additional pertinence here. He lived in the temple of Artemis and was a philosopher of mystery who was dear to both Nietzsche and de Chirico, as previously noted. Majestically holding her chopped-off head at her feet, the virgin Artemis is in dialogue with the kore who is paying respect to her, while another kore statue seems to be approaching in the background. These statues are more generally and liberally derived from characteristic votive Greek figures and with Artemis constitute a precise context with the painting's first title. Virgins and Muses of destiny emerge from archaic eras and allude to the disquieting mystery of the domination of Time and of the Eternal Return. The density of thought and form seen in this painting caused James Thrall Soby to define it as "the greatest painting of de Chirico's entire career".

A similar theme of the domination of time (this time explicitly defined as Nietzsche's "eternal hourglass") was dealt with in an innovative key by the painter shortly after (less than one year) in one of his first paintings of the "Return to Order" and reproduced in *Valori Plastici*: *The Virgin of Time* (1919), having her left breast naked, just like the mannequin seen from behind in the foreground of *The Disquieting Muses*.

In Ferrara metaphysical art became a "predestined" crossroad, not an actual movement, but a movement *in nuce*, formulated but not completed and consisting of a homogeneous, though not numerous, group who transformed de Chirico's autonomous invention into the shared language of a

Facing page:
The Troubadour, late 1917,
private collection.

Following pages:
Hector and Andromache, late 1917,
private collection.

The Great Metaphysician, late 1917,
private collection.

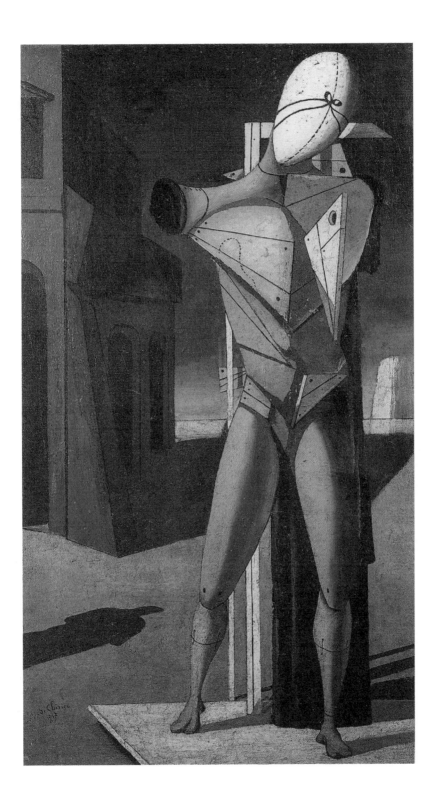

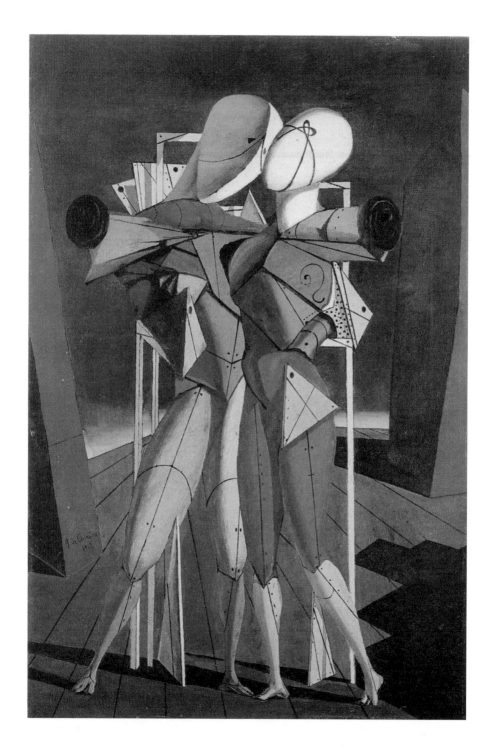

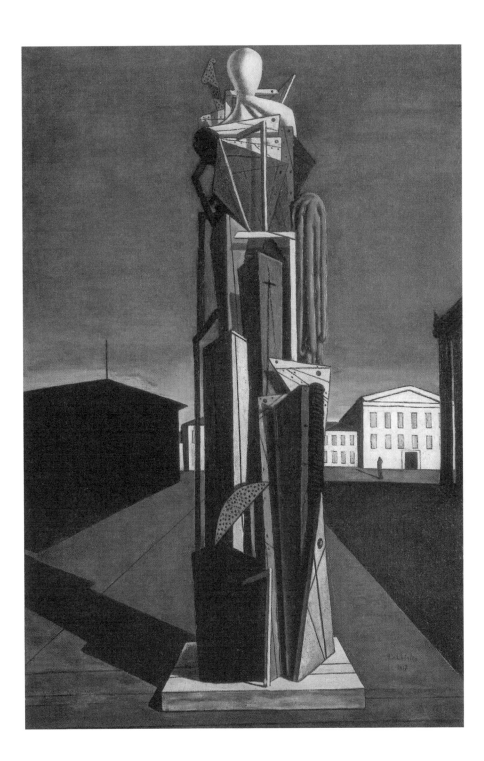

small phalanx of artists that stood in parallel with the contemporaneous European sensibilities of classical "reform" toward the prewar avant-gardes. De Chirico's vision spread like a circle in water to Carrà, who promptly took up its salient themes (mannequins, incubating rooms of dreams, mysterious objects, even biscuits and breads seen in bakery windows in the Ferrara ghetto), and shortly reverberated on Giorgio Morandi (who grasped in his own way the disturbing absence of atmosphere and "metaphysical" suspension), on the young Filippo de Pisis and on de Chirico's brother, Alberto Savinio, at the time still only in his capacity of poet and critic, and on the tutelary deity of all of them, Ardengo Soffici.

The period between autumn 1917 and the first half of 1918 saw de Chirico definitively expand the spaces of his metaphysical works: both in those featuring large mannequins arranged in town squares, similar to the ones painted in Paris in 1915 by virtue of their precipitous, decklike flooring (*The Troubadour*, *Hector and Andromache*, and *The Great Metaphysician*), and in such masterly, iconic representations of his metaphysical world as *Evangelical Still Life II* (September 1917) and *The Disquieting Muses* (June 1918), which combine interior with exterior spaces. Only a few works date from this period during which de Chirico found it difficult to paint (he repeatedly wrote that he had to "steal time from sleep and the night" to work). However, he also began a series of highly refined drawings, a medium he had somewhat neglected until that point, preferring quick preparatory sketches over complete and detailed compositions, which he evidently found easier to fit in between the military commitments that constantly impeded his work. Carrà must have been disconcerted by the power of these few works since, as we shall see, he would do everything possible to avoid exhibiting in Milan alongside de Chirico (in December 1917), employing all kinds of subterfuge to this end.

16. Rome and the Classicism of *Valori Plastici*

On January 1, 1919, de Chirico was summoned to Rome by the army. At the end of the First World War, between 1918 and early 1919, Rome had rediscovered a dynamic cultural life teeming with artistic debates. After Italy's entry into the war, in 1915, Rome (as in Paris) experienced a state of restless suspension caused by the spreading conflict and the departure of most artists for the front, interrupted by significant but separate rare episodes: the solo show of Fortunato Depero's "abstract" works in 1916 (inaugurated by Marinetti on leave), the fourth exhibition of the Secession, which opened quietly at the end of 1916 and closed at the beginning of 1917, the arrival of Diaghilev's Ballets Russes in 1917, with the presence in town of Picasso, Cocteau, Mikhail Larionov, and Natalia Goncharova, and the contemporaneous staging of Giacomo Balla's *Feu d'Artifice* (ballet by Igor Stravinsky), the presentation of Léonide Massine's collection in the foyer of the Teatro Costanzi, and the opening of the Bragaglia gallery (Casa d'Arte Bragaglia) with a solo show by Balla in October 1918. Furthermore, the capital was being repopulated with the return of various artists (Felice Carena and Mario Sironi from the war, Carlo Socrate from France and Spain, Ferruccio Ferrazzi from Switzerland, while Cipriano Efisio Oppo was recovering from war wounds), and the arrival of new artists.

In the late spring of 1918, two almost simultaneous exhibitions presented a movement toward a reform of secessionist and futurist languages, by now dated and insufficient to satisfy the sense of classical order that years of war had stimulated in European intellectuals. Though aimed in a revisionist direction but still with avant-garde intent, it traced out research based on formal tradition and compositional stability. In May, a collective exhibition opened at the Galleria dell'Epoca (*I mostra indipendente*) in which, among others, Giorgio de Chirico exhibited his metaphysical paintings (for the first time in Rome—actually, in Italy at all).[1] The exhibition also included Carlo Carrà, who had embarked on the new metaphysical path,

Benvenuto Ferrazzi, Ardengo Soffici, and Enrico Prampolini. The following month an exhibition of young artists of secessionist orientation opened at the Casina del Pincio, organized by Marcello Piacentini and Carlo Tridenti, with Cipriano Efisio Oppo, Armando Spadini, Pasquarosa, Carlo Socrate, Attilio Selva, Alfredo Biagini, and Ferruccio Ferrazzi.

The critic Goffredo Bellonci astutely identified a common factor in the two shows, the return to "a painting in order": "We agree. Contemporary art, the new order, has not yet been won over with full awareness. But we need only look at two exhibitions, at the Pincio gallery and the Galleria dell'Epoca, to see with how much anguish, between practical and programmatic chaos, it is being sought."[2] "Return to tradition," "Artists of Italian spirits and forms," "New Italianness of painters and sculptors" are the titles of other reviews that insisted on the newness taking shape in Roman art.[3]

The events multiplied toward the end of the year, as Rome took a decisive place as one of the European capitals of the heated avant-garde/Return to Order debate: the periodical *Valori Plastici* began publication at the end of 1918. In October Anton Giulio Bragaglia opened his famous art gallery with an exhibition by Balla, followed by the unforgettable exhibitions by de Chirico—still metaphysical, with his first solo show—Sironi, Depero, Filippo de Pisis, Ossip Zadkine, Johannes Itten, the dadaists, and so on in the years 1919 to 1922.

In 1918 Rome was ready to be a leading player in Europe, which was itself in slow recovery. The terms of the Return to Order were initially fairly summary and fluid: Picasso's 1917 stay in Rome had caused more echoes in the futurist ranks (and vice versa)[4] than in those oriented toward a new classicism; in Rome Picasso was still the champion of cubism and his neoclassical launching, definitively elaborated and brought to maturity precisely in Italy, remained unknown to the public.

The beginning of a "classicist" change in de Chirico, even if in the form of reflection that was not yet condensed into explicit works, may be identified in his brief week of leave spent in Rome in May 1918, when he must have taken note of the new cultural tension that the city radiated and which was also highlighted by the abovementioned reviews of the show at the Galleria dell'Epoca (in which he had taken part: his presence at the opening was the reason for his brief stay in Rome)[5] and the almost simultaneous exhibition at the Casina del Pincio. His acquaintance with Roberto Melli of Ferrara, and

Metaphysical Muses, first half of 1918,
private collection.

Alcestis, June–July 1918,
Galleria Internazionale d'Arte Moderna—Ca' Pesaro (on loan from the Carraro Collection), Venice.

Facing page:
Metaphysical Interior with Matchbox, mid-1918,
private collection.

through him, with Mario Broglio (ex-futurist who was already preparing *Valori Plastici*, the journal to which de Chirico would later contribute enthusiastically), increased this perception. De Chirico wrote to Soffici on this matter on July 23, 1918, not only announcing a solo show he intended to hold in Rome in December[6] but also manifesting the intention to exhibit on that occasion a "female head": "I work all the time and will certainly have a solo show in Rome. I'll also be exhibiting a portrait, the head of a woman done here in Ferrara, so those Romans will see that when we want to be, we are more classic than the classics."[7] The debate on "classicism" evidently began to make a breach in de Chirico's ideal as he put forward his first trials in this sense. The "female head" done between June and the first half of July 1918 (identifiable as *Alcestis*)[8] was the first short-circuit to occur between the metaphysical world and the classical idea nourished by references to Greek art: we find a first hint of the Niobids' skyward glance so often reprised in the painting of his "neoclassical" period.

Self-Portrait, July–November 1918,
private collection.

In the following months, July to November, before moving to Rome, he probably painted *Self-Portrait* (which, with the portrait of Alcestis-Antonia Bolognesi, constituted a loving double portrait) and *Still Life with Waterfall and Landscape*. On November 15 *Valori Plastici* came out (this is the official date, but it was actually delayed for bureaucratic reasons) with de Chirico's abovementioned text, "Zeuxis the Explorer," dedicated to the magazine's founder, Mario Broglio, and on the first day of the following year, with the war over, de Chirico, still a soldier, moved to Rome.

On February 2, 1919, his exhibition opened at Bragaglia's avant-garde gallery. Initially conceived for drawings only, it was transformed, with the arrival of his metaphysical paintings from Ferrara, into his first real solo show.[9] Gallery owner Bragaglia considered it irksome and difficult for the Roman public, as indeed he wrote in his foreword to de Chirico's self-presentation titled *Noi metafisici* [We Metaphyisicians] in the February 15, 1919, issue of *Cronache d'Attualità* (the Casa d'Arte's journal), where, referring to contrasting opinions on the new metaphysical art, he wrote that many considered it "one of the most skillful impostures of the modernists." In fact, it was not a commercial success, and the critics were unenthusiastic.[10] Among those paintings listed in the reviews (a catalogue was not produced) were some undisputed twentieth-century masterpieces: *The Enigma of the Oracle* and *The Enigma of an Autumn Afternoon* of 1910, in addition to more recent works such as *The Disquieting Muses*, *The Great Metaphysician*, *The Troubadour*, *Evangelical Still Life II*, *Metaphysical Muses*, *The Philosopher Poet*, and *Alcestis* (the only painting sold).

Here, we should digress for a moment to consider the criticism de Chirico's work received from Roberto Longhi (who was soon to be one of Italy's prominent art critics) on this occasion, precisely at the moment when the artist was to go beyond his metaphysical period, since it would have a direct bearing upon the critical history of the term and its reception, at least in Italy. Of all the malicious criticism de Chirico received during the course of his life, this had rather modest consequences as its impact was provincial rather than international. However, within Italy it exerted considerable influence in terms of the reputation of metaphysical art: it is no coincidence that not a single Italian museum has a significant work dating from that era in its collection (a scenario as unimaginable as a French museum not owning a work from Picasso's cubist period). Even today, reverence for Longhi obstructs the understanding of the true motivations behind his article, some seeking to explain it in terms of critical dissent or his captious tastes, which might be the basis for his attack, but does not account for the reasons behind it.[11] Yet we should reflect on the fact that the lack of understanding regarding a number of the greatest mas-

Still Life with Waterfall and Landscape, July–November 1918,
private collection.

Metaphysical Interior with Lighthouse, late 1918,
Museo d'Arte Contemporanca del Castello di Rivoli, Cerruti Collection, Rivoli.

terpieces of Italian and European art expressed by such an important critic (moreover, if one considers this occurred parallel to his appreciation of Carrà who based his works quite literally on those of de Chirico), would have seriously undermined his reputation regarding his discernment of contemporary art. I do not know if it is better to consider Longhi incapable of recognizing some of the highest achievements in contemporary European painting or to believe that he chose not to do so in bad faith. Certainly, Longhi's preference for the work of Francesco Trombadori over that of Picasso puts his judgment in question, but this case is so striking as to question his good faith. I believe that de Chirico was right in his later interpretation of the reasons for the attack, and that he was not at all "embittered," but rather specific and even measured in his analysis of Longhi's excoriating review.[12]

Essentially, a hidden war was underway. The metaphysical art of Carrà, while possessing its own characteristics, was indeed an act of plagiarism of de Chirico's iconography. Carrà, obviously well aware of this, had in fact presented, with a witting deception, himself and his new works on his own in a show at Milan's Galleria Chini on December 18, 1917. This should have been a joint exhibition, but Carrà claimed that de Chirico's paintings had not arrived in time (he had indeed requested them once the exhibition had already opened),[13] thereby transforming, by means of a premeditated deception, a joint exhibition into a solo show, thus ensuring that Carrà was presented as the founder of the "new" metaphysical art[14] on its first presentation to the Italian public.[15] However, many soon realized what the actual artistic genealogy of this style was and wrote of it on the occasion of the following exhibition of the artists' works at the Galleria dell'Epoca in May 1918,[16] speaking in no uncertain terms of Carrà's "plagiarism," despite the deception he had attempted a few months earlier at the Galleria Chini. Carrà would not have been happy and must have spoken about the matter with his closest friends: Soffici, Papini, and, through them, Longhi, who already knew him from his futurist period. A cunning attempt to obscure the true state of affairs was thus devised: after all, in Italy de Chirico's "French" period was unknown, and almost all of his paintings from that time were in the hands of Guillaume. In fact, in a letter that was intended to present the artist to the collector Angelo Signorelli at the beginning of 1919, the greatest praise that its author could muster was: "They tell me that he is a young man of talent."[17] By contrast, Carrà had a lengthy career, and over the years a significant amount of Italian press coverage had been devoted to his work. The project, in truth an underhanded one, was therefore to attribute to Carrà the invention of metaphysical painting. The term, which de Chirico had used in relation to his works since his French period, and which Apollinaire himself

had also used to define it, never possessed the efficacy of a slogan such as "futurism" for the solitary de Chirico, despite the fact that he began to use it consciously starting with an article of June 18, 1918 ("L'arte metafisica della mostra di Roma").[18] But Carrà, who had been involved with the international marketing project of futurism, understood the value of an artistic label, of its nominal primacy. This cynical plan, in which Papini and, perhaps to a lesser extent, Soffici himself, participated, intended to present Carrà as the creator of a "movement," the leader of a new tendency in contemporary art. De Chirico was aware of this, slightly later on. In the introduction to the catalogue of his solo exhibition at Bragaglia's gallery (*We Metaphysicians*) he pointedly described the characteristics of the "new art" as "the invention of we metaphysicians (I say "we" *par delicatesse*)." At the time, he wanted a small, united circle of associates to support him in Italy where, paradoxically, he was still considered a perfect unknown, almost a novice painter. He felt genuine friendship for Carrà, as is evident from his letters, and even attributed the snub he had received over the Milan exhibition to a misunderstanding, despite knowing in his heart that this was not the case. But he also made it clear that the invention of metaphysical art was his and his alone: a sign that by the time of the show at Bragaglia's gallery (February 2, 1919, but certainly even earlier) he had perceived an attempt to steal this primacy from him. De Chirico perhaps considered this to have been an isolated incident on Carrà's part, or a misunderstanding as, in fact, he still trusted Papini when he put him in contact with Longhi for the purposes of a review. Yet Papini was in perfect agreement with his old friend Carrà, to the extent that in late 1918 he himself proposed to Carrà to write a book titled *Metaphysical Painting*[19] in which de Chirico was not even mentioned. As de Chirico wrote in his autobiography, he was too late in realizing that he was at the center of a conspiracy, and that he was not dealing with the ambitions of Carrà alone:

> Before the exhibition opened, Giovanni Papini, who was in Rome at the time, advised me to turn to Roberto Longhi for an article. . . . I took the advice given by the author of *Un uomo finito* [*A Finished Man*] and went to see Longhi. He came to my exhibition, looked at the paintings, said nothing . . . already preparing deep down in his mind, in a perfidious, devilish, and horrifying way his treacherous blow. In fact, a few days later there appeared on the third page of the newspaper "Il Tempo" [a newspaper in which Papini, who had asked Longhi to collaborate, wrote regularly and was also the director of the literary pages, *author's note*] a scathing article entitled *To the Orthopaedic God*.[20]

Aided by his effective literary prose, Longhi wrote what amounted to an assassination of de Chirico and his work. It was shrewdly published on

February 22, the day after the exhibition closed, thereby deliberately depriving the artist of even a *succès de scandale*.[21] Among the pointless and gratuitous accusations contained in the article is one that Breton would also later peddle: namely, that certain themes of metaphysical art derived from Savinio's work (an observation that cannot have been Longhi's own, since he did not know the two brothers at that point), thereby presenting de Chirico's inventive powers to be half the strength they appeared. As stated, the article had the effect of elevating Carrà—Longhi's friend—above de Chirico. Even if the repercussions were somewhat haphazard, they lingered for a long time in Italian culture, if only by sanctioning the trenchant judgments of other critics on the work of the greatest, and certainly the most complex, Italian artist of the twentieth century.

17. The Beginnings of Classicism

In the early months of 1919, de Chirico's pictorial classicism was only episodic and conceptual in nature, and his vocabulary remained substantially "metaphysical." During that time, he would paint some of the final masterpieces of his metaphysical phase, such as *The Sacred Fish* and *Hermetic Melancholy*, as well as two still lifes incorporating, respectively, salami and Sicilian cassata: transitional works, in which the substance of the paint grew thicker with the aim of endowing it with an autonomous quality, enriched by means of glazes and, above all, denser and more modulated pigments. The anti-naturalistic, oneiric space of the Ferrara works is also restructured in terms of a more plausible unity, even if it is not yet definitively classical. A first, instinctive, and visionary ("metaphysical") interest in museums took shape around the time the Bragaglia exhibition was underway: "It was one morning at the Villa Borghese, in front of a painting by Titian, that I had a revelation of what great painting was: I saw tongues of fire appear in the gallery, while outside, beneath the clear sky over the city, rang out a solemn clangor, like weapons beaten in salute, and together with a great cry of righteous spirits there echoed the sound of a trumpet announcing a resurrection."[1]

The effect, however, was not immediate. Until summer 1919 the artist remained purely metaphysical and the plastic, visionary power of his scenes was not averse to the avant-garde, futurism in particular, which he considered an "unquestionable . . . necessity,"[2] a movement that did "immense good"[3] to new art. It was only after midyear that his position was overturned in the search for an anti-avant-garde classicism and the return to the craft of the ancients, when all aspects of futurism became an aberration that "has done no good whatever to Italian painting," as he would remonstrate in the November–December 1919 issue of *Valori Plastici*.[4] With the "return to craft" after the war, begun under the aegis of Mario Broglio (editor of the magazine to which the painter contributed assiduously), a further stylistic leap came about: the "metaphysical" or interior meaning of the pictorial

The Sacred Fish, early 1919,
private collection.

Hermetic Melancholy, early 1919,
Musée d'Art Moderne de la Ville de Paris, Paris.

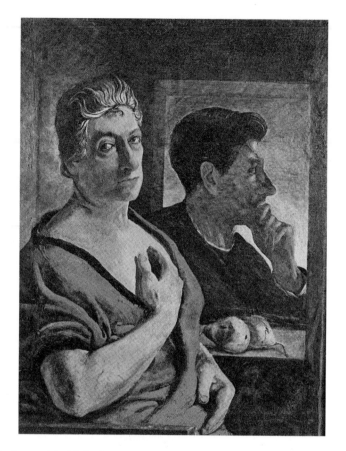

Portrait of the Artist with his Mother, late spring 1919,
Centre National d'Art et de Culture Georges Pompidou, Paris.

composition would now permeate, not by means of a bewildering assemblage of disparate and oneiric objects, but from "classical" compositions inspired by the abstractive and absolute meaning of Renaissance painting, in an ideal reconstitution of the constructional order of classic Italian art.

In the first half of the torrid July of 1919, accompanied by his new friend, the painter Armando Spadini (closely tied to his new collector Signorelli), de Chirico made his first attempt at copying a classic painting, a portrait by Lorenzo Lotto in the Borghese Gallery: "It was the summer of 1919. It was very hot in Rome. . . . I had decided to copy a painting by Lorenzo Lotto at Villa Borghese. I had never copied paintings in museums before; I mentioned my plan to colleagues and friends and they all smiled more or less benevolently to themselves. . . . While I was copying Lorenzo Lotto's painting I often saw Spadini when he came to the museum and I talked

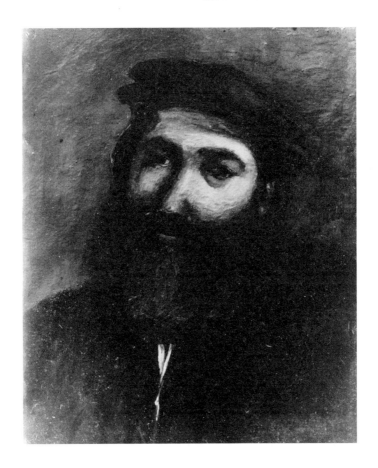

Portrait of a Man (detail from *Portrait of a Gentleman* by Lorenzo Lotto, Galleria Borghese, Rome), July 1919.

about classical painting with him."[5] It should be noted how a strange return of psychosomatic stomach pain[6] linked this incubational period of a new classicism to the innovation of metaphysical art in Florence. It is indeed peculiar how the artist's state of being, brought on in both cases by physical discomfort, created a new "vision" in art, this time in a key of idealist Platonism although still with a vein of Schopenhauer's pessimism and Nietzsche's visionary quality.

To tell the truth, in the spring he had already painted classically inspired works, such as *Self-Portrait with His Mother*, which was included in the monograph that went to print at the time and was evidently influenced both by Raphael and an "out-of-time" classicism in which metaphysical intensifications were still present. The current state of preservation of this painting, oxidized and covered with deep *craquelure*, is also a sign of an initial re-

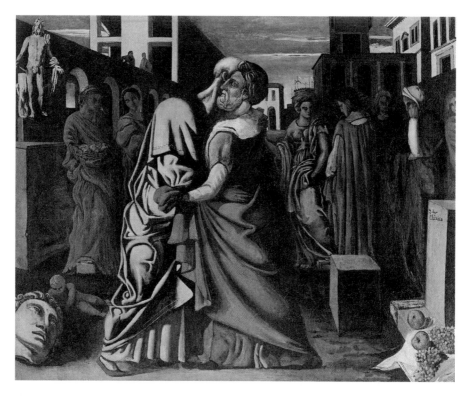

The Return of the Prodigal Son, July–November 1919,
private collection.

flection on classic painting techniques, while the artist's solid metaphysical
mixtures persist. Setting out precisely from these alchemical meditations,[7]
suggested by the museum copy and by exaggerated although inexpert glaz-
es, he would execute a series of paintings between July and November in-
cluding a *Self-Portrait*, *The Return of the Prodigal Son*, *The Virgin of Time*,
Still Life with Pumpkins, and *Diana*, all of which are marked by oxidation
and drying caused by tentative experimentation with oil technique *all'antica*.
In *The Return of the Prodigal Son*, the first painting of a particularly com-
plex compositional structure executed in this new climate of research, the
buildings play a background role, like theater wings, thus within the squared
formal devices used in metaphysical art, whereas the group of figures in the
forefront takes inspiration from Carpaccio's austere art.[8] The magnificent
Self-Portrait with Brush and Antique Bust (also dated 1919), a true manifesto
of classical painting, is much better preserved and demonstrates a maturer
(and therefore subsequent, actually toward the end of the year)[9] control of
painting technique.

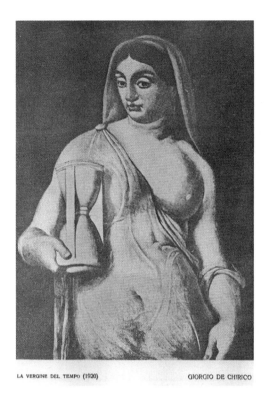

LA VERGINE DEL TEMPO (1920) GIORGIO DE CHIRICO

The Virgin of Time, July–November 1919,
private collection.

From *Valori Plastici*; the painting has been entirely repainted.

In truth, at its outset the periodical *Valori Plastici* was not yet a great war machine of a new classicism, nor were Carrà's mediumistic articles or Giorgio de Chirico's and Alberto Savinio's sublime deliberations. Edita Walterowna von Zur Muehlen (later Broglio's wife) still presented the incandescent *Landscapes* shown at the Roman Secessions with their Central European echoes and "Blaue Reiter" visionary qualities, as plausible works of the new movement, publishing reproductions of these in the journal in 1919 (and exhibiting them at the *Valori Plastici* group show in Germany in 1921).

A modernization that foresees the interpenetration of an older order with avant-garde rules (de Chirico's positive appreciation of the futurists, mentioned above, is a decisive factor), although still comprehensible in the context of metaphysical art, must have seemed like heresy in mid-1919 Rome: if the moment was indeed to be a Return to Order, it should have been a total one, a "return to craft," a transference with the painters of antiquity and a denial of every

Still Life with Pumpkins, July–November 1919,
private collection.

aspect of the "modern" and analytic or synthetic formulas of the avant-garde.
As unquestionable dogmas, the museum, tradition, and classicism left no more
space for modernizing nostalgias. De Chirico was its most radical theoretician:

> Neglect and deformation of anthropomorphic representation has encouraged
> entire legions of painters to turn out stupid and facile reproductions. . . . To
> return to craft! This will not be easy and will demand time and effort. . . . With
> the fading out of hysteria [the "avant-garde," *author's note*], more than one
> painter will return to craft, and those who have already done so can work with
> freer hands, and their work will be more adequately recognized and recom-
> pensed. As for me, I am calm, and define myself with three words that I wish to
> be the seal of all my work: *Pictor classicus sum.*[10]

Between 1919 and 1921 de Chirico would execute very few paintings
characterized by experiments in technique that, in an almost alchemistic
complication, would jeopardize their preservation (as in the works of Leon-
ardo). His main models included the young Raphael and the fifteenth-cen-

Diana (Vestal Virgin), July–November 1919,
Palazzo Merulana, Cerasi Collection, Rome.

tury Renaissance (Perugino, Carpaccio, et al.) and were evocative of a classi-
cism he would call "Olympian."[11] In the course of 1919 he traveled to Milan,
Ferrara (where he once more saw his fiancée), Bologna (where he certainly
met Morandi), and above all Arezzo (where he would see the work of Piero
della Francesca, precisely in that moment of prophetic inspiration from the
most abstractive Renaissance).[12]

In the autumn–winter of 1919, de Chirico's choices were now clear and
accompanied by a vast theoretical and critical activity expressed in the leading
journals of the day.[13] The artist moved to Milan in November 1919 in order to
gain contact with the Milanese milieu dominated by Carrà, who had held his
first "metaphysical" exhibition in the city, presenting himself as the creator of
that movement. De Chirico would organize a solo exhibition of his own in Mi-
lan in January 1921,[14] displaying works from his "youthful period 1908–1915"
that would unquestionably establish his primogenial relation to metaphysical
art. Yet the works of 1919–20, including such masterpieces as *Mercury and the
Metaphysicians* and *The Salutation of the Departing Argonauts*, as well as vari-

Self-Portrait with Antique Bust and Paintbrush, November–December 1919, private collection.

Mercury and the Metaphysicians (The Statue that Moved), 1920,
private collection.

Greek Icon, 19th century,
Benaki Museum, Athens.

Miss Amata, 1920,
private collection.

Oedipus and the Sphinx (*The Temple of Apollo*), 1920,
private collection.

Self-Portrait, spring 1920,
private collection.

ous portraits and mythological heads, and mysterious scenes such as *Oedipus and the Sphinx (The Temple of Apollo)*, painted between Milan, Rome, and Florence (where he was a long-term guest of his friend, collector, and benefactor Castelfranco),[15] expressed timeless "Greek" and Renaissance qualities, in which perspective conformed to the centralized Renaissance system and the figures recalled those of Raphael as well as the traces of Apelles in classical painting. There was even a subtle echo of Greek icon painting, evidently interpreted as representing the last manifestation of the sublime art of ancient Greece (Apelles is mentioned in his writings of the time), which would lead de Chirico to conceive of a "return" to earlier techniques (something evident, for example, in works of the 1920s such as *Oedipus and the Sphinx [The Temple of Apollo]* and *Miss Amata*). His familiarity with icon painting dated back to the years of his Greek education, as well as to his friendship with Stàvros Kantzìkis, who continued to practice it.[16] De Chirico's initial oil-based technique progressively gave way to the use of egg tempera, which, as he wrote to Breton[17] at the end of 1921, "illuminates painting with a new light."

The *Valori Plastici* periodical was focused on inspiration of a classical leaning without compromises: the *plastic values* are those of the Renaissance (de Chirico) or the Italian fourteenth century (Carrà). In the November–December issue of the journal there appeared a reproduction of Carrà's *Daughters of Lot*, the first painting that definitively moved away from metaphysical art to declare the principles of "the renewal of painting in Italy" in accordance with the plastic values of primitive and Giottesque painting. In the same issue, Giorgio Morandi presented a still life that was still linked to metaphysical art (which he had approached through the example of Carrà) and a more recent work in which the order of an objective reality already placed objects in a Renaissance dimension of squared space. In July–August 1920, de Chirico's first neo-Renaissance paintings were published (*Self-Portrait*, *The Beloved Young Lady*, *The Virgin of Time*, and *The Return of the Prodigal Son*); but as early as 1919, the programmatic *Self-Portrait with Mother*, a synthesis of his idea of the classical, appeared in his monograph by *Valori Plastici*, together with metaphysical works of 1918–19.

De Chirico's paintings of this period are among the foremost and highest achievements of an imminent and monumental classicism: portraits, figures, and nudes stand out against neutral backgrounds, in shadowy rooms or in the open air in which the landscape ("nature") rarely attempts more than a timid, somewhat generic appearance. In *The Salutation of the Departing Argonauts*, for the first time one finds a reference to a place, even if imaginary. The composition takes up, as a counterpart, the setup of *The Enigma of an Autumn Afternoon*, the first painting in accordance with "metaphysi-

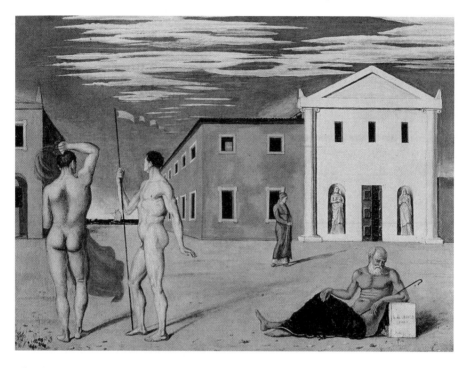

The Salutation of the Departing Argonauts, 1920,
Museo d'Arte Contemporanea del Castello di Rivoli, Cerruti Collection, Rivoli.

cal" criterion,[18] almost as if to confirm the emblematic meaning of the first painting of a new vision. Similarly, the painting *Argonauts* was intended as the *manifesto* of de Chirico's new classicist direction: the temple, which in the *Enigma* is on the left of the composition, is now on the right, and is codified in accordance with traditional, classical canons (the architectural order is Ionic and the facade is punctuated by three windows and two niches with markedly classical statues); the sail that appeared mysteriously behind a wall is now clearly seen on a beach in the background; the small building at the side of the temple has become a large square palazzo with windows set in classical frames. From mystery, from the enigma of the primordial, de Chirico achieved neo-Renaissance clarity populated by people like statues and no longer by statues like people: apprehension, the demon, first brought to light through the combination of subtly contradictory and mystifying perspectives, now springs from situations and characters, from the classical-style spaces rendered with reassuring centrality. He now considers himself and his companions the new Argonauts, whose untiring metaphysical research is that of classicism.[19]

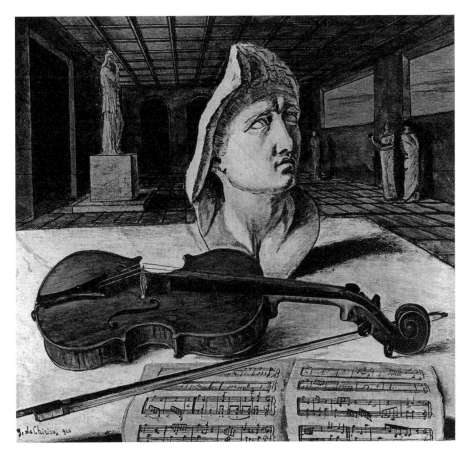

Apollo's Room, 1920,
Fondazione Pasquinelli, Milan.

In this phase we find the meaning of representation deeply changed and the stylistic coordinates radically modified. It is not without aesthetic and theoretical implications that de Chirico omits representing the *Stimmung* of metaphysical places to devote himself to the human figure: what he represents are figures of gods, no longer "prehistoric" oracular men caught at the dawn of time. After the beginnings of history, his interest is now concentrated on a higher level, an order taking over from the chaos and "terror" of creation. The mysteries of *plastic values* are those directly announced and ratified by the gods, no longer those foretold by oracles, which discover the non-meaning of everything. From the Nietzschean Dionysian state of metaphysical art, his vision has shifted to an Apollonian calm. Clear and subtle mysteries set order to the world under a cerebral and transparent

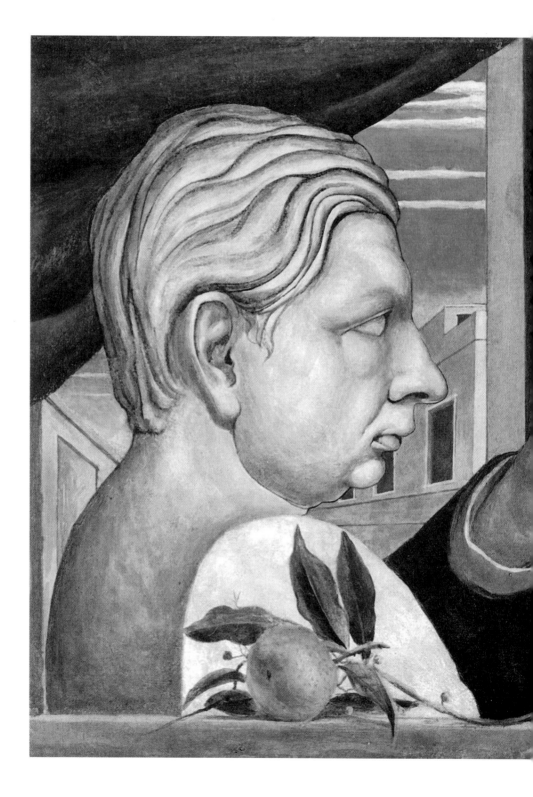

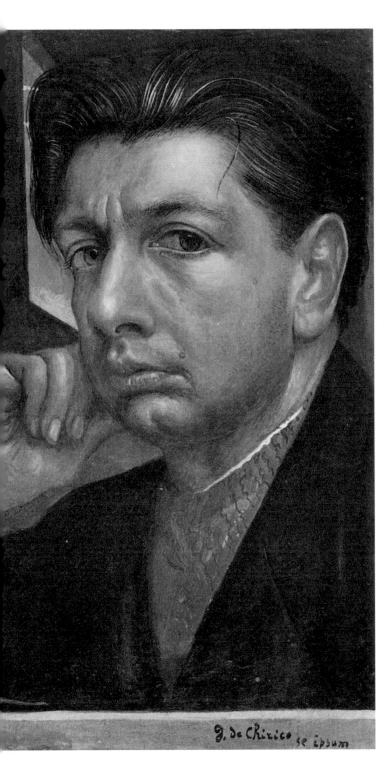

Self-Portrait, 1920–21,
Toledo Museum of Art,
Toledo.

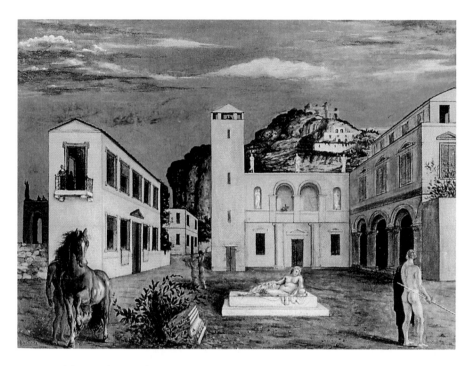

Mercury and the Metaphysicians, late 1920,
private collection.

light: it is not by chance that he celebrates the divine protector of the arts in
Apollo's Room. The scene is set in an enclosed arcade reminiscent of Piero's
Flagellation in Urbino: the mysteries it contains are those of harmony—not
of melancholy.

The subsequent *Mercury and the Metaphysicians* (of late 1920; the title
was later changed to *The Statue That Moved*) seems rather to identify in
the stately classicality of Rome the *topos* of immanent myth. Here, as in
The Salutation of the Departing Argonauts, one finds elements of a meta-
physical piazza revisited with compositional fidelity but subjected to a pro-
nounced classical reworking: *The Joys and Enigmas of a Strange Hour* con-
tained the same compositional elements (a narrow building to the left, a
tower and another front-facing element at the center, a foreshortened struc-
ture at the right, and a statue lying in the middle of the square). Yet here
too, the *Stimmung* is not associated entirely with the solitary space (as in
the metaphysical works) but is more precisely identified in the mysterious
relationship between the hermetic Mercury and his metaphysical followers,
as the title suggests. It is the demon of classicism that de Chirico possesses

Lucretia, 1919–21 [?],
La Galleria Nazionale, Rome.

at this moment, the demon of History, of the past as accumulation of significant experiences and, at bottom, as abstraction of reality. Dated 1921, *Lucretia*, inspired by Dürer, was instead probably begun in 1919 and completed in 1921. The foreshortened window at the upper right-hand corner of the image seems to confirm this dating as it is an element still evocative of his metaphysical style. The intensely worked surface of the figure, which suggests a long period of gestation, was brought to completion in accordance with the noblest classical spirit, seen in the skillful and refined depiction of the roses resting on the ground.

At the height of his classical maturity, de Chirico asked his Parisian friend and dealer Paul Guillaume to mount an exhibition of his works in Paris. The artist presented the project in a letter of December 28, 1921, passionately describing a "nouvelle peinture" that would change the minds of all those who considered him to be merely a museum copyist and felt he had lost his way: "I have resolved the problem of painting technique in a striking way: you will see painting of astonishing solidity, clarity, fascination and mystery."[20] Evidently, there was already a certain amount of perplexity in Paris concerning de Chirico's change of style, as he mentions in a letter sent to Breton the same day.[21]

Despite the international acclaim of *Valori Plastici*, sanctioned by the success of the exhibition in Germany of 1921[22] and the influence it exerted on those artists associated with tendencies such as New Objectivity and Magic Realism, a series of conflicts occurred within the movement itself. The most significant of these, between de Chirico and Carrà, was occasioned by the publication of the latter's book *Pittura metafisica* in late 1919, which did not even mention de Chirico. In reality, this concerned a past dispute that had found resolution once both painters discerned a new outlet for their ideas in the classicist "Return to Order" promoted by *Valori Plastici*. However, the worsening of relations between the two main pillars of the journal also profoundly jeopardized its existence.

Self-Portrait with Bust of Euripides, 1922,
private collection.

18. The "Romantic" Period

Throughout the course of 1921, de Chirico had been the major theoretical adversary of the tendency toward "*secentismo*"[1] (the return to an eclectic and "historicist" order, which represented a Roman counterpart to the "purist" aesthetics of *Valori Plastici*). However, when the journal folded in 1922, its programmatic and avant-garde bulwarks also collapsed to a certain extent, and de Chirico substantially revised his purist positions, beginning to explore an original romantic and eclectic lyricism that echoed the work of Courbet,[2] Böcklin, and Hans von Marées.[3] His new paintings even included works evoking seventeenth-century still lifes and reimagined, picturesque views of baroque Rome, with masterpieces of elevated and evocative poetry. His visit to the exhibition *Pittura italiana del Seicento e del Settecento* [*Italian Painting of XVII and XVIII centuries*], organized in 1922 by Ugo Ojetti in Florence, as well as possible discussions with his friend Castelfranco, must have inspired the artist to change his mind.[4] De Chirico therefore progressively moved away from the abstract idea of classicism, a cold and programmatic concept, unable to contain the fullness of his poetic sensibility, once the tension within the group led by Broglio (who wanted to establish a European classicism as an alternative to that of France) had eased.

With the reorientation of de Chirico's inspiration, his *Valori Plastici* phase came to a close, while the movement's influence simultaneously spread throughout Rome, giving rise to the dominant style of the day: an eclectic return to the ancient, characterized by imagery with a lucid and calculated structure, infused with a sense of anticipation and the lyrical suspension of things, and pervaded by an atmosphere of the museum and of antiquity, which represented the evolution of the great legacy of the radical Return to Order promoted by the journal. The museum became a privileged point of comparison and history, as a whole, the inspiring muse.

By the time of the 1922 *Valori Plastici* exhibition in Florence, there were no further theoretical splits or polemics between the Renaissance and baroque, between purists and historicists, taking place within the Roman Return to Order.

Self-Portrait with Rose, 1923,
private collection.

From that moment on, a vision of broad tradition unfolded as an expression linked to a lyrically purified and "magic" reality in an atmosphere of suspension resulting from the search for metaphysical bonds between image and painting (based on citation).[5] With the programmatic moment of *Valori Plastici* substantially over, de Chirico's expression made room once more for an inspiration that drew on the intense depth of the great ideal master of his youth, Böcklin, resulting in those paintings that he himself willingly called "romantic." Böcklin thus prevailed over Piero della Francesca and Giovanni Bellini; de Chirico began to meditate once again on forms and representative systems that had formerly been fundamental in the elaboration of metaphysical art. At this point he freely brought together all the elements that had found expression in his painting in the past, without an apparent programmatic order, in a moment of free

inspiration. It is now reality, associated with history, making his strings vibrate, the result of which was an explicit, refined lyricism. There had always been a strong lyrical dimension to de Chirico's thought, something that was perhaps sharpened by his contact with the other great lyricist of the Parisian avant-garde, Apollinaire. It is sufficient to glance through the titles of the metaphysical paintings he created in Paris and Ferrara to note how he always combined his philosophical premises ("enigma," "meditation," "philosopher") with purely lyrical contents and terminology ("the silent statue," "the delights of the poet," "the dream transformed," "the melancholy of departure," "the song of love," "the double dream of spring," etc.). Moreover, one of the main reasons for de Chirico's interest in Nietzsche and his philosophical thought was the essentially lyrical form through which the German philosopher expressed himself—even more, I would say, than the contents themselves (or rather, why the contents assumed *that* form).[6] This particular appreciation for Nietzsche's thought *sub specie lyricae* emerges with great clarity in a later passage by Savinio:

> Nietzsche is a lyric poet. He is the most typical example of the lyric poet. He is the most lyrically complete man I know. In addition to his work, his life itself is a lyrical fact: his philology, his philosophism, his philosophy of the hammer, his will to power, his political notions, his ideas concerning states and war are all equally forms of lyricism, and if I do not say that his aesthetic is itself a form of lyricism, it is because I would not be followed down such subtle paths. Ergo Nietzschean philology, philosophy, and politics should be considered *more lyrici*, dissociated from any ultimate idea.[7]

It is no doubt for this reason that from Nietzsche's complex philosophical system certain collateral concepts, such as the *Stimmung* of an autumn afternoon, became particularly significant for de Chirico, while others, such as the idea of the superman [*Übermensch*], did not—at least not theoretically—that is, in a purely lyrical concept, that could not be rationalized in traditional philosophical terms. This undoubtedly characterized de Chirico's other youthful "philosophical" interests, such as Schopenhauer, Papini, the pre-Socratic philosophers, and Heraclitus in particular.

The Roman Villas, for example, had their origin in the model provided by Böcklin's *Villa am meer* (1864), but were in fact inspired by actual Roman locations (only rarely, and just once explicitly, would de Chirico be inspired by a Florentine landscape, although even in this case the preparatory drawing for the work was based on a Roman view, as we shall see). The earliest of these paintings (1922) was inspired by a view of the Parioli hills seen more or less from Villa Strohl-Fern, an artistic community de Chirico used to frequent. The two houses below the looming tufaceous cliff still exist, and at the time

Roman Villa (Roman Landscape), 1922,
private collection.

Roman Villa (Landscape with Horsemen), 1923,
private collection.

Orestes and Electra (first version), 1923,
private collection.

Ottobrata (Indian Summer), 1924,
private collection.

were among the first buildings of the new Parioli district, standing solitary in a Roman landscape infused with a mythical atmosphere, on the threshold of urbanization. The work's subtly disquieting quality proceeds from this juxtaposition of primordial antiquity with modern buildings, recently constructed for bourgeois families. The inclusion of a female or hermaphroditic figure high up in the clear sky of an autumn day, who agitates the clouds like Mercury, further accentuates this contrast. It is difficult to identify this character, who probably represents nothing more than the embodiment of an immanent sense of myth, a "genio aptero," like those the painter would evoke in *Hebdomeros* a few years later: "The explorer would muse as he gazed at the great wingless genii lying on the clouds; he would think then of the unfortunate polar bears, desperately clinging to the drifting icebergs, and tears would come to his eyes."[8] Without entering into an iconographic analysis of the beautiful though small series of "villa" paintings, one can note that almost all of them depict "romantic," evocative, and elegiac areas of Rome—and more rarely, of Florence. *Orestes and Electra* (second version), which was closely related to the painting exhibited by de Chirico at the Second Rome Biennale of 1923,[9] is based on the Horti Farnesiani on the Palatine Hill, a view that was also

The Departure of the Adventurer (first version), 1923,
private collection.

depicted in a contemporary work titled *Ottobrata (Indian Summer)*. The portico at the bottom of the image, the high building with loggias, divided into two sections—which can be even more clearly discerned in *Ottobrata*—the classical and leafy aura of the noble hill behind it: all these elements capture the *Stimmung* of that fateful place, in an atemporal context that transfigures it. *The Departure of the Adventurer*, exhibited in 1929 with the title *Florentine Landscape*, also had a Roman starting point. Proof of this can be found in the preparatory drawing, titled *The Return of the Knight-Errant*, which incorporates a view of the Tiber from Porta Portese, depicting the Aventine Hill and the Neo-Romanesque church of Sant'Alessio at its summit, with the loggia reminiscent of the Piranesian buttresses of the Knights of Malta. Nevertheless, in the final version of the painting, intended for de Chirico's Florentine friend and supporter, Castelfranco, the artist decided to make the image more Florentine by incorporating a series of Tuscan reference points: accordingly, the round temple next to the river is based on an existing one in Via Romana, while the building on the left is a typical fifteenth- to sixteenth-century

The Departure of the Adventurer (second version), 1923,
private collection.

Florentine palazzo, and the hill resembles that of San Miniato, with the small
district of Porta San Miniato at its foot. Another painting, *The Nymph Echo*,
incorporates a glimpse of Castelfranco's house in Florence,[10] by way of a fur-
ther tribute to de Chirico's art historian friend.

In the first version of *Orestes and Electra*, one can instead recognize Via
d'Alibert in Trastevere, near the botanical gardens, where de Chirico had his
studio. The eighteenth-century Villa Alibert is almost literally paraphrased
in the construction in the background of the painting, where—in a meta-
physical collage in which time and space are nullified—the Florentine loggia
of Via Romana also appears.

The 1923 Roman Biennale's most innovative room included almost all the
artists (Oppo, Guidi, Severini, Ferruccio Ferrazzi, Biagini) contemporary
critics spoke of in terms of "neoclassicism." De Chirico showed a group of no
fewer than eighteen works, almost a solo exhibition, with Severini's abstract
classicism serving as a comparison. It was de Chirico's "autumnal" season,
marked by a climate that became a metaphor for languor and infinity, sealed
by the theme of one of his best-known paintings of the period, *Ottobrata*, an
allusion to the famous, gentle October days in Rome. A *topos* is thus found
in every painting of this period between 1922 and 1924, a sort of poetic
seal: that of autumn. The very genesis of metaphysical art was intellectually

The Return of the Knight-Errant, 1923,
private collection.

View of Aventino with the Knights of Malta and Saint Alessio Church.

Orestes and Electra (second version), 1923,
private collection.

Villa d'Alibert, Rome.

bound to the mood of the autumn afternoon, a privileged moment of pro-phetic intuition—a profound and lyrical theme Nietzsche had instilled in de Chirico's soul.[11] Even the still lifes painted between 1922 and 1924 allude implicitly to autumn: pomegranates, grapes with a glass of new wine, game, apples, each element harks back, as in the ancient allegories of the seasons, to autumn. In the same way, the titles of the paintings exhibited at the time often allude to this season: *Fruits of Autumn*, *The God Bacchus*, *Autumn Afternoon*, right down to the enigmatic *Ottobrata* [*Indian Summer*], exhibit-ed at the 1924 Venice Biennale and criticized from the start for its "obscure" subject matter. The true subject of each of the works painted in this "roman-tic" period is precisely autumn, the atmosphere of autumn. Rome and, by extension, Florence with its Böcklinesque aura, were until 1924 the privi-leged place of de Chirico's free and extensive poetry, the notes of his elegiac song. The emotions of farewell and departure are represented in yet another intense and poignant work of the period, correctly identified by Fagiolo dell'Arco as *Tibullus and Messalla*: an image of the great Roman elegiac poet who, while ill, takes leave of his friend who is preparing to go into battle.[12] Autumn becomes a *topos*, a temporal place no less pregnant with meaning than the real and evocative structures of the Roman villas.

Considered from this perspective, places become a complex category of the spirit, a combination of nature, history, culture, and myth, capable of crystallizing the artist's *Stimmung*. With themes identical to those of the first metaphysical works, containing the same philosophical and structural prem-ises, yet explored in an entirely different manner, the content of de Chirico's work continued to be impeccably consistent.

Previous pages:
The Glass of Wine, 1923,
private collection.

Still Life with Classical Bust, late 1923,
private collection.

Tibullus and Messalla (The Poet's Farewell), 1923,
private collection.

Self-Portrait with Savinio, 1924,
private collection.

19. The Second Parisian Period and Surrealism

Between the end of 1924 and the beginning of 1925 de Chirico's style changed direction once again, this time radically. On the timeless art of *Valori Plastici*, and on the secluded, faraway romantic elegy of the "Roman Villas" (which came immediately after), he superimposed an enthusiastic and decisive research that, once again, actively participated in contemporary art. Contacts with the avant-garde and proto-surrealist scene in Paris were intense and positive (a milieu he had been familiar with since the 1910s, from the days of his friendship with Apollinaire), and in particular with Breton,[1] favored by their shared veneration of the dead poet. This contact was intensified by the high and unconditional consideration the surrealists accorded de Chirico at this initial stage, which was consolidated during a brief yet productive visit to Paris in November 1924.[2] De Chirico contributed to the first issues of the periodical *La Révolution Surréaliste*, with essays, drawings, and photographs of new works that revisited metaphysical painting in a wholly new key, monumentally classic, in which he revived elements of his native Greek and Mediterranean culture.

After the clamorous breakup with the movement, no matter how hard de Chirico tried to differentiate himself, even polemically, on a theoretical, poetical, and philological level from surrealism, his new "Parisian" painting style, which began as early as the end of 1924,[3] can undoubtedly be interpreted in light of renewed contact with the Parisian avant-gardes and his initial adherence to Breton's movement. There appears to be no doubt that his ideas, despite the effort later made to deny this notion, were not only rapidly renewed in that very circumstance, but that they coincided perfectly at the time with those upheld by the followers of the new movement.

Between 1922 and 1924 de Chirico created a series of paintings inspired by the mannequins of the Ferrara period, updated in accordance with the artist's new "romantic" sensibility and executed using the *tempera grassa* (oil and tempera emulsion) technique typical of that era.[4] These were undoubtedly a consequence of the relationship he began in 1921 with Breton, a passionate admirer of de Chirico's metaphysical paintings. The works did not

Study, second half of 1924,
private collection.

Composition, late 1924,
in *La Révolution Surréaliste*, no. 2, January 1925.

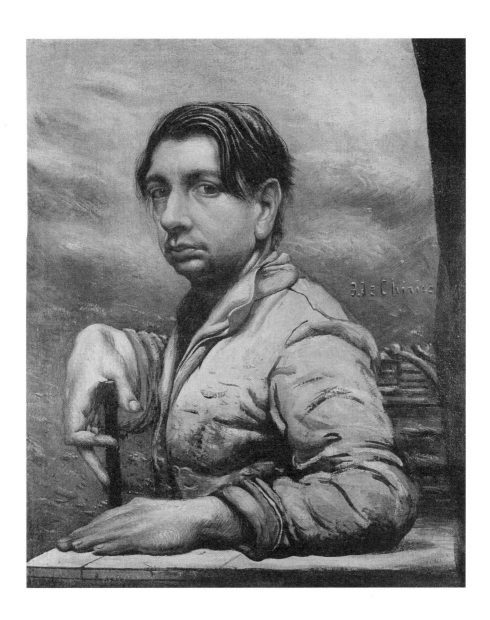

Self-Portrait, winter 1923–24,
private collection.

La Révolution Surréaliste, cover, no. 1, December 1924.

Photograph of the surrealist group by Man Ray published on the cover of the first issue of *La Révolution Surréaliste* (*back row from left*: Jacques Baron, Raymond Queneau, André Breton, Jacques-André Boiffard, Giorgio de Chirico, Roger Vitrac, Paul Éluard, Philippe Soupault, Robert Desnos, Louis Aragon; *front row*: Pierre Naville, Simone Collinet-Breton, Max Morise, Marie-Louise Soupault).

The Automata, late 1924–early 1925,
private collection.

represent copies but rather modernizations of his themes that contained nu-
merous variations, and which were realized in accordance with a new picto-
rial inspiration perfectly attuned to the nostalgic phase of the "Roman villas."
During the first half of 1924, additional works contained references to earlier
pieces, such as *The Philosopher*, in tempera, for Gala Éluard.[5] The painting
was based on *The Revenant (The Child's Brain)* of 1914, thereby accentuating
the resonance between de Chirico's works and themes dear to the surrealists.

Following his visit to Paris in November 1924—or perhaps immediately
prior to it—he decided once again to make an abrupt technical and stylistic
change. His new oil technique was a clear, fast, compendious style, like that
employed in the frescoes of Pompeii, which often left large areas of the canvas
unpainted, or covered solely by graphic marks. The technique set aside the
"old-fashioned" use of tempera, and which also overcame the slow, method-
ical, and refined characteristics associated with it. De Chirico revisited meta-
physical themes at this time but did so in the context of totally new imagery,
with different colors and a robust technique that rivaled Picasso. New versions
of the theme of objects in rooms began to appear (geometric toys, trophies of
archaeological-mnemonic discoveries, and Hellenic buildings), thus regener-
ating the Ferrara Interiors by means of a Mediterranean vision. The manne-
quin-philosophers, although renewed in terms of their iconography and con-
tent, were based on clear metaphysical themes. But the multifarious objects
held in their laps—classical architectural fragments and set squares—now al-
luded nostalgically and autobiographically to the artist's childhood, set, as they
were, facing out toward Mediterranean skies and seascapes. The nature of de
Chirico's relationship with Picasso became specific and refined: the year 1925
saw the production of a *Female Figure at the Seaside* and a series of *Ciociare*
reminiscent of the massive bulk of Picasso's neoclassical figures. Reviewing the
1925 Rome Biennale (where a *Ciociara* was exhibited), art critic Margherita Sar-
fatti even noted: "Giorgio de Chirico appears to have been strongly impressed
by the more recent classical-synthetic style of Picasso."[6] Modern criticism has
likewise simplistically considered the influence of Picasso;[7] in fact, the matter
is decidedly more complex. The dialogue that de Chirico established was in-
tentional and considered but sought to underline the many stimuli Picasso had
found in his own works, thereby maintaining a controversy-free relationship
between the two protagonists on the Parisian stage. The Mediterranean skies
with horizontal clouds that Picasso transformed into one of the *topoi* of his
Mediterranean-cubist classicism undoubtedly derived from some of the most
famous paintings produced by de Chirico during the last years of his Parisian
metaphysical phase (1915), such as *The Double Dream of Spring, The Disquiet
of Life, The Poet and the Philosopher*, and so forth. Even the new synthetic and

The Philosopher (The Revenant), early 1924,
private collection.

The Ciociara Woman, 1925,
private collection.

Previous page:
Female Figure at the Seaside, 1925,
private collection.

The Painter, 1925,
private collection.

The Tremendous Games, 1925,
private collection.

Theodor Breidwieser, *Walrus Hunt*, ca. 1900,
Fondazione Giorgio e Isa de Chirico, Rome.

compendious painting style had distant roots in his earlier imagery (*The Poet and the Philosopher*), and the technique of leaving the canvas white, with only pencil marks showing, was likewise a technique adopted from the Parisian metaphysical phase. In short, de Chirico engaged not so much in a contest as in a friendly dialogue with Picasso, revisiting what he had himself already explored and that which the Spaniard had in turn adopted from his *imagérie*.[8]

In particular, the paintings of late 1924 and 1925 have, even in their spatial approach, a close link with the complicated and jumbled agglomerations of the Ferrara Interiors, with set squares, deck planking set in headlong perspective, bright colors (reds, greens, etc.), mannequins (still barely humanized), and skies with stylized clouds in alienating, hyperrealistic paintings (such as the scene taken from a minor Austrian painter, Theodor Breidwieser, which Paolo Picozza kindly pointed out to me) inserted in his paintings: all elements inspired by his metaphysical painting, which, from 1926, abated to give way to a more classical and museum-inspired stimulus, with softer and more pastel-like colors and less forced perspectives. The first examples of

Metaphysical Interior—The Summer Afternoon, 1925,
Yale University Art Center, Gallatin Collection, New Haven.

Exhibited in New York in 1926.

these were shown in May 1925 at Léonce Rosenberg's Parisian gallery along-side works of various precedent periods.

What might have led de Chirico to rethink his earlier style if not his intense socializing with the surrealists during his stay in Paris in November 1924 and his undoubted adhesion to the movement? As we have said, he took active part in the first issues of Breton's magazine *La Révolution Surréaliste* and sent material for publication during his brief return to Italy, including a photo of the first *Metaphysical Interior* painting in the new "surrealist" style, reproduced in the January 15, 1925, issue and evidently executed at the end of 1924. De Chirico appears in two group photos with the surrealists printed on the cover of the first number of the magazine. Following the "transfer" into the past during his Roman *Valori Plastici* period, he was greatly attracted by the ideas of "modernity," which he was newly enthusiastic about in Paris where he felt the beating of the intellectual heart of the world: "The great mystery of Modernity dwells everywhere in Paris. . . . spirit, intelligence, lyricism and talent increase continually. . . . And everywhere you go you encounter smiling and amiable faces, friendly hands grasp your own, people with intelligent and serene expressions look to you with admiration, curiosity and congeniality. Like the Athens at the time of Pericles, Paris is today the city of excellence for art and the intellect."[9] Who if not Breton, Morise, Aragon, and all the surrealists, were those figures with the intelligent and serene expressions whom he frequented assiduously in Paris and who made the city the new Athens?

Flattered by deferential attention from the new avant-garde in Paris, a milieu he had been in epistolary contact with since 1921–22,[10] which intensified at the end of 1923 (when Paul and Gala Éluard visited him in Rome, almost in a devoted pilgrimage), de Chirico evidently rethought those themes of metaphysical art that the surrealists (Breton first and foremost) knew best and favored in his painting.[11] He modified his aesthetic of "timeless" lyricism typical of 1922–23 into a contiguous lyricism of visionary modernity as already seen in his metaphysical art, and now in surrealism, by making associations between disparate elements in an alienating symbiosis, illuminations and memories of childhood in scenes of clear-cut objectivity, models of his earlier painting with archaeological elements. In this, he did not contradict his recent past but followed Nietzsche's principle of the Eternal Return, of the immanent poetic enigma.

Generally speaking, to distinguish de Chirico from surrealism, critics have superficially supported their arguments with aspects dipped in the ink of controversy, regarding both the painter and the surrealists themselves (subsequent, it should be noted, to the breakup between the painter and the

Still Life with Brioche, 1925,
Museo del Novecento, Milan.

The Saddened Poet consoled by his Muse, 1925,
Philadelphia Museum of Art, Arensberg Collection, Philadelphia.

movement, which only took place in 1926). Criticism such as this ignored the fact that for roughly two years there had been a substantial harmony and undoubtedly active participation by de Chirico in the nascent surrealist ideologies and poetics, in the riverbed of which his new style was formed. The consonance of this new direction is easy to link up with the theories expounded in the periodical's first issues, theories moreover inspired in turn and to a fair extent by de Chirico's visionary and anticipatory metaphysical thunderbolts. The reasons employed as a pretext, which the surrealists aimed at the unconscious and de Chirico at memory, the former toward automatism and dream and the latter toward clarity and vision, cannot lead us into error: apart from Breton's egocentricity, there are many kinds of "surrealisms" that are often very different one from the other, as also demonstrated by the frequent abjurations within the group, but above all Breton's own principal consideration on "surrealism in painting."[12] On one hand there is no automatism in René Magritte or Salvador Dalí and, on the other, dream and unconscious emerge (certainly to a lesser degree than in Max Ernst, for example) from de Chirico's works as well, as seen with his "novel" *Hebdomeros*,[13] published in 1929 and highly appreciated by the surrealists, a fact that confirms their continued interest in his work at the end of the decade and a subtle but deep continuity of inspiration in a metaphysical-surrealist sense even in the years 1926–29.

A surrealism *sui generis* then, which from 1924 to 1926 developed at the heart of the official one and was theorized clearly in the magazine's first issues. When Max Morise wrote "It is here that we achieve truly surrealistic activity—forms and colors pass from one object to the other and are organized in accordance with a law that escapes all premeditation—that does and undoes in the very moment of its manifestation,"[14] we grasp a total ideal continuity with the Metaphysical Interiors of 1924–25, packed with indeterminable objects in which forms and highly vivacious colors interpenetrate without order. Or even the mannequins, whose visceral forms materialize in ruins, toys, and set squares and do not appear to differ from a dream rendered confused by recent awakening, of which Aragon speaks: "At the moment in which they form, these machines of practical life still have the sleepy awakening of dream, that mad glance, unsuited to the world that relates them then to a simple poetic image, to the slippery mirage from which they barely emerge, almost as if recovering from drunkenness. So only the engineer escapes his genius, resumes this hallucination and, so to speak, traces it, translates it, puts it within reach of the incredulous."[15] Aragon's idea of invention then singularly coincides with de Chirico's philosophical convictions held since the days of metaphysical art[16] and are certainly largely inspired by them:

Philosophical knowledge that deserves to be called such considers objects, ideas, not as empty abstractions or vague opinions but with their absolute content, in their special meaning, in their minimum extension, that is, in their concrete form. One sees that this is no different from the image, which is the way of philosophical knowledge, and that it is itself poetic knowledge. At this point philosophy and poetry are all one. The concrete form is the last moment of thought and the state of concrete thought is poetry. . . . Since it denies the real, philosophic thought establishes firstly a new relationship between its materials, the unreal, and invention, for example, immediately moves within the unreal. Then in turn it denies the unreal, evades it, and this double negation, far from arriving at affirmation of the real, rejects it, confuses it with the unreal, and it overcomes these two ideas by seizing a compromise where they are at the same time denied and affirmed, which reconciles and contains them: the surreal, which is one of the determining aspects of poetry.[17]

This is the kind of Dechirichian surrealism that existed between 1924 and 1926, still fluid and divining like that of the early movement itself and in perfect harmony with it. His working method, theoretically and poetically declared in *Hebdomeros*, is based on automatic "associations" from his metaphysical art clearly coinciding with surrealism:

Be methodical, do not waste your strength; when you have found a sign, turn it round and round, look at it from the front and from the side, take a three-quarter view and a foreshortened view; remove it and note what form the memory of its appearance takes in its place; observe from which angle it looks like a horse, and from which angle it looks like the molding of your ceiling; see when it suggests the aspect of a ladder or a plumed helmet; in which position it resembles Africa, which itself resembles a huge heart.[18]

With these premises it is evident that the themes represented in the paintings are substantially "surrealist inventions," some of which already present in the oneiric metaphysical imagination, but reinterpreted in the light of a suffused reality, familiar, dreamlike, which precisely in the apparent bourgeois familiarity of the interiors bears the implicit alarm, the detachment between the real thing and the product of the imagination.

20. The Break with Breton and Its Critical Consequences

De Chirico's relationship with surrealism, which we have so far considered in specific terms of painting and the reciprocal exchange of ideas, would play out in his more personal and conflicted relationship with Breton. This situation crystallized in 1924 when de Chirico was drawn into the new movement by Breton, who considered him its standard-bearer and prophetic precursor.[1] It should be noted that at the time Breton made a living selling paintings. A few years earlier, in November 1921, Breton had acquired a number of metaphysical works through the intermediation of Jean Paulhan at the extremely favorable price of 500 francs.[2] These were paintings that de Chirico had left behind in his Parisian studio that had been recovered by Giuseppe Ungaretti. Given the remarkably low price at which they were acquired and also considering that a good part of his work had been entrusted to Guillaume in 1915, these would have mostly been unfinished paintings (de Chirico himself recalled leaving behind several incomplete works).[3] Ungaretti had purposely left these with Paulhan[4] with the intention that they be offered to Breton and later recalled that he had personally arranged the negotiations.[5] To Breton's further, insistent requests to buy paintings from de Chirico's first metaphysical period in Paris—works that de Chirico no longer had—the painter responded by offering *The Revenant* of 1918 in a letter of 1922.[6] Somewhat curiously, de Chirico informed him that it would take one week for him to get the painting, saying that it was in storage with a dealer (Mario Broglio).[7] Even stranger is that he specified a price of 1000 francs for this "assez grand (quite large)" painting, after having requested 600 francs for a "petite toile" (small canvas: a portrait, therefore a less sought-after subject). It is possible that *The Revenant* was an unfinished painting (or rather, by de Chirico's choice, included areas of the canvas that were merely sketched out), and that a week was required in order to finish it and make substantial changes. Certain inconsistent elements within the work (seen by X-ray), including the blue veiled ceiling and the mannequin's body, seem to suggest this.[8] In parallel to Paul and Gala Éluard's visit to Rome in 1923,[9] at which time they bought several recent works by de Chirico,[10] Breton continued in his endeavor, asking the artist to look for other metaphysical works belonging to collectors. De Chirico replied in two let-

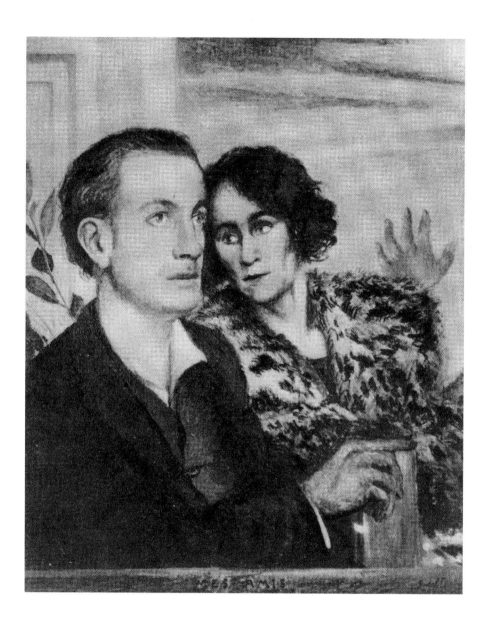

Portrait of Paul and Gala Éluard, early 1924,
work destroyed during the Second World War.

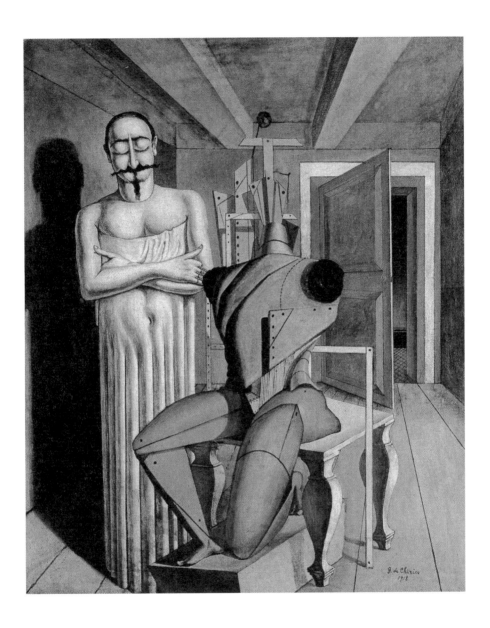

The Revenant, 1918–22,
Centre National d'Art et de Culture Georges Pompidou, Paris.

ters, dated November 18–21, 1923,[11] promising to send photographs, including one of *The Disquieting Muses*, the price of which was indicated as "2000 Lire (1900 *frc français*)."[12] A letter to Breton's wife, Simone Kahn, followed on February 23, 1924, in which he continued the negotiation because an accord had not yet been reached. Through his wife, Breton had offered 1200 francs[13] to Castelfranco, the owner of the painting, explicitly cited in the letter. The letter makes also clear that Breton was personally interested in buying one of de Chirico's recent paintings, *The Departure of the Adventurer*. The artist wonders if Breton was upset due to the long silence between communications. A further letter, dated March 10, 1924, which we shall consider in greater detail below, because, although addressed to the wife of Breton—with the vague term "madame"—the latter subsequently passed it off as having been sent to Éluard's wife, Gala,[14] in order to hide the fact that he had commissioned de Chirico to paint a replica of the *Muses*: a plot in which Éluard was an accomplice.

The letter also presented a distinctive situation: evidently annoyed by the attempt to lower the price of the work, Castelfranco now asked 3500 lire[15] for the *Muses* instead of the original price of 2000 lire, while Mario Broglio, owner of *The Sacred Fish*, requested 5000.[16] It was at this point that de Chirico, noting the difficulty of the negotiation, and feeling himself to be helpless in assisting with the negotiations, proposed to make a copy of the *Muses* and of the *Fish* for a price of 1000 lire each,[17] by way of a conciliatory gesture. He reassured him that the works would be identical, only better painted: "these replicas will have no defect other than that of being executed with more beautiful materials and a more skillful technique,"[18] in line with his current research. The letter sheds light on a disconcerting circumstance involving Breton: as de Chirico had addressed the letter to his wife with the generic term "madame," Breton later passed it off as having been sent instead to Éluard's wife, Gala, to hide the fact that it was he himself who had accepted de Chirico's offer to make a copy of the *Muses*. De Chirico's intention was not, therefore, to make mere copies, but to create new versions of the works. Breton did not reply for some time, leading de Chirico to inquire as to whether he was annoyed over "the matter of the *Disquieting Muses*" in a letter to Gala Éluard of June 4.[19] Ultimately, however, since de Chirico proceeded with the new version of the painting (his first exact copy of a metaphysical image, which was very skillfully executed, and was created with the permission of the owner of the original work, Castelfranco, whom de Chirico had correctly asked prior to executing the copy),[20] Breton accepted the compromise. Evidently, he then sold the copy as an older piece.

However, many details concerning the copy remain difficult to ascertain. Where and when did de Chirico execute it? In Rome, Florence, or Paris?

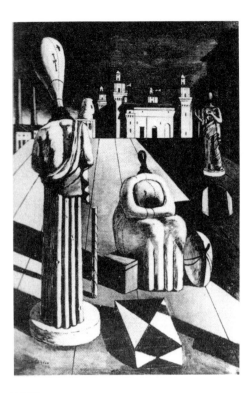

The Disquieting Muses, mid-1924,
private collection.

Breton, one of the principal witnesses, had no intention of providing accurate information: since one of the key arguments in his critical "destruction" of de Chirico was that the artist copied his own works, he could not very well reveal that he had solicited a copy—indeed, the first such work—from the artist. Breton's ambiguous and deceitful position was also revealed in a letter he sent to Bernard Poissonnier, in which he claimed to have personally seen de Chirico execute the work,[21] in which case he would have seen him do so in Paris, at the home of his host, René Berger. This seems unlikely, for many reasons. De Chirico stayed at his friend's house for less than a month.[22] Moreover, the main reason he was in Paris at that time was to work on the ballet *The Jar*, which was performed on November 19: presumably, therefore, between November 3 and 19 he would have been much occupied with his first major theatrical work, and involved in overseeing the completion of the stage scenery. Over the following ten days or so he frequented the surrealists, was photographed with the group by Man Ray (whose images would appear on the cover of the movement's journal), and attended its evening get-togethers. He also saw Jacques Doucet and

visited the Louvre on several occasions. Indeed, his enthusiastic engagement with that cultural world would inspire him to write the article "Vale Lutetia."[23] In the meantime, prior to painting a new version of the *Muses* during his visit to Paris, de Chirico would have first had to ask permission of Castelfranco, receive it, and then put together a studio, with canvas, paints, and easel in his friend's home. Moreover, this would have had to occur without Berger's knowing of it since in recollection of the paintings received from de Chirico, he makes no mention of his having painted a version of *The Disquieting Muses* in his home—something that would have constituted an episode of extraordinary interest. In any case, it would be truly far-fetched to suggest that the artist would have had time to execute a painting requiring such commitment in the time available to him while in Paris. Breton did not witness de Chirico creating *The Disquieting Muses* either in Paris or in Italy, but the fact that Breton personally commissioned it led him to invent this apocryphal version of events.

Another witness who might have proved more reliable in relation to this matter was Castelfranco, who instead appeared somewhat vague, at least in the testimony he provided in 1939, when he decided to sell the *Muses* through the Milanese gallery owner Gino Ghiringhelli as a consequence of the problems he was facing following the passage of the racial laws.[24] During the sale, the problem of the 1924 version emerged, having been published as the original work on a number of occasions, first and foremost in surrealist exhibitions and publications. Accordingly, this "scam" was not created by de Chirico, but by Breton who, while being aware of the date of his own version, instead claimed it dated from the metaphysical years. Following a number of tense exchanges, Ghiringhelli wrote to Castelfranco on March 18, 1939, summarizing the matter: "You then explained the matter clearly to me, i.e. that DE CHIRICO, with your permission, had executed a copy of the original work in your possession for the poet Éluard in Paris in 1924. Indeed, you assured me that you would look for letters that could verify the above account."[25] In this letter we have confirmation that de Chirico asked, in all correctness, the owner's consent before making the copy; however, two discrepancies emerge: that the copy was made in Paris, and that it was commissioned by Éluard instead of Breton. The latter mistake must be ascribed exclusively to Ghiringhelli, who evidently conflated Castelfranco's extensive and detailed stories (which would certainly have included the significant episode of Éluard's visit to Rome and Florence in 1923–24, when he bought several works from him). Castelfranco later recounted the story with greater accuracy in a 1968 interview with Luciano Doddoli: "In 1924 de Chirico held an exhibition in Paris and Breton was enthusiastic about the artist and his painting. He asked me if I would allow a copy to be made and I stupidly said yes. In fact, I seem to remember that Breton wrote me a letter to thank me."[26] The client was thus correctly identified

as Breton, and de Chirico's request for permission was reiterated, although another of Castelfranco's recollections was certainly incorrect: de Chirico did not hold an exhibition in Paris in 1924; Castelfranco was evidently thinking of a show of May 1925, organized by Rosenberg. However, Castelfranco at least confirms that the work was not executed in Florence, in the presence of the original, for this point would surely not have escaped his memory.[27] Given the consensus regarding the date of the copy's execution (1924), it can only have occurred between March (when de Chirico first proposed the idea) and October, prior to his departure for Paris. On this basis, it could not have been Éluard who commissioned it, since he left for the Far East on March 24, 1924, returning to France on September 28, with Gala and Max Ernst following a few months later. Forgetting, or perhaps underestimating the fact that someone could reconstruct this autobiographical detail, Éluard himself informed Soby that the version was "promptly" completed in 1924, immediately after de Chirico's letter proposing the copy.[28] But at that time Éluard was not in Europe, and Gala could not have commissioned the painting in the absence of her husband: being completely penniless,[29] she and Ernst hastened to sell Éluard's collection of paintings[30] in order to obtain the funds that would allow them to follow him to the East as soon as possible—not the most opportune moment to make a purchase. Given that de Chirico was in Vichy in August 1924 (as documented by a postcard sent to Trombadori on August 23), he may have consigned the new version of the *Muses* to Breton on that occasion (if not, then the following November). Since Vichy is approximately 350 km from Paris, the round trip could have been completed in a day or two by train. It is less probable that the copy was made during the period between December 1924 and de Chirico's next visit to Paris in May 1925: due to the exhibition at Léonce Rosenberg's, there were already "ruptures on the horizon" (see note 32) that would have made any such transaction unlikely.

As we have seen, the relationship between de Chirico and Breton was consolidated during the artist's visit to Paris at the end of 1924, but de Chirico's links with his new merchant, Rosenberg—who would almost immediately organize an exhibition of his works in Paris in May 1925—led Breton to perceive that their exclusive partnership and "complicity"[31] with regard to the production of replicas was destined to decline.[32] (Breton had probably introduced them to one another, since de Chirico had asked Breton to speak to Rosenberg about him in a letter of December 5, 1921.) The first signs of a worsening of relations appeared in Max Morise's review of the show at Rosenberg's gallery, published in *La Révolution Surréaliste*.[33] Cold, rather than explicitly negative, his comments constituted a warning of sorts. Morise's attitude was undoubtedly due to the fact that, in addition to a selection of more recent works, de Chirico had chosen to exhibit several meta-

Galerie Surréaliste in ca. 1927 with *The Disquieting Muses* of 1924 in the window, photograph by Man Ray, Musée national d'art moderne, Centre de création industrielle, Paris.

physical paintings owned by Castelfranco, one of which was *The Disquieting Muses*. The appearance of this painting in Paris must have alarmed Breton, who had perhaps already sold the 1924 version as if from the metaphysical period.[34] With de Chirico's definitive move to the French capital in November 1925 and his signing of two exclusive contracts, one with Rosenberg and a renewal of the agreement with his first dealer Paul Guillaume (signed on January 9, 1926), the relationship irrevocably broke down: Breton was clearly not going to be able to corner the market on de Chirico's paintings. Irritated by this implicit blackmail and, not one to sit by peacefully, de Chirico himself perhaps launched the first offensives. Certainly, he would have contested the decision to give several of his works alternative titles (such as, *J'irai. . . le chien de verre* [I'll go . . . the Glass Dog] and others)[35] when he saw them exhibited at Galerie Pierre from November 14 to 25, 1925, at the exhibition *La Peinture Surréaliste* organized by Breton. It is also possible that he had detected a few works of his that had been completed by someone else (from the group of "unfinished" paintings handed over to Breton), and that he had voiced his concerns about this (as he would later explicitly do). In 1925, the well-known collector Jacques Doucet bought a fake or completely repainted painting titled *Metaphysical Composition* (now in The Menil Collection, Houston). Most likely, this had been sold to him by Breton, who curated his collection and had previously sold him *The Revenant* in 1922.[36] De Chirico, who knew Doucet through Breton,[37] would not have let this go

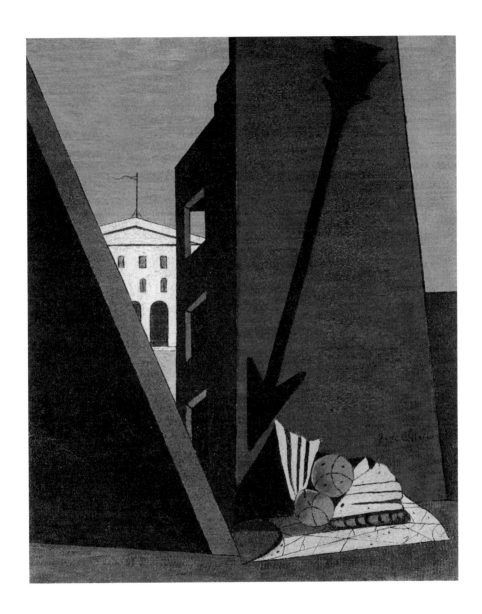

Metaphysical Composition,
private collection.

Fake painting; possibly left unfinished by de Chirico and later radically altered, declared fake by de Chirico.

Orestes and Electra, defaced reproduction,
in *La Révolution Surréaliste*, II, no. 6, March 1926, p. 32.

unnoticed and neither the collector nor Breton would have taken it well. In March 1926 a vandalized image of de Chirico's *Orestes and Electra*, a painting of 1923, was reproduced in *La Révolution Surréaliste*,[38] and the attacks continued in the following issue with Breton's vitriolic text "Le Surréalisme et la Peinture" (he would even go on to denounce the American collector Albert C. Barnes—a friend of de Chirico's and Guillaume's best customer—simply for being a patron of the artist). De Chirico was denounced as a "forger of his own work [who] has put into circulation a large number of characteristic fakes, among which are several servile copies, which for the most part are backdated."[39] Breton naturally avoided mentioning the fact that it was he who had requested these "servile copies" and introduced them onto the market. And we know that he would not hesitate afterward to have other forged paintings executed out of purely venal intentions, as well as to discredit the artist.[40] The purpose of all this (in addition to exacting revenge on de Chirico) was to set himself up as the arbiter of metaphysical painting in relation to questions of authenticity, over and above the artist himself.

Parallel to this issue, we should also consider the existence of an unspecified number of unfinished works[41] from de Chirico's Parisian studio. These works, collected by Ungaretti after the war, had been left with their mutual friend Paulhan with the purpose of being sold. What remained in

his studio were essentially personal effects, books, and manuscripts (the Paulhan manuscripts, together with those acquired by Éluard and later by Picasso, constitute one of the most important sources of information concerning the artist's years in France), and a number of possibly unfinished paintings, which he had left behind in the hope that he would return to Paris following the war. But, as we know, the conflict lasted far longer than predicted, and by 1919 de Chirico no longer considered returning to Paris a possibility,[42] resolving instead to sell what remained of his works. The negligible transaction of 500 francs revealed in the aforementioned letter to Breton of 1921 related to this material: works left in an unfinished state, a record of the artist's creative process. In Paris at that time, the practice of revising or reworking unfinished or roughly executed works was not uncommon at even the highest commercial levels. A passage from the memoirs of Daniel Wildenstein concerning Degas's pastel works (and the paintings of other artists), which were adulterated in order to make them appear more "pleasant" and polished, is extremely enlightening in this regard.[43] Rosenberg himself requested that de Chirico refine his paintings, which, for expressive reasons, he frequently left in a somewhat raw state, since his customers preferred more "finished" works.[44] However wrong it may have been, the practice of "completing" works was not unusual and often occurred within markets that escaped the watchful eye of an artist. For example, this was the case of Degas's pastels that were greatly desired by American buyers. Today, in fact, there are no longer any traces of de Chirico's sketchier and less refined imagery.[45] His absence from Paris, considered to be permanent at the time, made such an approach possible and certainly profitable.[46] Upon his return to the city these, and other, exploitations evidently came to light and the irascible artist denounced as fake works that had an authentic provenance but which had clearly been tampered with to varying degrees. Accordingly, a close analysis of certain paintings could lead to new evaluations and reveal the legitimacy of the artist's assertions. At the time, an aggressive, cynical propaganda campaign (in which Breton played no small part) sought to present these as hysterical and irresponsible outbursts on the artist's behalf. Indeed, by 1934 de Chirico himself would define the attitude of the surrealists as follows:

> The surrealists are among the most menacing enemies and are those who employ the most perfidious and dishonest means against me. This hostility originated with the two leaders: Breton and Éluard who, right after the war, managed to accumulate very inexpensively and at times even for nothing, a certain number of paintings which I had painted before the war. With these

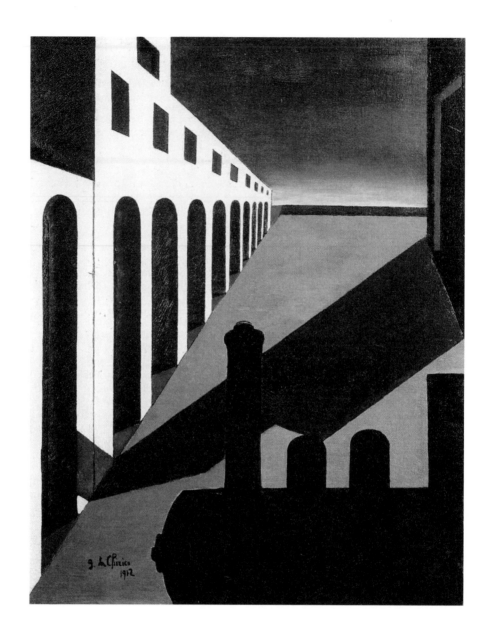

The Anguishing Morning, dated "1912".

Possibly left unfinished by de Chirico and later repainted, it appeared for the first time in December 1921.

paintings and taking advantage of the fact that I was in Italy, they hoped to stage a coup like the kind that was staged against Rousseau, Le Douanier. They began talking about me in their review, describing me as some kind of hallucinated person who painted a number of paintings that only they owned . . . etc. etc. Then, in 1925 when I returned to Paris and started selling my new paintings to art dealers and exhibiting my work and getting people to talk about me, they became furious because they understood that I was going to spoil their business which, by the way, is exactly what happened. Since then, they have not stopped boycotting me and using the worst and most dishonest methods to denigrate my recent work.[47]

In light of the above, and of the stringent chronology of the facts, de Chirico's words would appear to contain a great deal of truth.

Within the Parisian art world, similar to a village, such bitter hostilities did not mean that the two rivals never encountered each other. We have an account of at least two such meetings following the breakdown of their friendship in 1926, and there would have been others, no less acrimonious than those described. The first was recalled by Max Ernst,[48] who on an unspecified date (sometime around 1932) visited de Chirico's studio with Breton. With Olympic serenity, de Chirico showed them both a series of Venetian landscapes. Breton flew into a rage and "started to insult de Chirico in a horrible manner. De Chirico ignored him." Ernst must have been mistaken in his reference to views of Venice, for de Chirico only began these much later; it would therefore seem to have been a casual reference to another series of paintings executed *all'antica* by de Chirico, such as that depicting Italian landscapes (1931–33) with views of locations such as Genoa, Milan, Turin, and Lake Como, or possibly that "Renoiresque" collection of nudes and still lifes that so impressed Magritte. It was to be expected that sparks would fly between the pair, but it is remarkable that although escorted by Ernst, Breton was still fatally drawn to de Chirico and dared to visit him; equally surprising is the fact that de Chirico agreed to receive him. Perhaps Ernst had benevolently attempted to bring about a reconciliation, although by this point it was no longer possible.

The second episode, recalled by Gualtieri di San Lazzaro,[49] can be dated to October 1935, and recounts a violent clash during which de Chirico exclaimed that they would soon settle their scores; Breton angrily replied that they would do so immediately, punching de Chirico to the ground and repeating this outrageous act five or six times. Gualtieri di San Lazzaro was a friend and supporter of the artist and was a guest in his Roman house during the difficult years of the war. However, in 1944 he became de Chirico's sworn

enemy, having shown him a photograph of a painting he had bought, which the artist declared to be a clumsy counterfeit;[50] accordingly, his account of de Chirico being repeatedly knocked to the ground by a proud Breton is not entirely reliable, since it may have been colored by feelings of resentment. Of course, this does not alter the fact that his recollection refers to a real quarrel between the two, even if it may not have manifested in the terms described.

This complex sequence of events that I have described at length here reveals a rather miserable panorama of vested interests, which are a far cry from unbiased art criticism. Breton not only appreciated and considered buying more recent paintings by de Chirico, including post-metaphysical works such as *The Departure of the Adventurer* (in a letter of August 23, 1925, mention is made of a *Still Life* that needed to be paid for, perhaps the same piece for which de Chirico had requested payment on September 9 the previous year), as well as also publishing them in his magazine. His friend Éluard also bought several of those later works, and even considered purchasing the large piece *Duels to the Death*, exhibited at the Venice Biennale of 1924. Breton's rather squalid stinginess is also striking, given his refusal to buy works that he considered to be—and which are—absolute masterpieces at anything other than very low prices (it is for this reason that we have reported the current values of the figures involved), so as to make his dealings in Paris as profitable as possible, taking advantage of the fact that de Chirico was far away in Italy and exploiting his economic difficulties. Breton's greed and impropriety is also remarkable: he did not hesitate to commission a new version of *The Disquieting Muses*, yet subsequently denied his role in the affair and attributed it to his accomplice Éluard, in order to be in a position to discredit his mortal enemy.[51] Equally striking is the unjustified acrimony of Éluard—whom de Chirico had never wronged—in going along with Breton's plan. The final affront to de Chirico occurred with the publication of the *Anthologie de l'humour noir* in 1938, in which de Chirico was slyly ousted by Breton from the altar where he had placed him, claiming that "all of modern mythology, which is still in development, finds its origins in two oeuvres, the spirit of which is almost undiscernible, of Alberto Savinio and his brother Giorgio de Chirico." De Chirico's status was thereby diminished—the artist being described as the "brother of" Savinio—and the invention of metaphysical art was no longer attributed solely to him.[52]

All this brings to mind the idea of rivalry between artists, of a hatred to equal that which has existed throughout the history of art, such as between Bernini and Borromini, or Michelangelo and Raphael. However, Breton's resentment, and the role of the intellectual that he created for himself in

France and America, led to drastic and paradoxical consequences that eclipsed those of past rivalries. In particular, the influence he had on American intellectuals was enormous, especially during his stay in the United States in the war years, and not only in relation to the painting of his fellow surrealist emigrants, who laid the foundations of abstract expressionism. Breton had, indeed, a great organizational and intellectual capacity. James Thrall Soby's book on de Chirico, first published by the Museum of Modern Art in New York in 1941[53] (and in an expanded edition in 1955) represents an exceptional example of how this influence manifested itself. We will focus here on the 1955 edition, which contains a preface and a very detailed list of acknowledgments that reveal just how deeply Breton's criminal and defamatory project had taken root.

The text is undoubtedly a fundamental volume for the reconstruction of de Chirico's art between 1910 and 1917 (this being the period investigated by Soby, in a manner entirely consistent with Breton's assertion that de Chirico was intellectually dead after that year). The book is full of previously unpublished documentation and provides a reliable reconstruction of the artist's story, albeit in a rather simplistic way: its objective soundness made it the basis of de Chirico studies for decades. Yet it contained a paradox that was unique in the history of art: in the very long and extremely detailed list of thanks appearing in the volume, only one name was missing: that of Giorgio de Chirico himself. Never before or since has a monograph been written about a living artist who was not consulted by its author.[54] It appears that de Chirico only learned about the 1941 publication in 1947 (this first edition contained far less documentation than the following amplified version of 1955). He subsequently published an understandably damning article in *La Fiera Letteraria*,[55] having correctly intuited that the book had been written in the interest of destroying his post-1917 work. De Chirico was disdainful of Soby, observing that he was not even able to write his name correctly (using "Chirico" instead of de Chirico). Soby took note of this, yet still made no contact with the artist when working on the 1955 edition of his text.[56] The list of names he included in his acknowledgments is extremely significant: all the Italian critics of note appear, and even Savinio, de Chirico's brother, as well as a series of acquaintances, collectors, and both former and current art dealers. However, the central dedication was to Breton, who had "encouraged the preparation of *The Early Chirico* and also the present, completely revised monograph." In light of the foregoing, there is no doubt how Breton had indeed encouraged the monograph and that he managed to influence Soby to the point that the latter did not even meet with or contact the artist. Additionally, there was a procession of surreal-

ists, among whom Éluard stands out: Breton's accomplice in the business of selling paintings, one of the few of the movement who remained loyal to his boss and who participated in the shady exchange of letters concerning *The Disquieting Muses*—an episode to which Soby refers, repeating the doctored version of events. In a letter to Soby of March 27, 1951, Éluard stated that de Chirico had made a copy of *The Disquieting Muses* for him in 1924: "in 1924 I asked de Chirico to copy it, since its owner, signor Castelfranco, did not want to sell it to me. De Chirico copied it at the same size and from a photograph. The manner of painting is completely different: in place of the flat colors there are very light brushstrokes, like iridescent feathers."[57] As noted, Éluard supported the claim that de Chirico's letter had been written to his own wife, Gala. This statement—made around thirty years after the fact—is not credible as it was deliberately intended to hide the fact that it was Breton himself who had commissioned the copy. Indeed, the issue regarding de Chirico's replicas formed the basis of Breton's attacks against the artist. Moreover, Breton consistently lied about de Chirico, as we have seen, particularly in regard to the matter of the *Muses*.[58] Yet he was also sufficiently clever to prevent any of the dissident surrealists or autonomous intellectuals who supported de Chirico and who continued to admire him and play an active role in his life, to come into contact with Soby: figures such as Cocteau, who wrote one of the earliest—and very beautiful—monographs on the artist, Georges Ribemont-Dessaignes, Max Ernst, and Marcel Duchamp (all of whom were, moreover, in New York during the war years, when the first version of the book was being prepared).[59]

Ultimately, despite his undoubted scholarly abilities, poor Soby was in this instance a puppet in Breton's sly hands, and de Chirico was well aware of it:

> The publication is clearly tendentious. . . . The author is a certain James Thrall Soby. In a long text where, confusedly and stupidly, there is talk of many things that have nothing to do with metaphysical painting, rather than praise the pictures reproduced, Soby subtly attempts to discredit that other painterly style of mine which is now in full development and which follows the renaissance of European art. First of all, Mr Soby should know that my name is Giorgio de Chirico and not Chirico, or Sciricò, as certain idiots from beyond the Alps write and pronounce it, and which Soby, with his American Modernist mentality, mimics in provincial fashion. It should also be known that his noble attempts to hinder me in my arduous effort of renewal are destined to fail.[60]

In due course we will consider to what extent these words are an important tool for understanding de Chirico's painting of the time. It is evident that

they underline Soby's "mirroring" of Breton's positions, without the need for de Chirico to name him explicitly.

By bringing to light fundamental material composed of de Chirico's manuscripts dating from his first Parisian period (owned in part by Paulhan and Éluard, who later passed his to Picasso), the 1955 edition of Soby's book provided a solid overview. The published material contained a significant amount of information, albeit somewhat disorganized, and a thorough investigation into the origins of de Chirico's iconography that presented a careful periodization of the complex development of the artist's metaphysical period. The final chapters concerning de Chirico's postwar evolution are based on Breton's reflections and are full of banalities not only with regard to the European Return to Order (which was at that time undervalued by avant-garde criticism) but above all regarding de Chirico himself, whose return to "classical" painting is attributed predominantly to his relationship with an obscure art conservator named Nicholas Lochoff [sic],[61] thereby reducing the artist's deep meditations in favor of contingent factors and acquaintances of minor significance, as if these were not the fruit, as they were for Picasso and half of Europe, of a profound avant-garde reflection.

The influence exerted by a detailed and thorough English-language publication, endowed with that aura of prestige afforded by New York's Museum of Modern Art (Soby became director of its Department of Painting and Sculpture in 1943), meant that postwar analyses of de Chirico's work were led down a biased and paradoxical path—certainly in terms of international scholarship, and partially also that of Italian art history.

In Italy, the critics were divided between a somewhat pompous and outdated conservative contingent that showed appreciation for de Chirico, and a more avant-garde group that was certainly more interesting and up to date, but which accepted Breton's arguments—and those of Soby. For the rest of his life, de Chirico's contentious personality, by that point hostile to anything declaredly modernist—as if it incarnated the faction that was hostile to him—practically impeded any reflection by dragging it into rancorous polemics. I remember the 1978 celebrations organized in Rome to mark the artist's ninetieth birthday, attended by de Chirico himself and the mayor of Rome, and how the well-known art critic Giulio Carlo Argan—the most significant exponent of internationalism in the field of art criticism—presented de Chirico, with subtle perfidiousness, as "the brother of the great painter Alberto Savinio"; there followed a banal and predictable introduction by another "orthodox" spokesman, Nello Ponente, and an analysis that fortunately contained novel points of interest delivered by Maurizio Calvesi, an avant-garde historian clearly more alert and inquiring than many

others. Over everything towered the Olympian indifference of Giorgio de Chirico—a monumental presence, in every sense, even physical. However, during the final years of the 1970s a certain critical curiosity indeed began to reawaken, especially, but not only, in Italy, after the drugged torpor induced by Breton and his "disciple" Soby. De Chirico passed away the year he turned ninety; Soby died in 1979 and Breton had passed away in 1966. Once the protagonists of the fiercest struggle in the history of twentieth-century art were gone, reflections could flow more freely, although assassins lingered in the halls of museums and on the pages of increasingly inconsistent books.

21. Mediterranean Classicism

After the break with Breton in 1926, the true, distinctive *topos* of de Chirico's painting became the museum. A polemical institution, in the eyes of the surrealists, with whom he was by that point in bitter and open dispute, the museum represented an almost heraldic metaphor of his origins and culture, opposite to the anti-traditional and nonconformist enthusiasms of his former colleagues. .

The crucial point, however, consists in the fact that antiquity, Greek classicism, the "Roman arcade," and the classical statue had all constituted central and essential components of de Chirico's metaphysical vocabulary. Directed inward toward the psyche, de Chirico's innovation did not, unlike that of many of his avant-garde companions, necessitate abolishing links with the classicist past in order to elaborate a completely innovative figurative style.

In claiming an osmotic relationship with antiquity and myth, de Chirico therefore did nothing more than assert those very principles that had been the basis of his artistic vision since the metaphysical period. This is clearly illustrated by his interest in one of the champions of the dreamlike-mythical implications of archaeological investigation, Salomon Reinach, something that scholars used to trace back to the 1920s and the time of his first wife, Raissa,[1] who was initially a ballerina and actress, but who studied archaeology after moving to Paris with de Chirico in 1925. In fact, a very significant passage (which has already been mentioned) in a letter addressed to his dealer Paul Guillaume on June 3, 1915[2]—that is, in the midst of his metaphysical research—indicates that his consideration of Reinach's texts on ancient history and religions, and his ancient iconographic compendiums, had much earlier roots and was integral to the elaboration of the metaphysical aesthetic. He evidently shared this interest with Guillaume and most certainly also with Apollinaire.

It was in the face of this incomprehensible ignorance on the part of the surrealists, and their inability to penetrate the true sense of de Chirico's painting—even the metaphysical work that they themselves exalted—that de Chirico developed his calculated emphasis on an updated archaeological

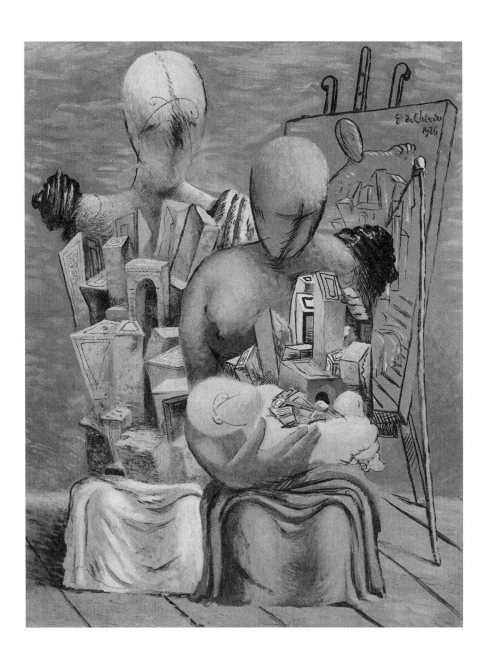

The Painter's Family, 1926,
Tate, London.

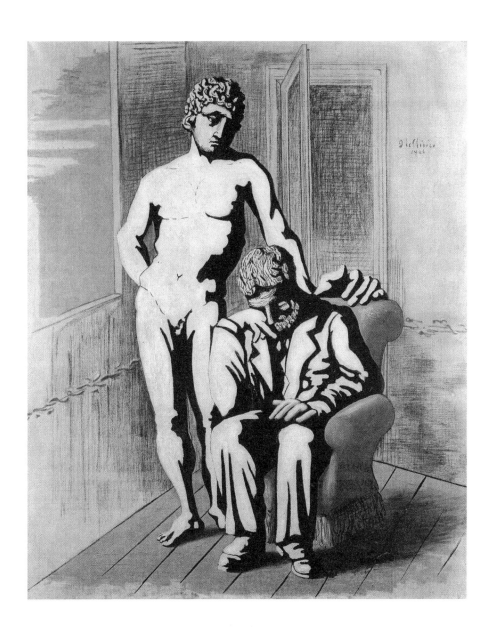

The Prodigal Child, 1926,
private collection.

antiquity, something that was in perfect harmony with the classicist spirit pervading Europe in the 1920s.[3] By contrast, this was something Jean Cocteau perfectly understood, noting the links among metaphysical painting, the Italian Renaissance, and Greek antiquity.[4]

De Chirico's conflict with Breton did not affect his relationship with the avant-garde circles of Paris; indeed, it may even have strengthened them initially. In particular, he maintained cordial relations with those surrealists who gradually abandoned Breton (whom the latter charitably defined as "cadavers," as he had also defined de Chirico).[5] In 1927, Roger Vitrac would write a monograph on de Chirico, and having carried out an initial Bretonian hatchet job on the artist, Georges Ribemont-Dessaignes would later become his friend, writing of his work in a complimentary manner. Good relations also existed and continued for a long time with figures such as Robert Desnos, Jacques Baron, Georges Bataille, Antonin Artaud, Marcel Duchamp, Francis Picabia, and Max Ernst. Other relationships were consolidated, such as those with his dealers Rosenberg and Guillaume, with Jean Paulhan, and, especially, with Jean Cocteau. The latter wrote *Le Mystère laïc* [The Lay Mystery], an "indirect study" on de Chirico that constitutes perhaps the most acute examination of his work from both the metaphysical period and the 1920s. This essay, original in terms of both form and content, clearly situates de Chirico on the Parisian stage as the alter ego of Picasso: the two solitary giants of the century, who constituted opposing yet complementary forces. Considering the close and enduring friendship that existed between Cocteau and Picasso, we can suppose that the latter's consideration of de Chirico was analogous. Cocteau's emphasis on this binomialism is pervasive, insistent, and cardinal, even genealogical: "Mrs. de Chirico is Genoese, as is Mrs. Picasso";[6] "Too many legitimate children have been born of a bourgeois marriage between Picasso and de Chirico";[7] "solitude continued even after the world was born. Picasso preserves it by trying to be full. De Chirico by trying to be empty. These two obstacles prevent the public from entering";[8] "Picasso and de Chirico paralyze the public, which in Picasso's still lifes reads as: *Please do not enter*, and in de Chirico's streets: *Road closed*";[9] "We always talk about religious art. Art *is* religious. Picasso's furious engagement with painting raises up authentic crucifixions. Terrible works made with nails, sheets, torn fragments, wood, blood. De Chirico never becomes angry. The calmness of his work is that of those archers in the paintings of the primitives who witness torture and look out of the picture";[10] "Picasso tricks the spirit. By which I mean that in order to catch our birds, he has invented a worthy grape. De Chirico uses *trompe-l'oeil* in the same way that a criminal reassures his victim: 'Don't be afraid. Look, here is a bell, the window is a real window, the door is open, all you have to do is call . . .'";[11] "One day our era

will be called the age of mystery. We paint mystery the way they used to paint the circus. De Chirico is a painter of mystery. Picasso is a mysterious painter. . . . Picasso's work appears dressed up and disguised, and as such is intriguing and mysterious. De Chirico is instead a painter of mysteries. He substitutes the representation of the miracles with which the primitives manage to amaze us, with miracles that come from him alone."[12]

As can be seen, in Cocteau's vision of contemporary art Picasso and de Chirico stand out as the two protagonists of modernity. Unlike Vitrac, who spoke mainly of de Chirico's metaphysical work in his essay of 1927, while only briefly acknowledging the quality of his subsequent output, Cocteau focused instead on almost all of de Chirico's recent themes for which he provided lucid interpretations, to an even greater extent than on his metaphysical themes. He also made a jibe at Breton's expense, comparing him to Creon, while de Chirico's work is Antigone:

> When I tried to rejuvenate Greece, trying to make the old actress work, stretching her skin (with my work on *Antigone*), I was unaware that de Chirico had seated, against a white backdrop close to the sea, large figures with egg-shaped heads and open chests revealing monumental hearts, likewise ensnared by the young Antigone. We later encountered these figures at Rosenberg's. Of those trophies and those glorious scaffoldings, I would have liked, at least, to pay tribute to the heroic heart of Antigone. Creon and grateful cities cover her with spit.[13]

Although de Chirico decided to contest Cocteau's enlightening words after the Second World War,[14] insomuch as he interpreted his entire career in light of his own prevailing ideological updated positions, it is true that Cocteau's essay closely reflected de Chirico's ideas at that precise moment in the 1920s. Many of his observations were evidently derived from direct confidences the artist shared with Cocteau;[15] but, above all, de Chirico himself longed at that time for a modern and avant-garde art, from a technical as well as a stylistic and pictorial point of view.

In December 1927—the month Cocteau dated and signed the essay about his painter friend *Le Mystère laïc*—de Chirico gave an interview in which this desire was evident: "There is no modern art movement in Italy. . . . Modern Italian painting does not exist. There is Modigliani and myself; but we are practically French. . . . The Italians . . . are hostile to any modern movement. When you show them a canvas reflecting new tendencies they laugh. . . . As a painter and modern spirit, I feel more harmony in France than in Italy. . . . I love the most advanced and newest things."[16] If these words leave us in no doubt as to the modern qualities de Chirico attempted and even attributed to

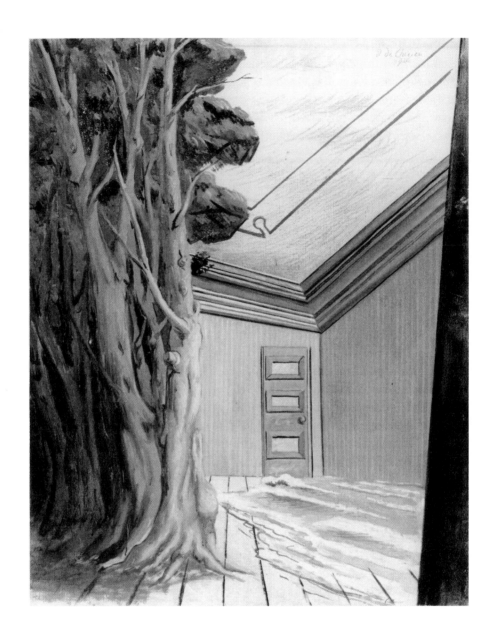

Woodland Interior (Equinox), 1926,
private collection.

his paintings, his technique favored a swift execution that denied any return to classical painting of the kind he had experimented with during his preceding Roman period, being characterized instead by a painterly and chromatic anti-naturalism—a summary technique based on the use of flat, unelaborated colors that was closely related to much contemporary French painting. As noted, this was an economy of execution so audacious and raw as to lead his dealer, Rosenberg, to request that he finish his paintings more completely, refining them with the care demanded by collectors during the late 1920s, as we have seen. In July 1928 he wrote to him asking to paint new works on "ancient" themes, and to "finish them as much as possible, since very refined paintings are the order of the day,"[17] thereby pushing him to adopt a less impulsive and more considered style than that which had characterized the paintings of 1925–28. However, his *Piccolo trattato di tecnica pittorica* [Brief Treatise on Painting Technique] of 1928, far from being a cornerstone of the return to a painterly style inspired by the ancients, was a reflection on the artist's specific methods that did not condemn, but rather praised, the search for a modern approach, considering his past experimentation "all'antica" (of the *Valori Plastici* period of 1919–22) to be a closed and archived chapter:

> Every era has its own spirit, its own genre, its own special atmosphere in which it lives and breathes, I would almost say its own artistic morality. To sigh eternally before the perfections of the ancients does not seem to me to be something worthy of a modern painter. I too had my *ancient period* and I am proud of it; nothing is lost in passing under those Caudine Forks, if only for the subsequently greater freedom that it gives one. But I have never forgotten that our era also has its own perfections, its own *tours de force*, that are in no way inferior to those of the Ancients.[18]

Cocteau fully grasped the fundamental continuity of de Chirico's art, which unfolded seamlessly from his metaphysical imagery to that of the 1920s. From the tragic sense of disorientation to the permanence of the link with Hellenic classicism: "Judging the *Return to Order* from an aesthetic point of view is to confuse an instrument with an artistic object. I am not at all interested in determining whether de Chirico paints better or worse than previously, whether he repeats himself or invents anew. These would be aesthetic considerations, while de Chirico interests me from an ethical point of view. He testifies that there is a truth of the soul that excludes every picturesque element, together with the hinterland in which it finds nourishment";[19] "Compared with other pictures, de Chirico's paintings highlight the immobility of statues, the solemn calm of incidents that have just happened, and show the gestures, the grimaces of a speed that has been surprised by immobility without having had the time to pose. The horror of an accident that

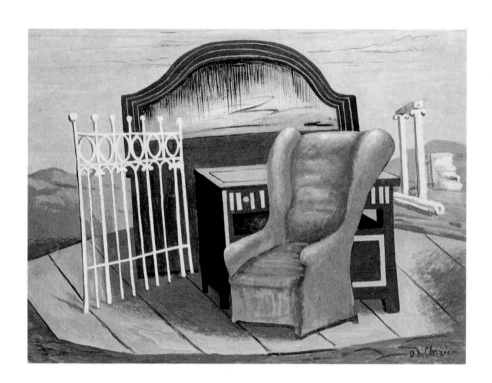

Furniture in a Valley, 1927,
private collection.

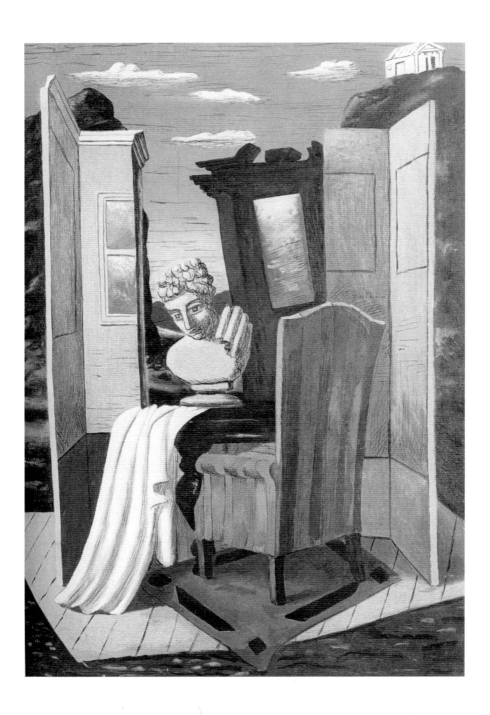

Furniture in a Valley, 1927,
private collection.

Pericles's Night, 1926,
Galleria Internazionale d'Arte Moderna—Ca' Pesaro (on loan from the Carraro Collection), Venice.

we encounter on the street stems from the fact that it is immobile speed, a cry turned to silence (and not silence after a cry)";[20] "The imperturbable charm of intermingled civilizations. A Buddha with a Greek torso and curls. The figures of Antinous, Roman faces that are able to keep their eyes wide open in death, like Egyptian figures and divers in the sea. Sleep, death: frontiers. After all, great beauty always hesitates between life and death. Effigies and sleeping figures fascinate us in museums even when fatigue comes to weary us. At times, the union of Italian perspective and Greek miracle has spoken to me in de Chirico's work even when nothing spoke to me anymore";[21] "Born in Greece, de Chirico no longer needs to paint Pegasus. A horse by the sea acquires mythical significance by means of its color, its eyes, its mouth."[22]

Between 1926 and 1927 de Chirico created several groups of works that constituted true thematic cycles, thus adding to the two key subjects of 1924–25 (interiors with objects, and mannequins-archaeologists), that were renewed and interpreted in accordance with a simplified and syncopated painterly style that was condensed and deliberately "modern." Marcel Duchamp also perceived that the continuity of metaphysical concerns did not stop in 1917, as Breton argued, but in 1926, at the time of de Chirico's dispute with surrealism and, paradoxically, with his transition to a more "modern" or even "unruly" approach to painting: "Around 1926 de Chirico abandoned his 'metaphysical' conception and dedicated himself to a less disciplined pictorial ductus. His admirers may not have followed him, considering the second de Chirico to have lost the flame of the first. But posterity might have something to say."[23] The subtle and intelligent Duchamp never accepted Breton's position, and consistently showed an appreciation for de Chirico's painting: in 1966 he exclaimed once more, scandalized, that "Getting back to Breton, the way they condemned de Chirico after 1919 was so artificial that it irritated me deeply."[24]

The *Furniture in a Valley* series—the iconography of which derived from anguished childhood memories of the frequent earthquakes in Athens, when furniture was brought out onto the streets[25]—was often described by the artist in his theoretical writings in which he identified his sources of inspiration in more recent everyday experiences: items of furniture displaced in the process of moving house create a sense of disorientation that invests them "with a strange solitude," forming exotic islands surrounded by hostile oceans and transforming them into characters that reveal a peculiar kind of shared intimacy; de Chirico also saw them "on a Greek plain, deserted and covered with ruins."[26]

The Metaphysical Interiors of 1924–25 soon became transformed into rooms inhabited by buildings, classical ruins, and natural elements, creating disorienting imagery that brought into play one of the crucial themes of those years: the notion of a "Mediterranean" art.

The House with Green Shutters, 1926,
private collection.

Temple and Forest in a Room, 1928,
private collection.

Antique Nudes, 1926,
Pushkin State Museum of Fine Arts, Moscow.

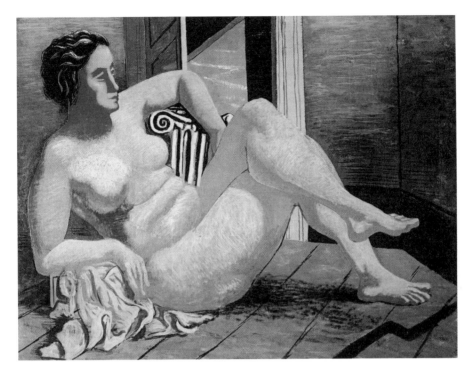

The Spirit of Domination, 1927,
private collection.

I have depicted on a floor, under a low ceiling, Greek temples surrounded by rocks and fountains, with roads on which the tracks left by wagons remain visible. It is very important that the ceiling of the room be low, for the metaphysical atmosphere of Greek art is largely due to this sense of correct limits that can be found in the lines of the landscape and even in the air: in Greece, the sky does not give the same impression of infinity as it does in other countries. One sometimes imagines that one could touch it with one's hand; this explains the familiarity between gods and humans in Greek mythology. . . . This intrusion of nature into houses, which I have attempted to suggest, recalls that alliance concluded between gods and men that permeates all Greek art.[27]

As we can see, the insistence on Greece, which remained a consistent nucleus of the artist's culture and youthful experiences, reemerged strongly (if it had ever diminished), indicating a precise path to the debate on *mediterraneità* in art that was then underway in Europe, and which de Chirico helped bring into focus.[28]

The great classical nudes (many of which are seen in similar bourgeois and disquieting interiors) constitute a more limited series that was predom-

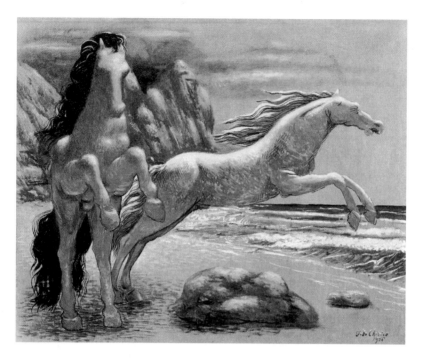

The Sudden Joy, 1926,
private collection.

Salomon Reinach, *Répertoire de la statuaire grecque et romaine*, t. II, 2, Paris 1909, pp. 742–43.

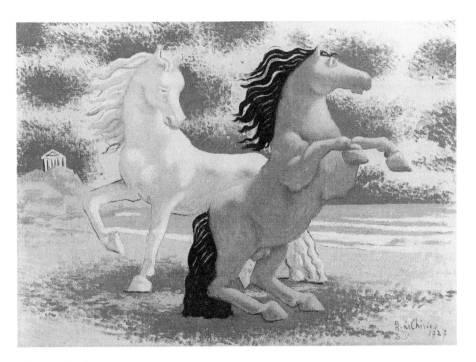

Horses on a Beach, 1927,
private collection.

inantly executed between 1925 and 1927. De Chirico's relationship with Picasso developed further in these works in the direction of Mediterranean classicism, in paintings that are related to the unsettling theme of statues in interiors, which strike uncannily human postures (*L'enfant prodigue*, 1926).[29]

Images of classical and monumental horses on the dreamlike shores of de Chirico's native Thessaly, against backdrops of ruined temples and columns, also express his preference for Hellenic classicism in contrast with surrealism and were one of the most successful themes of that period. Indeed, de Chirico later described having painted such images on commission to the point that he grew tired of them.[30] But they had much earlier origins in a visionary meditation dating back to the Parisian metaphysical period: "And I still think of the enigma of the horse in the sense of the sea god: in the darkness of a temple that stands on the seashore I once imagined the speaking and vaticinatory steed which the glaucous god gave to the king of Argos: I imagined it sculpted in marble as white and as pure as a diamond, crouching like a sphinx on its hindquarters, with its eyes and the movements of its white neck expressing all the enigma and all the infinite nostalgia of the waves."[31] The iconography of such works was often inspired by Reinach's repertory of illustrations of sculpture, underlining their ancient roots that were correctly identified by Cocteau, but

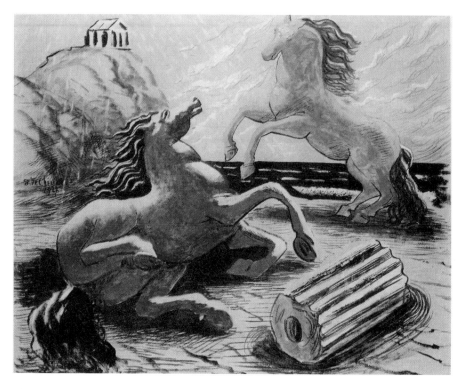

The Late Reproaches, 1927,
private collection.

in absolute continuity with the metaphysical aesthetic: "Born in Greece, de Chirico no longer needs to paint Pegasus. A horse by the sea acquires mythical significance by means of its color, its eyes, its mouth."[32]

The "archaeologists" represent perhaps the point of greatest continuity in terms of de Chirico's themes, which he tirelessly updated from both an iconographic and formal point of view: "It was an idea that came to me when I was looking at certain gothic sculptures in cathedrals, which when seated have a very majestic air because they have a large trunk and small legs, and since they never stand up one always has the impression that they are very majestic. It was from there that I came up with the idea of making these characters with highly developed upper bodies and small legs . . . because it gives a sort of grandness to the characters themselves."[33] If this reading might appear to be a partial simplification, given that the "archaeologist mannequins" were also— and above all—born of metaphysical research (the mannequins of *The Disquieting Muses*, for example), the idea of the medieval statues was certainly one that was grafted onto it in the course of the more classical elaboration of the

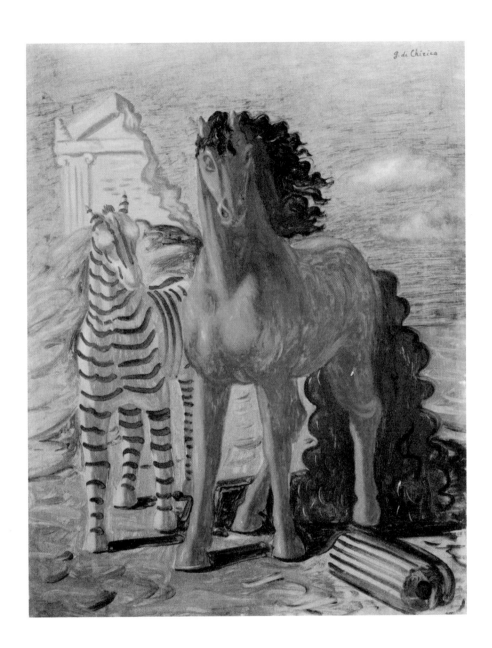

Horse and Zebra, 1929,
private collection.

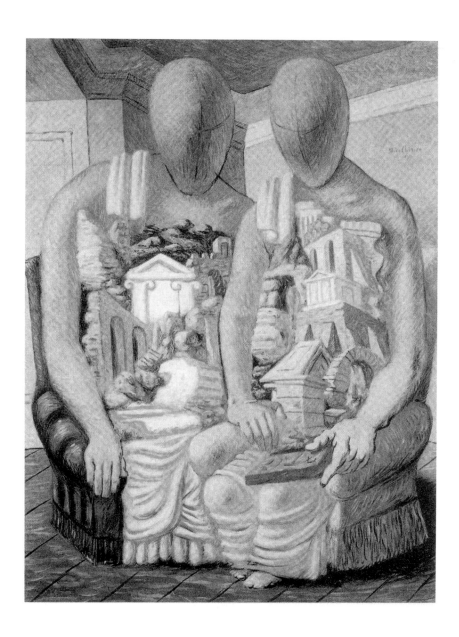

The Archaeologists, 1927,
La Galleria Nazionale, Rome.

Facing page:
The Archaeologist, 1928,
private collection.

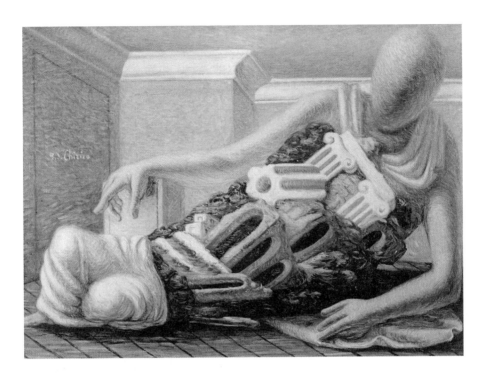

theme, reestablishing the meaning of more humanized creatures, daughters of Mnemosyne, within whom emotions-concretions-autobiographical memories are set and framed. The amalgamations of memories, ruins, archaeological elements that emerge from their chests are sometimes isolated in heraldic compositions, autonomous trophies that stand out in the center of the composition.

The last great theme of the 1920s was that of the gladiators, which de Chirico only began to work on in 1927. A transposition of the Ferrarese mannequin motif, updated in line with the artist's profound "late-antique" classicism, its metaphysical ancestry is evident from numerous iconographic references to paintings dating from the 1910s. Their expressionless faces, lacking all psychological identity, perfectly parallel those of the metaphysical mannequins. However, represented in terms of an ever-more explicit and defined *mediterraneità* these characters stage dramas and secular mysteries of disturbing ineluctability: massacres carried out with the skill of a ballet, or ritual killings that reveal the "nonsense" of existence, observed by distant and spectral arbitrators. They profoundly convey a sense of the metaphysical nonsense, unbreakable even in the face of death, and clothed in classical garb in accordance with the spirit of the age.[34] Waldemar George made an extremely acute interpretation of this series, identifying remarkably pertinent iconographic comparisons that subsequently became widely accepted,

Trophy, 1926,
private collection.

Previous page:
The Consoler, 1929,
private collection.

End of Combat, 1927,
private collection.

Facing page, top to bottom:
Lion and Gladiators, 1927,
Detroit Institute of Art, Detroit.

The Triumph, 1928–29,
private collection.

Combat, 1928,
private collection.

Warriors, 1928,
private collection.

Head of Gladiator (Portrait of Apollinaire), 1927–28,
private collection.

but which should certainly be disentangled from their implicitly fascist un-
dertones (those references to a new world and to new spiritual values, which
for George coincided with those of the fascist new order):[35]

> A man from the Late Roman Empire. De Chirico is linked to the Constantin-
> ian style. Like the anonymous sculptors of sarcophagi at the time of Rome's
> decline, he transubstantiates the spiritual values of art. . . . If the work of Gior-
> gio de Chirico is one of the dominant facts of our era, it is because it directs the
> attention of the public, its disquiet and curiosity beyond its specific painterly
> elements, because it breaks the infernal and vicious circle of art considered as a

Alberto Giacometti, *The Palace at Four O'clock in the Morning*, 1932,
Museum of Modern Art, New York.

morphology, because it makes it an idiom of the spirit. . . . if [de Chirico] seeks
inspiration in works of the Late Empire it is because he discovers in those late
messages, dispatched from a culture in which decline is imminent, the generat-
ing principle of an order, of a type of civilization that will transform the world.
Like Riegl, I believe that the art of the Late Roman Empire was the product
of a society nurtured by Neoplatonic philosophy, a society that had ceased to
believe in the reality of physical matter. . . . The public believes it can discern
the rumblings of a classical Renaissance. On the contrary, I see the precursory
signs of a mental, anti-materialist art, of an art which employs an old vocabu-
lary that endows it with a quality of surprise and which, without changing the

Frontispiece of G. Apollinaire, *Calligrammes*, Librairie Gallimard, Paris 1930, Fondazione Giorgio e Isa de Chirico, Rome.

The Wine-grower of the Champagne Region, from G. Apollinaire, *Calligrammes*, Librairie Gallimard, Paris 1930, Fondazione Giorgio e Isa de Chirico, Rome.

Marelli Fan, model in production since 1926.

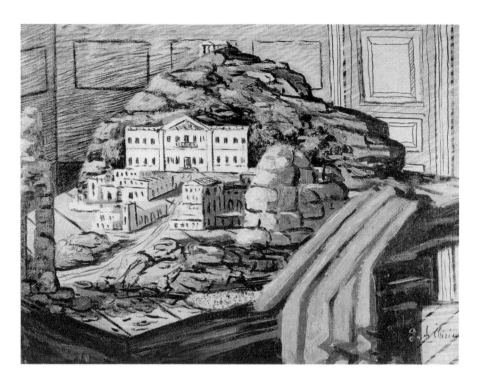

Landscape in a Room, 1927,
private collection.

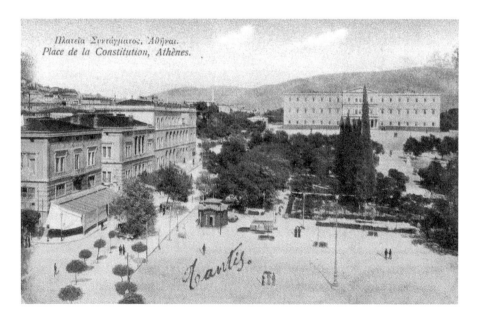

Syntagma Square with view of the Royal Palace in Athens, 1910.

Pergamon Altar in the Pergamon Museum, Berlin.

external appearance of the world, overturns and transfigures its soul. This is why I firmly believe that the revolution started by Giorgio de Chirico is more essential, more profound, more active than the Cubist thrust.[36]

One aspect of the Gladiators that has never been highlighted—and which, together with the idea of the classical transposition of the mannequin motif, highlights their links with the metaphysical experience—is their implicit reference to Apollinaire, the artist's great and unforgettable friend, whom de Chirico would certainly have had in mind while painting them. An automatic, surrealist (or better, metaphysical) chain of ideas links Apollinaire not only to the first appearance of the gladiator motif in de Chirico's writings,[37] but also one of his first graphic studies depicting this subject: a drawing of a gladiator's head that is actually a perfect portrait of Apollinaire in profile, taken from the "numismatic" silhouette of his 1914 painting.

But still other, new series were elaborated by de Chirico toward the end of the 1920s, including the melancholic and esoteric suns that illustrated Apollinaire's text *Calligrammes* (published in 1930), deriving from a typically surrealist interweaving of memories of Greece, alchemical illustrations, and modern objects, such as a famous fan manufactured by the Marelli industry

Waldemar George, *Gladiators* by de Chirico in juxtaposition with Piero della Francesca in an article on *L'Amour de l'Art*, 1932.

around that time (1926), the radial grill of which gave it the appearance of a mechanical sun. These lithographic illustrations also incorporated the disquieting silhouetted shadow-figures that would, like the suns, be revisited during the artist's final "neometaphysical" period, thereby demonstrating the constant thematic circularity of de Chirico's work.

In fact, his position would also be central to the *Italiens de Paris* group (and fully backed by their main critic and defender Waldemar George) in an attempt to build up and rationalize an effective Italian originality with respect to the contiguous research of the surrealists. Even a Swiss Italian like Alberto Giacometti, who actively participated in the group *Italiens de Paris* prior to approaching surrealism, was profoundly influenced by de Chirico. Such an influence is found in his sculpture, *The Palace at Four O'clock in the Morning* (1932), made at the moment of his transfer to surrealism. De Chirico in this particular moment employed his various classical legacies as interchangeable stylistic features (Reinach's archaeological *Répertoires*[38] became one of his main references, from which he copied subject matter to compose his paintings: not antiquity itself but its reflection on the history of culture). The landscapes are generic, the temples almost always in ruins, the statues in fragments: there is no longer a recognizable place if not that which brings together and identifies all of them, which is to say the museum. There is no doubt that the *Temples in a Room* series grew from youthful memories, seen in the strange classical presence of the Royal Palace of Athens (present in various works) or the presence of neoclassical Greek houses and the dis-

orienting singularity of the Pergamon Altar enclosed in the out-of-the-time room in a museum in Berlin. This eclectic trace tells us of the nature of the surreal places in de Chirico's paintings of the late 1920s: the museum, precisely, as collector of fragments of past lives, of multiform cultures, of childhood memories and strange interiorities.

Although such interiorities are neither spoken of, nor possibly even accepted in the Freudian terms suggested by Breton, in truth, they are not very far from the concept of concealed magma that is brought to light by artistic action: "The rooms which sheltered them were like those islands which are found outside the main sea routes and where the inhabitants sometimes wait entire seasons until a tanker or a friendly sailing ship comes to throw them a few cases of spoiled preserves; like these islands they were outside the human mainstream; outside, without at the same time being so remote as not to notice the passage and not to hear the echoes of those armies on the march."[39]

A singular episode in Italian art around the 1930s was thus constituted by the group of *Italiens de Paris*, or "Italian painters resident in Paris."[40] After the violent clash between de Chirico and the surrealists, around the artist's ever-greater charismatic persona, and the equally consolidated figure of Severini (both of whom were fully backed by the art dealer Léonce Rosenberg), there gathered a group formed by Savinio, Mario Tozzi, René Paresce, Filippo de Pisis, Massimo Campigli, and others (including Alberto Giacometti and Osvaldo Licini), as an alternative and counterbalance to surrealism. The group took shape between 1928 (the year of the first group exhibition presented by the "Italianist" critic Waldemar George) and 1929, when a second exhibition was significantly presented by Georges Ribemont-Dessaignes, a dissident surrealist who had supported Breton's criticisms of de Chirico in 1926.[41]

Drawn together under Mario Tozzi's guidance, the group, which had deep roots in Margherita Sarfatti's "Novecento Italiano," was shaken by some initial polemics.[42] The majority of artists expressed themselves in an "original" classicism, which, to use Savinio's words, "is not a return to antecedent forms, pre-established and consecrated by an earlier epoch, but the achievement of the form most suitable for the realization of artistic thought and will."[43] Waldemar George[44] spoke clearly of Mediterraneanity in reference to the *Italiens de Paris* ("these painters demonstrate unquestionably that Italian art represents a subtle link between the spirit of the Mediterranean and the European spirit tout-court").[45] On the basis of Romanism and Mediterraneanity the game was therefore played in terms openly declared by Waldemar George who became the group's standard-bearer:

This art marks the return of Latin tradition and its extraordinary faculty of abstraction. A Latin and a Greek feign clarity. But it is easier to decipher the texts of the Cabala than to establish the sacred canons behind the building of the Parthenon and the temples of Paestum, or certain statues of Venus and Apollo: these are not works but enigmas, incarnate and materialized concepts. . . . Be that as it may, the Judeo-Romantic style of Soutine and Surrealism, the references to the Orient and the North, the calls of the subconscious, all this realm in disorder, these unexplored lands, these elementary forces, crash against the bastion of magic realism over which the Gallic-Roman legions, consisting of highly elect warriors, bravely keep watch. Which of the two ranks will win? The betting is open.[46]

The position of the *Italians in Paris* (and of de Chirico) was that of a national and international identity at the same time, not classicist but classical (Mediterranean, that is) in substance, though open to research that did not elude the languages of the Paris avant-gardes (from cubism to surrealism), but they elaborated them critically in an openness quite other than autarkic with regard to Italian art. De Chirico's dizzy perspectives on the subconscious taken up by the surrealists were reclaimed in autonomous, polemical, proud terms and redone precisely in a "Mediterranean" key against the "elementary forces and realms in disorder" of surrealism, which polemically would have had de Chirico dead in 1918 with the end of his metaphysical period. Savinio clearly pointed out (but only much later, after the end of the Second World War) the distance from the movement and Breton: "Surrealism, as far as I can see and as far as I know, is the representation of the formless, or rather that which has not yet taken form; it is the expression of the unconscious, or rather what consciousness has not yet organized. As for a surrealism of my own, if I must speak of surrealism, it is exactly the contrary . . . because it is not content to represent the formless and express the unconscious but aims to give form to the formless and consciousness to the unconscious."[47]

In Paris in April 1926 Giorgio wrote to his brother in Italy, who had sent him his very first artistic efforts (some drawings and temperas) and who was planning to move to the French capital, warning him: "Do not however get mixed up with the surrealists: they are idiotic and hostile people. We'll arrange something with Guillaume or Rosenberg."[48] Savinio joined his brother the same year, beginning his career as a painter in March 1927 and thus augmenting the already dense community of Italians living in Paris. In a perspective of antagonism delineated morally and aesthetically by de Chirico, the Italians closed ranks with the intention of creating an alternative group

Alberto Savinio, *The Poet's Dream*, 1927,
private collection.

in competition with the surrealists (who were by now highly averse to de Chirico). De Chirico was attracting vast attention internationally, by playing the cards of the most suggestive aspects of classical antiquity (wholly Italian) and the metaphysical tradition (in which his extraordinary supremacy was moreover acknowledged by his adversaries themselves). With the numerous late-cubist group members in Paris, oriented toward a synthetic research that saw a unitary direction in classical and mathematical-proportional principles, there were no disagreements, but rather a tacit and respectful reciprocal consent, based on a shared aversion to futurism. Moreover, some significant cubist exponents such as Jean Metzinger, for example, had adhered to a proportional and purist classicism, clearly adhering to Severini's point of view.

Nonetheless the "Ville Lumière" was a chimera dense with allure and encounters, which could not always be controlled by de Chirico's clear and Manichean use of tactics. In fact, precisely in the context of Léonce Rosenberg's gallery there took place one of those "liaisons dangereuses" that the austere de Chirico feared and advised against. Rosenberg pragmatically published (in his significant magazine *Bulletin de l'Effort Moderne*, which bore the same name as the gallery), exhibited, and sold, without prejudice, cubist, surrealist, and Italian classical-surreal paintings. These standpoints formed part of an active debate, in which the Italian artists were considered to be equal to or somewhat stronger than the French modernists. In 1928 he also commissioned the most famous of his artists to decorate his new house near Trocadero: one room to be entirely created by each of them. The artists included Severini and Picabia, de Chirico and Metzinger, Léger and Herbin, Savinio and Ernst. In the context of the gallery and especially in domestic intimacy with its owner, each staged his own most typical themes: de Chirico did a series of *Gladiators* fighting mortal battles in disquieting calm in the rooms of a bourgeois apartment.[49]

For de Chirico, these were years of great critical and commercial success. Three monographs on the artist appeared in 1928, two in France (written by Jean Cocteau[50] and Waldemar George,[51] respectively) and one in Italy, written by Boris Ternovetz.[52] These were preceded by a 1927 study by Roger Vitrac,[53] a dissident surrealist who broke away from the movement together with his friend Antonin Artaud.

22. The Early 1930s:
Between Renoir and Derain,
a New Idea of Modern Classicism

De Chirico had revealed an interest in Renoir around the time of his Return to Order in an article concerning the artist that was published in the magazine *Il Convegno* (I, 1920). The classicism of his bathers and the volumetric quality of his imagery had made the work of the great French master a point of reference even then. But at the end of the 1920s a quite different, and more eccentric and heretical, perspective on Renoir's work was suggested. Two of de Chirico's associates played leading roles in this critical-historical revaluation: Waldemar George and Paul Guillaume. George was at that time one of de Chirico's greatest supporters in Paris (and of the *Italiens de Paris* group as a whole), as well as an adviser to Guillaume, one of the artist's two dealers. The public presentation of Guillaume's collection in 1929—a crucial year in which a latent Renoirian influence began to emerge in de Chirico's work— gave rise to considerable debates concerning contemporary art. Presented by George, the exhibition aimed to represent and practically demonstrate a line of "traditional painting" at the heart of the avant-garde, which extended from Renoir to Derain, the neoclassical Picasso, the Braque of the 1920s, and so on. During this brief period, Renoir was therefore interpreted within de Chirico's Parisian circles as a champion and a forerunner of pictorial classicism, "a purely southern genius,"[1] whose Mediterranean nudes constituted a cornerstone of that avant-garde ambition to renew ancient values. In some way an alternative to the line of thought connecting Cézanne to the development of modern art. De Chirico himself, in a slightly later period and different way, aesthetically speaking (around the time of his distinction between "antique-style" painting and the avant-garde), considered Renoir to be "the only French painter who holds himself upright without injections of camphorated oil and without inhaling oxygen [as opposed to Manet, Cézanne, Van Gogh, Gauguin and the Impressionists, *author's note*] and this is because his painting is pleasing, and it is pleasing because he was a real painter."[2]

The collection of de Chirico's dealer Guillaume, who died a few years later in 1934, is now owned by the French state and is exhibited at the Musée du

Self-Portrait in the Studio, 1930,
private collection.

Female Nude (with Cliffs and Temple), ca. 1930,
private collection.

Jeu de Paume in a modified version of its original form, having been expand-
ed, spoiled, and flattened by his wife and her second husband. For example,
it no longer contains paintings by de Chirico, which they had parted with over
time. However, despite these changes it still reflects the possibility of, and
aspiration to, tradition in contemporary art through the Jewish expressionist
painters of the École de Paris, who were supported by George.

 In the 1929 catalogue, the collector and dealer Guillaume was seen as a
heretic: "His spirit of denial, his haughty scepticism, the contempt he pro-
fesses for the traditional order . . . make him a dangerous enemy of mod-
ern society."[3] And there is no doubt that de Chirico would have recognized
much of himself in this antagonistic and anti-institutional portrait of Apol-
linaire's old friend. There is no doubt that George perceived the same char-
acteristics in the work of de Chirico: "Chirico, you have no equal. You have
not misled anyone. You have proclaimed your hatred and contempt for a

Female Nude (Alcmene in Repose), ca. 1932,
La Galleria Nazionale, Rome.

universe where a grievous fate forced you to be born. You contributed to its
ruin and its redemption. Chirico, are you not the conscience of the West, its
inner voice?"[4]

Like de Chirico, Picasso was also defined as a painter of the Late Roman
Empire,[5] thereby affirming the alternative continuity of this interpretation of
contemporary art. Moreover, Picasso likewise studied Renoir closely, explicit-
ly echoing and reworking his classical nudes in the monumental and neoclas-
sical figures of the early 1920s. Indeed, he owned several works by the artist,
of which seven—including a number of classical nudes—remained in his col-
lection throughout his life, thereby confirming the perspicuity of the genealo-
gy proposed by Guillaume, and the shared interests of the two painters.[6]

In the context of modern art's "alternative tradition," one can identify
the first signs of a "Renoiresque" approach in de Chirico's work around
1927–28, characterized by a loose, light, and transparent style, and the use
of interwoven brushstrokes. Such qualities were particularly evident in the
Gladiators series on which de Chirico was working at this time, but explicit
references also appear in later female nudes painted around the turn of the
decade, which directly recall Renoir's late works on the theme of bathers.
Even when he engaged with long-standing motifs (*Horses on the Beach*, *Ar-
chaeologists*, *Trophies*, etc.), de Chirico's works of the early 1930s employed
a transparent technique by way of an explicit homage to the "anti-impres-
sionist" Renoir, the founder of a vision of modern classicism and of a sump-
tuous Mediterranean painting, full of vibration. Magritte would be deeply

Pierre-Auguste Renoir, *Sitting Bather*, ca. 1895–1900,
Musée Picasso, Picasso Collection, Paris.

Horses at the Seashore, ca. 1933,
private collection.

Still Life with Knife, 1932,
Fondazione Giorgio e Isa de Chirico, Rome.

Southern Song, ca. 1931,
Galleria d'Arte Moderna di Palazzo Pitti, Florence.

affected and influenced by the Renoirian de Chirico, particularly in his paintings of the 1940s, as well as in a series of female nudes depicted in natural surroundings. Openly acknowledging de Chirico's work as his own point of departure, Magritte distanced himself from the hostility exhibited toward the artist, despite being closely associated with surrealism. This was most evident in his marked refusal to subscribe to an anti-de Chirico proclamation published in 1928 by the small Belgian surrealist group, a document that was nevertheless signed by his close friend and supporter Paul Nougé.[7]

Between 1930 and 1934, de Chirico also paid tribute to Derain, an "archaistic, and a painter of the Late Empire who, like the two-faced god Janus, is spiritually attuned to both the past and the future,"[8] in works that focused mainly on synthetic and Mediterranean landscapes. This reveals the extent to which de Chirico subscribed to this alternative interpretation of the modern movement promoted by Guillaume (a great admirer of Derain's and—let us not forget—a close friend of Apollinaire's, with whom he certainly shared such ideas). However, it is intriguing to note de Chirico's radical change of opinion in regard to this artist over the years (in fact, decades), for when Guillaume organized an exhibition of Derain's work in the autumn of 1916 de Chirico expressed little enthusiasm for it; yet this may simply have been a result of jealousy, caused by the fact that his own exhibition had been replaced by one on Derain.[9]

Facing page, top to bottom:
René Magritte, *The Principal of Incertitude*, 1944,
private collection.

André Derain, *The Big Tree*, ca. 1929–30,
Musée de l'Orangerie, Paul Guillaume Collection, Paris.

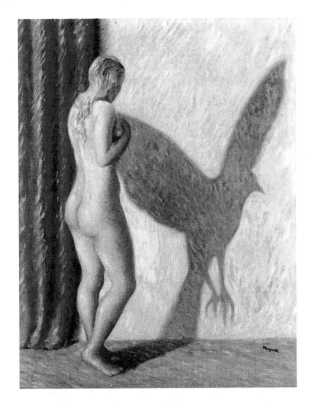

San Juan les Pins, 1930,
private collection.

23. Between "Surrealism" and Realism

As early as 1928, de Chirico had written his *Piccolo trattato di tecnica pittorica* [Brief Treatise on Painting Technique], which, in parallel with the "surrealist" exploit of *Hebdomeros*, posed the open-ended question of the heritage of painting technique, but in a very open way: "I well know, as does every man whose head is not in the clouds, that unforgettable works can be created with little means when one has genius or at least talent, but what is not permitted is ignorance, and, as far as I know, there is no painter who respects himself, classical or modern, who did not know and does not know painting technique."[1] Initially, the technical aspects of painting that were explored in de Chirico's *Brief Treatise* did not directly influence his research into current and modern pictorial vocabularies (see the contemporary polemical interview in *Comœdia* previously mentioned), but operated slowly, and beneath the surface, on the basis of the notion that the accuracy of a painterly style cannot in itself invalidate the profound—and modern—significance of artistic research. The contemporary work of artists such as Magritte or Balthus, whose technical finesse was an important component of their peculiarly effective imagery, neatly contextualizes these reflections. Later, toward the end of the following decade, the pleasure of beautiful painting takes such possession of the artist that he makes it the unqualified center of his interests.

Like many other artists, de Chirico left Paris as a consequence of the effects of the economic crisis of 1929[2] but would subsequently return at various times throughout his life. During the 1930s, when he worked in Italy, the United States, and France,[3] he arrived at a free interpretation of the poetic and stylistic themes with which he had engaged over the course of previous decades, in addition to inventing others. He passed with ease from the Parisian subjects of the second half of the 1920s (horses on the beaches of Thessaly, archaeologists with bodies constructed from classical ruins and fragments of memories, landscapes enclosed within rooms, mysterious objects and disquieting gladiators rendered in accordance with an oneiric interpretation of *romanità*) to a form of realism inspired by earlier painting (from the sunniest and most "Mediterranean" work of Renoir to that of Velasquez's Roman period),[4] as well as to

Horses and Horsemen at the Seaside, ca. 1932–33,
private collection.

the astonishing new series of *Mysterious Baths*[5] (presented for the first time at
the 1935 Rome Quadriennale). In addition to these, there appeared theatrical
scenes with costumed "bourgeois" figures (inspired by the staging of Bellini's
Puritans at the Maggio Musicale Fiorentino festival of 1933), and also very
rare examples of metaphysical replicas (which at that time still tended to be
reinterpretations), classical scenes, and strangely realistic landscapes and still
lifes, all of which were executed in an autonomous and self-referential paint-
ing style in terms of its *ductus* and pigment, rich in unusual timbres.

This curious mixture of styles, dominated by the artist's unifying and brilliant
personality, was fully presented for the first time in the room dedicated to de
Chirico at the second Rome Quadriennale of 1935. Owing to the eclecticism
that saw seemingly realistic or traditional themes (self-portraits in the studio,
nudes in landscapes) juxtaposed with totally invented images in the metaphys-
ical spirit (*Mysterious Baths*) and the disturbing or mythological subjects of the
1920s (bourgeois conflicts, images of the Dioscuri with their horses), de Chirico
was spared no criticism from Italy's more traditional cultural commentators.

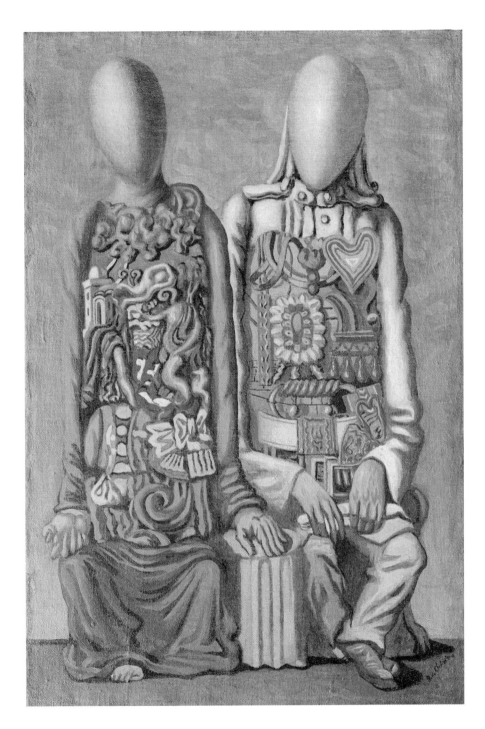

Colonial Mannequins, ca. 1933,
private collection.

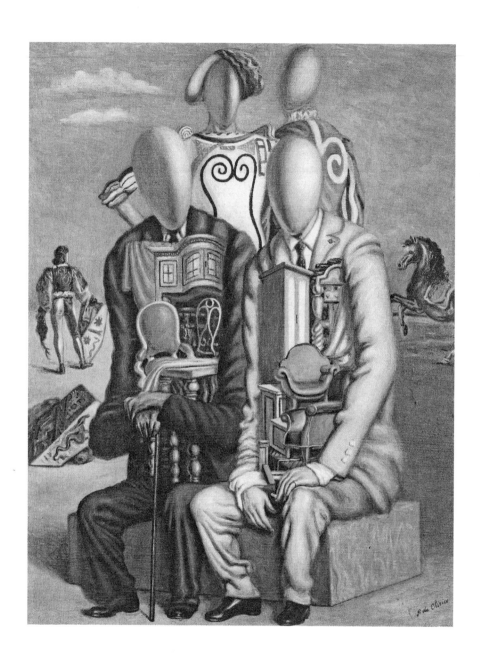

Nobles and Bourgeois, 1933,
private collection.

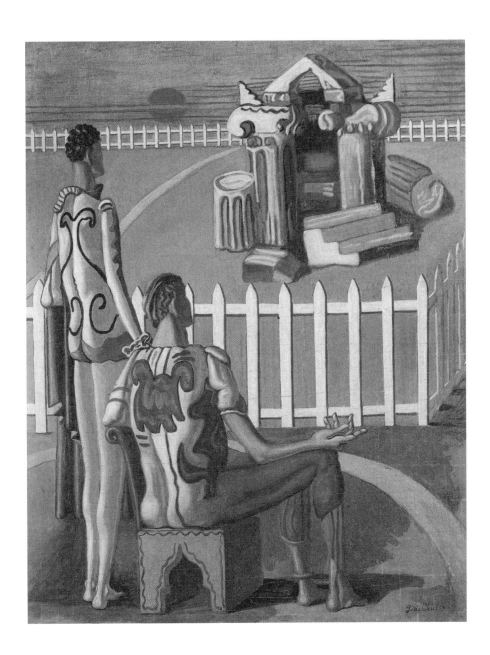

Strange Ruins (The Contemplators of Ruins), ca. 1934,
private collection.

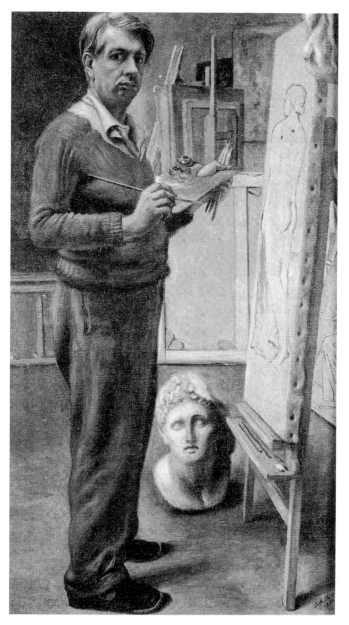

Self-Portrait in the Studio, 1934,
La Galleria Nazionale, Rome (Isabella Far Donation).

Facing page, top to bottom:
Puritans and Centaur at the Seaside, ca. 1934,
private collection.

The Dioscuri and Companions at the Seaside, 1934–35,
private collection.

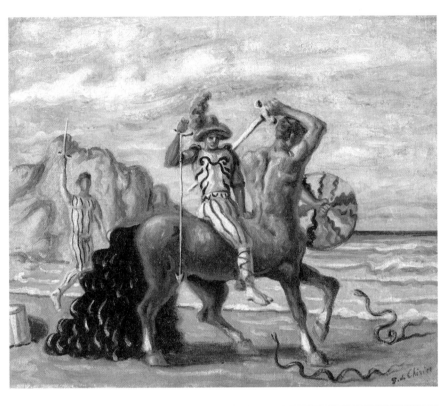

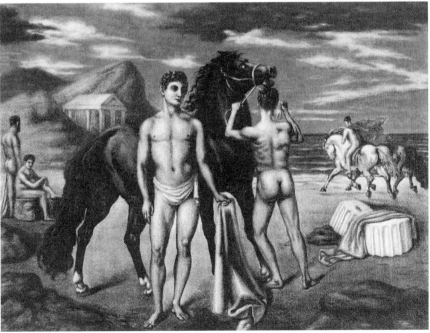

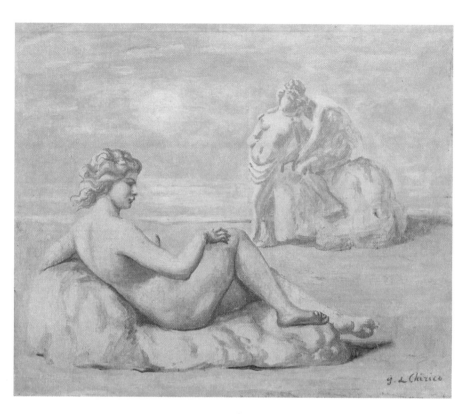

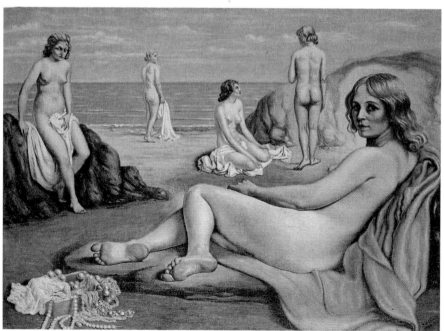

The more markedly realistic paintings constituted de Chirico's first experiments with a style that was deliberately (but only apparently) free from the metaphysical/surrealistic "inventions" that had characterized his painting of the second half of the 1920s, engaging with ever-greater conviction in a Platonic dialogue with a technique capable of rendering the appearance of reality, rather than "reality" itself, as in the work of the painters of the past. This meaning is confirmed by the coexistence of subjects drawn "from life" and the various motifs and themes of his recent work, interpreted in a more realistic key, thereby leading to a "disconnect" between real appearance and surreal invention. Ultimately, the fundamental intention was to make those fantastic subjects appear even more enigmatic by means of the mimetic representation of reality.

As in ancient paintings, mythological or fantastic subjects were now rendered exactly, as if they had descended into a phenomenal existence. Paintings by Velasquez such as *Vulcan's Forge* or *Venus in the Mirror* would have offered an example of how fantastic subjects "metaphysically" ease themselves into concrete, daily experience. A comparison of the *Self-Portrait* and the *Mysterious Baths*, exhibited in the same room at the Quadriennale, in which the painterly style contains no expressive superfluities despite the radical semantic difference of the contexts, presents and reveals the new path embarked upon by de Chirico in his perennial exploration of "metaphysical" enchantment.

In 1934 we see the first real indication of the practical application of the technical canons that were initially registered in a very different context in the *Piccolo trattato di tecnica pittorica* [Brief Treatise on Painting Technique] of 1928, conceived as an almost purely conceptual study. In October 1934, while preparing the forty-five paintings destined for his room at the Rome Quadriennale of the following year, de Chirico wrote to his friend Nino Bertoletti: "Despite all this and, in a similar way to those monks who at dawn of the Middle Ages continued, unperturbed, to study and to write chronicles while the barbarians subjected Europe to fire and blood, like those monks in the midst of their woes I continue to perfect painting technique."[6]

The *Mysterious Baths* created in 1934 to illustrate Jean Cocteau's *Mythologie*[7] had their origins in the artist's childhood memories of the baths in Volos' seaside, combined with his sudden impression of a polished parquet floor re-

Facing page, top to bottom:
Summer Evening, 1934,
private collection.

Bathers on a Beach, 1934,
Valsecchi collection, Rome.

Top to bottom:
Mysterious Cabins, 1934–35,
Palazzo Merulana, Cerasi collection,
Rome.

The Mysterious Swan, 1934–35,
Albert C. Barnes Foundation,
Philadelphia.

Facing page, top to bottom:
Mysterious Baths, 1934,
private collection.

The Mysterious Baths, 1934–35,
private collection.

sembling an aquatic surface, into which those who walked across it seemed
to sink. While de Chirico would later speak specifically of the impression of
the parquet floor,[8] in an almost contemporary article (of 1936), containing
details that were provided by the artist, the disturbing childhood memory
was also clearly described:

> Apart from a feeling of suspended existence these paintings must depend on
> a literary transcription for an exposition of their esoteric meaning. When de
> Chirico was a child in his native Greece, his father, a Sicilian engineer working
> in Volos, occasionally took him to the baths. The boy was deeply impressed
> by the difference he perceived between the clothed and unclothed figures.
> They seemed like different species of animals in different spheres of existence.
> The clothed men, like overwhelming and majestic statues, towered over the
> swimmers, who appeared exposed and defenceless. The little cabins, with their
> pierced windows, were like masked heads looking on the scene. Sometime later
> a subconscious association was formed between this childhood impression and
> shining parquet floors which became identified with the water of the pools.[9]

These exquisitely surrealist short circuits (or rather, metaphysical, almost
psychoanalytic memories of childhood and automatic associations of imag-
es) overlapped with a source of artistic inspiration dating back to his time in
Munich. De Chirico had already described its profound meaning in an arti-
cle of 1920, at the height of the Return to Order, thereby revealing the extent
to which a sense of metaphysical mystery lingered within the classical sen-
sibility of that period. Inspiration came from an engraving by Klinger,[10] the
mysterious and inexplicable subject of which had long been present in de
Chirico's consciousness before establishing itself with the *Mysterious Baths*.
In fact, de Chirico had already taken inspiration from Klinger's *History of
a Glove* in painting *The Song of Love* (1914), a masterpiece of his Parisian
period metaphysical art. To these already numerous associations were prob-
ably added representations of water by means of a zigzag pattern, a solution
found in certain Roman mosaics in Tunisia and Libya (at that time under
Italian control) that de Chirico had carefully examined (for example, one
can discern the influence of such mosaics in the Gladiators cycle) and which
the many new archaeological discoveries were then bringing to light (rather
than the analogous but remoter—in terms of their impact on de Chirico's
vocabulary—images from Egyptian frescoes, to which Calvesi has referred).

During the second half of the decade de Chirico was continuously on the
move, returning to Paris several times, staying for a long period in the United
States (where he exhibited with the gallerist Julien Levy) and traveling to

The cabins at Anavros in Volos, ca. 1900.

Max Klinger, *Accords*, from *Brahmsphantasie—Opus XII*, 1894, private collection.

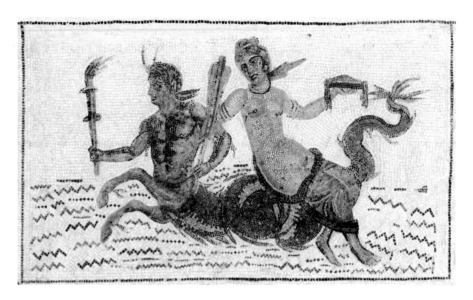

Roman villa mosaic,
El Jem Archaeology Museum (Tunisia).

London, before finally returning to Milan following the outbreak of the war. The international success he enjoyed—despite the economic crisis, and the prolonged hostility of the surrealists—is remarkable, and his exhibitions multiplied at a dizzying rate in cities across Italy, the rest of Europe, and America.

Alternating between an internal ("metaphysical") reworking of real data, and the construction of purely mnemonic spaces, de Chirico's vision altered his pictorial style over the course of the 1930s, which became more full-bodied and sensual, and his aesthetic conception itself revealed further new characteristics. Following his surreal-Mediterranean phase, the artist once again became passionately interested in the subject of "ancient" painting techniques. During the Second World War years, this would ultimately lead him to claim kinship with the great painters of the past, even going so far as to assert that a sort of transference had taken place between them and himself. To a certain extent, he resumed the Return to Order principles of the 1920s, but radicalized them, emphasizing the technical aspects of painting. Increasingly, he came to believe that the absolute value of the great works of the past depended mainly—if not exclusively—on the artist's technical expertise and the expressive refinement of the palette, and that consequently the essential values of art were expressed in a complete and organic manner through a technically skilled and brilliant painterly performance. In this complex process of substituting the specific contents of the

The Culture of Time, 1933, mural painting in the Hall of Honor at the V Triennale of Milan (destroyed).

In the niche: *The Arts*, mosaic by Gino Severini.

Antique Horses Frightened by the Voice of the Oracle, 1935,
private collection.

artistic medium with those considered complementary rather than intrinsic
to the essential substance of painting, de Chirico's polemical attitude toward
the international avant-gardes was decisive—first and foremost, surrealism,
which stubbornly insisted on contesting his activity after 1918. De Chirico
slowly but surely shifted the focus of his research toward those aspects of
artistic practice that interested him, arguing that all of his earlier activity had
in fact been entirely consistent with his present orientation.

In this new vision of the world the artist would gradually lose interest
in any references to reality, but also in his inner, symbolic, and mysterious
paradoxes. The themes of his painting—the product of timeless artistic ge-
nius—that would become the object of de Chirico's Arcadian dialogue were
now to be idyllic valleys and landscapes (classical or baroque) dotted with
picturesque or fabulous buildings, places of pure hedonistic abandon; offi-
cial-style portraits, which blended realism and pictorial fantasy with heter-
ogeneous citations from different centuries; and knights in heraldic dress
and nobles in bourgeois clothes—characters from melodramas who have
stepped down from the stage and are unable to notice the estrangement of
reality—who represent the metamorphosis of the archaeologist motif.

The Autumn, 1935,
Museo del Novecento, Milan.

24. A Theatrical Art

De Chirico's theatrical experiences began in 1924, when he created the sets and costumes for the ballet *The Jar* by Luigi Pirandello (with music by Alfredo Casella), presented by the Ballets Suédois at the Théâtre des Champs-Élysées in Paris. His theater work continued in 1925 for the "mimed tragedy" *Death of Niobe*, written by his brother, Savinio, and performed at the Odescalchi theater in Rome, where the artist would meet his future first wife, Raissa.[1] In 1929 he would work on *Le Bal*, staged by Diaghilev's Ballets Russes at the Théâtre Sarah Bernhardt in Paris, and set to the music of Vittorio Rieti. These theatrical commitments, regularly if infrequently spaced throughout the 1920s, exerted a certain influence on his contemporary paintings in terms of their "scenic" structure.

Over subsequent years de Chirico's interest in the theater intensified,[2] his work in this sphere eventually becoming something of a true vocation. The extraordinary staging of Bellini's *Puritans* at the first edition of the Maggio Musicale Fiorentino of 1933 enjoyed little success with conservative Italian audiences due to its heraldic and strikingly original visuals (the characters, plastered into rigid costumes decorated with brightly colored abstract designs on white backgrounds, could hardly move on the stage). However, this production inspired de Chirico to create a series of paintings (the "bourgeois" cycle) in which his earlier images of gladiators were developed in a more abstract manner.

If metaphysical painting undoubtedly possessed theatrical qualities (something already noted by several contemporary critics, although the apparent "scenographic" significance of such works was firmly—and justly—denied by the artist) in their presentation of dreamlike and incomprehensible tableaux, these characteristics became increasingly prevalent following de Chirico's return to Italy in the 1930s: the artist's visionary world became an ever-purer pictorial "motif" and was indissolubly intertwined with an integral and all-encompassing theatrical representation. De Chirico's work for the theater, which grew ever more intense during this decade, merged

Scenography for *The Jar*, 1924,
private collection.

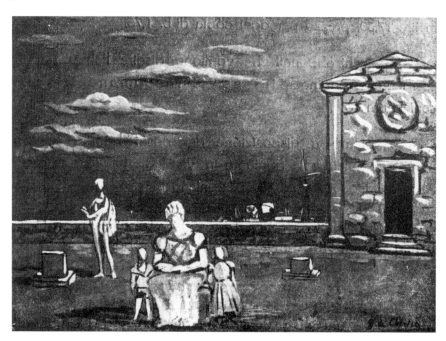

Scenography for *The Death of Niobe*,
in *La Rivista di Firenze*, II, no. 1, May 1925.

Scenography for *Le Bal*, 1929,
private collection.

Scenography for *The Puritans, Act I, scene III*, 1933,
Fondazione Teatro del Maggio Musicale Fiorentino, Florence.

Costume for *The Puritans, Servant*, 1933,
Fondazione Teatro del Maggio Musicale Fiorentino, Florence.

Facing page, top to bottom:
Scenography for *Amphion*, sketch, 1942,
private collection.

Scenography for *Orpheus, Opening Curtain*, 1949,
Fondazione Teatro del Maggio Musicale Fiorentino, Florence.

his vision of life as a stage set, which became an integral part of the *staging* of painting itself. In an ephemeral world made of solid appearances, de Chirico carried himself like a contemporary Calderón, a Pirandello outside of time. Continuing wittily to provoke a world in which he felt himself to be a stateless citizen, his pictorial compositions depicted timeless chivalric acts possessing a declamatory character set in fairy tale or the courtly poem worlds, becoming increasingly out of step with current trends.

The culmination of this process occurred in the early 1940s, when de Chirico published his *Discourse on Theatrical Performance*,[3] the first text in which he would specifically address and explore his reflections on the theater, and which would also have a decisive impact on his paintings. He would increasingly portray himself wearing theatrical costumes, while his still lifes and his horses and riders would also be poised at the forefront of imaginary stages, often framed by parted curtains. Landscapes become theatrical backdrops for the staging of the painting, considered to be an active "character" in the drama of life.

Scenography for *Don Chisciotte, Act III, scene I*, 1952,
Fondazione Teatro del Maggio Musicale Fiorentino, Florence.

Scenography for *Othello, Opening Curtain, Act I*, 1964,
Teatro dell'Opera, Rome.

25. De Chirico and the United States: The Metaphysics of the New World

De Chirico's extended stay in the United States represented a very fruitful period for the artist. Having departed from Genoa on the *Roma* ocean liner, he arrived in New York on August 27, 1936, and would return on the *Rex* on January 5, 1938. On his return journey, his traveling companions included the gallerist and countess Anna Laetitia Pecci-Blunt and the painter Corrado Cagli. De Chirico stayed in America for a year and four months, accompanied by his partner Isa (not yet his wife) who joined him in mid-November.[1] Julien Levy acted as his guide and mentor in America and organized two exhibitions of the artist's work at his gallery in October 1936 and December 1937. "The terrible-tempered Dr. Barnes no doubt had much to do with Giorgio de Chirico's first visit to the United States. He probably paid for his passage and certainly intended to play a prominent part in the presentation of de Chirico's work at my gallery."[2] This is how Levy remembers de Chirico's arrival in America and the role played by the American multimillionaire Barnes, a collector and admirer of de Chirico's work since the early 1920s in Paris. The trip should be seen in the context of de Chirico's growing international fame and the expanding market for his work, which, despite the prevailing economic climate, was in the process of developing during the 1930s, especially in the Anglo-Saxon world.

De Chirico had already made a number of trips to Britain, Germany, and Czechoslovakia following the organization of exhibitions of his work across Europe. He had a particular intellectual affinity for certain aspects of British culture[3] and had already visited the country during the second half of the 1920s; he would visit again in 1935, returning in 1938, 1948, and 1949.[4] During the 1930s his paintings would be exhibited in around thirty collective and four solo shows. The artist's important collectors and dealers (such as Roland Penrose, Edward James, Édouard Mesens, George Melly, Peter Watson, Arthur Jeffress, and Anton Zwemmer) raised his profile, and his imagery would have a profound impact on avant-garde British art. For

example, the art of Henry Moore cannot be properly understood without reference to the enormous influence de Chirico exerted on him via the numerous works owned by Moore's friend and associate Penrose.

Likewise, de Chirico had a long-established presence and many supporters in the United States.[5] His first presentation to the American public took place at an exhibition organized by the Société Anonyme in 1926 at the Brooklyn Museum in New York. Marcel Duchamp and Katherine Dreier included three paintings from 1925 in the show (an archaeological work titled *The Lovers* and two *Metaphysical Interiors*). However, in 1923 Albert Barnes had already bought the first of many (eventually about twenty) works by de Chirico. He became a friend of the artist, to the point of presenting his 1926 solo exhibition in Paris at Paul Guillaume's gallery. Toward the last quarter of the decade, interest in his painting expanded through the activities of other gallerists and collectors such as Albert E. Gallatin, owner of the Gallery of Living Art in New York (which opened in 1927), and especially F. Valentine Dudensing, the owner of New York's Valentine Gallery. After opening in 1926, the gallery would host the first two solo exhibitions by de Chirico (1928 and 1928–29), predominantly focusing on recent paintings. Many American-based artists, such as Arshile Gorky, were also impressed and influenced by de Chirico's work.[6]

During the 1920s the American art market made no distinctions between de Chirico's metaphysical works and his more recent paintings; critical appraisals were similarly even-handed. Indeed, it could even be said that his success was based more on a consideration of the later pieces. However, at the time of his visit, in the mid-1930s, the surrealist vendetta was beginning to take hold within some of the intellectual circles linked to Breton. Dalí, who owed a great deal to de Chirico's stylistic example, was close to Levy but was even closer to Breton, and therefore repeated his accusations regarding de Chirico's artistic decadence, not without a hint of envy, as also occurred with various American critics. Although de Chirico's knowledge of English was labored and patchy, despite his long stay in the United States (Peggy Guggenheim reminds us in her autobiography that Max Ernst spoke almost no English while living in America, French being the *lingua franca* of the country's artistic circles), it would appear that de Chirico was very dynamic in worldly affairs, but could also sometimes be taciturn and somewhat dazed, absorbed in his thoughts.[7] In America he obtained several prestigious commissions associated with the glamorous world of fashion: a large panel for the Helena Rubinstein parlor on Fifth Avenue (1936), another large painting for Benno Scheiner's tailor shop (1937), as well as an interior design project,[8] and covers and illustrations for *Vogue* magazine (with which he

The Lovers, 1925,
Yale University Art Gallery, New York (painting exhibited in the United States in 1926).

Petronius and the Modern Adonis in Tails, 1937,
private collection.

The Mysterious Baths in Manhattan, 1936–37,
private collection.

had in fact collaborated since 1935). He even considered emigrating to the
States, but it proved difficult for him to extend his residency permit.[9]

The artist was intensely moved by the sublime and modern image of New
York:

> On the vast Atlantic Ocean, between Europe and what is called the new conti-
> nent, there is a liquid frontier; over there waves bubble, the water is lukewarm
> and soapy; a moist and humid warmth envelops the big vessels which roll and
> dance among the ghosts of caravels and half-fish emerge from the water, with
> their mouth open, in pursuit of an imaginary prey; it is the *Gulf Stream*. Up
> to this point a passenger, regardless of what corner of Europe he comes from,
> is still breathing in the *atmosphere of home*, if one may say so. Once this fron-
> tier is crossed, one is *on the other side*; whether it is better or worse, I do not
> know; what I know is that one is *in a different world*; in an imperceptible manner
> *everything has changed*; one feels a little bit *as if one had died*; clearly one keeps
> moving, eating, smoking, strolling, chatting, reading, doing absolutely everything
> just as before, but in all of this, there is a trace of the movement of a ghost . . .
> Upon arriving in New York everything that appears to you—the skyscrapers
> of Wall Street, the mist, the tugboats, the elongated, white, cubist architecture,
> properly lined-up, and reminiscent of the historical reconstructions of Babylon
> and of Imperial Rome, executed in plaster according to the plans and drawings
> of meticulous archaeologists—all of this is suffused with an otherworldly light.
> America has existed already for a few centuries as America; big cities have been

The Antique Woman, illustration for *Vogue*, March 15, 1937.

Sketch for *The Antique Woman*, illustration for *Vogue*, March 15, 1937, private collection.

Vision of New York, 1936,
private collection.

built; a deliberate and laborious people have expanded there, and expand-
ed ceaselessly. It seems to me therefore rather excessive to still call it *the new
world*. America is no longer a new world but is, and always will be, *another
world*. It is not simply a question of whether the civilization, mentality, stand-
ards, social, economic, or technical progress are more or less advanced than
in Europe; it is rather a question of molecules, of climate, of different atmos-
phere, of the special quality of the sun's rays. The light and temperatures there
are different. There is something of the humid torpor of a greenhouse, even
in the middle of the winter; there is also the light of a greenhouse. In America
human beings and objects *lose their shadow*. There is also a strange softness:
everything is suppler as if it were made of the same substance; human and ani-
mal bones, stones and metals appear less hard than in Europe: everything is
less hard and dry than in Europe. This explains the strange brightness of flow-
ers, fruits, vegetables, and women's skin in America. This soft weariness, which
weighs on everything, is also *an otherworldly* weariness.
European from old Europe, go and visit New York if you can. Go and visit that
feverish and dreamy city: there you will discover strange beauties; you will see
apparitions which have nothing in common with what cinema and literature
has shown of that country up till now.
Behind the barrier of the ocean, behind the customs houses and the Irishmen
with polished black guns, behind the ghosts in white gloves who unload the
waste of seven sins in the pale light of dawn, you will find, again and again, in
New York the magnificent, New York the eternally New, forgotten memories,
memories which emerge over there as they do during the hours of half sleep,

Horses and Sibyls with Draperies at the Seaside, 1936–37,
private collection.

during those mysterious hours when soul and spirit, disengaged from logic and reality, solve a multitude of enigmas and problems otherwise insoluble—forgotten, alas, as soon as they are unravelled.

Luxury and wealth, in an apotheosis of fireworks, create strange paradises in mysterious New York, in the very centre of this immense and ancient, mechanical and polymorphic city. These paradises carry us at a soft and imperceptible speed, without jolts and without hurdles, in padded sledges pulled silently by multicolored ducks and by the good storks of yesteryear . . . Splendid city of dream in a dream, city of Windows, Window-city, Storefront-City, before its storefronts parade day and night, like the characters of a very old clock, all the things of an enigmatic humanity, from the distant origins drowned in the mist of palaeontology, of forests and caves, up to the spectacular and electrifying aspects of its future darkness.

New York, the eternally New, draws us on its eternal parallels into the unlikely kaleidoscope of its storefronts, of its transparent towers, its magnificent bazaars, its windows lit throughout the long winter nights, where ineffable Dioscuri sleep, leaning against the harnesses of their exhausted horses; where the characters in a drama by Meyerling [*sic*] consult the sundials, bending over without seeing the long telescopes and the rusty sabers that the one-eyed buccaneers, long since vanished, used to grasp in their clenched fists.

In this forest of glass, of steel and concrete, in this extraordinary New York, difficult to define: traveller, you will find the gigantic masks of ancient gods, you will find the eternal sadness of plaster Antinous and the immense loneli-

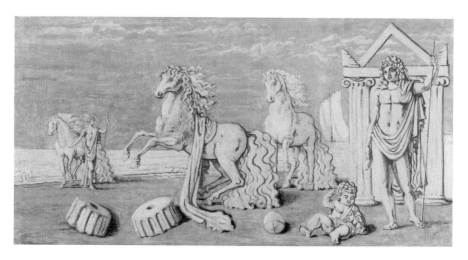

Divinities at the Seaside, panel for the Helena Rubinstein salon on Fifth Avenue, 1937, private collection.

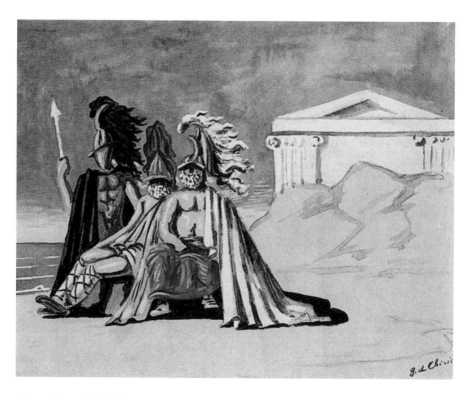

Heroes of Homer, 1936–37, private collection.

ness of the Parthenon on summer nights, under the immense sky glittering with stars. Paris, January 29, 1938.[10]

This period, with its new visual and environmental stimuli (which suggested allusions to ancient Greece), opened subtly different horizons and perspectives to de Chirico, breathing new life into his art. The *Mysterious Baths* incorporate skyscrapers, his classical compositions are interpreted with light and totally unrealistic colors, gods and goddesses wear sophisticated, glamorous peplums and chitons, horses prance gracefully and elements of ancient ruins are combined with echoes of metaphysical objects, transformed into theater stage wings. It represented a moment of apparent happiness, where a sense of mystery is concealed in a new world of altered colors and scenes, in which the Mediterranean is blended with an ethereal and rarefied atmosphere rendered in cool tones. Even in the most "realistic" paintings a solid but well-composed elegance prevails, as well as subjects of a lofty and refined painterly character.

Following pages:
Horses of tragedy, ca. 1936,
Albert C. Barnes Foundation, Philadelphia.

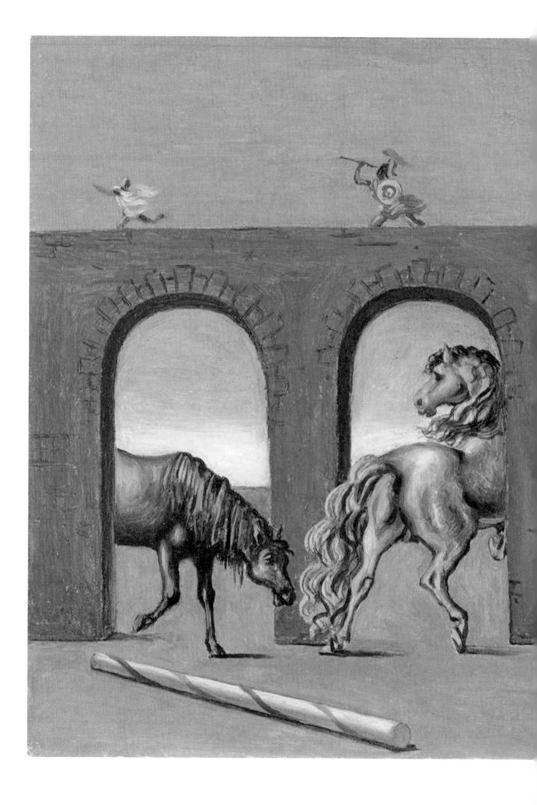

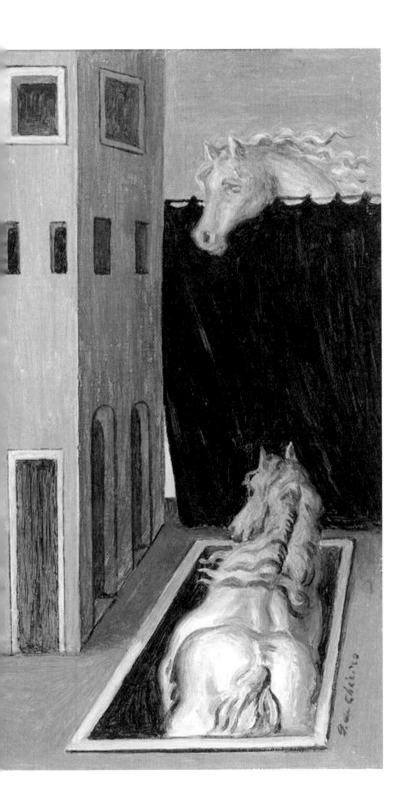

The Poetical Dreamer, 1937,
Israel Museum, Jerusalem.

26. Between 1938 and 1940: Omens of War

Upon returning to Europe, de Chirico stopped in Rome where he was struck by fascism's renovation of the city: the monumentality and beauty of Via dell'Impero made an impression on him (as it also had done on Le Corbusier), as well as the other architectural projects that were transforming the capital into a modern city.[1] His sense of surprise momentarily caused him to revise his opinion of fascism, although it is not certain whether this was out of a desire to avoid problems with the regime or was owed to genuine convictions. He decided to settle in Milan but also traveled to Paris and London in order to oversee exhibitions of his work. He promptly resumed such activity, organizing three successful solo shows in Milan, Genoa, and Venice. The mysterious elegance of his new approach was noted by the critics and was also appreciated by those who had been unimpressed by the experimental works of "realism" displayed at the 1935 Quadriennale,[2] the final major Italian exhibition in which the artist had participated prior to his departure for America.

But de Chirico's "aesthetic" appreciation of the regime would not last long, his perception of fascism undergoing a marked change once the racial laws were promulgated in November 1938. That same month he moved once more to Paris with his new companion Isabella, who was Jewish. The turbulent existence of that period is remembered with dramatic words in the artist's *Memoirs*:

> In the meantime, black clouds were growing denser in the sky over Europe. The destructive wing of the Spirit of Evil extended also, with inexorable gloom, over Italy. Mussolini had gone to Germany and had come back full of evil plans, perverse desires, intolerance, cruelty and sadism. The notorious racial laws were passed. . . . These so-called "decrees for the defence of the race" brought to the surface many obscure feelings, much wretched pettiness and much servility which, although cultivated during long years of dictatorship, still lingered deep down in the hearts of so many. . . . But the atmosphere in Italy was more unbearable than ever. In Rome some dear, witty friends, including

Dioscuri, 1938,
whereabouts unknown.

Frightened Horses, ca. 1938,
private collection.

Warrior at Rest with Horse Drinking at a Stream (Tranquillity), 1938–39, private collection.

Horseman with Red Cap and Blue Cape, 1938,
La Galleria Nazionale, Rome.

Man with Cap, 1938,
private collection.

the producer Anton Giulio Bragaglia, started the rumor that I and my brother Savinio were Jewish and they would say with a hypocritical air of concern, "What will the poor de Chirico do now?" In order to stop living in a country from where all humanity, dignity, civility, conscience, and shame had been completely banished, we decided to go back to Paris.[3]

In Paris, de Chirico returned to his study of ancient paintings in the Louvre. Paradoxically (but understandably) the encircling drama compelled him to seek out a timeless oasis, an Arcadia in which painting turned increasingly inward. The study of painting technique once again became a source of profound fascination, and not only on a theoretical basis, as on previous occasions: "This was the first step toward the conquest of great painting."[4] But Paris also soon became a restless city, menaced by war: "In the meantime the winter had ended and the fatal year 1939 had begun; spring came, then summer; the atmosphere became red-hot, charged with electricity; war was in the air, imminent. . . . Frightening rumors began to circulate."[5] De Chirico decided to leave Paris, fearful for his fate as a foreigner in a land that would soon become enemy territory, but above all for the fate of his Jewish wife. Initially, they traveled to Cannes; yet while a decentralized city, it still felt too dangerous as a consequence of the bombardments to which it was subjected, and they decided to move to Vichy. However, shortly thereafter Italy also entered the war, and the idea of being dispatched to a concentration camp impelled Giorgio and Isa to return to Milan. They were stopped in Nice but eventually obtained permission to cross the border thanks to the friendship of a collector of de Chirico's work.

27. The War Years

Having returned to Italy from France at the end of 1939, threatened by the war that had already begun and would soon also involve Italy, de Chirico settled in Milan with Isabella, where he remained until October 1942 when he moved to Florence to escape the bombing. In that period, he had worked out a painting technique he called "emulsion" (that he had begun to study in Paris in 1938): an elaborate method that tended to make the surface vivid and the painting pastes liquid and rich (allowing for veiling), but at the same time created a solid and compact chromatic fabric. The results were displayed at the 1942 Venice Biennale, where a large hall was dedicated to his work. The Italian critics seemed unable to grasp the significance of his move toward a theatrical and baroque form of art, which emphasized painterly effects, exotic subject matter, posed portraits, still lifes and landscapes, and horses and knights. Ultimately, this new direction was entirely personal and unique in the wider European context (with the exception of Balthus, as mentioned), and was more disquieting than the work of any avant-garde figure. Libero De Libero was one of the few to recognize its greatness.[1] In his 1942 monograph on the artist, Raffaele Carrieri also considered this now obvious change of direction at length, one that coincided with a dramatic psychological introjection[2] induced by the war, an intimate, solipsistic, and visionary colloquy, a form of mystical asceticism:

> De Chirico now thinks, imagines, and works within the limits of this sumptuous matter as he previously thought and imagined with geometry and perspective . . . he paints everything with the same intensity. He paints golden armor against the variegated backgrounds of tapestries, he paints feathers, fruit, horses, the Milan Cathedral, as well as the landscape seen from the window of his studio. The studio is his world. . . . The creator of *The Disquieting Muses* now goes in search of ripe peaches and theatrical costumes as subjects for his works. . . . He paints portraits. He paints self-portraits. He dresses up like a Pasha, wearing a turban of satin and pearls, because satin and pearls are difficult to paint. He paints Astolfo on the hippogriff. He paints three oranges. He paints everything.[3]

Moving around Milan, Florence, and Rome, the artist spent the war years engaged in industrious but also introverted and somewhat sporadic research, external events and constant shifts of location forcing him to experience periods of almost total inactivity. It was during his time in Florence and Milan that a specific interest in sculpture took root. In 1940, an *Ariadne* appeared as an illustration for his theoretical essay "Brevis pro plastica oratio" (Short Speech in favor of the Sculpture)[4] and was the first sign of the new endeavor, born of contact with his antiquarian friends, the Bellinis (at whose home he often spent holidays and who intended to produce a series in bronze). His

Self-Portrait (in Eastern Costume), late 1939,
private collection.

Facing page, top to bottom:
The Friends, ca. 1940,
La Galleria Nazionale, Rome.

Andromeda Freed by Perseus, 1941,
private collection.

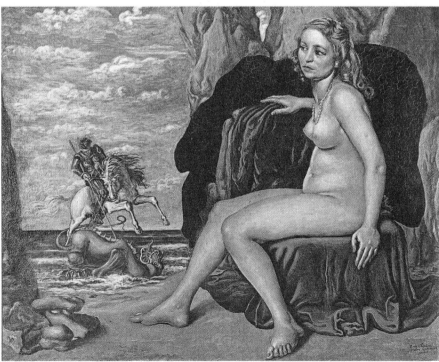

Still Life with Basket of Apples, 1940,
Galleria d'Arte Moderna di Palazzo Pitti, Florence.

work in terracotta was guided by the sculptor (or better, molder) Alietti.[5] It
was a rhabdomantic and profound discovery:

> The sculptor is the creator par excellence. . . .The sculptor is freed from the
> chore of neutralising the emptiness of the line. He excavates to pull from the
> block of clay or marble, with the instinct of the dowser, he begins to forage,
> and already that which is within, the wonder, the divine toy that will bring pure
> joy and the highest amusement in him and in other men, his brothers, begins to
> simmer on the surface, begins to move, to stir, like marble that awakens after a
> long sleep. . . . If a sculpture is hard, it is not sculpture. Sculpture must be soft
> and warm; as such, it will not only have all of painting's softness, but all of its
> color also. A beautiful sculpture is always painterly.[6]

In fact, the form of his sculptures is soft with painterly chiaroscuro.

In March 1941, at the Barbaroux gallery in Milan he showed this first pro-
duction in which some of his favorite themes were rendered in three dimen-

The Plucked Goose, 1941,
private collection.

sions: Archaeologists, Horses and Horsemen, Hector and Andromache. Un-
doubtedly, the continuation of the war made it difficult to create sculpture,
but certainly the desire to reify his visions, to transform his painted statues
into real statues, must have remained a constant in the artist who, from 1966
onward until his death (without counting the famous sculpture-fountain,
Mysterious Baths, created for the exhibition *Contatto Arte/Città* for the
XV Triennale in 1973, in Milan's Sempione Park) made a series of bronze
sculptures, modeled in clay,[7] that constitute a special chapter in his artistic
activity.[8]

In Florence, he elaborated a new technique similar to emulsion but more
effective: "The new technique I was using achieved better results than those
produced with emulsion. It was with emplastic oil that I painted my famous
self-portrait in the nude, which is perhaps the most finished painting that I have
carried out so far."[9] At the end of 1943, de Chirico settled in Rome, a city he had
lived in many times at various stages of his life and that he would never again

Hippolytus and his Horse, 1940,
private collection.

Previous page, top to bottom:
Ariadne, 1940,
Fondazione Giorgio e Isa de Chirico, Rome.

Archaeologists, 1940,
Fondazione Giorgio e Isa de Chirico, Rome.

Hector and Andromache, 1940–66,
Fondazione Giorgio e Isa de Chirico, Rome.

abandon. It is with this technique that he executed a series of paintings in Rome in 1944, which he exhibited: "I began to work again. After that long interval I really needed to do so. I had a small exhibition in the Margherita Gallery."[10] In this second postwar period, de Chirico began a new neo-baroque painting phase characterized by a ruffled and rapid *ductus* technique. This followed a long and meditated journey of over ten years that began with the *Brief Treatise on Painting Technique* in 1928 and continued through the 1930s but only took form, even from an ideological point of view, after the war. It was Velso Mucci, an Italian writer and close friend of de Chirico's, highly cultured and friend of the surrealists, who in 1945 identified the starting point of this new painting phase in an updated reading of Schopenhauer. The study underlined the artist's profound philosophical reflection (with such precision as to suggest a direct discussion between the two), as well as a conceptual and idealistic turning point that is anti-naturalistic, in continuity with the philosophical sources that had generated metaphysical art: "Schopenhauer's famous page on the metaphysical sense of certain calm still lifes and landscapes by Dutch painters has provoked in de Chirico a 'feeling for the object' made, or rather created, with the pure mastery of art, through craft that 'serves' inspiration and feeling. With regard to this subtler and more qualitatively painterly 'metaphysical art' than that of his very famous works, I will deal with at more length."[11]

This is the passage by Schopenhauer mentioned by Mucci, which fully expresses the sense of de Chirico's procedure:

> Consequently a great injustice is done to the eminent painters of the Dutch school, when their technical skill alone is estemeed, and in other respects they are looked down on with disdain, because they generally depict objects from everyday life. . . . The inward significance is the depth of insight into the Idea of mankind which it discloses, in that it brings to light sides of that Idea which rarely appear. This it doesa by causing individualities, expressing themselves distinctly and decidedly, to unfold their peculiar characteristics by means of appropriately arranged circumstances. In art only the inward significance is of importance; in history the outward. The two are wholly independent of each other; they can appear together, but they can also appear alone. . . . Even the fleeting nature of the moment, which art has fixed in such a picture (nowadays called *genre painting*) excites a slight, peculiar feeling of emotion. For to fix the fleeting world, which is for ever transforming itself, in the enduring picture of particular events that nevertheless represent the whole, is an achievement of the art of painting by which it appears to bring time itself to a standstill, since it raises the individual to the Idea of its species.[12]

In Schopenhauer, we clearly find expressed in almost the same words de Chirico's own ideas regarding contemporary critical tendencies that were averse to him at the time.[13]

Still Life with Fruit and Castle, early 1940s,
private collection.

Regarding what has already been said about de Chirico's "theatrical" art,
it should be noted that he published his aforementioned article on the the-
ater in 1942. The timing was extremely significant, for it was precisely at
that moment that the artist's first self-portraits in costume began to appear,[14]
representing an intensification of the baroque tendencies in his painting. At
the 1942 Venice Biennale he exhibited a *Self Portrait in Bullfighter's Costume*
(1941) and published a *Self Portrait in 16th Century Costume* (1940) in Car-
rieri's monograph,[15] while in 1943 he presented a similar *Self Portrait in
Costume* at the Rome Quadriennale. From the refined technique and the
internalized, distant, and mythical atmospheres of the late 1930s and early
1940s, de Chirico now plunged dramatically into a world of fantasy, dress-
ing up in explicitly theatrical costumes. This throws the viewer somewhat,
for such costumes do not appear in any way justified or explicable in terms
of the works' "antique" settings or mythical subject matter. In this way the
painter commenced his true "baroque" phase, creating a sense of disorien-
tation by means of manifestly artificial imagery that created, as Mucci ob-
served, a "subtler and more qualitatively pictorial sense of the 'metaphysical'
than that of his very famous works." His strictly contemporary comments
regarding the theater are illuminating in this context:

Battle near a Castle, early 1940s,
private collection.

We love "the unreal." We love everything that reminds us of our life, but "is not our life"; we love fiction. . . . The real aim of the theater is to satisfy the need we feel for fantasy and fiction and to give us a way of escaping from reality. . . . The theater is born from our need of a supernatural world. Organized in honor of the gods, such pantomimes and festivals are the cornerstones upon which the theater was built. These pantomimes tried to represent a world beyond, to be identified with it, to satisfy our desire of touching and seeing the invisible, of being immersed in mystery and of having one's doubts dispelled. Theater arose from these primordial sentiments, which have always obsessed humanity. . . . we ask theater to pretend to be life, an unreal life, without start or finish like in fables in which the authors conclude their stories with admirable fineness specifying that the heroes they have spoken of will continue to live right up to present times and further.[16]

The beginning of the "baroque" period was calibrated evenly in relation to metaphysical displacement, the pervasive sense of the theater and the "unreal," the controversy with modernist critics and the surrealists who were unable to see beyond the "unreal," in the profound sense of the metaphysics of the world.

Self-Portrait in 16th Century Costume, 1940,
private collection.

Self-Portrait in Matador Costume, 1941,
Casa Museo Rodolfo Siviero, Florence.

Self-Portrait in Costume (with Paintbrush), 1942,
private collection.

28. Revisiting Metaphysical Works

Indubitably, the aspects that critics contemporary to de Chirico have had the greatest problem with are the replicas he made of metaphysical paintings and his neo-baroque period from the 1940s to the mid-1960s. However, the origin of the critical misunderstanding surrounding de Chirico's work dates to much earlier—that is, to his break with Breton in late 1925 and 1926. It was at this point that a strong anathema was cast against de Chirico both through the media and thanks to Breton's grandiose reseau of international contacts that resulted in the creation of an irrational prejudice from which the artist would never manage to free himself. To this end, he fought intelligently through his art while employing caustic irony in denouncing the vulgar stupidity of this condemnation and transforming its terms of prejudice into paradox.

We have seen how de Chirico made his first replica of one of his metaphysical paintings in 1924, commissioned by Breton: "these replicas will have no defect other than that of being executed with more beautiful materials and a more skillful technique," as he wrote to Breton's wife on March 10, 1924.[1] This was the first time de Chirico had decided to make an exact copy of a previous painting of his. He had, in fact, already taken up themes from his Ferrara metaphysical period again (*The Prodigal Son* [1922], *Hector and Andromache* [1924], *The Troubadour* [1924], *The Philosopher* [1924], etc.), although interpreting these themes in a completely different way and renewal of style, in tune with his current aesthetic intentions. In the 1920s he would make very few other versions of his metaphysical subjects, according to Maurizio Fagiolo dell'Arco, presumably between the end of 1924 and 1926, but more probably between 1925 and 1930, evidently at the request of collectors and gallery owners, or his friends in Paris.[2]

Breton and de Chirico's relationship ended abruptly, and de Chirico was defined at that point by the "pope" of surrealism as a dead man who copied himself. Having been worshipped by Breton, he was now cut off with mortal rancor. Out of a purely commercial falling-out, Breton literally created a metaphysical question.

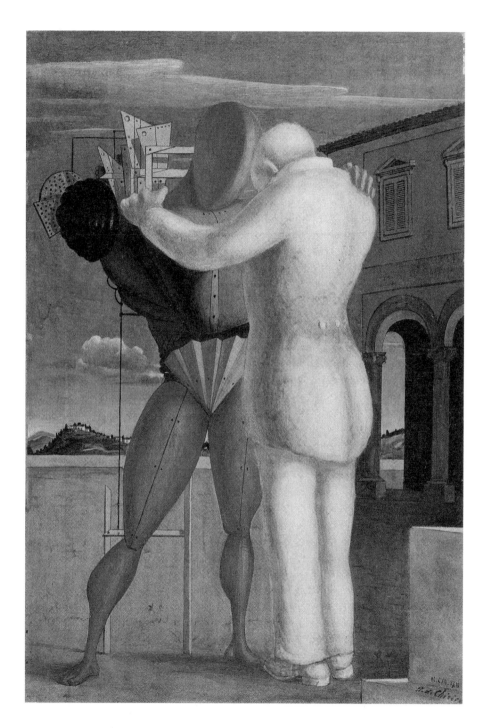

The Prodigal Son, 1922,
Museo del Novecento, Milan.

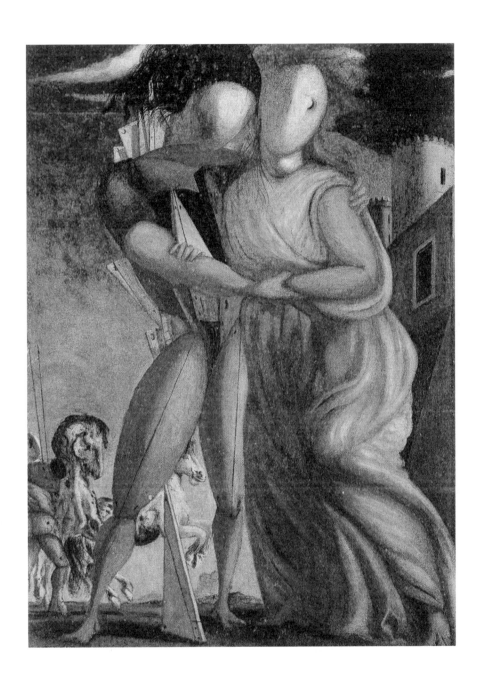

Hector and Andromache, 1924,
La Galleria Nazionale, Rome.

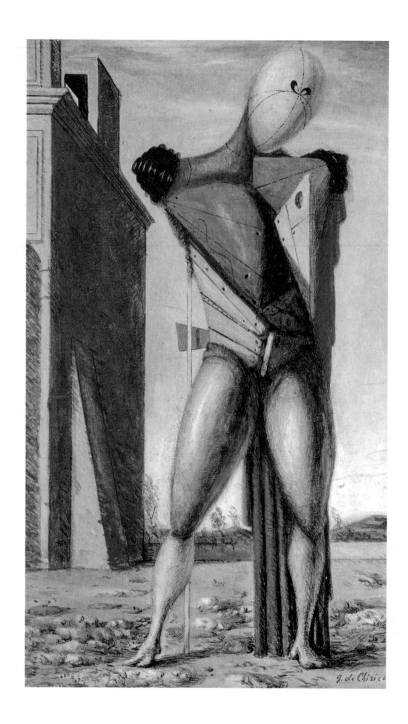

The Troubadour, 1924,
Museum Boijmans Van Beuningen, Rotterdam.

The Pink Tower, ca. 1928–30,
private collection.

From 1926 on, de Chirico initially fought this battle by continuing his research freely with a style that maintained many of the characteristics he himself had bequeathed to the surrealists: the Mediterranean-surreal brand of classicism that would find accord in the work of the *Italiens de Paris*, a group that aimed to consolidate a new idea of modern art inspired by Mediterranean classicism, which would represent an important tendency in the Parisian scene of the interwar years. The artist proudly proclaimed his preeminent role in having opened art up to the realms of the dream and the unconscious (something which not even the surrealists could deny), but did so in his own way, combining a love for classicism with a sparse and deliberately "modern" painterly style, in which only glimpses of older techniques could be perceived. The market thinned out after the terrible crisis of 1929 and de Chirico was no longer selling the quantity of paintings that had previously been requested of him (which he had trouble even satisfying). It was at this point that he probably took into consideration the opportuneness of replicating his metaphysical paintings, for which a more active market existed.[3] He did this, however, convinced of the higher quality of these works thanks to the refinement of his painting technique. It is for this reason that today the later Italian Piazza theme paintings are dated almost *ad annum*, regardless of the date he marked on them: in reality, even when de Chirico intended to mislead a purchaser, such paintings could not be described as

Italian Piazza, ca. 1926–27,
Museo di arte moderna e contemporanea
di Trento e Rovereto, VAF Stiftung, Rovereto.

trompe-l'oeil. In painting these works, de Chirico applied his current technique, while unabashedly emphasizing pride in his technical accomplishments, rather than replicating—as he might easily have done—his technique of the 1910s. In reality, he did use his early technique at times (starting from the mid 1930s), but this was his way of deriding presumptuous collectors who stubbornly preferred his early works to current paintings. Other contemporaries of his similarly adopted this attitude: Sironi, for example, backdated but even paradoxically postdated some of his works[4] that were reinterpretations of earlier periods (his "metaphysical" phase of 1919 that he replicated in the 1940s), thus creating a true chronological labyrinth. Like de Chirico, Sironi was also exasperated by the fetishistic search of collectors: he therefore sought to confuse them by backdating, postdating, repainting, and reworking his paintings. During the 1940s and 1950s (and sometimes even earlier) Carrà and Severini would likewise execute replicas of their more famous earlier works, retrodating them for similar reasons, a practice that reflected a certain disapproval of, or disdain for, those who valued the signature and the date of a painting more than the work itself.

However, during the early 1930s it was still rare for de Chirico to make replicas of metaphysical works (as previously noted, they tended more often to be reinterpretations).[5] Three such works are of particular interest. The first, documented from 1934,[6] is an Italian Piazza scene (*Memories of Italy*, circa 1933), which features a marble statue depicted with the volumetric plasticity typical of the figures of those years. The other two, which appeared in an exhibition of March 1937 in Los Angeles, were certainly painted in Paris between 1934 and 1936.[7] *Egg in the Street* is highly original in terms of its composition; the artist organized the pictorial elements in a new way compared to the works of the 1910s (depicting the Italian Piazza or the Mannequins). Executed in an almost cinematic manner (like the analogous *Plaster Head*), it seems redolent of Hollywood and America, a country he was soon going to know (and may have already begun planning to visit). An expansion of the pictorial space took place, along with a spectacularly elegant simplification of the work's individual elements. The titles themselves—perfectly descriptive rather than evocative—clearly illustrate the prevailing orientation of de Chirico's work.

Between the end of the 1930s and the early 1940s, in concert with the most in-depth technical reflections on (and applications of) "ancient painting," the first examples of mimetic reconstructions emerge, although today they are in fact perfectly distinguishable from the originals. Some of them began to appear in monographs bearing earlier dates—which prior to that had not been seen on replicas—and they can be dated to the late 1930s, around the end

Memories of Italy, ca. 1933,
private collection.

of de Chirico's time in Paris or, perhaps better, to the start of his subsequent Milanese period.[8] The economic difficulties of de Chirico, who was forced suddenly to flee wartime France and move to Milan with his Jewish companion, must have induced him to create a small number of "metaphysical" works so as to ensure economic stability in view of anticipated adversities.

But this production took on real significance in conjunction with an important and singular episode in de Chirico's career. In 1948, an exhibition of metaphysical art was organized at the first postwar Venice Biennale. The organizing committee included Carrà and Longhi, historical enemies of de Chirico (who, in 1945, had written a mocking and disdainful portrait of Longhi in his text *1918–1925 Ricordi di Roma* [Memories of Rome], which was later incorporated into *The Memoirs of Giorgio de Chirico*). The curator was Francesco Arcangeli—Longhi's student and successor at the University of Bologna—who carried out a rather grim and myopic hatchet job, without even consulting de Chirico, and including an obvious fake in the show (as well as publishing just one of his later works in the catalogue: a version of an Italian Piazza painted in the late 1930s, titled *Turin Melancholy*). Still more

Egg in the Street, ca. 1935,
private collection.

serious, if possible, was the attempt to elevate Carrà and Morandi (the latter
was awarded the Biennale prize) by minimizing de Chirico's role and impor-
tance. This anomaly was highlighted by the more attentive critics[9] and crit-
icized by de Chirico himself, opening up a fierce controversy. De Chirico's
authorship of metaphysical art was diminished once again. Moreover, his
works were displayed without his knowledge—in a selection that included
fake paintings—on Italian art's most important stage.

Faced with another attempt to deprive him of an objective primacy, de
Chirico responded by multiplying the images of the metaphysical piazzas,
commencing a vast production in a manner distinct from his prevailing style;
paintings that by means of their diffusion stubbornly attest to the identifi-
cation of the artist with "his" metaphysical art, even in terms of the media.
Unlike in previous years, de Chirico created them using a different, less fluid
technique, as recalled by one of his students, Gerard Tempest, an American,
during the crucial years 1948–49.[10] De Chirico worked along these lines, to
such an extent that the idea of an absolute art that transcends time became
a unique poetic element of his work (the Eternal Return he had read of in
Nietzsche). His replication of the Italian Piazza theme substantially took

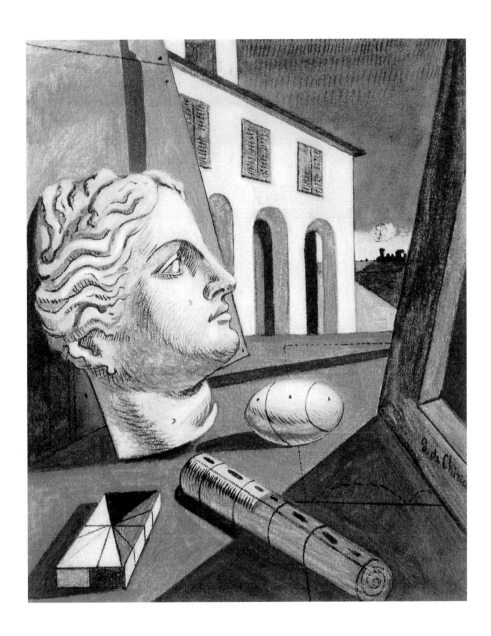

The Plaster Head, ca. 1935,
private collection.

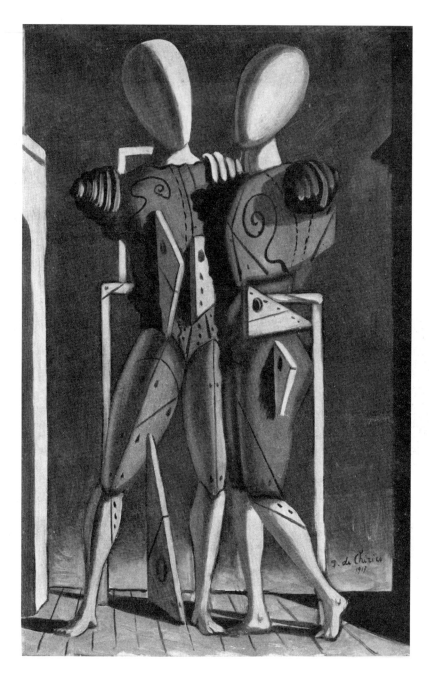

Hector and Andromache, 1938–39, dated "1917,"
private collection.

Facing page:
Turin Melancholy, 1939, dated "1915,"
private collection.

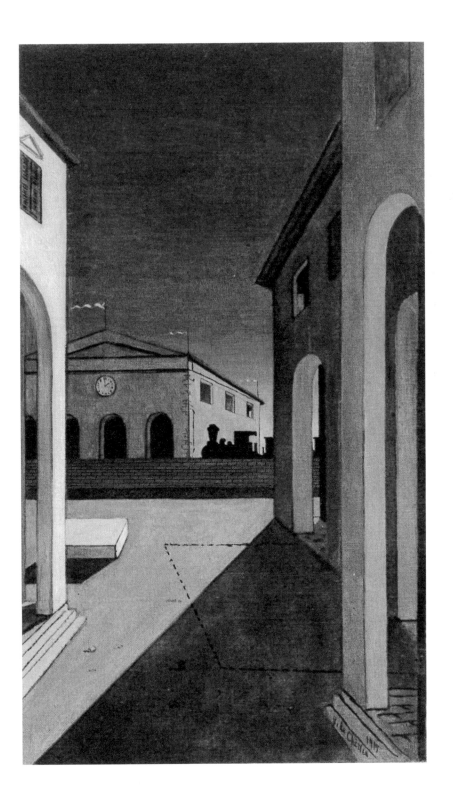

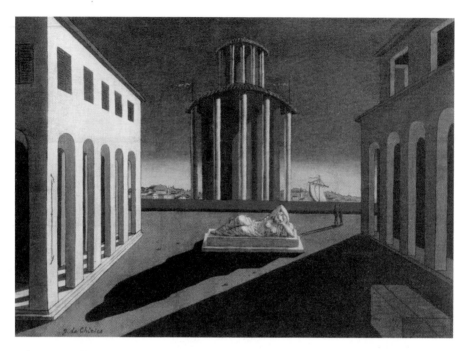

Italian Piazza, early 1950s,
private collection.

place as "pop" images within a world of his own making. The fact that Andy
Warhol made this theme the object of a series of his own works[11] renders
this expression not a mere "sensation" but a true foresight of what would
go on to constitute a highly modern sensibility that endorses process, media
coverage, and even active artistic procedure, centered on "different repeti-
tions."[12] One can identify here a constant and diachronic element with re-
spect to de Chirico's "other" production of a classical and baroque vein. The
fact that he often appended improbable dates to his "metaphysical" replicas
(not only those corresponding to the metaphysical era, but also later ones,
although not the current, actual date of execution) was simply intended to
highlight their perfect contemporaneity, or better, the timelessness of art.
The sale prices of such works were in no way adjusted to the date ascribed
as can be ascertained by the dealings with his art merchants.

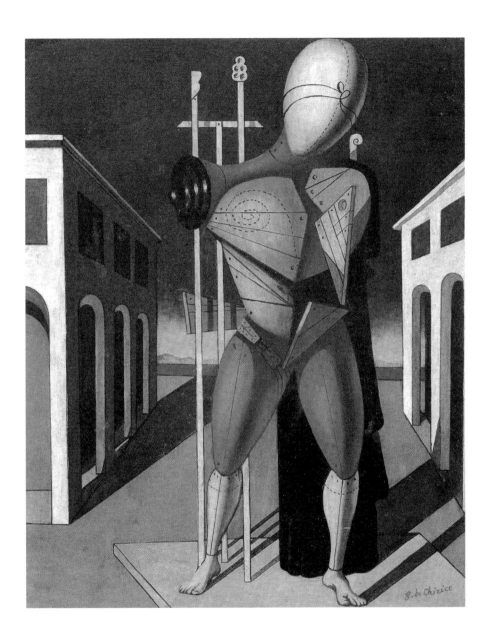

Troubadour, ca. 1948,
Bridgestone Museum of Art, Tokyo.

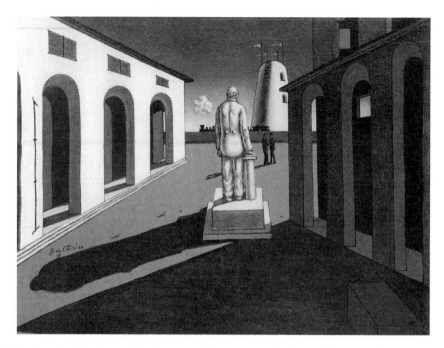

Italian Piazza (with Monument of a Politician), mid-1940s, dated "1917,"
private collection.

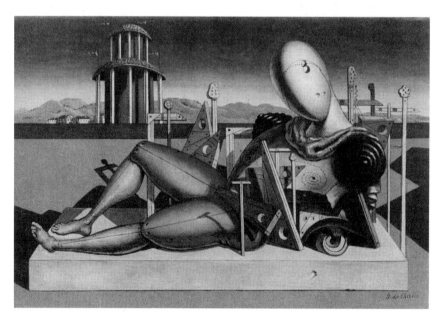

The Tired Troubadour, 1960,
private collection.

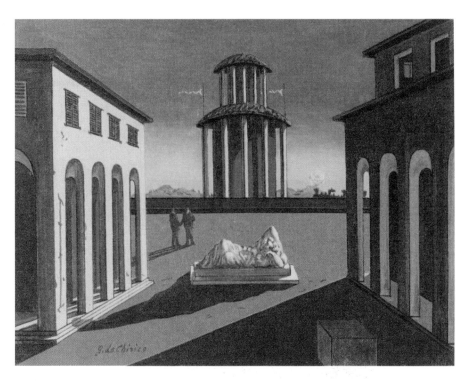

Italian Piazza, ca. 1956,
private collection.

Andy Warhol, *Italian square with Ariadne*, 1982, private collection.

Troubadour, 1955,
private collection.

29. The Postwar Period and the Late Return to Classical Painting: Avant-Garde / Anti-Avant-Garde

De Chirico's so-called neo-baroque period partially coincided with the painting of his metaphysical replicas.[1] At the start of the 1930s, as previously seen, the artist's style and aesthetic conception further evolved toward research focused on painting technique as its prime interest, as he enthusiastically returned to "traditional" painting systems with their alchemical secrets. This occurred with slow progression after his surreal-Mediterranean moment of the 1920s. He radicalized, even polemically so, his research into painting technique, while emphasizing "beautiful painting" as being capable of achieving any aesthetic undertaking, an objective that in itself did not exclude modernity, as why would quality painting be synonymous with an obsolete vision and not, quite the contrary, constitute the prospect of reaching more difficult objectives?

Similar to his "metaphysical replicas," de Chirico's love for classical painting was among the aspects most denigrated and criticized by the surrealists. His experimental application of "pure" or "classical" painting techniques (developed during the *Valori Plastici* period, 1919–22), was put aside for that of a more modern research, even technically speaking, as we have seen. But his passion for technical research returned with polemical verve, first through an interest in Renoir's painting at the start of the 1930s, and a further radicalization toward the end of the 1930s with a more heterogeneous range of direct references including Rubens, Fragonard, and Delacroix, which were more impressive from an iconographic viewpoint. Attention was given to French or Flemish, and Italian baroque rapid brushstroke painting, swift mastery, and an absolute control of the way paint was applied in order to create a brilliant and sumptuous effect.

The process matured over the course of the 1930s with the slowness of an idea entertained and examined at length, its many facets turned inside out and progressively adopted with ever-greater conviction and evidence. Certainly, as has been said, the antagonistic confrontation with the surrealists

Phaeton's Fall, from Rubens, 1945,
Fondazione Giorgio e Isa de Chirico, Rome.

was bound to push de Chirico toward more and more decisive antitheses regarding the surrealists' themes. He underscored an even greater difference to what Breton considered a deviation from his own aesthetic roots. Thus, the polemical aim was the fiery medium in which his reflections were immersed.

In a visceral and totalizing manner, de Chirico emulated the stylistic and painterly experiences of his great colleagues of the past, which he considered absolute and beyond time, and thus replicable to all effects, with that which concerned their stylistic and technical know-how: "At times, while thinking of the great masters, of the Italian, Spanish, French, Flemish, and German painters of centuries past, I imagine them in a symposium confabulating together and narrating one another's efforts in the conquest of the Golden Fleece of mastery . . . , I see the Great Flemish Masters, with the divine Rubens in the center, a master among masters, and the Spanish, the powerful and tranquil Velasquez, and Ribera and El Greco, and further on,

Antiope, from Watteau, ca. 1947,
Fondazione Giorgio e Isa de Chirico, Rome.

Goya."[2] He tended to identify genius with a technique in which the paint was applied through a series of small brushstrokes. In general, he favored the expressive, disdainful exuberance of masters like Rubens, Fragonard, and Delacroix, and the brilliant "light touch" and the impasto rendering of color in baroque painting.

In this, he continued to find a completely unexpected, and only apparently distant, kindred spirit in Pablo Picasso. In Picasso's own postwar painting, he too would continuously draw inspiration from the painters of the past, creating alternative versions of their images that constituted dialogues with, and meditations on, great classical painting (that of Velasquez, Goya, Raphael, et al.). As distant as they were, their paths ran parallel at this moment to a greater degree than might initially seem to have been the case, and de Chirico's scathing appraisals of modern art were never extended to the work of Picasso—the only one of his peers whom he believed to be truly great.

This new "timeless" point of view led him to depict images of pure painterly fantasy, in which reality is not a focus, except in portraits. He sought a traditional "motif" of a painterly quality to express the timeless, Schopenhauerian sense of the artistic imagination. At times when he did paint real

Portrait of a Man, from Titian, 1945,
Fondazione Giorgio e Isa de Chirico, Rome.

places, these were either exercises in painting from life or, more often, city-scapes of famous places like Venice that he chose to portray in well-known and habitual views, thus avoiding any specific representational will. As such, he transformed such places into a *topos*, a commonplace of the collective unconscious: a pure pictorial "motif." De Chirico's places become places of style, of painting and its glorious atemporal nature.

Even the allusion to myth became purely iconographic, a universal and timeless theme that seems removed from the strict context of a single, specific painting with its particular meaning and contextual iconology, toward a decisively "classical" expressive mode, a reference of "style." Even if, in truth, de Chirico only very rarely injected an iconological meaning into his compositions (as in the case of the *Portrait of Guillaume Apollinaire*). Jean Cocteau had already perceived this, with great lucidity, in *Le Mystère laïc* in 1928. To symbolism, and to the allusive representation of concepts, de Chirico always preferred to represent things and places solely with the language of images, giving eloquence to the pure meaning of the composition, just like Picasso. Not so much *ut pictura poesis*, but rather *ut poësis pictura*.

A few words ought to be spent in explanation of this willfully paradoxical and anachronistic position with regard to art history and especially to the history of the avant-garde of which de Chirico had been one of the leading figures up to the 1930s. Paradoxically, the more de Chirico spoke in a polemical vein at the start of the 1940s, a period to which he dated his "discovery of a new painting substance similar to that of the great painting of the past" (in a series of articles published in *L'Illustrazione Italiana*), the more he distanced himself from those very rules he indeed had a perfect grasp of, as is clear from paintings of the early 1940s (and many later ones). It is striking how, from after the war onward, the paintings he claimed were done following the example of classical painting, were actually less elaborated from a "fine painting" point of view, insomuch as they were quickly executed and somewhat neglected in favor of a strictly "old style" iconography. This curious impasse was also perceptively identified by Giuliano Briganti on the occasion of the show at Rome's Galleria del Secolo in 1945:

> At the base of de Chirico's attitude we find the usual artificial, literary, intellectual, and indirect system. The very choice of his sources of inspiration, the anonymous and shoddy painting of small seventeenth- and eighteenth-century battle-painters from the school of Bergognone to Simonini or Diziani, indicates a desired, polemical revolution on the value scale. Not to mention that which is most essential: the quality of the painting. High painterly quality is praised for its beautiful, robust, vibrant, luminous material. But it is exactly here where de

Nude Self-Portrait, 1943 (drapery added in 1949),
La Galleria Nazionale, Rome.

Hippolytus and his Friends on the Shore of the Aegean Sea, ca. 1945,
private collection.

> Chirico's recent work fails miserably. The material is slimy, dead, confused, the brushstroke imprecise, the drawing barely academic, but always mannerist and spontaneous.[3]

A great connoisseur of classical painting, Briganti grasped de Chirico's "intellectual and indirect" system, but he was obviously incapable of fully assessing just how advanced the painter's purely conceptual and "avant-garde" procedure was at the time. At the end of the war, de Chirico's outlook on "classical painting" had become a philosophical idea, rather than a technical one. At the same time, it was a method for *épater les bourgeois*, and especially his enemies and detractors. The informed lowering of painterly references, from Rubens to that "anonymous and shoddy painting" that Briganti spoke of (regarding which de Chirico's theoretical awareness derived from Schopenhauer), marks a precise conceptual intent that imposes a model of pure iconographic allusion and avant-garde gesture, in which the work is the thought it implies, not the object itself. An almost Duchampian diversion, or rather, a true premonition more than twenty years before the coming of conceptual art. The fierce controversy with his "modernist" an-

The Philosopher's Attic, 1945,
private collection.

tagonists that began precisely from the moment when Breton's stance, on
the one hand (with Soby's book of 1941), and that of Longhi and Venturi,
on the other (Longhi with his attempt to diminish de Chirico's role in the in-
vention of metaphysical art at the Biennale of 1948; Venturi with his "mod-
ernist" disapproval), were pushing him into a corner where he felt like a lion
trapped in an arena.

It is here that we find the ultimate paradox of de Chirico, a devilishly sub-
lime genius, surrealist and dadaist *ante litteram* and polemicist to the end, who
declared the opposite of what he really meant. And perhaps one should inter-
pret the entire period he spent in heroic resistance to the post–Second World
War avant-garde in this light, that is to say, in an absolutely dadaist sense much
in line with his character, which always concealed more than it revealed his
deepest sources of inspiration. His seventeenth-century-style painting of later
years, stimulated by a Schopenhauerian impulse for "timelessness" in paint-
ing—literally causing "time to be immobile," as explained above with regard

Facing page:
Self-Portrait in Black Costume, 1948,
La Galleria Nazionale, Rome.

Horses Frightened after the Battle, ca. 1945,
private collection.

to Velso Mucci's thoughts on Schopenhauer—paradoxically became a means
to outrage and irritate his adversaries, and is actually a neo-dadaist, conceptual
action. This key of a "reverse" reading of his work comes to light in the artist's
own words in 1941, at the very moment he commenced this practice:

> Understand who may, but such is my nature. And if those who do not under-
> stand are many, it is not my fault; it is the fault of futile and distracted men who
> do not know how to look inside the work of the creators. They do not know
> that to understand certain mysteries it is necessary to change one's approach;
> frontal attacks are a vain waste of energy. They do not know that to understand
> certain exceptional creations of the human spirit one must start searching from
> behind the work. Never look pointedly at the surface in hope of advancing into
> the depth. One must start from the side, from behind, in order to gain the sur-
> face and the front of the stage.[4]

He seems to have embraced, in a specific repertoire, all the iconographic
elements the current avant-garde had rejected as outrageous garbage: myth-
ological scenes, painterly decorativism (silks, velvets, pearl necklaces, etc.),
pleasant landscapes with horses and figures, conventional views of Venice,

Roman Landscape, 1945,
private collection.

Villa Falconieri, 1946,
Fondazione Giorgio e Isa de Chirico, Rome.

Following pages:
Villa Medici, 1945,
private collection.

g. di Chirica

realistic portraits in period costume. His painting became a meticulous and well-thought-out iconographic catalogue of the anti-avant-garde, carried out in spite of the new pontiffs who inveighed against him, he who had actually invented the avant-garde and influenced much of the century's art. Something similar had been contrived by Francis Picabia, the other great genius of dadaism and de Chirico's fellow Nietzschean, in various series of works (like the *Españolas* or the stereotyped, kitschy *Nudes* and figures of the 1940s). Both artists seem to be mockingly saying: we are geniuses, whatever we do will always bear the stamp of genius. Like Picabia, de Chirico seems to declare, in alternating metaphysical replicas and baroque paintings, that "one must be a lot of things" against the dominating cipher of the contemporary, prevalently monotonous and recognizable.[5]

The neo-baroque is a style that de Chirico initially created based on his research into "classical painting." Indeed, it was not foreign, but rather, implicitly linked to current debates or taste-oriented considerations taking place in certain Parisian avant-garde circles (that included Guillaume, as mentioned, Balthus to a certain extent, as well as critics such as Waldemar George, Eugenio d'Ors, and others). De Chirico would later defend the neo-baroque style as a purely conceptual act with respect to the new avant-garde, which would paradoxically decline into controversy. In the 1950s and 1960s, it became an emblem, an explicit act of scorn toward those who held him in disregard. Hence, in contraposition to contingent circumstances and the lack of myth in contemporary art, de Chirico transformed intrinsic myth into atemporal, classical mythology, delivered in a technique that at that point held within itself the entire conceptual abstraction of an avant-garde act.

30. The 1950s and 1960s: *Pictor classicus sum*

Having taken shelter in Milan and Florence during the war years—marked by the fear of racist fascism threatening his Jewish companion, Isabella—de Chirico elaborated an introverted style in dialogue with the ancient masters, with theatrical fiction in a clear search for an Arcadia that would enable him to escape the disasters of the war and the violence of the dictatorship. The creation of a secluded and distant poetic world was also evident in his continuous theoretical reflections, such as those concerning still life. In an article of 1942—a year full of ruminations regarding the definition of a new pictorial world—focused on this genre, de Chirico suggested that the Italian term *natura morta* (which translates as "dead nature") should be renamed *vita silente* as in English ("still life"), with a significant shift of poetic and semantic meaning: "In the German and English language 'natura morta' has another name that is far more beautiful and correct. This name is *Still leben* and *Still life*: 'vita silenziosa' [still life]. It refers to a genre of painting, in fact, that represents the silent life of objects and things, a calm life, without sound or movement, an existence that expresses itself by means of volume, form, and plasticity. In reality, the objects, the fruit, the leaves are motionless but could be moved by the human hand or by the wind."[1] In this way, still lifes were created, immersed in landscapes, enclosed within interiors, arranged by human hands, and moved by a gust of intimate, Arcadian poetry, beyond time and contingent circumstances: scenes and theaters of an intimist quality that resisted all psychological or programmatic influences and rejected the idea of progress as artistic evolution held by the upcoming avant-gardes, particularly those hostile to his work.

Following the war de Chirico established himself in Rome, which was to be his adopted city until his death. Once settled in his apartment in Piazza di Spagna, the incessant wanderings that had characterized the whole of his restless life came to a halt as he approached sixty years of age. The subsequent twenty years would see the development of his "baroque" painting in the baroque city, but it would not be an easy period. However, the snub he had received at the 1948 Biennale was immediately counteracted by his appointment to the position of Honorary Associate of the Royal Society of British Artists (in place of Édouard

Still Life with Small Tomatoes, ca. 1948,
Musée d'Art Moderne de la Ville de Paris, Paris (Isabella Far Bequest).

Still Life (Fruit in the Country), ca. 1955–56,
private collection.

White Horse in the Woods (Arion), 1948,
La Galleria Nazionale, Rome.

Angelica Freed by Ruggiero, 1949,
private collection.

Vuillard); this was followed in 1949 by a major exhibition celebrating his work
at the Royal Academy of Arts in London. He received numerous other honors
from overseas, being appointed to the French Academy in 1974 and awarded
the title of Grand Official of the Federal Republic of Germany in 1976.

But these were also years that saw his trenchant positions on modern art
and the critics who supported it subjected to attacks and contempt from that
very sector (in which the ideas of Breton and his friend Soby had become
widespread). De Chirico responded to those positions by increasingly em-
phasizing his caustic and dadaist spirit, raising the intensity of his affirmations
and scandalizing the right-minded with his extremist positions: a true clash of
ideologies. His statements were not always effective; indeed, their imbalance
made his comments regarding the revival of tradition seem an extreme form
of outmoded conservatism, although this was perhaps psychologically under-
standable, given the embattled position in which he found himself. He also
undertook controversial actions that inevitably had limited success. Such was
the case of the "antibiennial" of 1950, which he organized as a gesture of de-
fiance toward the Venetian institution that had insulted him two years earlier,

Angelica and Ruggiero, ca. 1950,
La Galleria Nazionale, Rome.

Landscape with Horsemen and Peasants, mid-1950s,
private collection.

and against which he had filed a lawsuit due to the forgery that had been ex-
hibited there. This took the form of an alternative exhibition, presenting his
work and that of some of his other painter friends[2] at the prestigious Circolo
Canottieri Bucintoro (near Piazza San Marco in the neoclassical Palazzina del
Santi in the royal gardens on Fondamenta Todaro). A brochure was printed
to accompany the exhibition titled *Biennale a fuoco* [Biennial on Fire]. This
caused a certain amount of alarm when its title was shouted by town criers,
causing people to think that a real fire was underway, in a pure dadaist act.
However, the text of the brochure contained little more than a series of gener-
ic criticisms of the Biennale[3] that trivialized his ideas somewhat.

At times, de Chirico's mischievous spirit seemed to relish this continuous
and brutal tactical battle, inflamed by a brand of polemics that makes one think
not only of dadaism but also of futurism. The "burning" of the Biennale is rem-
iniscent of the latter movement's manifesto against Venice, and its call for the
destruction of museums. However, another source of controversy provided a
much more distressing diversion: the question of forgeries of his work. The fal-
sification of de Chirico's paintings was a thorn that profoundly afflicted the art-
ist. He began to take legal action around this time, although by that point it was
perhaps too late; however, as we have noted, his previously peripatetic lifestyle
had not allowed him to pay continuous and dedicated attention to the matter.

Venice—Rialto Bridge, mid-1950s,
private collection.

In a *Report to the Chief of Police*, a typescript to which de Chirico per-
sonally contributed, he described in a broader "environmental" context the
framework of falsifications to which he was a victim. Yet by 1967, when the
report was drawn up, the market was already tragically polluted. De Chirico
denounced the beginning of the forgery of his work during the period 1926–
30, under the aegis of surrealism (although in my opinion this had start-
ed even earlier, between 1921 and 1922, when the surrealists—above all,
Breton—acquired the possibly unfinished material from de Chirico's aban-
doned Parisian studio, and completed it in order to make it more salable),[4]
as he himself underlined in another autobiography:

Following pages:
Venice—San Giorgio Island, mid-1950s,
private collection.

Still Life with Objects on a Table, 1959,
private collection.

The opening of the flood gates and the invasion of fake de Chirico's occurred after the end of the last war. An exercise of psychological preparation preceded this shady offensive. This psychological preparation dates back many years, all the way to the period following the other world war when in Paris, the surrealists, who had bought paintings of my metaphysical manner at extremely low prices, tried a coup similar to what merchants and collectors did with the paintings of Henri Rousseau, known as "Le Douanier." In fact, when the surrealists in Paris started their campaign to boost (the price, naturally) of works of mine in their possession, I was still in Italy where I stayed until 1925. The surrealists thought that I would never return to Paris, in which case they would have been able to create the "de Chirico legend" which, with exquisite naturalness they called "the Chirico case" and by dropping the pronominal particle "de," they pronounced "Shericò." This Mr. Shericò, who had been duly inflated in the material interests of the Breton gang was, according to the affirmations of this gang, supposed to have a sort of hallucinated mind, be a visionary, in a certain sense also an idiot, who during the few years he spent in Paris between 1911 and 1915 painted a series of "illuminations" of which they, the surrealists, held the exclusive rights and monopoly.[5]

De Chirico reported cases of this kind on several occasions during the 1920s and 1930s, which appeared above all in surrealist contexts, but as he pointed out: "The opening of the flood gates and the invasion of fake de Chirico's occurred after the end of the last war." In June 1946, the Galerie Allard in Paris mounted an exhibition in which twenty of the twenty-eight paintings on show were fake metaphysical works by surrealist Óscar Domínguez, an associate of Breton. De Chirico declared them to be fakes, but his claims were dismissed as the ravings of a madman. A number of these had belonged to the surrealists for some time, as was proved by a photo of Éluard in his apartment taken around 1940.[6] Evidently the issue was now widespread and profitable, and it was preferable to discredit the artist. Today, Domínguez is unanimously recognized as having been responsible for the counterfeited works, as reported by de Chirico.[7] However, Breton profited from the scandal some years later, insinuating that de Chirico had ordered the forgeries (naturally without naming names, given the clear involvement of the "surrealist gang" in the matter) and then declared them to be false, in order to obtain financial recompense from galleries in return for his silence: a truly funambulist and "surreal" version of events.[8]

Self-Portrait in a Park, 1959,
Fondazione Giorgio e Isa de Chirico, Rome.

Following pages:
Alexander's Landing, ca. 1958–62,
Fondazione Giorgio e Isa de Chirico, Rome.

Island with Floral Wreath, 1969,
Fondazione Giorgio e Isa de Chirico, Rome.

But there were not only forgeries of metaphysical works. In March 1947, an exhibition of de Chirico's recent works opened at the Acquavella gallery in New York. Organized by Giuseppe Bellini, in partnership with Robert Haggiag and Gustavo Ayò, the exhibition catalogue was printed in Italy by Bellini, and only reproduced some of the works that were on display, according to custom. Viewing them upon their return to Italy in 1963, de Chirico declared a number of them to be fakes. And they certainly were (I have examined these personally, with the label of the Acquavella gallery on the back, and they are almost perfect copies of the original works published in the catalogue). Evidently someone had replaced the authentic paintings with forgeries before sending them to New York. A dispute arose with Bellini,[9] who was apparently innocent of any wrongdoing; Haggiag also seems to have been uninvolved. Yet someone was responsible for it, ruining a thirty-year friendship with Bellini, who himself began to be suspicious of de Chirico.

In 1948, the scandal of the Venice Biennale occurred, outlined in chapter 28. On that occasion, the forgery of a *Troubadour* was exhibited, which

belonged to the collector Franco Marmont,[10] and came from the exhibition of fake works mounted at the Galerie Allard in Paris, where it had recently been displayed (listed as no. 23 in the catalogue). But instead of apologizing to de Chirico, the organizers of the Venice show—above all, Longhi—inveighed against him, arguing that the artist did not recognize his own paintings. From that moment on, this assertion influenced the opinions of the international artistic establishment, as Wieland Schmied remembers.[11] However, recalling a meeting with James Thrall Soby in the 1970s, shortly before the latter's death, Schmied reported that the American critic had changed his opinion on the matter: "We should pay attention to what de Chirico himself has said. In cases where he declares a picture attributed to him to be false, he is generally right."

These facts reveal just how insidious the issue of forgery was in relation to the most famous Italian painter of the twentieth century. De Chirico made his own lucid examination of the matter in the aforementioned report to the chief of police:

> Careful attention must be given to the forgery enacted on the work of maestro Giorgio de Chirico, as this forgery is, without doubt, of great relevance. In the first place, it should be noted that this forgery dates back many years. It began in France between the years 1926 and 1930 when his work had already reached a significant market quotation due to the attention it received by merchants such as Paul Guillaume and Léonce Rosenberg. At this time a number of fakes, often fairly well executed, were introduced into the market, fakes which today, after many years, are imported from France and validated as authentic for having been part of one or another collection. One of such fakes was recently exhibited in a big international exhibition in Strasbourg and even published in the catalogue (one must presume in good faith). The painting belongs to the [missing text] Gallery of Zurich, one of the most important in Europe. Years ago the art dealers Fratelli Russo, owners of the gallery by the same name in Piazza di Spagna in Rome, thought that a somewhat safe defence against forgery could consist in a notary public authentication of maestro Giorgio de Chirico's signature on the back of the canvas of paintings acknowledged by him as authentic, from his early production and especially his more recent production, since such paintings are of a greater number. It must be noted that the kind of guarantee thus devised is quite unique as it seems to be a practice no other artist has ever used. The formula used for the authentication was the following: I, Mr. Diego Gandolfo, Notary Public of Rome, certify as true and authentic the above signature of maestro Giorgio de Chirico, born in Volos, 10 July 1888 and domiciled in Rome, the identity of whom I am certain, appended in my presence without witnesses as agreed, with the title "X.Y." written by de Chirico himself. Thus the notary public authenticated the signature written by

The Folly of Horses, 1947,
published in the catalogue of the
de Chirico exhibition held at Acquavella
Gallery in New York in 1947.

Forgery of de Chirico's work, *The Folly of Horses*, 1947,
presumably exhibited at the de Chirico exhibition held at Acquavella Gallery in New York in 1947.

Back of the previous painting with a sticker from the Acquavella Gallery in New York.

Óscar Domínguez, *The Troubadour*,
fake painting exhibited as a work by de Chirico at the Venice Biennale of 1948 (cat. no. 24).

Óscar Domínguez, *Telephone and Revolver*, 1943,
private collection.

de Chirico on the back of the canvas and at times even the title, although he did not authenticate the painting itself nor the signature on the front. Besides the inadequacy of such an authentication, it offered the forgers new opportunities to produce fakes: 1) by trying to obtain a notary public's authentication on the back of a white canvas on which a fake could then be painted. This is the so-called system of the double canvas. The forgers would go to de Chirico or to the Fratelli Russo with an authentic painting placed deftly on top of a white canvas. The maestro would sign and the notary public would place his round stamp on the back of this canvas, although what they saw before them was actually overlapping the authentic canvas. 2) by appending a fake notary public authentication on the back of a fake painting. It has been proven that Notary Public Gandolfo, who authenticated the greatest number of Giorgio de Chirico's signatures on the back of his paintings, had to acknowledge on a few occasions his own handwriting, signature, and stamp as fake. It turns out that the repertory numbers have not always been false, which proves that the forgers were well informed. The writers of this note are not aware whether Notary Public Gandolfo ever proceeded to denounce the falsification of his signature on the back of Giorgio de Chirico's paintings. 3) by playing on the multiplicity of equivocal information and the eventuality of errors of evaluation committed due to such confusion, which the maestro himself may have incurred, in order to substantiate the thesis: "No fake Giorgio de Chirico paintings exist," and that it is more than sufficient that the notary's authentication corresponds to the inventory number XX in order to ascertain, even if the author is of the opposite opinion, that a specific painting is surely authentic.

Meanwhile, even if for a year now the maestro no longer uses this method of notary authentication, fake Giorgio de Chirico works continue to proliferate and, even those made recently, continue to be accredited on the market by passing from one gallery to the next, where the price goes up at each passage. There are cases of paintings declared false by Giorgio de Chirico that have arrived from France or the United States of America, which have undergone up to 7 passages from one merchant to another before reaching the private buyer who is misled (where he felt guaranteed) even by the documentation of such passages.

Generally speaking, fake de Chirico paintings can be classified in three groups: 1) of old execution (styled on works of the 30s; in the United States these were made by a certain Corbellini; in France by affirmed artists such as Domínguez, among others) with subjects known as "metaphysical" or on the theme known as the "archaeologists." 2) recent, made in Italy, some crudely executed, others by more expert hands using a method of projection of authentic works in order to copy a piece in its entirety or in some of its detail: various subjects from "horses" to "horsemen," from "gladiators" to "archaeologists," a few Venice's and a few still lifes; 3) very recent metaphysical subjects such as "Italian Piazzas" and "Mannequins" recomposed with elements from various well known

works stuck together. An important fact (indicated for what it's worth) concerns, for example, a photographer by the name of De Pretore of Rome, who maestro de Chirico entrusted in the past to take photographs of many of his works. The photographer claims to no longer have the group of negatives of these photographs in his archive. It is quite a peculiar situation, but since no law exists prescribing the photographers of artwork to guarantee the safekeeping of such negatives, makes it impossible to take legal action against De Pretore. This is another sector in which the legislator should afford greater rigour regarding regulation.[12]

Especially in later years during the compiling of the General Catalogue, when faced with having to appraise paintings through photographs (as was the procedure at the time), de Chirico may have made mistaken assessments of a few works. His opinion is, however, something to which careful attention must always be given. It must also be noted that a small number of authentic, documentable works have been declared fake by the artist. It is not always easy to understand the dynamics of such stances and a specific and careful study on this aspect is needed for clarification, to the extent that this is possible. It is necessary to say that for a few of these works (for example, *The Revenant*, 1918–22, sold to Breton) unclear circumstances appear that may suggest motivations on the part of the artist: the date 1918, as seen, is clearly inappropriate in regard to certain areas of the painting. The fact that it was owned by Breton, a mortal enemy, could have motivated in de Chirico a personal act of revenge, even for an authentic work he had conceived and executed (moreover, Breton did not conduct himself in a transparently ethical way toward the artist). In conclusion, it is probable that for each of these works de Chirico had a specific reason, above and beyond a reasonable doubt or even error (the majority of works were, as stated, judged on photographic material in later years: written in the artist's hand on the back of numerous photographs kept in the foundation's archive, one reads "see the original" noted in the artist's handwriting). It could be that, feeling powerless in front of a generalized hostility in his regard, this may have seemed the only way to lay claim to the matter and settle accounts that were either secret or overtly apparent such as the reworking of the paintings he had left in his atelier in Paris, described above.

31. The Final Years: The New Metaphysical Phase and the "Eternal Return"

During the last period of de Chirico's painting, the last years of the elderly genius's life, myth reappeared with a nostalgic and allusive significance that was no longer polemical. The battle, which we have defined as "neo-dadaist," and which saw his anti-modernist polemic complemented by an equally polemical neo-baroque painterly style, had led him to an angry reprisal and exasperation of terms, to the point of distorting the very nature and interpretation of his youthful work, which he reclaimed and updated, in defiance of his adversaries. However, the 1960s revealed a greater tranquility on de Chirico's part. This was not explicit, but we do find significant traces of it in his paintings as well as in several of his statements. A good example of this is his assessment of Cocteau. As noted, the avant-garde interpretation that the latter had made of the artist's work in *Le Mystère laïc*, and which de Chirico had certainly shared at the time, was directly challenged in his later *Memoirs*: "I am very grateful to Jean Cocteau for the interest he has shown in me, but I must say that I do not in fact approve the kind of praise he accords me and the interpretation he gives my paintings."[1] However, when a request was made for a brief text for an exhibition in England in 1976, he expressed a different view, transcribed here from the original typescript held in the foundation archives:

> I met Jean Cocteau in Paris in 1926. I must say we became friends very quickly. He was very interested in my painting and later wrote two books about my art which demonstrated great understanding for what I was doing. He was a man gifted with great intelligence and a poetic imagination that was out of the ordinary. He was also a very talented playwright. He possessed an exceptional understanding for the mysterious aspect of my paintings and above all understood the mystery of the Mysterious Baths. He was a brilliant conversationalist but was always sincere and one sensed that he felt deeply about what he said. The news of his death has caused me great sadness.[2]

With the aggressive polemics of the mid-1940s and 1950s behind him, de Chirico expressed his sincere opinion, thereby revealing the extent to which

Return of Hebdomeros, 1973,
Musée d'Art Moderne de la Ville de Paris, Paris (Isabella Far Bequest).

Ecstasy, ca. 1968,
private collection.

Metaphysical Interior with Hand of David, 1968,
Fondazione Giorgio e Isa de Chirico, Rome.

The Remorse of Orestes, 1969,
Fondazione Giorgio e Isa de Chirico, Rome.

The Sadness of Spring, 1970,
Fondazione Giorgio e Isa de Chirico, Rome.

the controversies had been underpinned by programmatic and a priori factors. It can be seen as a posthumous act of reparation in regard to Cocteau, and a sincere judgment on the real interpretation of his paintings, beyond the anti-modernist polemic, which had a purely instrumental, conceptual— and we would say today—*ante litteram* "process art" significance.

Another episode reveals an even profounder change of course in de Chirico's thought and painting. From 1953, de Chirico was bound by contract to the La Barcaccia gallery, owned by the Russo brothers of Rome, with whom he had worked since the late 1940s. Those were the years of his most acute objection to modernist positions (both critical and pictorial), and he undertook to supply three paintings and a dozen watercolors each month to his gallerist friends.[3] This commitment coincided with an existential and polemical *furor* that inspired such sustained activity—mainly in the context of "baroque"

Orpheus the Tired Troubadour, 1970,
Fondazione Giorgio e Isa de Chirico, Rome.

The Meditator, 1971,
Fondazione Giorgio e Isa de Chirico, Rome.

Figures over the City, 1970,
Fondazione Giorgio e Isa de Chirico, Rome.

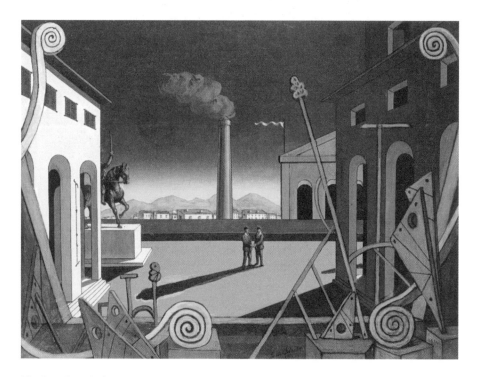

The Great Game (Italian Piazza), 1971,
private collection.

Sun Temple, 1971,
Musée d'Art Moderne de la Ville de Paris, Paris (Isabella Far Bequest).

paintings—conceived as a reification of that hostile attitude he exhibited toward his detractors. However, toward the mid-1960s this acrimony, and consequently, his extremist positions, increasingly began to lessen. Evidently, a contract binding de Chirico to a production of this kind,[4] and of such a sustained nature, which in former years had represented a committed conceptual act, came to be considered a burden by the artist, and a weight from which he intended to free himself. And in fact he did so, unilaterally breaking his contract in 1968,[5] as a consequence of which he was forced to pay the Russo brothers a very high penalty—over sixty million lire, which in today's money corresponds to around 700,000 euros. In order to pay it, de Chirico established a new short-term contract with another dealer, the Milanese Bruno Grossetti, to execute twenty-five Italian Piazzas (of which he would in fact only complete eighteen). But at this point the artist was completely free to choose the quantity and the quality of his output. He would not abruptly abandon his expressive baroque style (although he would in fact move away from it considerably over the following years), but would begin a new, very free pictorial and poetic phase.

Thermopylae, 1971,
Fondazione Giorgio e Isa de Chirico, Rome.

Mystery of Manhattan, 1973,
Fondazione Giorgio e Isa de Chirico, Rome.

The Muses of the Opera, 1973,
Fondazione Giorgio e Isa de Chirico, Rome.

The Venetian Decorators, 1973,
Fondazione Giorgio e Isa de Chirico, Rome.

From the second half of the 1960s, de Chirico took up once again the
themes of metaphysical art's heroic era of his painting and graphic work
of the 1910s, 1920s, and 1930s, in a completely new and original manner,
which Calvesi termed "new" metaphysical art and which today is known as
"neometaphysical art."[6] Myth returned to vividly animate the scenes of these
paintings, which are strong autobiographical visions. In this light, cues from
the style that he himself had invented are playfully taken up again.

There is a painting that more than others gives us the key to this auto-
biographical aspect, hidden behind the immanent Greek myth, which had
accompanied him all of his life: *The Return of Ulysses*. A room, very similar
to those of his Paris paintings of the 1920s, with an armoire and armchair
(they, too, taken from his repertoire) and a chair that would, in fact, suit
his Piazza di Spagna home. In the center is a sea, small as a rug, on which

Metaphysical Interior with Profile of Statue, 1962,
Fondazione Giorgio e Isa de Chirico, Rome.

Ulysses's ship is propelled by oars. On the left wall hangs a metaphysical painting from his first, heroic Parisian youth. On the right wall there is a window, in the distance we see a small Hellenic temple, a childhood memory. In the background is a half-closed door behind which lies darkness. It is a simple autobiographical memory, fresh and intense, openly Homeric: de Chirico-Ulysses-Hebdomeros traveled and navigated throughout his life, and as an elderly man now distinguishes in the distance, from a window, his Greek childhood; on the wall is a metaphysical painting, symbol of his important discovery; he sails toward something that is not fearsome, simply the opaque darkness of Hades, which hides behind the half-open door (like in Greek and Roman sarcophagus and funerary steles). In the end, the large sea of life is as small as a rug, and the entire route full of adventure, dangers, and knowledge, has no greater size or meaning than a journey in a room. Myth wraps up the meaning of a sequence of events that had begun as myth.

The beginning of this new phase in de Chirico's art dates from around 1968, coinciding precisely with the end of his contract with the Russo brothers, and a remarkable nucleus of paintings bearing this date demonstrates that the themes of his metaphysical years were taken up once more and reinterpreted

The Return of Ulysses, 1968,
Fondazione Giorgio e Isa de Chirico,
Rome.

Metaphysical Interior with Sun Turned Off, 1971,
Fondazione Giorgio e Isa de Chirico, Rome.

in an entirely new and "postmodern" sense. But in reality this type of reelaboration had its roots in an earlier period. A painting titled *Metaphysical Interior with Profile of Statue*, dated 1962, quite faithfully adopted the iconographic elements of the metaphysical paintings dating from de Chirico's Ferrara years, but a number of details distinguish it from the later "replicas": the marble bust viewed through the room's window and the "chocolates" in the foreground, transformed into abstract decorative plaques, in which references to past iconographies are playfully distorted, producing a completely new sort of graphic "game." The metamorphosis of the metaphysical aesthetic into a new style had therefore incubated over a long period in the mind of the artist, and if metaphysical themes were apparently favored in this process of profound reinvention, he actually incorporated the path of his artistic life in this revolutionary reorientation. From the themes close to surrealism of the 1920s, to those of the 1930s (*Mysterious Baths*, *Calligrammes*, ancient figures on stages,

Mysterious Spectacle, 1971,
La Galleria Nazionale, Rome.

beaches, or the fragile architectural trellises of theater sets), and the baroque knights and landscapes with castles of the 1940s and 1950s, transformed into dark and zigzagging entities. The theatrical character, something that de Chirico had continuously explored in his numerous installations and set designs, became the basic language of these scenes, in which the mystery of life is hidden in a theatrical *pièce* redolent of Pirandello's or surrealist ambiguity, where the subject appears with the fragility of a painted backdrop, on ambiguous stages open to the real world, in which indefinable and indecipherable passions unfold. Dark and nocturnal suns, powered by mysterious electric cables, observe other illuminated suns, impassive moons, and landscapes of ruins like impenetrable characters. Shadows of knights fight impossible battles. Unknown characters are enveloped by more indecipherable entities of the metaphysical troupe, as if by ambiguous and irresolvable thoughts. Modern cities that bear similarities to New York become the backgrounds of hotel rooms inhabited by gods. An iconography that is as new and original

Battle on a Bridge, 1969,
Fondazione Giorgio e Isa de Chirico, Rome.

as it is perturbing, despite being rendered with domestic familiarity, seems to complete the cosmic arc of a tragic and ambiguous century. Also his pictorial texture is getting clearer and more transparent, airy, leaving behind the thick and reworked matter of his baroque phase. Layers of opalescent colors are now veiling his canvases in a modern and fast technique, reflecting the taste of the very contemporary painting of the 1960s: Schifano, Festa, and Warhol, in a certain measure, but also recalling his rapid manner of the second half of the 1920s. A pearl-like luminescence emanates from his new paintings.

The first public presentation of these late works took place in 1968, in the monograph published by the artist's wife, Isabella Far.[7] Immediately afterward, they were exhibited at Galleria Iolas in Milan[8] and at the large monographic exhibition held in 1970 at Milan's Palazzo Reale;[9] they were subsequently displayed in numerous exhibitions throughout the world (New York, Toronto, Tokyo, Kyoto, Paris, Brussels, etc.), universally establishing the artist's final stylistic phase.

Return to the Ancestral Castle, 1969,
Fondazione Giorgio e Isa de Chirico, Rome.

The Mystery of a Hotel Room in Venice, 1974,
Fondazione Giorgio e Isa de Chirico, Rome.

Head of Mysterious Animal, 1975,
Musée d'Art Moderne de la Ville de Paris, Paris (Isabella Far Bequest).

Regarding these paintings Calvesi wrote: "Among the first Metaphysical Art and the 'new' Metaphysical Art, there is, if you wish, the same difference between a miracle and sleight of hand. . . . In the mind of the old de Chirico, memories of his metaphysical images flock together and, as so often happens with memories, that which is remembered is evaluated differently, from a point of view that has transformed in the meantime."[10] He also rightly emphasizes the explicit and substantial relationship with pop art:

His characters, his mannequins, his objects, and architectures have actually become toys, and the sense of play—which was also secretly latent in a corner of his early metaphysical art—now triumphs as a wholly new creative key, vitalized by an absolute awareness of freedom and mastery of his own poetical and even psychic world; by which he is no longer overcome but of which he has become the undeceived director; or, if you like, the puppeteer of a show rich in surprises; the conjuror of well known secrets. We are in the years in which Pop Art, a true vision of art that in some way resolved itself in

Philip Guston, *Pantheon*, 1973,
private collection.

play, is affirmed throughout the West. More than being influenced by it, de
Chirico successfully entered into a singular and probably unaware harmony
with this climate, due to the virtue that every great talent has to interpret his
time but also to look beyond. Indeed, there is no doubt that his proposition
outpaces the 1960s to announce the "postmodern" of the decades to follow.
Neither is it by chance that young Italian "Pop" artists such as Tano Festa,
Mario Ceroli, Lucio Del Pezzo, and Mario Schifano have looked upon de
Chirico with interest.[11]

But what emerges most clearly from these scenes of subtle and indeci-
pherable ambiguity is the nonsense of life and how play—if it is indeed a
matter of play—holds within itself a cosmic, profound, obscure melancholy
that is, deep down, both stoic and serene.[12]

De Chirico's final period recalls, in fact, that of Picasso, who also once again took up figures, themes, and styles of his extremely rich past, assembling, disassembling, and reassembling them with a sense of play backed by the certainty of his path. The images he had invented became a repertoire to tap into with the insouciant vigor of a genius creator coming to terms with a life drawing to a close. The immense wellspring of the images created, which had marked one of the principal paths of the twentieth-century avant-garde, now enters paradoxically into a dialogue with a "postmodern" vision; a vision in which architects, artists, and designers come together with the playful knowledge of being paramount heirs of a civilization, bearers of elements of the past crystallized in memory and in culture. As critic Lorenzo Canova notes: "It is not by chance that de Chirico chose to return to a low-key technique for these works by means of a luminous chromatic laying on of color that emphasized the design of the project. This intentionally simplified manner made more space for the Idea and for the vibrant revelation of new Metaphysical Art that revealed many of contemporary art's conceptual solutions in advance."[13]

From Andy Warhol to Mario Ceroli, Mario Schifano, Philip Guston, David Hockney, Giulio Paolini, and Sol LeWitt; from Aldo Rossi to Michael Graves, from Louis Kahn to Philip Johnson, and to the theater of Robert Wilson, the supreme vision of the metaphysical art has never ceased to be a source of inspiration, and to nourish imaginations that have sought to access the ineffable power of ancestral memory and dream.

Notes

Introduction

[1] *Giorgio de Chirico: Catalogue of Works (1912 to 1976)*, vol. 1 (Falciano: Maretti, 2014); *Giorgio de Chirico: Catalogue of Works (1910 to 1975)*, vol. 2 (Falciano: Maretti, 2015); *Giorgio de Chirico: Catalogue of Works (1913 to 1976)*, vol. 3 (Falciano: Maretti, 2016); *Giorgio de Chirico: Catalogue of Works (1913 to 1975)*, vol. 4 (Falciano: Maretti, 2018).

[2] Maurizio Calvesi, *La Metafisica schiarita. Da de Chirico a Carrà, da Morandi a Savinio* (Milan: Feltrinelli, 1982).

[3] *La Metafisica. Museo documentario*, exhibition catalogue edited by Maurizio Calvesi, Ester Coen, and Giovanna Dalla Chiesa (Bologna: Grafis Multimedia, 1981).

[4] Maurizio Fagiolo dell'Arco, *Giorgio de Chirico: Il tempo di Valori Plastici 1918–1922* (Rome: De Luca, 1980).

[5] Id., *Giorgio de Chirico: "Le rêve de Tobie" 1917—Un interno ferrarese e le origini del Surrealismo* (Rome: De Luca, 1980).

[6] Id., *Giorgio de Chirico: Il tempo di Apollinaire. Paris 1911–1915* (Rome: De Luca, 1981).

[7] *Giorgio de Chirico: Parigi 1924–1929. Dalla nascita del Surrealismo al crollo di Wall Street*, edited by Maurizio Fagiolo dell'Arco (Milan: Philippe Daverio, 1982); the volume was expanded in a later work: *De Chirico: Gli anni Venti*, exhibition catalogue edited by Maurizio Fagiolo dell'Arco, Galleria dello Scudo, Verona 1986–87 (Milan: Mazzotta, 1986).

[8] Id., *De Chirico: Gli anni Trenta* (Milan: Berenice, 1991) (new edition Milan: Skira, 1995); later republished in an updated edition: Maurizio Fagiolo dell'Arco, *De Chirico: Gli anni Trenta*, exhibition catalogue edited by Maurizio Fagiolo dell'Arco, Galleria dello Scudo and Museo di Castelvecchio, Verona, 1998–99 (Milan: Mazzotta, 1998).

[9] Giuliano Briganti, "I nuovi falsari," in *La Repubblica*, September 6, 1984; Giuliano Briganti, "Non passo e chiudo," in *La Repubblica*, September 18, 1984.

[10] *Giorgio de Chirico: Pictor Optimus*, exhibition catalogue edited by Fabio Benzi and Maria Grazia Tolomeo Speranza, Palazzo delle Esposizioni, Rome, 1992–93, and Palazzo Ducale, Genoa, 1993 (Rome: Carte Segrete, 1992).

[11] The second volume of the catalogue was published to accompany the fine monographic exhibition curated by Pia Vivarelli at Rome's Galleria Nazionale d'Arte Moderna in 1981, which sought to treat the biographical and bibliographical aspects of de Chirico's life and work in a philologically accurate manner; however, the exhibition also reflected the reductive nature of art historical attitudes toward de Chirico's activity following the Second World War.

[12] The numerous previously unpublished letters that have proved to be of fundamental importance in reconstructing the artist's career, in addition to de Chirico's correspondence with Breton, include: Léonce Rosenberg, Julien Levy, Guillaume Apollinaire, Olga Resnevich Signorelli, Luigi Bellini, and Cornelia Silbermann, et al.

[13] In addition to the republication of de Chirico's writings (*Giorgio de Chirico: Scritti/1 Romanzi e Scritti critici e teorici. 1911–1945*, edited by Andrea Cortellessa, edition directed by Achille Bonito Oliva [Milan: Bompiani, 2008]), see Eugenio Bolognesi, *Alcestis. A Ferrara Love Story: Giorgio de Chirico and Antonia Bolognesi* (Falciano: Maretti, 2016); Victoria Noel-Johnson, *De Chirico and the United Kingdom (c. 1916–1978)* (Falciano: Maretti, 2017; *Giorgio de Chirico: Lettere 1909–1929*, edited by Elena Pontiggia (Cinisello Balsamo: Silvana Editoriale, 2018); Riccardo Dottori, *Giorgio de Chirico: Immagini metafisiche* (Milan: La nave di Teseo, 2018), dealing with the artist's relationship with philosophy.

[14] Paolo Baldacci, *De Chirico: 1888–1919. La Metafisica* (Milan: Mondadori, 1997), English

translation *De Chirico 1888–1919: The Metaphysical Period* (New York: Bulfinch, 1997).

[15] *La Metafisica. Museo documentario*, exhibition catalogue edited by Calvesi, Coen, and Dalla Chiesa.

[16] Maurizio Fagiolo dell'Arco, *L'opera completa di de Chirico 1908–1924* (Milan: Rizzoli, 1984).

[17] James Thrall Soby, *Giorgio de Chirico* (New York: Museum of Modern Art, 1955), 97, 117, 159.

[18] See, for example, Nicol M. Mocchi, *La cultura dei fratelli de Chirico agli albori dell'arte metafisica. Milano e Firenze 1909–1911* (Milan: Scalpendi, 2017), in which hypothetical data presented as fact is combined with distorted historical evidence in order to endorse baseless convictions, being discussed and interwoven in such a long-winded manner as to tangle the threads of authentic evidence. For this reason, the present volume only refers to established facts, often without commenting on them with needlessly long exposition.

[19] It seems decidedly paradoxical that without the support of any proof (the only piece of evidence seeming to give his position any credence having been demonstrated to be false), he could continue to maintain a point of view that is not backed up by anything factual.

[20] See "The Constants of History—Old and Recent Falsification of Giorgio de Chirico's Artwork. Paolo Baldacci: A Case Study," in *Metaphysical Art* 11–13 (2014): 321–45.

[21] The Fondazione Giorgio e Isa de Chirico holds a very clear letter from Wieland Schmied, dated October 31, 2013, in which the scholar states that the fake painting *La Mélancolie du départ* dated "1913," therefore passed off as being a work from the early metaphysical period, had been included in the exhibition without his approval (see *Die andere Moderne: De Chirico, Savinio*, exhibition catalogue edited by Paolo Baldacci and Wieland Schmied, Düsseldorf 2001 and Munich 2001–2 [Berlin: Hatje Cantz Verlag, 2001], cat. 25, 214). Baldacci's most significant contribution to the study of de Chirico's work (and perhaps the only one that is correct) is without doubt the exhibition catalogue he edited titled *Giorgio de Chirico. Betraying the Muse: de Chirico and the Surrealists* (New York: Paolo Baldacci Gallery, 1994).

[22] Testimony to this is found in the collection of 462 letters regarding the artist's professional and personal life recently published in the volume edited by Pontiggia, *Lettere*.

Preface: "Eternal Return" / "Eternal Avant-Garde"

[1] Maurizio Calvesi, "Giorgio de Chirico and 'Continuous Metaphysics,'" in *Metafisica* 5–6 (2006): 29.

[2] In another famous self-portrait of 1920 he would inscribe the question: "*Et quid amabo nisi quod rerum metaphysica est?*" (*And what will I love, if not what is the metaphysics of things?*) thus clarifying the relationship between the "enigma" and the "metaphysics of things," or "metaphysics" *tout court*.

Chap. 1
Education in Greece

[1] The family name Cervetto has clear origins in Genoa. On Gemma's death certificate (issued the day after her death on June 14, 1937), her place of birth is given as Genoa, daughter of Augusto Cervetto and Margherita Rossi. It must be taken into consideration that this document was issued shortly prior to the Italian racial laws going into effect in Italy, a period in which the de Chirico brothers were suspected of having Jewish origins. This circumstance may have caused the family to "Italianize" her birth (I thank Paolo Picozza for sharing this unpublished document with me). Nevertheless, in a period of a less tense nature, Jean Cocteau recalled: "Mrs. de Chirico is from Genoa, as is Mrs. Picasso" (*Le Mystère laïc. Giorgio de Chirico: Essai d'étude indirecte* [Paris: Éditions des Quatre Chemins, 1928, 7]).

[2] On de Chirico's family, see Giovanna Dalla Chiesa, "Verso i luoghi della formazione. Atene: scenario dell'anima. Monaco: strumento della Bildung," in *De Chirico nel centenario della nascita*, exhibition catalogue edited by Maurizio Calvesi, Museo Correr, Venice, October 1, 1988–January 15, 1989 (Milan-Rome: Mondadori-De Luca), 50–58; Nikolaos Velissiotis, *La nascita della "Metafisica" nell'arte di Giorgio de Chirico* (Milan: Centro Ellenico di Cultura, 2011); Paolo Picozza, "Evaristo de Chirico," in *Metafisica* 11–13 (2014): 111–28; Nikolaos Velissiotis, "The Origins of Adelaide Mabili and Her Marriage to Giorgio de Chirico: Restoration of the Historical Truth," in *Metaphysical Art* 11–13 (2014): 88–110. Gerd Roos's book, *Giorgio de Chirico e Alberto Savinio. Ricordi e documenti. Monaco Milano Firenze 1906–1911* (Bologna: Bora, 1999), which also examines the Greek period, is a confused collection of notes and documents, of-

ten erroneously interpreted. The book is generally unreliable insomuch as it tries to interpret the two brothers as if they were twins of the same age, by attributing the experiences of one to the other without considering that, in the period examined, their ages are: Savinio fourteen to fifteen and eighteen to nineteen and Giorgio seventeen to eighteen and twenty-two to twenty-three years old. Anyone can understand that the experiences, readings, reflections, and intuitions of a fifteen-year-old (Savinio) cannot be compared to those of an eighteen-year-old (Giorgio) who had at the time spent three years studying at the Athens Polytechnic. Baldacci (*De Chirico 1888–1919*) presents discordant information about the family's origins, besides attempting a psychoanalytic analysis (pp. 18–19). I personally am aware, due to family circumstances, of de Chirico's amorous adventures when he was around seventy years old that contradict the "psychoanalytic-sexual" fantastic interpretation that Baldacci presents. In addition, the recent discovery of his unknown love story with Antonia Bolognesi during the Ferrara and Rome years (1917–19) allows for the drawing of quite different conclusions, as does the even more recent discovery of his passion for Cornelia Silbermann, at the end of the 1920s, without considering his two marriages, first to Raissa Gourevitch and then to Isabella Pakszwer.

3 Alberto Savinio, *Infanzia di Nivasio Dolcemare* (Milan: Mondadori, 1941).

4 Living in Greece, de Chirico obviously wrote and spoke Greek fluently, proof of which is found in a letter to Dimitris Pikionis of 1912 (see Michela Santoro, "Letter by Giorgio de Chirico to Dimitris Pikionis, 1912," in *Metafisica* 7–8 [2008]: 585–88). His mastery of German also implies a level of immersion that allowed for a direct knowledge of Nietzsche and German philosophy in the original language, something that art historians have largely underestimated. Worthy of note is that in his letter to Pikionis, he shows perfect knowledge of both spoken Greek (*dimotiki*) and its cultured form (*katharèvusa*), of which he makes careful and conscientious use, alternating each according to tone. A few small spelling errors (in the difficult transcription of the equivalent phonemes in Greek) derive from his unpracticed use of the language in those years, since his grammar and syntax are perfect (the letter has a refined, correct sound to it).

5 Giorgio had a German-speaking governess from Trieste: see, Giorgio de Chirico, *Memorie della mia vita* (Rome: Astrolabio, 1945), English translation, *The Memoirs of Giorgio de Chirico* (London: Peter Owen, 1971), 16. In a letter to his father dated

April 11, 1895, at seven years of age, he wrote: "I am studying piano and German" (*Lettere*, 15).

6 On Mavìlis, see Alberto Savinio, *Narrate, uomini, la vostra storia* (Milan: Bompiani, 1942); Antonio Triente, "Savinio e Mavìlis: grecità, identità, lingua," in *Notos*, March 2014. https://doi.org/10.34745/numerev_067.

7 Moreover, Palamàs was also a friend of one of de Chirico's art teachers at the Polytechnic, Geòrgios Roilòs, who painted his portrait.

8 Angelo Bardi (pseudonym of Giorgio de Chirico), "La vie de Giorgio de Chirico," in *Sélection. Chronique de la vie artistique* 8 (1929): 21.

9 *Memoirs of Giorgio de Chirico*, 24.

10 Chimneys also stood on Syngrou, not far from the Olympeion. Near Gazi there were also houses of tolerance, which de Chirico was probably familiar with ("Smirneos was 18 years old and frequented the brothels near the gasworks," recalls Alberto Savinio, in "Primo passo," in *Circoli* V, 4 [June 1935]: 434).

11 A panorama of Greek culture in de Chirico's time and the relationship of his family with that milieu is found in Claudio Crescentini, *Giorgio de Chirico. L'enigma velato* (Rome: Erreciemme, 2009).

12 As declared by his mother, Gemma, when she and her son Andrea were interviewed in *Corriere della Sera* on October 19, 1907.

13 For a preliminary investigation, see Fabio Benzi, "L'influenza di Nietzsche e dell'idea di mito immanente in Giorgio de Chirico: Mavìlis e Palamàs e il contesto letterario ateniese all'inizio del XX secolo," in *Storia dell'Arte*, nuova serie 2, 150 (luglio-dicembre 2018): 137–149, English translation: "New Evidence on the Origin of the Influence of Nietzsche and of the Idea of Immanent Myth in Giorgio de Chirico: Mavilis, Palamàs and the Early XX Century Athens Literary Scene," in *Metaphysical Art* 19–20 (2020): 13–26.

Chap. 2
Munich: Between Academic Restrictions and Intellectual Development

1 See Baldacci, *De Chirico 1888–1919*, 23.

2 Although there is a general tendency to attribute this choice to favoring his fifteen-year-old brother Andrea's music studies (see Baldacci, *De Chirico 1888–1919*, 22), it should however be noted that while Munich was unquestionably prestigious for artistic studies, Italy would have been more appropriate for musical ones, which

is how it shortly turned out with his mother and brother moving to Milan in 1907 while Giorgio remained alone in Munich to continue his academic studies. De Chirico spoke of this moment in an interview with Jean José Marchand filmed in 1971 (see "Interview with de Chirico. Archives du XXᵉ Siècle," in *Metafisica* 11–13 [2014]: 287): "MARCHAND: Why did your mother take you to Munich? DE CHIRICO: Because Munich had a reputation then of being a city where painting was highly developed. There was the Munich Secession, which would later influence the Salon d'Automne in Paris. It also had the reputation of being a city where the academy was very important . . . the painting academy of course. MARCHAND: At the Fine Arts Academy you took a course in drawing for several months and then moved on to painting. How did it differ from the Athens Polytechnic? DE CHIRICO: No difference really. The system was the same."

³ Not in Ferrara, as Baldacci states (*De Chirico 1888–1919*, 39–40). In this regard, a recollection of de Chirico's close friend Giorgio Castelfranco is decidedly reliable and will be examined further on in this text: Giorgio Castelfranco, *Introduzione all'arte del nostro tempo* (Chieti: Solfanelli, 2013), 38–39. Castelfranco was a Florentine art historian who was in contact with de Chirico since at least late 1919. He bought many of the artist's metaphysical masterpieces including *The Disquieting Muses*. His testimony is therefore precise and valuable, based on personal confidences induced by a historian's method and at a very early date.

⁴ An undeniable and definitive confirmation that de Chirico in Germany studied and deepened his knowledge of Nietzsche's written works (probably already known to him in Greece) and Schopenhauer, a fact a number of polemical "scholars" have tried to deny, is provided by a clear testimony the artist gave to the Police Prefect in Paris on September 8, 1930, in a previously unpublished document (see Katherine Robinson, "Giorgio de Chirico: lettere a Cornelia. Carteggio inedito [1929–1951]," in *Metafisica* 14–16 [2016]: 146–47), in which de Chirico states, in circumstances that had nothing to do with his artistic activity, that he "had lived in Germany to perfect Greek fine arts and also to study German philosophy, particularly Schopenhauer and Nietzsche." Evidently, these were his true and most profound interests in Munich. He did not even mention his official studies at the academy, which he evidently found rather stifling and did not leave a vital mark on him.

⁵ *Memoirs of Giorgio de Chirico*, 54. The Gartz correspondence (written in German) is published with Italian and English translation in *Metafisica* 7–8 (2008): 521–79. It was published by Gerd Roos in *Giorgio de Chirico e Alberto Savinio*, 421–30, and revealed in advance by Baldacci (*De Chirico 1888–1919*) with serious errors. Not only does de Chirico discuss Nietzsche with Gartz as a topic commonly shared between them (thus necessarily relative to his Munich period, the only time the two spent together), but his *Memoirs* recall that Gartz's brother Kurt, who committed suicide, had an excessive passion for but an unclear understanding of Nietzsche. They must have spoken at length on this subject in Germany, in order for de Chirico to give a similar judgment (see further in this text, note 15).

⁶ Castelfranco, *Introduzione all'arte del nostro tempo*, 83–84.

⁷ De Chirico recalls (*Memoirs of Giorgio de Chirico*, 57) that while he waited for his brother he leafed through a richly illustrated monograph on Böcklin: obviously this does not mean (as some scholars have hypothesized) that he discovered the artist in this circumstance since the famous Schack Collection (which he must have visited as soon as he arrived in the city) had no less than sixteen masterpieces by the Swiss master. De Chirico accompanied his brother in order to translate German for him. (See also Giorgio de Chirico, *Prefazione della mostra di Alberto Savinio*, exhibition catalogue [Milan: Galleria del Milione, 1940]; *Scritti/1*, 880.) The circumstance is an indication of de Chirico's familiarity with German, while his brother lacked even a rudimentary knowledge of the language. This also may be one of the practical reasons for Andrea's move to Italy with his mother in March 1907, only a few months after arriving in Munich.

⁸ See Giorgio de Chirico, "Considerazioni sulla pittura moderna. Parte III. Hans Thoma e Adolfo Menzel," in *Il Primato Artistico Italiano* III, 4–5 (April 15–June 15, 1921); now in *Scritti/1*, 767–73.

⁹ Shortly before de Chirico's stay in Munich, official attitudes toward Böcklin had been established in a volume by Julius Meier-Graefe, *Der Fall Böcklin und die Lehre von den Einheiten* (Stuttgart: Hoffmann, 1905), which excluded him from the list of German academic examples.

¹⁰ Castelfranco, *Introduzione all'arte del nostro tempo*, 37.

¹¹ The manuscript is one of those owned by Picasso (formerly Éluard) dating from 1911 to 1915, now in *Scritti/1*, 611.

¹² Full of contortions and linguistic tampering, Baldacci's attempt (*De Chirico 1888–1919*) to re-

construct de Chirico's early path both during the German period and in the subsequent Milanese and Florentine phases, is completely inadmissible.

13 Except for the summer holidays of 1908, when he returned to Italy.

14 From the manuscript belonging to Picasso; now in *Scritti/1*, 607.

15 *Memoirs of Giorgio de Chirico*, 55. De Chirico recalls that, in his opinion, Kurt Gartz had not grasped the profound meaning of Nietzsche's thought, which he tried to explain to him, "but I felt that he did not understand and would never have understood." Evidently, his own knowledge of Nietzsche was already fairly advanced by this point.

Chap. 3
Milan and the "Böcklinesque" Paintings

1 As noted above, the *damnatio memoriae* of his Munich period production is seen in the fact that the right half of the photograph taken in his atelier, possibly by his friend Gartz in Munich in 1907, had been cut off (Fondazione Giorgio e Isa de Chirico Archives, Rome).

2 Furthermore, a later statement by de Chirico in a concise biographical note, dating from 1962, confirms this version of events (see *Memorie della mia vita* [Milan: Rizzoli, 1962], Appendix). The biography is brief; for example, the Parisian period of 1911–15 is summarized in one sentence: "In Paris he continues and develops his Metaphysical painting" (and is admittedly not free of mistakes, such as de Chirico's visit to New York being dated 1935 instead of 1936). In the passage dedicated to the years 1906–9 we read: "In 1908 he went to Milan [for the summer holidays: July–October 1908, *author's note*]. Still thinking of the paintings of Arnold Böcklin that had impressed him in Munich with their poetic and narrative content and plastic qualities, he painted a series of pictures with a Böcklin-like flavor, portraits of his mother and brother and also self-portraits. He then went to Florence, where he visited the Uffizi and the Pitti Palace. He painted a few more pictures of a Böcklin-like flavor, but under the influence of the works of Friedrich Nietzsche, of whom he was a fervent admirer at the time [in fact, a few lines earlier, he states that in Munich he had already been 'very interested in German literature and philosophy,' obviously referring to Nietzsche, *author's note*], he began that series of pictures which form a prelude to Metaphysical painting." It is clear that the artist associated his Böcklin-inspired works with his definitive return to Italy in 1909 (works that included the *Portrait of the Artist's Brother* of 1910; we have no trace of the self-portraits and the portrait of his mother, unless he was alluding to those later works from the Florentine period) and not with the short Milan vacation of 1908 (indeed, a full stop closes that sentence), since he "still" had in mind those works that had struck him previously "in Munich" (and de Chirico continued to live in Munich until the summer of 1909). Moreover, he consistently dated all his works of this genre to 1909 in the first volumes of the *Catalogo generale*.

3 In *Metafisica* 7–8 (2008): 560.

4 Further proof that this sudden change occurred in Milan rather than in Munich is contained in a subsequent letter to Fritz Gartz, written at the end of 1910, in which de Chirico states: "Do you know for example what the name of the most profound painter who ever painted on earth is? You probably do not have an opinion on this. I will tell you: his name is Arnold Böcklin, he is the only man who has painted profound paintings" (*Metafisica* 7–8 [2008]: 561–62). If de Chirico had already embarked upon his Böcklin phase in Munich, his friend would certainly have been aware of it, and de Chirico would not have had to explain his admiration for the painter in 1910, almost a year and a half after his departure from Germany, as if it were a brand-new revelation.

5 The visit to Rome in October 1909 was particularly important in terms of the architectural elements that would be incorporated into his Parisian works. Additionally, the Italian translation of Nietzsche's *Beyond Good and Evil*, a copy of which de Chirico acquired from an antiquarian in Rome, although he had probably already known of it and read it in German, marked a significant step toward his metaphysical maturity (Crescentini, *Giorgio de Chirico. L'enigma velato*, 58–62).

6 On April 11 he wrote to Gartz telling him he had found an atelier (in Viale Regina Vittoria, not far from his house in Via Lorenzo il Magnifico, where he had been living for a while). In April he had taken books out of Florence's National Library (see further on); in January 1910 he was still in Milan, not in Florence, as Baldacci maintains (*De Chirico 1888–1919*, 86).

7 Contrary to what various authors state, at the time Milan objectively held no important meaning for de Chirico. He limited himself to painting Böcklinesque paintings such as the *Portrait of the Artist's Brother*, and probably helped Andrea in his musical composition, as he would later do

in Florence (letter to Fritz Gartz, December 26, 1910: see Paolo Picozza, "Giorgio de Chirico e la Nascita della Metafisica a Firenze nel 1910," in *Metafisica* 7–8 [2008]; Fabio Benzi, "Giorgio de Chirico e la nascita della Metafisica. L'altra' avanguardia italiana, 1910–1911," in *Secessione e Avanguardia: L'arte in Italia prima della Grande Guerra 1905–1915*, exhibition catalogue edited by Stefania Frezzotti [Rome: Electa, 2014], 68). The date of the letter was correctly identified by Picozza as December 26, 1910, before finding the stamped envelope with the date. In a word, after a trip to Venice for the Biennale, and trips to Rome and Florence, he would decide to move to the latter city where he settled in 1910 (as stated, sometime between March and the beginning of April: on April 11 he was already in Florence). There is no documentary evidence of any particular issues arising in Milan, but rather the desire to leave it for a more suitable city.

8 *Scritti/1*, 607.

9 Once again, Baldacci (*De Chirico 1888–1919*, 68) dates it to the previous year, regardless of the evidence of the date on the painting, solely in order to make it fit his incorrect chronological reconstruction of the period.

10 Ester Coen ("Pensavo ai racconti omerici . . . Carrà/De Chirico 1917–1931 e altri epistolari," in *La Metafisica. Museo documentario*, exhibition catalogue edited by Calvesi, Coen, and Dalla Chiesa) correctly identifies the costume worn by Alberto as that of Hamlet, noting that the de Chirico family referred to the painting as *Portrait in Costume of Hamlet* (whom Nietzsche defines as a "Dionysian man" in *The Birth of Tragedy*). Coen however incorrectly identifies the centaur with Silenus who is never "depicted as a centaur in Greek mythology." Crescentini (*Giorgio de Chirico. L'enigma velato*) instead correctly recognizes the image of the centaur as Chiron. The significance of the Hamlet costume is clearly explained by the event of Alberto's first publication, a short essay of 1910 in the Almanac of the magazine *Coenobium* (published at the beginning of that year, pp. 139–40), the subject of which was a meditation on death that in fact seems to be an evolution [captious, yet evident] of Hamlet's reasoning on being and not being, the fulcrum of Shakespeare's drama: ". . . men . . . fear 'not being' because in the meantime *they are* and they are used to *being*. . . . But, if . . . one imagined an existence in *non-existence* . . . what fear . . . would they experience . . . thinking . . . that they would have to pass from *not being* to *being*: to die, that is, from Death." Giorgio de Chirico's pride in

his brother's first literary achievement (in truth, a rather convoluted text from both a structural and conceptual point of view) led him to represent him symbolically as a "young Hamlet."

11 See note 7; "my brother and I have now composed the most profound music."

Chap. 4
The Florentine Period and the Birth of the Metaphysical Aesthetic

1 "I did more reading than painting. Above all I read books on philosophy and was overcome with severe crises of black melancholy," *Memoirs of Giorgio de Chirico*, 61. De Chirico's words find full confirmation in a fundamental article (Victoria Noel-Johnson, "De Chirico's Formation in Florence [1910–1911]. The Discovery of the B.N.C.F. Library Registers," in *Metaphysical Art* 11–13 [2014]: 137–77), which identifies numerous texts that de Chirico and Savinio (who had decisively different interests) fervently read at Florence's National Library. Paintings, such as *Serenata*—not technically dissimilar to the Böcklinesque ones painted in Milan—can be attributed to this period, works with a "profound" and mysterious aspect when compared with the more explicitly mythological character of earlier paintings. Although no fault is to be found in these works, they are, however, limited. A new glance on the Florentine period, with new evidences, is in Fabio Benzi, "The de Chirico Brothers in Florence (1910–1911). The Musical, Pictorial, Literary, and Philosophical Context," in *Metaphysical Art*, 21–22 [2022]: 15–30.

2 On the exhibition, see Jean-François Rodriguez, *La réception de l'impressionnisme à Florence en 1910: Prezzolini et Soffici maîtres d'œuvre de la Prima esposizione italiana dell'impressionismo francese e delle sculture di Medardo Rosso* (Venice: Istituto Veneto di Scienze, Lettere ed Arti, 1994).

3 Calvesi, *La Metafisica schiarita*.

4 *Ibid.*, 58.

5 For a detailed analysis on this matter and on the importance of de Chirico's knowledge of Rousseau through Soffici and *La Voce*, see Benzi, "Giorgio de Chirico e la nascita della Metafisica," in *Secessione e Avanguardia*, exhibition catalogue edited by Frezzotti.

6 In-depth study of Nietzsche's philosophy certainly dates to his time in Munich, as we have said (even if his introduction to the philosopher occurred in Greece), just as his knowledge of

Böcklin, even if this was only elaborated on in his painting after his move to Milan.

7 Calvesi, *La Metafisica schiarita*, 55–62.

8 Ardengo Soffici, "Divagazioni sull'arte," in *La Voce*, September 22, 1910; see in particular the paragraph titled "Le due prospettive."

9 Calvesi, *La Metafisica schiarita*, 56.

10 Paolo Baldacci, "Giorgio de Chirico e il 'Novecentismo.' Alcune riflessioni," in *Novecento: Arte e vita in Italia tra le due guerre*, exhibition catalogue edited by Fernando Mazzocca (Cinisello Balsamo: Silvana Editoriale, 2013), 372.

11 De Chirico himself recalls how the "vision" of the metaphysical art struck him in the autumn of 1910. From that moment the poetics of autumn, with its long shadows and marblelike light, remains a constant of his poetics.

12 Ardengo Soffici, "Henri Rousseau," in *La Voce*, September 15, 1910: "It has something of the divine about it and if you get up close when you are tired and disheartened by your own intelligence, it consoles you and restores you, as if you breathed the air of an ancient homeland that perhaps would have been better never to have abandoned." Here Soffici seems to almost prefigure de Chirico's theme of "nostalgia" and of the abandonment of the country of his birth.

13 Narrating the birth of his first metaphysical painting, de Chirico recalls how he was physically and morally prostrate and how the vision gave him an "imaging that awakens in our soul, at times surprise, often meditation and always the joy of creation"; now in *Scritti/1*, 652.

14 We will not dwell here on the number of analogies between what Soffici writes in his article on Rousseau and de Chirico's early metaphysical approach, referring the reader instead to Benzi, "Giorgio de Chirico e la nascita della Metafisica," in *Secessione e Avanguardia*, exhibition catalogue edited by Frezzotti.

15 Soffici, "Henri Rousseau," in *La Voce*.

16 Giorgio de Chirico, now in *Scritti/1*, 614.

17 *Ibid.*, 607.

18 Soffici, "Henri Rousseau," in *La Voce*.

19 Giorgio de Chirico, *Une vie*, now in *Scritti/1*, 584, English translation in "Giorgio de Chirico. The Collected Poems," in *Metaphysical Art* 14–16 (2016): 196.

20 *Une nuit*, in *Scritti/1*, 587; *Metaphysical Art*: 197.

21 *Août 1911*, in *Scritti/1*, 591; *Metaphysical Art*: 199.

22 *Une fête*, in *Scritti/1*, 653; *Metaphysical Art*: 202.

23 *Le chant de la gare*, in *Scritti/1*, 652; *Metaphysical Art*: 201.

24 Giorgio de Chirico, *Méditations d'un peintre. Que pourrait être la peinture de l'avenir*, in *Scritti/1*, 649.

25 *Scritti/1*, 625.

26 Soffici, "Henri Rousseau," in *La Voce*.

27 *Scritti/1*, 612.

28 *Scritti/1*, 611.

29 *Scritti/1*, 613.

30 *Scritti/1*, 612.

31 De Chirico, *Méditations d'un peintre*, 649.

32 *Memoirs of Giorgio de Chirico*, 55.

33 Giorgio de Chirico, "Arte metafisica e scienze occulte," in *Ars Nova* 3 (1919).

34 A further reference regarding de Chirico's interest in primitive painters, although much later, is of an extraordinarily concrete significance. It comes from the *Memoirs* of Julien Levy, de Chirico's New York dealer (my thanks to Katherine Robinson for the reference). It was 1936, and de Chirico had just arrived in New York when Levy took him for a tour of the city one evening with Arthur Everett "Chick" Austin Jr. (director of the Wadsworth Atheneum, Hartford): "In Sands Street there is a bar, or was a bar, with murals by a primitive Sunday painter of Italianate name and mysterious de Chirico technique. We ordered beer and drank it while the belligerent barman told us that if we didn't remove our madman friend (Giorgio) who was staring furiously at the murals, he would have to remove one or the other himself. I wanted to buy those murals, would have bought them, or at least have learned the painter's name had I been sober. He was my candidate for the laurels of Customs Inspector Rousseau. . . . What de Chirico was really like became clear later at one of the sailor's dance halls where we wound up the evening. The lights were painful, the music was tortured, and the dancers threw themselves about in a kind of agony that was neither pleasurable nor simulated. Giorgio was really frightened. Chick and I were having fun; de Chirico, for a moment I understood, really saw *things as they were*." De Chirico's hypnotized amazement while staring at the murals shows how he was reflecting on the origins of metaphysical painting. Levy's careful account is part of his memoirs (Julien Levy, *Memoir of an Art Gallery* [New York: Putnam, 1977]) in which he reveals an extremely introspective portrait of de Chirico. Republished in *Metaphysical Art* 7–8 (2008): 707–15.

35 Apollinaire's text appears in the monograph on de Chirico published by *Valori Plastici*, Rome 1919.

[36] Ardengo Soffici, "Italiani all'estero," in *Lacerba* II, 13 (July 1, 1914): 207.

[37] Id., "Henri Rousseau," in *La Voce*.

Chap. 5
A Proto-Metaphysical Painting: Procession on a Mountain*, 1910*

[1] De Chirico later dated the painting 1908.

[2] Maurizio Calvesi, "La nuova Metafisica," in *De Chirico. La nuova Metafisica*, exhibition catalogue edited by Maurizio Calvesi and Mario Ursino, April 27–September 27, 1995, RTV headquarters, previously Palazzo dei Congressi, Republic of San Marino (Rome: De Luca, 1995), 19–20. The evidence provided regarding this influence has been unanimously accepted.

[3] On the painting see Leo Lecci, "Su un antico quadro di Giorgio de Chirico. Processione su un monte," in *Metafisica* 1–2 (2002): 229–32. The author observes that after Cottet's painting *L'office du soir en Bretagne* was exhibited in 1903 at the Venice Biennale, a colored etching of the same subject was shown in 1907 (again at the Biennale). Innocenti surely saw it and was perhaps inspired for the painting he exhibited in 1909. While de Chirico saw the Biennale in 1909, he did not see the 1907 edition and could have perhaps seen Cottet's image only as a reproduction. In Innocenti's painting, the street upon which the figures walk is upward, with the church at the top, as in de Chirico's painting, while Cottet's work depicts a plane. Lecci makes the mistake of dating de Chirico's painting to 1909, by taking as true an incorrect dating of metaphysical art, as also erroneously maintained by other authors (Baldacci, Roos, et al.).

[4] See *Lo stupore nello sguardo. La fortuna di Rousseau in Italia da Soffici e Carrà a Breveglieri*, exhibition catalogue edited by Elena Pontiggia, Fondazione Stelline, Milan (Cinisello Balsamo: Silvana Editoriale, 2011), 96.

Chap. 6
The First Metaphysical Enigma: The Enigma of an Autumn Afternoon

[1] De Chirico, *Méditations d'un peintre*, in *Scritti/1*, 650.

[2] Noel-Johnson, "De Chirico's Formation in Florence (1910–1911)", in *Metaphysical Art* 11–13 (2014): 141, 145.

[3] James Thrall Soby, *Giorgio de Chirico* (New York: Museum of Modern Art, 1955).

[4] Soffici, "Henri Rousseau," in *La Voce*. Further proof of de Chirico's careful reading of this passage by Soffici, and of the lasting effect it had on his reflection, is seen in a text written a few years later: "Behind straight walls (red for the terracotta of the overlapping tiles), along the factories and the suburban buildings, behind the doors and shutters of the city dwellings"; in the first version of *Zeuxis the Explorer*, sent to Giuseppe Raimondi, from which the more explicit references to Soffici's article were amended in the final version published in *Valori Plastici* (see Giorgio de Chirico, *Zeusi l'esploratore e la corrispondenza con Giorgio Raimondi* [Rimini: Raffaelli Editore, 2018], 19).

[5] The letter was published by Roos with an incorrect date in *Giorgio de Chirico e Alberto Savinio*, 421–30; (Baldacci revealed its contents in advance in *De Chirico 1888–1919*). The question was extensively analyzed by Picozza, in "Giorgio de Chirico and the Birth of Metaphysical Art in Florence in 1910," in *Metafisica* 7–8 (2008); and Id., "Betraying de Chirico: The Falsification of Giorgio de Chirico's Life History over the Last Fifteen Years," in *Metaphysical Art* 9–10 (2011): 28–60. For the dating of the letter to December 26, 1910, see note 7 chap. 3.

[6] See previous note. The letter dates to January 5 for Picozza, but I considered it to have been written between January 9 and 14, 1911.

Chap. 7
The Enigma of the Oracle

[1] The painting is dated 1910 but was probably newly signed and dated later as another signature in the form of a monogram is present in the painting; in any event, its execution dates to the autumn of 1910.

[2] Fabio Benzi, "I luoghi di de Chirico," in *Giorgio de Chirico: Pictor Optimus*, exhibition catalogue edited by Benzi and Tolomeo Speranza. The text was republished with additional material in Benzi, *Eccentricità. Rivisitazioni sull'arte contemporanea* (Milan: Electa, 2004). The identification has been widely accepted: see Baldacci, *De Chirico 1888–1919*, note 59, 85. Moreover, a further hypothesis regarding the localization has been recently formulated by Nikolaos Velissiotis, who indicates the small hilltop town of Makrinitsa situ-

ated above Volos on Mount Pelion. See Velissiotis, *La nascita della "Metafisica" nell'arte di Giorgio de Chirico*, 11.

3 Charles Maurras, *Anthinéa: D'Athènes à Florence* (Paris: Ernest Flammarion, 1901, ed. 1936, in particular, *Préface* and 169–70). This matter, which is perhaps marginal but by no means inessential, will be dealt with in a later study. Here are some lines from Maurras: "A stay in Florence made me understand the similarity between Greece and Tuscany in the best they have to offer"; a passage seems to have inspired the mood of the first metaphysical painting: "I found myself thinking about the familiar silhouettes of Florence. Despite the great instability of their nature, they were composed together with the monuments. For the whole evening I could not shake this persecutory dream, animated and regulated by the spring breeze which, in winter as in summer, would rise up from the Florentine Arno. The sensation was nothing new. I felt it immediately when I arrived. But it became ever stronger, an intoxication. . . . Following my stroll in a dreamy state still undefinable, I went down Via Dante and passed the house of the father of the most beloved of poets. . . . This thin and humble facade, which has the character of an architectural transposition of the character of the poet."

4 Savinio, *Infanzia di Nivasio Dolcemare* (Turin: Einaudi, 1973), 58.

5 There is no reason to date Savinio's drawing differently. It was gifted to art collector Signorelli (the first Italian collector to purchase a painting by de Chirico). Savinio himself dated the drawing to the same epoch of the donation (1918), a fact well remembered in the family, published as such (*Alberto Savinio*, exhibition catalogue edited by Maurizio Fagiolo dell'Arco, Daniela Fonti, Pia Vivarelli [Rome: De Luca, 1978], drawings cat. n. 1, without page number). My friend Vera Signorelli Cacciatore (who once owned the drawing) and whom I remember here fondly, confirmed this date to me in person. De Pisis also referred to it as from the Ferrara period, when he visited the brothers daily (this could eventually predate it to 1917, a date relative to the same moment, however): there is no documentary evidence that allows for a predating of the drawing, as has been arbitrarily done (see Paolo Baldacci, *Alberto Savinio: Musician, Writer and Painter*, exhibition catalogue, Paolo Baldacci Gallery, New York 1995, 17 and Id., *De Chirico 1888–1919*). A historical summary of the drawing can be found in Pia Vivarelli, *Alberto Savinio: Catalogo generale* (Milan: Electa, 1996), 230. The drawing is in fact an echoing of de Chirico's painting *The Enigma of the Oracle* and not an anticipation of the painting.

6 De Chirico, *Scritti/1*, 625.

7 *Ibid.*, 623.

Chap. 8
The Enigma of the Hour

1 The painting has been correctly identified by Paolo Picozza ("Giorgio de Chirico and the Birth of Metaphysical Art in Florence in 1910," in *Metafisica* 7–8 [2008]: 56–92) as one of the very earliest metaphysical works painted by the artist, being implicitly referred to (with exact measurements) in a letter to Fritz Gartz of late 1910.

2 Identified as such by Soby, *Giorgio de Chirico*, 58.

3 Federica Pirani, "L'ora meridiana in Giorgio de Chirico," in *Art e Dossier* 74 (December 1992): 23–26.

4 Id., "L'ora meridiana in de Chirico e Ungaretti," in *Legami e corrispondenze. Immagini e parole attraverso il '900 romano*, edited by Federica Pirani and Gloria Raimondi (Rome: Palombi Editori, 2013), 19–33.

5 Giorgio de Chirico, "Zeusi l'esploratore," in *Valori Plastici* I, 1: "'The world is full of demons,' said Heraclitus of Ephesus, strolling in the shade of the porticoes, in the high noon hour pregnant with mystery, while in the dry embrace of the Asiatic gulf, the salty water was simmering beneath a southwestern wind. *You must find the demon in every thing.*" English translation in *Metaphysical Art* 14–16 (2016): 54.

6 Giorgio de Chirico, "Gaetano Previati," in *Il Convegno* I, 7 (August 1920): 29–36.

7 Pirani, "L'ora meridiana in de Chirico e Ungaretti," in *Legami e corrispondenze*, edited by Pirani and Raimondi, 23.

8 Giorgio de Chirico, *La mort mystérieuse*, in *Scritti/1*, 652, English translation in *Metaphysical Art* 14–16 (2016): 202.

9 *Une fête*, in *Scritti/1*, 653; *Metaphysical Art*: 202.

10 *La volonté de la statue*, in *Scritti/1*, 656; *Metaphysical Art*: 204.

11 "*The Enigma of the Oracle* contained a lyricism of Greek prehistory"; in *Memoirs of Giorgio de Chirico*, 71.

Chap. 9
Paris, the Metaphysics of Nostalgia

[1] Guillaume Apollinaire, "La vie artistique," in *L'Intransigeant*, October 9, 1913.

[2] Giorgio de Chirico, "Guillaume Apollinaire," in *Ars Nova* 2 (1918).

[3] Carlo Carrà, "L'italianismo artistico e i suoi denigratori," in *Il Selvaggio*, December 30, 1927.

[4] Friedrich Nietzsche, *The Birth of Tragedy or Hellenism and Pessimism* (translated by W.M.A. Haussmann), London and New York 1909, 22–23.

[5] Roger Allard, in *La côte*, October 18, 1912.

[6] Louis Vauxcelles, in *Gil Blas*, September 30, 1912.

[7] *The Melancholy of Departure, The Enigma of the Hour, The Enigma of the Arrival and the Afternoon.*

[8] De Chirico and Apollinaire's relationship began between the winter of 1912 and the first half of 1913.

[9] Giorgio de Chirico, "Quelques perspectives sur mon art," in *L'Europe centrale*, April 1935: "Recalls that alliance concluded between gods and men that permeates all Greek art. From being mixed with the lives of men, gods end up even more divine. I felt this at Olympia during a clear moonlit night seeing a statue of Hermes, a masterpiece by Praxiteles. The statue was resting on a low base, which when in the presence of visitors, makes it seem alive. One could say that it was about to move, speak, and even start walking, going out and disappearing."

[10] Angelo Bardi (pseudonym of Giorgio de Chirico), "La vie de Giorgio de Chirico," in *Sélection. Chronique de la vie artistique*: 20–26.

[11] De Chirico, "Zeusi l'esploratore," in *Valori Plastici*.

[12] In March 1912, de Chirico returned to Turin for military service but deserted after a few days and returned to Paris (Federica Rovati, "Giorgio de Chirico disertore e contumace: I documenti processuali 1911–1913," in *Studi online* II, 3 [January 1–June 30, 2015]: 1–5).

[13] De Chirico himself recalled the importance of Turin in the context of Nietzsche's madness in a later text "Quelques perspectives sur mon art," in *L'Europe centrale*.

[14] Architect Alessandro Antonelli left the Mole practically finished on his death (1888); that fatal year 1888 also marked the madness of Nietzsche in Turin and Giorigo de Chirico's birth: could the painter, visiting the city, have been unaware of all these connections?

[15] See Calvesi, *La Metafisica schiarita*, 58–60.

[16] Benzi, "I luoghi di de Chirico," in *Giorgio de Chirico: Pictor Optimus*, exhibition catalogue edited by Benzi and Tolomeo Speranza, 50–51. See also Benzi, *Eccentricità. Rivisitazioni sull'arte contemporanea*, 92; Soby, for example, associated it with the colonnades of Roman temples such as that of Vesta (*Giorgio de Chirico*, 51).

[17] De Chirico, *August 1911*, now in *Scritti/1*, 591; *Metaphysical Art* 14–16 (2016): 199.

[18] Manuscript 1912–ca. 1914, *Scritti/1*, 616.

[19] *Scritti/1*, 616.

[20] Benzi, "I luoghi di de Chirico," in *Giorgio de Chirico: Pictor Optimus*, exhibition catalogue edited by Benzi and Tolomeo Speranza, 51.

[21] Inexplicably, Fagiolo dell'Arco (*L'opera completa di de Chirico 1908–1924*, note 52) has dated the painting to 1914. However, the pictorial quality is still delicate and nuanced and is therefore perfectly consistent with the date of 1912.

[22] Letter from de Chirico to Fritz Gartz, December 26, 1910 (see note 7 chap. 3).

[23] The volume's first poem, *Nur Narr! Nur Dichter! (Only Fool! Only Poet!)*, is taken from *The Song of Melancholy* in section IV of *Thus Spoke Zarathustra*; the theme is revisited in several other lyrics.

[24] Palm trees also appear in the painting *L'arrivée* of the same year.

[25] In *The desert grows: woe to him in whom deserts hide . . .* : "To me, a European under palm trees"; "drinking in this fairest air, / with nostrils swollen like goblets, / without future, without memories, / thus I sit here, / most beloved maidens, / and watch the palm tree, / as it, like a dancer, / bends and arches and sways at the hips."

[26] On the chronology of the relationship between de Chirico and Apollinaire, see chap. 11. The relationship between the poem and the series of paintings of Ariadne has been suggested by Matthew Gale, "Rewinding Ariadne's Thread: De Chirico and Greece, Past and Present," in *Giorgio de Chirico and the Myth of Ariadne*, exhibition catalogue edited by Michael R. Taylor, Philadelphia Museum of Art, 2002–3 (Philadelphia: Philadelphia Museum of Art; London: Merrell, 2002), 54–55. The catalogue is interesting and carries out a predominantly stylistic and iconographic survey of the cycle of paintings, underlining how they reveal the influence on de Chirico of the art of French avant-garde between 1912 and, especially, 1913: from Picasso and Matisse, to Duchamp, Medardo Rosso, and Archipenko. The relationship with Nietzsche is mentioned more generically and focuses on the link with Dionysus.

Chap. 10
The Evolution of the Metaphysical Aesthetic Between 1912 and 1913

1 *The Enigma of the Hour*, 1910.
2 *The Enigma of the Arrival and of the Afternoon*, 1912.
3 De Chirico's atelier was at 115, rue Notre-Dame-des-Champs; that same month he would move to another, located at 9, rue Campagne-Première. The former address is cited in the reviews by Adolphe Tabarant (*Paris-Midi*, October 8, 1913) and Apollinaire (in *L'Intransigeant*, October 9, 1913), while Maurice Raynal (*Gil Blas*, October 16, 1913) mentions the new address at rue Campagne-Première into which de Chirico had evidently just moved, and where he remounted the exhibition.
4 *Memoirs of Giorgio de Chirico*, 67–68.
5 The paintings executed to date are: *The Enigma of an Autumn Afternoon, The Enigma of the Oracle, The Enigma of the Hour* (1910), *Self-Portrait, Portrait of the Artist's Mother* (1911); *The Enigma of the Arrival and of the Afternoon, The Delights of the Poet, Solitude (Melancholy), The Lassitude of the Infinite* (first half of 1912); *Morning Meditation, Autumnal Meditation* (second half of 1912); *Chrysanthemums*, of 1912 (dated), is an atypical painting and not easy to place in the course of the year; *The Melancholy of Departure*, exhibited in March 1913, is not identifiable but could hypothetically be *The Arrival*, very similar to the paintings of the second half of 1912, which de Chirico later could have changed the title of.
6 Guillaume Apollinaire, "La vie artistique," in *L'Intransigeant*, October 9, 1913. Apollinaire mentions *The Enigma of the Oracle, The Sadness of Departure, The Enigma of the Hour, Solitude*, and *The Whistling of the Locomotive. The Sadness of Departure* (perhaps *The Melancholy of Departure*, cited in the previous note?) and *The Whistling of the Locomotive* cannot be identified with any certainty.
7 *Portrait de Madame L. Gartzen: The Melancholy of a Beautiful Day, The Red Tower. Study*. A fifth work was exhibited but not included in the catalogue: a head of *Aurora* mentioned in certain reviews, but of which there remains no trace (see Baldacci, *De Chirico 1888–1919*, 198).
8 Van Gogh's influence was also apparent in paintings such as *The Uncertainty of the Poet*, also of 1913.
9 For example, *The Transformed Dream*.
10 Apollinaire, "La vie artistique," in *L'Intransigeant*.

11 Writing to Paul Guillaume on June 3, 1915 (*La pittura metafisica*, exhibition catalogue edited by Giulio Briganti and Ester Coen [Vicenza: Neri Pozza, 1979], 114; now in *Lettere*, 63), de Chirico affectionately referred to him as "dear metaphysician" (*métaphysicisant*), proving that it was a term they both used in a semantically precise manner.
12 Michael R. Taylor has suggested this persuasive yet currently unverifiable hypothesis in his "Between Modernism and Mythology: Giorgio de Chirico and the Ariadne Series," in *Giorgio de Chirico and the Myth of Ariadne*, exhibition catalogue edited by Taylor, 41.
13 During the same crucial period (for de Chirico) as his essay on Rousseau, Ardengo Soffici published an essay titled "Divagazioni sull'arte," in *La Voce* (September 22, 1910), in which he undertook an analysis of medieval perspective, and suggested the use "of psychological rather than geometrical perspective, as the great moderns do and as the great primitives did." In particular, the paragraph "Le due prospettive" would have greatly influenced de Chirico.

Chap. 11
Apollinaire and the Avant-Garde

1 On Apollinaire's critique of de Chirico's work, see Willard Bohn, "Metaphysics and Meanings: Apollinaire's Criticism of Giorgio de Chirico," in *Arts Magazine* 55, 7 (March 1981): 109–13.
2 Apollinaire claimed that their first meeting took place in 1912: "It was in 1912 that I had occasion to say to a number of young painters such as Chagall and G. de Chirico: 'Go ahead! You have a talent that is destined to attract attention!'" (Guillaume Apollinaire, "Nouveau peintres," in *Les Arts*, June 15, 1914; now in *Œuvres en prose complètes*, vol. II [Paris: Gallimard, 1991], 824); for his part, de Chirico clearly reports that, after the October 1912 exhibition "taking the advice of people who knew the 'environment,' I sought out Guillaume Apollinaire" (*Memoirs of Giorgio de Chirico*, 65). However, Apollinaire did not write about the paintings exhibited in March 1913 at the Salon des Indépendants; accordingly, during the early part of that year their relationship cannot yet have been fully established.
3 Katherine Robinson, "Letters by Giorgio de Chirico to Guillaume Apollinaire. Paris-Ferrara 1914–1916," in *Metafisica* 7–8 (2008): 611–22. From a letter dated January 26, 1914 (now in *Let-*

tere, 49), in which de Chirico invites the writer to his home for the first time, it is clear that Savinio did not yet know Apollinaire.

⁴ "Onirocritique" was published in *La Phalange* on February 15, 1908; the passages cited here are taken from an article on Jean Royère, also published in *La Phalange*, January 15, 1908.

⁵ Castelfranco, *Introduzione all'arte del nostro tempo*, 38–39.

Chap. 12
The Portrait of Apollinaire *and the Dreamlike Space of Metaphysical Art*

¹ The history of the painting, acquired by the Musée National d'Art Moderne in Paris from the heirs of Apollinaire, is straightforward. Executed in 1914, probably before the summer (after July, Apollinaire would no longer be in Paris, due to the war), the painting was then bought by Paul Guillaume with the purpose of giving it to Apollinaire (see letter of Giorgio de Chirico to Francesco Meriano of July 20, 1918, *Lettere*, 175); it would remain in de Chirico's possession until May of the following year. In fact, Apollinaire asked Guillaume to arrange the delivery of it from de Chirico's studio to his house: "to M. Paul Guillaume, 6 May 1915 / My dear friend. I would be grateful if you would ask G. de Chirico to deliver, or to consign to my doorman, who will put it in my house, the portrait of me as a man-target [*homme-cible, author's note*]. It would make me happy to know that it is at my house"; "My dear friend. I would prefer that the man-target was at my house, where my mother could look at it whenever she wished, since in addition to being a singular and profound work, it is also a good likeness, a work or rather a silhouette of the kind they used to make in the early XIX century" (Apollinaire's two letters to Guillaume are published in *Les Arts à Paris*, 7, January 1923). A detailed and definitive analysis of this painting can be found in Benzi, "I luoghi di de Chirico," in *Giorgio de Chirico: Pictor Optimus*, exhibition catalogue edited by Benzi and Tolomeo Speranza. Bohn's reading of the painting ("Giorgio de Chirico, Apollinaire and Metaphysical Portraiture," in *Metaphysical Art* 11–13 [2014]: 67–74) fails to take account of Apollinaire's very clear letters to Guillaume cited here, and his interpretation of the portrait of Apollinaire in terms of the head in the foreground, rather than the silhouette (*homme-cible*), leads him to erroneous conclusions.

² See the letter of January 26, 1914, in which de Chirico tells Apollinaire that his mother and brother would like to make his acquaintance (Robinson, "Letters by Giorgio de Chirico to Guillaume Apollinaire. Paris-Ferrara 1914–1916," in *Metafisica* 7–8 [2008]: 600; now in *Lettere*, 49).

³ *Memoirs of Giorgio de Chirico*, 66.

⁴ Alberto Savinio, *Achille innamorato* (Florence: Vallecchi, 1938), 49. This recollection undoubtedly dates to 1914 since, unlike his brother, Savinio did not know Apollinaire before the end of January 1914.

⁵ For a philological reconstruction of the compositional phases of *The Poet Assassinated*, see Michel Décaudin's critical apparatus in the complete edition of Apollinaire's works in prose (Guillaume Apollinaire, *Œuvres en prose complètes*, vol. I [Paris: Gallimard, 1988]).

⁶ Décaudin (*ibid.*, vol. I, 1160) hypothesizes that the source of the name Croniamantal would be a contraction of Cro-Magnon and Neanderthal, indicating the poet as the original, mythical, and primogenial man. However, I find more convincing the Greek etymology of "diviner of eternity" (χρόνια, chrónia: times [years], eternity; μαντεια, manteía: divination).

⁷ Benzi, "I luoghi di de Chirico," in *Giorgio de Chirico: Pictor Optimus*, exhibition catalogue edited by Benzi and Tolomeo Speranza.

⁸ Chap. XVII, titled "Assassination," near the end of the story, was written between 1911 and 1913 (see Décaudin, in *Œuvres en prose complètes*, vol. I, 1157). It starts like this: "Comme Orphée, tous les poètes étaient près d'une malemort [Like Orpheus, all the poets were close to a tragic death]" (*ibid.*, 294). Orpheus-Croniamantal-Apollinaire, a poet-prophet, was destined to a violent death, to martyrdom. He then meets his adversary, the fake poet Tograth cheered on by the crowd, and he attacks him, but the populace stones him: he gets hit first by a baton, then by a rock, slapped and spit in the face (like Christ on the Via Crucis), but it is the blow of a reed blinding him in one eye that cuts him down (the seer who is deprived of sight); then the crowd (particularly the women, who like Bacchus's followers kill Orpheus the poet) massacre his body, turning it into that of "a sea urchin" (*ibid.*, 300).

⁹ *Ibid.*, 301.

¹⁰ This point has been suggested by Maurizio Fagiolo dell'Arco, *Il tempo di Apollinaire. Paris 1911/1915*, 9.

¹¹ Giorgio de Chirico, "Guillaume Apollinaire," in *Ars Nova* 2 (1918).

[12] "In your pools, and in your ponds, / Carp, you indeed live long! / Is it that death forgets to free / You fishes of melancholy?" (English translation A.S. Kline, *Apollinaire: Selected Poems*).

[13] "His heart was the bait: the heavens were the pond! / For, fisherman, what fresh or seawater catch / equals him, either in form or savor, / that lovely divine fish, Jesus, My Savior?" (*ibid.*, 20). It is Orpheus who speaks in these verses of Apollinaire's *Le Bestiaire*.

[14] Guillaume Apollinaire, *Le Poète assassiné*, chap. XIII, in *Œuvres en prose complètes*, vol. I, 275–76.

[15] It was invented by Mercury, who then gave it to Apollo.

[16] See the poem *La tortue*, in *Le Bestiaire*. Maurizio Fagiolo dell'Arco (*Il tempo di Apollinaire. Paris 1911/1915*, 12) has proposed this strange interpretation, which is completely implausible.

[17] De Chirico, "Zeusi l'esploratore," in *Valori Plastici*.

[18] This reading is confirmed by a later passage written by Jean Cocteau, who clearly alludes to this head in *Le Mystère laïc* with a phrase that can only have derived from de Chirico: "Certain Greek statues wear smoked glasses so that the sun does not end up blinding them" (Paris: 1928, 63).

[19] See Benzi, "I luoghi di de Chirico," in *Giorgio de Chirico: Pictor Optimus*, exhibition catalogue edited by Benzi and Tolomeo Speranza. At the beginning of *The Poet Assassinated*, Croniamantal's mother has a fleeting amorous encounter with a traveling musician, as a result of which she conceives the story's protagonist. The first words she addresses to the child's future father are: "Hahaha. Hohoho. Hihihi. Tes paupières ont la couleur des lentilles d'Egypte" [your eyes are the color of Egyptian lentils]. In French, *lentille* means both lens (as in spectacles) and lentil. The marble bust that stands in the lower part of the painting could therefore represent the bust of Apollinaire's father, who appears idealized and threatening (because he never knew him: one more psychological vacuum among the painting's other voids), and whose eyes (or the glasses that cover them) are black. Apollinaire was in fact the son of an unknown father (perhaps a Roman bishop, or a certain Francesco Flugi d'Aspermont, who in any case abandoned Apollinaire's mother when the child was only five years old and never recognized him as his own) and of an adventurous mother of noble Polish origins. Apollinaire never spoke of his father, even with his closest associates, veiling him in a mystery that greatly intrigued his friends. Accordingly, he was able to become a secret and looming enigma,

transformed in the painting into the cold and vaguely threatening statue of a modern *commendatore* (strangely, this bust is also the only concrete element in a painting made up of pure spiritual signs, of "empty" representations).

[20] Salomon Reinach, *Orpheus. Histoire générale des religions* (Paris: Picard, 1909). De Chirico had been reading Reinach's books since 1910 (Noel-Johnson, "De Chirico's Formation in Florence [1910–1911]", in *Metaphysical Art* 11–13 [2014]: 192). It is interesting that he shared this interest with Guillaume, and therefore probably also with Apollinaire.

[21] "It is fate. *Veniet felicior aetas*!!, as Sal. Reinach would say"; in *Lettere*, 63.

Chap. 13
De Chirico and Apollinaire: The Non-Places of the Final Parisian Metaphysical Years; the Mannequins

[1] Roberto Longhi, "Al dio ortopedico," in *Il Tempo*, November 22, 1919. Reconstructing the genesis of the mannequin motif, Maurizio Calvesi challenged Longhi's claims (*La metafisica schiarita*, 94–100).

[2] See chap. XVII, referring to ideas of 1904, but rewritten between 1911 and 1913.

[3] See chap. XIV, the initial elaboration of which dates to the years 1911–12.

[4] An old man was killed in the bombing and a child had her leg fractured, as the artist recalls in his memoirs (*Memoirs of Giorgio de Chirico*, 69). At the end of August, following these episodes, he went to Normandy for a few weeks with his mother, his brother, and Paul Guillaume.

[5] The drapery is copied from a statue of Kore as a Roman lady in the Capitoline Museums, Rome. The identification was made by Eugenio La Rocca, "L'archeologia nell'opera di de Chirico. Alcune note," in *Giorgio de Chirico*, exhibition catalogue edited by Pia Vivarelli, Galleria Nazionale d'Arte Moderna, Rome, 1981 (Rome: De Luca, 1981), 33–34.

[6] See Maurizio Calvesi, "De Chirico e le metamorfosi del destino," in *De Chirico nel Centenario della nascita*, exhibition catalogue, 16–17.

[7] See Guillaume Apollinaire, *La fin de Babylone* (Paris: Bibliothéque des curieux, 1914), chap. XV.

[8] See Id., *Œuvres en prose complètes*, vol. I, 240; Jean Clair, "Dans la terreur de l'Histoire," in *Giorgio de Chirico*, exhibition catalogue edited by William Rubin, Wieland Schmied, Jean Clair, Centre

Georges Pompidou, Paris, February 24–April 25, 1983 (Paris: Centre Georges Pompidou, 1983), 45: Clair acutely compares the cannon with the two balls and the artichokes in *The Philosopher's Conquest* to Omphalos of Delos (actually a phallic representation dedicated to Dionysus).

[9] See Giovanna Dalla Chiesa, "La vicenda parigina della metafisica," in *La Metafisica. Museo documentario*, exhibition catalogue edited by Calvesi, Coen, and Dalla Chiesa, 75–102.

[10] See Paolo Baldacci, "Giorgio de Chirico, l'estetica del Classicismo e la tradizione antica," in *Giorgio de Chirico: Parigi 1924–1929*, edited by Fagiolo dell'Arco, 54.

[11] Giorgio de Chirico, "Carlo Carrà," in *La Vraie Italie* 2 (1919) (the article was sent to the magazine at the beginning of April).

[12] Id., "L'arte metafisica della mostra di Roma," in *La Gazzetta Ferrarese*, June 18, 1918.

[13] Id., "Il ritorno al mestiere," in *Valori Plastici* 11–12 (November-December 1919), English translation in *Metaphysical Art* 14–16 (2016): 33–36.

[14] Alberto Savinio, *Hermafrodito* (Florence: Libreria della Voce, 1918; Turin: Einaudi, 1974, 202).

[15] Giorgio de Chirico, Parisian manuscripts, now in *Scritti/1*, 607.

[16] Soffici, "Italiani all'estero," in *Lacerba*.

Chap. 14
The Early Metaphysical Art of Ferrara

[1] In a letter to Guillaume of September 16, 1915 (*Lettere*, 66), de Chirico tells him that his mother is leaving for Paris the following day, and for him to give her custody of all the paintings in his atelier, including the unfinished ones. However, his mother must have done otherwise, as various works (especially unfinished ones, among others) remained in the atelier until after the war when Ungaretti went to pick them up (see chap. 20); Guillaume surely took a number of paintings for himself, since as early as October 1915 he had urged de Chirico to honor his contract, to which de Chirico responded that he was unable to send him more than "5 or 6 paintings a month, at most" (de Chirico letter to Paul Guillaume, October 9, 1915, in *Lettere*, 71), reminding him that he already had so many paintings of his that "even if for a year I don't send you even one painting, it seems to me that you already have enough canvases in your gallery" (de Chirico letter to Paul Guillaume November 1, 1915, *Lettere*, 72). A group of paint-

ings was in any case deposited in a storeroom in 5, rue du Colisée (de Chirico letter to Paul Guillaume November 6, 1918, *Lettere*, 185).

[2] See the correspondence with Paul Guillaume, *ibid.*

[3] *Memoirs of Giorgio de Chirico*, 80.

[4] Victoria Noel-Johnson, "De Chirico's Formation in Florence (1910–1911): The Discovery of the B.N.C.F. Library Registers", in *Metaphysical Art* 11–13 (2014): 137–177. Among the volumes read by de Chirico in this area of research were: Ernst Curtius, *Storia della Grecia* (Turin: Loescher, 1877); Theodor Mommsen, *Storia di Roma antica* (Rome-Turin: Casa Editrice Nazionale Roux e Viarengo, 1903, vol. I, 1904, vol. II, and 1905, vol. III); Gaston Maspero, *Histoire ancienne des peuples de l'Orient*, 4th ed. (Paris: Librairie Hachette et Cie, 1886); Salomon Reinach, *Cultes, mythes et religions*, 2nd ed. (Paris: E. Leroux, 1908); Auguste Sabatier, *Esquisse d'une philosophie de la religion d'après la psychologie et l'histoire* (Paris: Fischbacher, 1897); Paul Decharme, *Mythologie de la Grèce antique*, 2nd ed. (Paris: Libraires-Éditeurs Garnier Frères, 1886); Salomon Reinach, *Manuel de philologie classique*, 2nd ed. (Paris: Librairie Hachette et Cie, 1883, vol. I, and 1884, vol. II); Ernest Renan, *Histoire du peuple d'Israël*, 5 vols. (Paris: Calmann-Lévy, 1887–93); Eugène Goblet d'Alviella, "Un curieux problème de transmission symbolique: les roues liturgiques de l'ancienne Égypte" (Brussels: Hayez, 1899), taken from the *Bulletins de l'Académie royale de Belgique*; Theodor Gomperz, *Les penseurs de la Grèce: histoire de la philosophie antique* (Paris-Payot, Lausanne: F. Alcan, 1908–10).

[5] Ara H. Merjian, "L'ora ebrea' di Giorgio de Chirico. Pittura metafisica e primitivismo semitico: 1915–1918," in *De Chirico a Ferrara. Metafisica e avanguardie*, exhibition catalogue edited by Paolo Baldacci, Palazzo dei Diamanti, Ferrara (Ferrara: Fondazione Ferrara Arte, 2015).

[6] Reinach, *Orpheus*, from which de Chirico took his motto "Veniet felicior aetas," mentioned in a letter to Guillaume (see note 21 chap. 12).

[7] "Mercury god of Mysteries" is the title given to a drawing dating from the 1950s (private collection).

[8] In the visionary prose typical of his metaphysical period, Carrà writes: "In the shadow of a Jewish café we unite with the Negro Age of vast, unexpected splendors" (Carlo Carrà, "Arcobaleno di latta smaltata," in *Avanscoperta*, May 25, 1917).

[9] Letters of September 16 and November 1, 1915, in *Lettere*, 66 and 72.

10 Giorgio de Chirico, *Penso alla pittura, solo scopo della vita mia. 51 lettere e cartoline ad Ardengo Soffici 1914–1942*, edited by L. Cavallo (Milan: Scheiwiller, 1987), 44; now in *Lettere*, 78.

11 The curved objects that appear in the metaphysical compositions painted in Ferrara are tools used to draw curved lines of different radii, once common in the studios of engineers and cartographers, and do not represent *litui* (ceremonial staffs—see Merjian, "L'ora ebrea' di Giorgio de Chirico," in *De Chirico a Ferrara. Metafisica e avanguardie*, exhibition catalogue edited by Baldacci).

12 On de Chirico's relationship with futurism, see Maurizio Calvesi, *Dinamismo e simultaneità nella poetica futurista* (Milan: Fabbri, 1967), 310–12, republished in Calvesi, *La Metafisica schiarita*, 207–9.

13 *Evangelical Still Life I, The Melancholy of Departure, Politics,* and *The Corsair,* all dated 1916.

14 *Evangelical Still Life I* and *The Corsair.*

15 One of the four paintings with maps is titled *The Melancholy of Departure*, although this title was written on the frame by Paul Guillaume rather than by de Chirico himself. The map in this work, which, like those of Istria, is inverted and seen in close-up, thereby rendering it unrecognizable at first glance and seeming to depict an unknown land, may illustrate a detail of de Chirico's native Gulf of Volos (ancient Iolkos) from where the Argonauts departed. De Chirico mentions the Argonauts for the first time in a letter to Papini of March 12, 1916 (they would subsequently become a recurring subject of his work), referring to them in relation to himself and his friends ("I am happy and proud to be placed in the group of Argonauts by you." See de Chirico, *Penso alla pittura, solo scopo della vita mia*, 47; now in *Lettere*, 85).

16 Letter from de Chirico to Soffici, December 12, 1915 (de Chirico, *Penso alla pittura, solo scopo della vita mia*, 45; now in *Lettere*, 77).

17 Capodistria, September 20, 1880–Pola, August 10, 1916.

18 This was not only due to the barbaric hanging of the Italian hero in the prison at Pola, but also to the emotions aroused by two letters Sauro had written to his family before embarking on his perilous mission. Gabriele D'Annunzio was also moved by this episode, which naturally generated a renewed wave of anti-Austrian irredentism throughout Italy.

19 Flavio Fergonzi's identification of submarine interiors in the "metaphysical" paintings of Sironi (in particular, *The Studio of Wonders*) is convincing (see *Sironi metafisico. L'atelier della meraviglia*,

exhibition catalogue edited by Simona Tosini Pizzetti and Stefano Roffi, Fondazione Magnani Rocca, Mamiano di Traversetolo [Cinisello Balsamo: Silvana Editoriale, 2007], 58–59). However, it is likely that Sironi took inspiration from those works by de Chirico referring to Nazario Sauro, which he would have considered carefully, being in close contact with the artist in Rome (they would exhibit their works a few months apart at the Bragaglia gallery): see *Mario Sironi: Dal futurismo al classicismo 1913–1924*, exhibition catalogue edited by Fabio Benzi and Francesco Leone, Galleria Harry Bertoia, Pordenone, September 15–December 9, 2018 (Cinisello Balsamo: Silvana Editoriale, 2018), 92–102.

20 Letter to Soffici, September 9, 1916: the line is taken from *Atelier*, in *Bif§zf+18. Simultaneità—Chimismi lirici* (de Chirico, *Penso alla pittura, solo scopo della vita mia*, 61; now in *Lettere*, 97–98).

Chap. 15
From the Alliance with Carrà to the Disquieting Muses

1 Letter to Carrà, August 1916. *Carlo Carrà—Ardengo Soffici. Lettere 1913–1929*, edited by Massimo Carrà and Vittorio Fagone (Milan: Feltrinelli, 1983), 98.

2 *Ibid.*, 96.

3 De Pisis and his sister were associated with a charity that provided support for the military. Being from Ferrara, he probably had sufficient influence to obtain places for the two friends where they could work in peace for a time.

4 Apollinaire was a great critical supporter and true friend of de Chirico and his brother Savinio in Paris. In a letter to Soffici of December 7, 1918 (Apollinaire died on November 9), Savinio wrote: "I have decided not to return to Paris . . . because with Apollinaire's death, the strongest motivation for me to return to Paris is lacking" (Alberto Savinio, "59 lettere ad Ardengo Soffici," edited by Maria Carla Papini, in *Paradigma 4* [February 1982]: 358–59). This consideration would have been equally important for de Chirico, perhaps more so; yet in addition to Apollinaire, he still had links with Paul Guillaume, Apollinaire's dealer friend, with whom he had an agreement concerning the sale of his paintings. In fact, as can be seen from the letters to his fiancée Antonia Bolognesi (see Fabio Benzi, "Unpublished Correspondence by Giorgio de Chirico Sheds New Light on the

Artist's Activities from Metaphysical Art to the Return to Craft," in Bolognesi, *Alcestis*, 190–91), he still hoped to move to Paris during 1919, before a temporary rupture with Guillaume made him decide to remain in Italy.

5 See Calvesi, *La Metafisica schiarita*, 115–24.

6 This painting belonged to Jean Cocteau, who published it on the frontispiece of his monograph on de Chirico in 1932 (*Le Mystère laïc. Essai de critique indirecte* [Paris: Éditions Bernard Grasset, 1932]) and had obtained it from either de Chirico himself or Paul Guillaume (or possibly from the ambiguous surrealist circle). The history of the painting, which de Chirico declared to be false in 1962, is summarized by Noel-Johnson, *De Chirico and the United Kingdom (c. 1916–1978)*, 83, note 21, and 163–83.

7 Carrà painted at least four works: *The Metaphysical Muse*, *The Enchanted Room*, *Solitude*, and *Mother and Son*; he may also have begun *The Fortune Teller* (see *De Chirico a Ferrara. Metafisica e avanguardie*, exhibition catalogue edited by Baldacci, 221–25.

8 Brought together in the two important lyrical-theoretical texts "Parlata su Giotto" and "Paolo Uccello costruttore," respectively in *La Voce* III (March 1916) and VIII (September 1916).

9 See de Chirico, *Penso alla pittura, solo scopo della vita mia*, 44.

10 *Memoirs of Giorgio de Chirico*, 65. On the identification of the site, see Benzi, *Eccentricità. Rivisitazioni sull'arte contemporanea*, 103–4.

11 Gianluca Poldi, *Sotto i cieli di smeraldo. Tecnica e materia del de Chirico ferrarese*, in *De Chirico a Ferrara. Metafisica e avanguardie*, exhibition catalogue edited by Baldacci, 111.

12 Giorgio Castelfranco, "La XXIV Biennale Internazionale d'Arte di Venezia," in *Bollettino d'Arte* XXXIII, 3: 281. This important notation has strangely escaped critical attention.

13 The original title was mentioned in a letter from de Chirico to Carrà on June 10, 1918, in which he tells him he had just finished the painting: "I have finished a painting: *The Disquieting Virgins*" (de Chirico, "Ventisette lettere a Carlo Carrà," in *Paradigma 4* [February 1982]: 316; now in *Lettere*, 168–69).

14 The principal study on this sculpture was carried out by Stefanos Koumanoudis, "Trìa gliptà archaïkà," in *Archailogiké Ephémeris* (1874): 480–82, pl. 71. The scholar retraced the history of the sculpture, which was found exhumed in Arcadia, near Asea, and identified it with Artemis thanks to the epithet "Hegèmone" ("agenò" is a contracted,

atypical archaic form, elaborated to allow for it to be read as a palindrome). He considers the sculpture unique due to the rarity of this inscription and provides extensive reflection on this, an interpretation still considered valid today. Given the unique similarity with de Chirico's "Muse" (and the context from which it derives), the suggestion made of the statue's vague resemblance to a page of Reinach's *Apollo* representing a kore conserved in London and a statue of a king sitting in the Louvre is doubtful (see Baldacci, *De Chirico 1888–1919*, 392–93).

Chap. 16
Rome and the Classicism of Valori Plastici

1 A painting by de Chirico had indeed been exhibited for a few days in February 1917 in the exhibition *Collection de tableaux de Léonide Massine*, at Teatro Costanzi (*The Nostalgia of the Engineer* [*sic*], 1916), a small work towered over by futurist and especially cubist works.

2 Goffredo Bellonci, "Alla mostra del Pincio e dell'Epoca': Pittura in ordine," in *Il Giornale d'Italia*, July 3, 1918.

3 Fabio Benzi, *Arte in Italia tra le due guerre* (Turin: Bollati Boringhieri, 2013), 28.

4 *Ibid.*, 29.

5 At the exhibition held at Galleria dell'Epoca in Via del Tritone from May 20 to June 30, organized by Enrico Prampolini and Mario Recchi, de Chirico exhibited as many as six paintings (*The Troubadour, Hector and Andromache, Evangelical Still Life II, The Great Metaphysician, Cassandra, The Revenant*) and eleven drawings.

6 The exhibition, initially planned as an exhibition of drawings, would be held in February in Bragaglia's gallery (as results from the artist's correspondence with his fiancé, see Benzi, "Unpublished Correspondence by Giorgio de Chirico," in Bolognesi, *Alcestis*, 191). It was later expanded to include paintings after they arrived from Ferrara.

7 De Chirico, *Penso alla pittura, solo scopo della vita mia*, 91.

8 A portrait of his fiancée Antonia Bolognesi. See, Fabio Benzi, "The de Chirico-Signorelli correspondence (1918-1919) and the Painter's Classical Debut," in *Metafisica* 1–2 (2002): 173–82.

9 See note 6.

10 The exhibition, for which no catalogue or list of the works on display was printed, was scheduled for only about fifteen days, which the exten-

sion to February 21 brought up to just under three weeks. If one considers that the subsequent exhibition of drawings by fourteen-year-old Romano Dazzi lasted the whole month of March to the first days of April, we understand the surprising discrepancy of treatment accorded to the "difficult" art of de Chirico.

[11] Flavio Fergonzi, "'Ah Ferrara!' In margine al *Dio ortopedico* di Roberto Longhi," in *De Chirico a Ferrara*, exhibition catalogue edited by Baldacci, 205–20.

[12] *Memoirs of Giorgio de Chirico*, 94–95.

[13] Carrà had even set up an alibi, writing on November 5 and December 10 to Papini concerning his desire to mount a "personal exhibition," and adding that "I have invited de Chirico to exhibit, I am awaiting his response. I have convinced Garbari to exhibit" (*Il carteggio Carrà–Papini. Da "Lacerba" al tempo di "Valori Plastici,"* edited by Massimo Carrà [Milan: Skira, 2001], 96). But the letter with which de Chirico responded to Carrà, accepting his invitation, is dated December 21: Carrà must have only written to him the day before. De Chirico sent three paintings to Milan the following day; however, the exhibition had already opened on the eighteenth, and once he realized this de Chirico grew very cold toward his "friend."

[14] Tullio Garbari also participated in the exhibition, which was not cause for concern by Carrà; Carrà in fact exhibited the three works that de Chirico had sent him (*Evangelical Still Life II*, *The Troubador*, and *Hector and Andromache*), but only once his own exhibition closed.

[15] "Carlo Carrà . . . In Milan he hastily organized an exhibition . . . in the hope of persuading his contemporaries that he was the one and only inventor of metaphysical painting, while I in fact was one of his obscure and modest imitator" (*Memoirs of Giorgio de Chirico*, 84. See also Baldacci, *De Chirico 1888–1919*, 378–79; De Chirico's correspondence with Giorgio Raimondi at the time provides pertinent material on this matter, published in de Chirico, *Zeusi l'esploratore e la corrispondenza con Giorgio Raimondi*).

[16] See Cipriano Efisio Oppo, in *L'Idea Nazionale*, May 28, 1918; Aurelio Enrico Saffi, in *Il Tempo*, June 17, 1918.

[17] See Fabio Benzi, "Il carteggio de Chirico—Signorelli e gli esordi classicisti del pittore," in *"Nulla sine tragoedia gloria." L'opera di Giorgio de Chirico attraverso la storiografia contemporanea,* conference proceedings, edited by Claudio Crescentini, conference held October 15–16, 1999 (Firenze: Artout-Maschietto Editore, 2002), 113–14.

[18] Giorgio de Chirico, "L'arte metafisica della mostra di Roma," in *La Gazzetta Ferrarese*.

[19] Letter from Papini to Carrà, December 28, 1918, in *La Metafisica. Museo documentario*, exhibition catalogue edited by Calvesi, Coen, and Dalla Chiesa, 122.

[20] *Memoirs of Giorgio de Chirico*, 94–95.

[21] See Benzi, "Il carteggio de Chirico—Signorelli e gli esordi classicisti del pittore," in *"Nulla sine tragoedia gloria,"* edited by Crescentini, 116.

Chap. 17
The Beginnings of Classicism

[1] *Memoirs of Giorgio de Chirico*, 96–97. The painting by Titian was naturally the most classical of those owned by the museum, *Sacred and Profane Love*, as Leonida Rèpaci informs us ("Giorgio de Chirico," in *L'Illustrazione Italiana*, March 9, 1941), evidently having been told this by his artist friend.

[2] Giorgio de Chirico, "Carlo Carrà," in *La Vraie Italie* 2 (1919) (the manuscript was sent to the magazine at the beginning of April).

[3] Id., "L'arte metafisica della mostra di Roma," in *La Gazzetta Ferrarese*.

[4] Id., "Il ritorno al mestiere," in *Valori Plastici* 11–12 (November-December 1919): 15.

[5] *Memoirs of Giorgio de Chirico*, 97–98.

[6] De Chirico wrote to his friend Olga Signorelli on July 9, 1919: "I cannot say that I am happy; it's hot; the temperature oppresses me and I suffer from stomach cramps; it makes me ponder on the relativity of human condition and the infinite vanity of everything" (Fabio Benzi, "The de Chirico–Signorelli correspondence [1918–1919] and the Painter's Classical Debut," in *Metafisica* 1–2: 178; now in *Lettere*, p. 244).

[7] De Chirico himself uses this term in two letters of 1921, to Paul Guillaume (December 28: "I had to start from scratch by grinding the pigments and boiling the varnishes, submerging myself like an alchemist in the study of ancient painting treatises") and to André Breton (December 28, 1921, or January 3, 1922: "I set about with the patience of an alchemist, filtering varnishes, grinding pigments and preparing canvases and plates"; now in *Lettere*, 284 and 282).

[8] A particular reference is found in *Meeting of San Joachim and Saint Anne at the Golden Gate*, in the collection of the Gallerie dell'Accademia of Venice, which de Chirico had surely seen during his stays in the city. The theme of two people embracing, portrayed by Carpaccio in various com-

positions (*Visitation*, Ca' d'Oro, Venice) was copied in a literal fashion by de Chirico, even in the folds of the robes and in the layout of the buildings, from the painting in the academy.

9 The date is confirmed in a letter to Soffici of December 8, in which he speaks of the finished painting (Giorgio de Chirico, *Penso alla pittura, solo scopo della vita mia*, 106; now in *Lettere*, 261). For de Chirico's "Milanese" period (November 1919–April 1920), see Elena Pontiggia, "'In the Immense Desert of this City.' De Chirico in Milan," in *Metafisica* 5–6 (2006): 163–73.

10 Giorgio de Chirico, *Il ritorno al mestiere*, 19.

11 Id., "Classicismo pittorico," in *La Ronda* 2, 7 (1920).

12 Fabio Benzi, "Unpublished Correspondence by Giorgio de Chirico," in Bolognesi, *Alcestis*, 190.

13 Not only the Roman periodicals *Valori Plastici*, *Ars Nova*, and *La Ronda*, but also the Milanese *Il Primato Artistico Italiano* and *Il Convegno*, and Florence's *La Vraie Italie*.

14 At the Arte gallery.

15 On de Chirico's relationship with Castelfranco, see Giovanna Rasario, "Le opere di Giorgio de Chirico nella Collezione Castelfranco. L'Affaire delle 'Muse Inquietanti'," in *Metafisica* 5–6 (2006): 277–351. The article, which includes a variety of unpublished documents, presents a number of doubtful critical interpretations.

16 See chap. 1.

17 Letter to Breton, probably of December 28, 1921, in *Littérature*, 2^{éme} série, 1, March 1922, 11–13; now in *Lettere*, 94.

18 As Pia Vivarelli noted in *Giorgio de Chirico*, exhibition catalogue edited by Vivarelli, 94.

19 "We are explorers ready for new departures," wrote de Chirico in the first issue of *Valori Plastici* ("Zeusi l'esploratore").

20 *Lettere*, 284.

21 Letter from Giorgio de Chirico to André Breton, December 28, 1921, *ibid.*, 282.

22 See Lucia Presilla, "Alcune note sulle mostre di Valori Plastici in Germania," in *Commentari d'arte* V, 12 (gennaio-aprile 1999); Jolanda Nigro Covre, "De Chirico e Däubler," in *"Nulla sine tragoedia gloria,"* edited by Crescentini.

Chap. 18
The "Romantic" Period

1 In the March–April 1921 issue of *Valori Plastici*, de Chirico launched his famous "polemica sul Seicento"—to which numerous critics and artists also contributed—with the article "La Mania del Seicento." This had its origins in the controversial organization of an exhibition in Florence concerning Italian art of the seventeenth century. His arguments were very brusque, maintaining that "The 17th century was a prelude to the decline we see in today's painting" due to its realism and bourgeois character, which militated against "every principle of revelation and discovery"; his ideal at this time remained Quattrocento abstraction.

2 He would soon afterward publish an article on Gustave Courbet (in *La Rivista di Firenze*, November 1924) and a monograph published by *Valori Plastici* (1925).

3 Marisa Volpi Orlandini, "Hans von Marées: appunti sui 'Tedeschi romani' e l'arte metafisica di Giorgio de Chirico," in *Studi in onore di Giulio Carlo Argan* (Rome: Multigrafica, 1984), vol. 2, 337–58.

4 See Rasario, "Le opere di Giorgio de Chirico nella Collezione Castelfranco. L'Affaire delle 'Muse Inquietanti'," in *Metafisica* 5–6 (2006): 227–29; on the exhibition on the seventeenth century in Florence see *Novecento sedotto. Il fascino del Seicento tra le due guerre*, edited by Anna Mazzanti, Lucia Mannini, and Valentina Gensini (Florence: Polistampa, 2010).

5 See Benzi, *Arte in Italia tra le due guerre*, chap. 1 and 3.

6 See also Wieland Schmied, *L'art métaphysique de Giorgio de Chirico et la philosophie allemande: Schopenhauer, Nietzsche, Weininger*, in *De Chirico*, exhibition catalogue edited by Rubin, Schmied, and Clair, 95.

7 Alberto Savinio, *Nuova enciclopedia* (Milan: Adelphi, 1977), 270.

8 Giorgio de Chirico, *Hebdomeros* (Paris: Editions du Carrefour, 1929), English translation, The Four Seasons Book Club, New York, 1966, 40.

9 Due to the evident similarity of the subject with the first version, which was published in the exhibition catalogue.

10 See the conversation with Giorgio Castelfranco in *Alberto Savinio*, exhibition catalogue edited by Maurizio Fagiolo dell'Arco, 19.

11 "A new song has reached my ears—and the whole world appears totally changed—the autumn afternoon has arrived, the long shadows, the clear air, the serene sky—in a word: Zarathustra has arrived"; letter to Fritz Gartz of January 1911 (in *Metafisica* 7–8 [2008]: 565).

12 See the entry on this work in *De Chirico: Gli anni Venti*, exhibition catalogue edited by Fagiolo dell'Arco, 82.

Chap. 19
The Second Parisian Period and Surrealism

1 Their relationship, initially only epistolary, dates to December 1921. They got in touch through friends in Paris, perhaps through Ungaretti. On de Chirico and Breton see Gérard Audinet, "Le lion et le renard," in *Giorgio de Chirico. La fabrique des rêves*, exhibition catalogue edited by Jacqueline Munck, Musée d'art moderne de la Ville de Paris (Paris: Paris Musées, 2009), 111–34.

2 De Chirico was in Paris to prepare the sets for the ballet *The Jar* (*La Jarre*), written by Luigi Pirandello with music by Alfredo Casella, staged at the Théâtre des Champs-Elysées. He arrived in Paris on November 2 and left at the end of the month.

3 The first paintings in the new style that echoes metaphysical art had already been executed in 1924, and not 1925 as commonly dated. One of these was published in the January 15 issue of *Révolution Surréaliste*, therefore the photo of the finished painting would have had to arrive at the editorial office before the end of 1924. De Chirico made his definitive move to the capital in the autumn of 1925, after returning to Italy for a few months.

4 These are revived subjects such as *The Troubadour*, *Hector and Andromache*, and *The Return of the Prodigal Son*, of which de Chirico painted at least two versions.

5 De Chirico wrote to Gala Éluard on February 10, 1924: "I am about to finish *The Troubadour* for your husband and the *Cerveau de l'enfant* [The Child's Brain, *author's note*] for you. I do not hide the fact that I do not like this title; to me, this painting is entitled *Le Revenant* and that is what it is. There is something disagreeably mad and surgical about the other title which has nothing to do with the essence of my art" (Jole de Sanna, *Giorgio de Chirico—André Breton: Duel à mort*, in *Metafisica* 1–2 [2002]: 155; now in *Lettere*, 308).

6 Margherita Sarfatti, "La seconda Biennale di Roma," in *Il Popolo d'Italia*, March 27, 1925; Id., "Pittori e scultori alla Terza Biennale in Roma," in *Rivista Illustrata del Popolo d'Italia*, April 15, 1925: 39–43.

7 *De Chirico: Gli anni Venti*, exhibition catalogue edited by Fagiolo dell'Arco, 106.

8 Picasso was one of the few artists de Chirico appreciated throughout his life: "Picasso was a curious spirit who painted things that were curious in a certain sense, as well as very good and impressive; it is very interesting to look at that whole series of large women by the sea, and also his drawings, all of his illustrations . . . the bullfights, the toreadors, all his references to Greek mythology, he made these the themes of many of his drawings and paintings. I find everything he does interesting because he is a curious spirit and has something to say, unlike what happens today" (Jean José Marchand 1971, filmed interview with de Chirico, transcribed in *Metaphysical Art* 11–13 [2014]: 286–98).

9 Giorgio de Chirico, "Vale Lutetia," in *La Rivista di Firenze*, February 1925, English translation by Stefania Heim, in "Giorgio de Chirico. The Collected Poems," in *Metaphysical Art* 14–16 (2016): 214–17.

10 As early as 1922 Max Ernst had represented de Chirico in the monumental painting *Le rendez-vous des amis*, concretely documenting a profound consideration—almost veneration—toward the artist (though *in absentia*) in French dada and pre-surrealist circles. De Chirico and Breton, as mentioned, had been corresponding since 1921.

11 But his "romantic" works were also well known and appreciated by members of the group, such as Paul Éluard, who bought some of his paintings of the time during a visit expressly to see the 1923 Rome Biennale (where the painter showed many recent works); on that occasion Éluard also commissioned a portrait of himself with his wife, Gala.

12 That is, there is no "surrealist painting" but if anything a "surrealism in painting," to underscore the plurality of meanings that are not identified in a "style" (see André Breton, *Le Surréalisme et la peinture* [Paris: Gallimard, 1928]).

13 De Chirico, *Hebdomeros*, 61. The novel, a unique case, besides being a literary masterpiece, is structured as a stream of consciousness, which, on the principle of free surrealist (or better, metaphysical) associations assembles multiple literary references. Based on the oneiric structure of Lautréamont's *Chants de Maldoror* (one of the keystones of the surrealist imagination), of which it also echoes various passages, the novel is also clearly influenced by James Joyce's *Ulysses* (apart from the fame the novel enjoyed in Paris, one must not forget that de Chirico's friend Bontempelli published a few chapters from it in the periodical *900* in 1926), as well as the flashing and symbolic writing of Jean Cocteau. The general context is based on the artist's childhood and on memories of Greece (as is all of de Chirico's painting): a pervasive plot in which seamless later memories of Paris, Rome, Munich, Venice, etc., weave together,

modulated by means of the principle of free psychic association. There are many allusions to his paintings (gladiators, trophies, "Roman villas," etc.) that give way to a spirit of displacement and a profound interlacing of reflections that hint at its genesis. To deepen the meaning and references of the novel, see my "Introduction" to its recent edition (Milan: La Nave di Teseo, 2019, IX–XLIX).

[14] Max Morise, "Les yeux enchantés," in *La Révolution Surréaliste* I (1924): 27.

[15] Louis Aragon, "L'Invention," in *La Révolution Surréaliste* I (1924): 22.

[16] See de Chirico's Parisian writings, in *Scritti/1*, 573–659.

[17] Aragon, "L'invention," in *La Révolution Surréaliste*: 23.

[18] De Chirico, *Hebdomeros*, 65–66.

Chap. 20
The Break with Breton and Its Critical Consequences

[1] "J'estime qu'une véritable mythologie moderne est en formation. C'est à Giorgio de Chirico qu'il appartient d'en fixer impérissablement le souvenir" [I consider that a true modern mythology is in formation. It's up to Giorgio de Chirico to set its enduring memory] (André Breton, *Les pas perdus* [Paris: Editions de la Nouvelle Revue Française, 1924], 111).

[2] Equivalent to around 575 euros in 2019. This information, and that which follows, is taken from de Chirico's letters to André Breton, published by de Sanna, *Giorgio de Chirico—André Breton: Duel à mort*, 62–87. The letter in which de Chirico accepts this price is dated December 5, 1921 (*ibid.* 146, now in *Lettere*, 280).

[3] See chap. 14.

[4] In an undated letter, but of October–November 1921, by which point Ungaretti had returned to Italy, and was living at 8, Via Carlo Alberto in Rome, he wrote to Paulhan about offering Breton (but eventually also Aragon, Soupault, and Gide) the group of paintings for the sum of 1000 francs; one of these would be given to Paulhan "by way of gratitude" (*Correspondance J. Paulhan—G. Ungaretti 1921–1928* [Paris: Gallimard, 1989], 33). Paulhan bought one for himself in addition to the one received as a gift, and the remaining works were bought by Breton at half the original price, as we have seen (*ibid.*, 35). Nevertheless, the paintings indicated as acquired by Paulhan—*The Silent*

Statue and *Ariadne* of 1913—cannot be included in that group as these were finished paintings handled by the Paul Guillaume gallery. It is probable that one of the two works mentioned was actually the plaster statue of Ariadne, made by de Chirico, which had remained in his studio.

[5] "I met de Chirico after the war, but I was perhaps the first Italian to have direct knowledge of his Piazze, which were discovered with amazement by Apollinaire at the Salon des Indépendants, and praised to the skies by him: these were the Piazze that I was able to recover from the owner of the phalanstery on rue Campagne-Première where I lived with my wife immediately after the war, and which I subsequently sold to Breton. I sent the money to de Chirico, who at that time was in dire straits" (Giuseppe Ungaretti, "Nota introduttiva," in Id., *Vita di un uomo. Tutte le poesie*, edited and with an introductory essay by Carlo Ossola [Milan: Mondadori, 2009], 747).

[6] Letter of January 12, 1922, in de Sanna, *Giorgio de Chirico—André Breton: Duel à mort*, 146–47. The painting was offered for the price of 1000 francs (approximately 1150 euros in 2019).

[7] The painting was possibly that which appeared under the same title in the list of works (n. 3) sent to Mario Broglio as part of the contract signed with him on October 23, 1919. See Fagiolo dell'Arco, *Giorgio de Chirico: Il tempo di Valori Plastici 1918–1922*, 83.

[8] This is clearly confirmed by a chemical analysis of the color of both the ceiling and the greenish chest of the mannequin, which appear to have been painted with cobalt blue (see the *Analisi tecnica* [technical analysis]—X-Ray Fluorescence—performed on the painting by the company Ars Mensurae of Rome, at Fondazione Giorgio e Isa de Chirico's headquarters). During the period 1917–18, de Chirico only used Prussian blue (Gianluca Poldi, "Sotto i cieli di smeraldo. Tecnica e materia del de Chirico ferrarese," in *De Chirico a Ferrara*, exhibition catalogue edited by Baldacci, 111), which does not appear in the painting. However, there is perfect homogeneity in terms of the zinc white ground and the use of the remaining colors. Additional X-ray analyses have also revealed several important *pentimenti*: for instance, the figure on the left was originally smaller, and had a bowed head (other changes concern the mannequin's pelvis and the relationship of its arm on the side to the door). If de Chirico made these alterations (as seems certain from the technical data), particularly in terms of the blues and greens (the figure on the left appears more homogeneous), they certainly

took place during a period following his meta-physical phase: that is, in 1922, around the time of the sale of his work to Breton. In order to sell the painting to Doucet, Breton used the expedient of depositing it at Paul Guillaume's gallery and then persuaded him to buy it (as if it wasn't his), as emerges from a testimony by Simone Collinet, Breton's first wife, that Carmen Baron indicated to James Thrall Soby in a letter of November 9, 1972 (JTS Papers, MoMA Art Archives, New York; my thanks go to Katherine Robinson for bringing this letter to my attention).

9 This trip can be identified as having taken place between December 1923 and January 1924 (see Jean-Charles Gateau, *Paul Éluard et la peinture surréaliste: 1910–1939* [Paris: Librairie Droz, 1982], 98); Gateau's volume is very detailed, but presents Breton's version of events in relation to the *trichage* of the letter concerning *The Disquieting Muses*, which Breton elaborated with the complicity of Éluard [see below], and the reading of his relationship with de Chirico is completely distorted. Rome was at that time blanketed with snow, which greatly affected Gala and her painter friend (*ibid.*, 98). This evidently explains a number of self-portraits by de Chirico from the time in which he appears wearing winter clothes. One of these (formerly in the Deana collection) depicts the artist's body as having been partially transformed into a frozen statue against the backdrop of a snowstorm, and even the artist's signature is dusted with snow. Ernst did not travel with the couple (*ibid.*, 98) as Baldacci assumes without proof: initially claiming that he "probably" did (*Giorgio de Chirico: Betraying the Muse*, exhibition catalogue edited by Baldacci, 48), and subsequently asserting it as a fact, despite presenting no evidence to support his claim (*Giorgio de Chirico. Gladiatori 1927–1929*, exhibition catalogue edited by Paolo Baldacci [Milan: Skira, 2003], 144). The matter is confirmed in a letter de Chirico wrote to Paul and Gala Éluard after their visit to Rome (accurately datable to the first days of February 1923), in which he sends greetings to Max Ernst: "Say hello to Max Ernst for me, whom I hope to meet one day" (*Lettere*, 305).

10 They bought others from Castelfranco in Florence, as well as commissioning a replica of *Ulysses* of 1922 and new versions of *The Revenant* [*The Child's Brain*], 1914), titled *The Philosopher*, and of *Trouvière* (*The Troubador*, 1917), which were executed in accordance with de Chirico's current technique and substantially reinvented (see letter to Éluard of February 10, 1924; *Lettere*, 308);

Éluard also commissioned a double portrait of himself and his wife.

11 De Sanna, *Giorgio de Chirico—André Breton: Duel à mort*, 122; now in *Lettere*, 301–2.

12 Equivalent to around 1900 euros in 2019.

13 Approximately 1100 euros in 2019. Letter of February 23, 1924, in de Sanna, *Giorgio de Chirico—André Breton: Duel à mort*, 124; now in *Lettere*, 310.

14 *Ibid.*, Jole de Sanna correctly identified the recipient, evident from the references and the sequence of the letters.

15 Corresponding to around 3330 euros in 2019.

16 Around 4760 euros in 2019.

17 Around 950 euros in 2019.

18 Giorgio de Chirico letter to Simone Kahn (Breton's wife) of March 10, 1924, in *Lettere*, 311.

19 De Sanna, *Giorgio de Chirico—André Breton: Duel à mort*, 136; now in *Lettere*, 313.

20 Rasario, "Le opere di Giorgio de Chirico nella Collezione Castelfranco. L'Affaire delle 'Muse Inquietanti'," in *Metafisica* 5–6 (2006): 250.

21 See *Giorgio de Chirico: Parigi 1924–1929*, edited by Fagiolo dell'Arco, 479: the letter, identified as belonging to an unspecified "private Parisian archive," is cited without reference to its date, and its contents are merely summarized.

22 De Chirico arrived in Paris on November 2 and left again at the end of the month. In a letter dated November 28, 1924, he said goodbye to Doucet, informing him of his return to Italy (see note 37).

23 Giorgio de Chirico, "Vale Lutetia," in *La Rivista di Firenze*.

24 The relevant correspondence is published in Rasario, "Le opere di Giorgio de Chirico nella Collezione Castelfranco. L'Affaire delle 'Muse Inquietanti'," in *Metafisica* 5–6 (2006).

25 *Ibid.*, 250.

26 Luciano Doddoli, "Sono un prigioniero," in *La Fiera Letteraria*, April 25, 1968.

27 The existence of a version in tempera and pastel on cardboard (94x62 cm), which is certainly inauthentic, has been described by Baldacci (*De Chirico 1888–1919*, 420, fig. A7) as "probably executed as a study for the oil painting belonging to Paul Éluard [*sic*]."

28 James Thrall Soby, *The Early Chirico* (New York: Dodd, Mead & Co., 1941), 134.

29 Following her husband's departure, "Gala reste avec 400 F, la petite" [Gala is left with 400F, poor thing], wrote Breton's wife Simone to her cousin Denise Lévy (Georgiana Colvile, *Simone Breton. Lettres à Denise Lévy 1919–1929* [Paris: Éditions Joëlle Losfeld, 1995], 169–71).

30 The auction was held on July 3 at the Hôtel Drouot in Paris.

31 As noted, de Chirico did not intend to make straightforward copies of his paintings. With de Chirico absent from Paris, Breton could indeed pass them off as early works. The matter was highly deceptive.

32 De Chirico returned to Paris for the exhibition in May, and the first cracks began to appear: "Chirico is in Paris, his shares are going down rapidly: a break-up on the horizon" (letter from Pierre Naville to Denise Naville of May 1, 1925, in Pierre Naville, *Le Temps du surréel*, I [Paris: Galilée, 1977], 109).

33 Max Morise, "A propos de l'exposition Chirico," in *La Révolution Surréaliste* 4 (July 15, 1926): 31–32.

34 There are different opinions regarding which version of the *Muses* was on display, but Castelfranco's ownership of it (proved by transportation documents held in the Rosenberg archives) confirms that it was the original of 1918 (Rasario, "Le opere di Giorgio de Chirico nella Collezione Castelfranco. L'Affaire delle 'Muse Inquietanti'," in *Metafisica* 5–6 (2006): 244–46; Rasario incomprehensibly maintains that it was the 1924 version, despite evidence to the contrary. If (as I believe) the second version had already been sold, it must have been returned to Breton, since it reappeared in the window of the Galerie Surréaliste around 1927 (where it was evidently for sale again, after the situation had calmed down; see Man Ray's photograph of the gallery).

35 In October 1927, de Chirico would go so far as to send a circular letter to various newspapers objecting to this scandalous practice of the surrealists, which by that point had become commonplace (*Lettere*, 387).

36 See letters from de Chirico to Breton of January 12, March 25, and June 17, 1922 (*Lettere*, 286, 288, 290, respectively).

37 De Chirico had visited Doucet on November 18, 1924, together with Breton, and wrote Doucet a letter on November 28 of the same year (*Lettere*, 320).

38 *La Révolution Surréaliste* II, 6 (March 1, 1926): 32.

39 André Breton, "Le Surréalisme et la peinture (suite)," in *La Révolution surréaliste* II, 7 (June 15, 1926): 5.

40 See de Sanna, *Giorgio de Chirico—André Breton: Duel à mort*; Gérard Audinet, "Le lion et le renard," in *Giorgio de Chirico. La fabrique des rêves*, exhibition catalogue edited by Munck, 111–34. See also chap. 28.

41 De Chirico himself mentions the existence of unfinished paintings in a letter to Guillaume of September 16, 1915 (*Lettere*, 66).

42 Benzi, "Unpublished Correspondence by Giorgio de Chirico," in Bolognesi, *Alcestis*, 190–91.

43 Daniel Wildenstein and Yves Stavridès, *Marchands d'art* (Paris: Plon, 1999, 62).

44 Letter from Léonce Rosenberg to Giorgio de Chirico of July 29, 1928 (Paris, Centre Georges Pompidou, Bibliothèque Kandinsky), quoted in Christian Derouet, "La Fureur guerrière malgré J.T. Soby est entrée au musée," in *Giorgio de Chirico. La fabrique des rêves*, exhibition catalogue edited by Munck, 142.

45 Only three apparently incomplete paintings exist: *The Vexations of the Thinker*, *The Prophecy of the Savant*, and *The Poet and the Philosopher*. The latter was the only one to be subsequently signed and dated (with the date of 1914 instead of 1915, and Broglio's records certify that it was part of a group that returned to Italy; in fact, it was exhibited in 1921 in de Chirico's solo exhibition at the Arte gallery in Milan, where it was described in the catalogue as being an "unfinished youthful work"). The other two pieces seem to bear dubious dates and signatures (particularly the first, although a thorough examination would be required in order to be certain) and could be part of the group that was originally owned by Paulhan. Mysteriously, there is no trace of the others.

46 *The Anguishing Morning* (private collection, currently on loan to MART in Rovereto) was almost certainly one such unfinished painting that was largely completed by another hand. It was reproduced in the December issue of the periodical *The Dial* the same month Breton concluded the purchase of the paintings left in de Chirico's studio for 500 francs (although there doesn't seem to be sufficient time to imagine the painting passing from Breton to the Belmaison Gallery, who appeared as owner at the time, and the following publication). However, Breton was certainly already in possession of the paintings when the negotiation to buy them at half the asking price was concluded on December 5. Considering the usual delay literary reviews are subject to, this could explain the painting's origin: the rigidity of the perspectives and the tonal characteristics of the colors do not correspond to those typical of de Chirico's work. Another could be *Le printemps* [*Spring*] (which is unsigned and seems to have been completed in certain areas). Accordingly, those works that raised legitimate concerns on the part of the

artist (and various scholars) should be carefully re-examined from this point of view.

47 De Chirico, letter to Julien Levy, November 10, 1934. The important correspondence with Julien Levy, the artist's American dealer, was published by Katherine Robinson, in "Giorgio de Chirico—Julien Levy. Artist anda Art Dealer: Shared Experience," in *Metafisica* 7–8 (2008): 326–56 and 672–78. The letter is translated on pages 673–74. De Chirico spoke of this phenomenon in one of the first court cases regarding the falsification of his paintings against Dario Sabatello in 1947 (see Picozza, "Origin and Persistence of a tòpos about de Chirico: de Chirico—Sabatello—Il Milione Gallery. The first trail (1947–1956)," in *Metafisica* 1–2 (2002): 334–41.

48 Published in *Giorgio de Chirico and the Myth of Ariadne*, exhibition catalogue edited by Taylor, 173–75.

49 Gualtieri di San Lazzaro, *Parigi era viva* (Milan: Mondadori, 1966), 148–49.

50 *Memoirs of Giorgio de Chirico*, 165.

51 As we shall see, Soby was the first to be subjected to Breton's fraudulent claims, aimed solely at discrediting and destroying his sworn enemy.

52 This passage represents a grotesque twist on the very different sentiments expressed in 1924 (see note 1), in which Savinio was naturally not mentioned at all.

53 Soby, *The Early Chirico*.

54 Admittedly, fleeting and chance encounters between de Chirico and Soby had occurred during de Chirico's visit to the United States (1936–38). Yet at that time, while already infatuated with his metaphysical works (which he had started to collect in 1935), Soby had probably not yet planned to write a monograph on the artist. Moreover, contact with Italy was problematic during the war years, which might explain the lack of communication in regard to the first book, published in 1941. However, his initial appreciation of de Chirico's work had already passed through the malign filter of Bretonian surrealism, which explains the diffidence he exhibited toward de Chirico during their meetings in New York, of which only one "casual" encounter is recorded as having taken place, in the house of Eugène Berman and Leonor Fini, on which occasion de Chirico "talked learnedly on a variety of subjects related to art, he looked disheveled and even imperial, and he ranted against many of his former colleagues in the School of Paris, most of whom, he said, couldn't even draw . . . There was already much of the academician in his character"; see Pamela Koob, "James Thrall Soby and de Chirico,"

in *Giorgio de Chirico and America*, exhibition catalogue edited by Emily Braun (New York: Hunter College of the City University, 1996), 114. Koob's text (111–24) is informative but ignores the extent of Breton's influence on Soby.

55 *La Fiera Letteraria* II, 5 (January 1947): 6. It seems that in 1946 Soby deigned to send a copy of his book to de Chirico (Koob, "James Thrall Soby and de Chirico," in *Giorgio de Chirico and America*, exhibition catalogue edited by Braun, 119), although I have been unable to confirm this. Indeed, why send an artist a text stating that he had "died" in 1918? Only as an affront—surely not in anticipation of a favorable response.

56 Although he wrote to Wyndham Lewis in 1947 commenting that it was "hopeless to expect any help from Chirico himself" (Koob, "James Thrall Soby and de Chirico," in *Giorgio de Chirico and America*, exhibition catalogue edited by Braun, 119), it is clear that he had never sought to clarify anything subsequently with de Chirico, believing that "He hates all his early pictures, accuses everyone who likes them of being 'surrealist pederasts.'" In making such a statement he was evidently not voicing the sentiments of the artist, but merely repeating Breton's opinion as a matter of fact.

57 See de Sanna, *Giorgio de Chirico—André Breton: Duel à mort*, 145.

58 See above. Regarding the malevolent untruths that Breton fed Soby, we can see a curious and enlightening document dating from February 9, 1943 held in the archives of New York's Museum of Modern Art. This is Soby's record (as told to Alfred Barr) of an evening at the home of Peggy Guggenheim, when he spoke at length with Breton on the subject of de Chirico. Even Soby was perplexed on that occasion, and suspected Breton of being drunk. Among other enormities Breton claimed that it was he who had discovered de Chirico in 1918 and had introduced him to the other surrealists (correcting himself when Max Ernst approached the two men and momentarily joined the conversation); that it was not de Chirico who had given his works their titles, but rather Apollinaire and, later, Paul Guillaume; that *The Enigma of the Oracle* and *The Enigma of an Autumn Afternoon* were either fakes or much later works by the artist; that the only interesting sections of the journals belonging to Éluard were those he had himself published; and that he had expressed doubts about the mannequins of 1915. The only compliment Breton paid de Chirico concerned *Hebdomeros*, stating that "Chirico spoke like an angel in French, with extraordinary shades of meaning and thought."

Subsequently, however (when sober), Breton must have been very convincing, providing Soby with important documents such as the Éluard manuscripts, as well as both true and (indeed, above all) false information. Some confusion on Soby's part was revealed in another letter to Barr of October 27, 1950, regarding the idea that the surrealists considered de Chirico dead after 1917, having discovered that *Sacred Fish*, like *Hermetic Melancholy*, dated from 1919. However, in other contemporaneous or subsequent letters his pro-surrealist affiliations were consolidated: in a letter of 1949 to Monroe Wheeler, he noted that he expected to be denounced by de Chirico, and that he would be happy if it happened, believing that the artist had been effectively "boiled" in 1918. Again, writing to Ada Cumins on December 5, 1959, he asserted: "I do not like de Chirico's paintings of this kind at all: they seem hopelessly empty and academic." A letter of March 13, 1970, to the merchant Memo Toninelli concludes this florilegium: he absolutely refused to be associated with the extensive Milan retrospective of that year, and also denied the loan of his paintings, not even having replied to two letters that de Chirico himself had sent him; he also expressed regret that William S. Lieberman, director of MoMA's Department of Painting and Sculpture, had agreed to be part of the exhibition committee, and that he would have discouraged him had he known about it. His words express irritation with de Chirico for having refused to be considered senile after 1918. My thanks go to Katherine Robinson for bringing to my attention these documents held in the JTS Papers, MoMA Art Archives, New York.

[59] Neither Ernst nor Duchamp agreed with Breton's views, despite being close to him during the New York period. Duchamp clearly and consciously proclaimed the greatness of de Chirico: "CABANNE: At that time, you took an active part in Surrealist demonstrations. You defended de Chirico against the anathema of Breton and his friends, maintaining that, in the end, it is posterity who will decide. . . . DUCHAMP: Certainly. It is the posthumous spectator, because the contemporary spectator is worthless, in my opinion. His is a minimal value compared to that of posterity, which, for example, allows some things to stay in the Louvre. To get back to Breton: the way they condemned de Chirico after 1919 was so artificial that it rubbed me the wrong way. There had already been other rehabilitations, and I thought: 'Wait for posterity'" (Pierre Cabanne, *Dialogues with Marcel Duchamp* [New York: Da Capo Press, 1971], 76).

[60] Giorgio de Chirico, "De Chirico, a spada tratta," in *La Fiera Letteraria* II, 5 (January 1947): 6.
[61] De Chirico himself mentioned the restorer Nicola Locoff [*sic*] in his *Memoirs*, 113, who simply "explained to me that many old pictures, which seem to be oil paintings, are in fact varnished tempera."

Chap. 21
Mediterranean Classicism

[1] See, for example, *Giorgio de Chirico. Gladiatori 1927–1929*, exhibition catalogue edited by Baldacci, 145.
[2] "It is fate. *Veniet felicior aetas*!!, as Sal. Reinach would say"; in *Lettere*, 63.
[3] *On Classic Ground. Picasso, Léger, de Chirico and the New Classicism 1910–1930*, exhibition catalogue edited by Elizabeth Cowling (London: Tate Gallery, 1990).
[4] Cocteau, *Le Mystère laïc*.
[5] In the second surrealist manifesto of 1930.
[6] Cocteau, *Le Mystère laïc*, Paris, 1928, 7.
[7] *Ibid.*, 14–15.
[8] *Ibid.*, 26.
[9] *Ibid.*, 31.
[10] *Ibid.*, 41–42.
[11] *Ibid.*, 44.
[12] *Ibid.*, 46–47.
[13] *Ibid.*, 64–65. Cocteau also explained the natural superiority of de Chirico's method over that of the surrealists: "Outside of their rather solemn atmosphere, de Chirico's paintings borrow nothing from the dream. Indeed, his paintings seem to be sleeping rather than dreaming. . . . I congratulate de Chirico because he creates in accordance with the processes of sleep instead of copying from sleep. To describe dreams is a mistake, just as, in 1916, it was to describe machines" (57).
[14] In his *Memoirs*, 121, de Chirico stated: "I am very grateful to Jean Cocteau for the interest he has shown in me, but I must say that I do not in fact approve of the kind of praise he accords me and the interpretation he likes to put on my pictures." Nevertheless, his true position was rather different (see forward, chap. 31).
[15] For example, information concerning the artist's family, which allowed Cocteau to identify de Chirico's imagery with a strain of genial madness that was almost genetic in character: "De Chirico's paternal relations: a mad uncle and aunt. His uncle pushed a chair in front of himself in order

to avoid falling into an abyss. Aunt Olimpia loosened her superb hair, knelt in front of a sofa, and rubbed her cranium until she became bald. Similar precedents contribute to remove any picturesque qualities from de Chirico's work" (Cocteau, *Le Mystère laïc*, 5–6).

16 Interview by Pierre Lagarde to Giorgio de Chirico, "M. de Chirico, peintre prédit et souhait le triomphe du modernisme" [Mr. de Chirico, a painter predicts and hopes for the triumph of Modernism], in *Comœdia*, December 12, 1927 (republished in *Metaphysical Art* 14–16 [2016]: 401–2). This interview's *tranchant* tone provoked a small earthquake, generating controversy both in Italy (where many, including his old colleague-enemy Carrà, responded with bitterness, and de Chirico's invitation to the Venice Biennale was withdrawn) and among the Italian painters based in Paris, who at that moment were in the process of forming a group: indeed, it led to the exclusion of both de Chirico and his brother, Savinio, from the group's first exhibition in 1928. However, the controversy subsided shortly thereafter, in France but not in Italy, and de Chirico and his brother were able to participate in the second exhibition. A group of Milanese artists (including Virginio Ghiringhelli, Amerigo Carpanetto, Contardo Barbieri, Umberto Lilloni, Amerigo Canegrati, Oreste Bogliardi, Francesco De Rocchi, among others) wrote an extremely violent letter to the administrator of the Venice Biennale on December 20, 1927: "Following the declarations made by the painter Giorgio de Chirico published in the journal *COMŒDIA* . . . this traitor must never exhibit in Italy again . . . we are determined, by whatever means, including the destruction of de Chirico's works wherever we find them. We hope that the Venice Biennale Committee will refuse to grant hospitality to the paintings of this livid bastard." It followed a letter from Orsi, the Venetian Podesta, in which he communicated to de Chirico: "following your interview published in the journal *Comœdia* on 12 December, your invitation to exhibit at our XVI Biennale has been revoked." Carrà, for his part, wrote to Soffici in very crude manner, telling him to intervene through the Secretary-General Antonio Maraini so that "de Chirico must never exhibit in Italy again" (see Giorgia Chierici, "Giorgio de Chirico e Venezia: 1924–1936," in *Metafisica* 17–18 [2018]: 255–351).

17 Letter from Léonce Rosenberg to Giorgio de Chirico of July 29, 1928 (Paris, Centre George Pompidou, Bibliothèque Kandinsky), quoted in Derouet, "La Fureur guerrière malgré J.T. Soby est entrée au musée," in *Giorgio de Chirico. La*

fabrique des rêves, exhibition catalogue edited by Munck, 142.

18 Giorgio de Chirico, *Piccolo trattato di tecnica pittorica* (Milan: Scheiwiller, 1928), 18.

19 Cocteau, *Le Mystère laïc*, 15.

20 *Ibid.*, 9–10.

21 *Ibid.*, 23–24.

22 *Ibid.*, 67.

23 *Salt Seller: The writings of Marcel Duchamp*, edited by Michel Sanouillet and Elmer Petersen (New York: Oxford University Press, 1973), 143.

24 See Cabanne, *Dialogues with Marcel Duchamp*, 144.

25 "Another unpleasant fact that I recollect was a series of earthquakes which occurred regularly every evening after sunset. The whole house moved slowly like a big ship on squally sea. The inhabitants of the district, including ourselves, carried their mattresses outside into a square in order to sleep in the open. On this occasion also the cook Nicola excelled himself in endless ways. He carried out mattresses, cases and even some furniture, and in the morning he took everything back into the house" (*Memoirs of Giorgio de Chirico*, 17). In a later filmed interview, the artist spoke of a chance inspiration that was certainly connected to his childhood memory: "Furniture in a Valley is an idea that came to me when I saw furniture—I think in Paris. In fact in any city, also in other countries, you come across these shops that sell inexpensive furniture and display it outside on the pavement, beds, armchairs. These are objects we are accustomed to see inside a house. Seen outdoors they have a strange effect, so I thought of actually setting them in the countryside [laughs] rather than on the pavement. So I started painting pictures of furniture which I called 'Furniture in a Valley'" (Jean José Marchand, "Intervista con de Chirico," in *Metafisica* 11–13 [2014]: 286–98).

26 Giorgio de Chirico, "Statues, Meubles et Généraux," in *Bulletin de l'Effort Moderne*, October 1927; the same theme was revisited in Id., "Quelques perspectives sur mon art," in *L'Europe centrale*.

27 Id., "Quelques perspectives sur mon art," in *L'Europe centrale*.

28 See Benzi, *Arte in Italia tra le due guerre*.

29 Giorgio de Chirico, "Statues, Meubles et Généraux," in *Bulletin de l'Effort Moderne*.

30 Interview between de Chirico and Georges Brunon Guardia in *Beaux-Arts*, October 13, 1933.

31 Éluard—Picasso Manuscripts; now in *Scritti/1*, 625.

32 Cocteau, *Le Mystère laïc*, Paris, 1928, 67.

33 Taken from the filmed interview of 1971 with Jean José Marchand, transcribed in *Metaphysical Art* 11–13 (2014): 286–98. An initial reference to this source of inspiration appeared in a passage written by de Chirico during the 1930s ("Barnes collezionista mistico," in *L'Ambrosiano*, February 16, 1938): "sitting with a monumental trunk and short legs like apostles in Gothic cathedrals."

34 Baldacci's interpretation of these scenes as being homosexual in character, and even as being based on scenes from gay saunas (*Giorgio de Chirico. Gladiatori 1927–1929*, exhibition catalogue edited by Baldacci), is somewhat ridiculous given their marked iconographic dependence on frigid sketch illustrations derived from Reinach's archeological books. Moreover, one of the earliest works on this theme depicted women (*Amazon's Training*, 1927), which contradicts any exclusively gay reading. It is difficult to understand how a psychoanalyst could have brought himself to support such an argument, even taking into account his own incompetence regarding pictorial matters, which he states in the catalogue text. I am not opposed to psychoanalytic interpretations, even those of a sexual character, but I do believe that these should be based on something more than the opinions of a sauna visitor. With respect to the series of works depicting horses, we fear an interpretation of de Chirico as a practicing zoophile.

35 See Mark Antliff, "Waldemar George: A Parisian Art Critic on Modernism and Fascism," in *Fascist Visions: Art and Ideology in France and Italy*, edited by Matthew Affron and Mark Antliff (Princeton, NJ: Princeton University Press, 1997), 171–205. A number of facts prove that de Chirico was not pro-fascist at this time. Following the aforementioned article published in *Comœdia* on December 12, 1927, in which the painter expressed his objections to the prevailing Italian cultural environment, his invitation to the Venice Biennale of 1928 was withdrawn (see the unidentified, undated, and anonymous press cutting entitled "L'Esposizione di Venezia deve ritirare l'invito al pittore De Chirico" in the Fondo Ugo Ojetti at the Galleria Nazionale d'Arte Moderna in Rome, Serie I, "Corrispondenti: artisti," f. "De Chirico Giorgio [pittore]"). Following the news of his renewed invitation to the Venice Biennale, de Chirico wrote a letter to his friend the painter Nino Bertoletti (who had informed him of the news) in a forthright tone that suggests his interlocutor was just as critical of fascism as he was: "Dear Bertoletti . . . I am very 'touché' by the invitation to the

Biennale but unfortunately it is impossible for me to send any paintings to Italy now. I have no paintings here, and the dealers would certainly not lend any, especially for an exhibition in Italy, because we know that in Italy modern art has never been in vogue and now, with Francophobia, the return to tradition, Fascist art, and so on, it is less so than ever. . . . So there it is, dear Bertoletti, even if I had paintings I would be careful not to send them to Italy" (letter to Nino Bertoletti from Paris, dated July 14, 1930, in *Gli artisti di Villa Strohl-Fern*, exhibition catalogue edited by Lucia Stefanelli Torossi [Rome: De Luca, 1983], 142). Nevertheless, de Chirico would in fact exhibit at the Biennale, in the room devoted to the *Italiens de Paris* group. Subsequently, despite being commissioned to paint the mural in the Hall of Honor for the Milan Triennale in 1933, he again wrote to Bertoletti from Milan on October 31, 1933: "I have decided to return to Paris; there is no longer any air for me here; too much hostility and too much boycotting. I'm really beginning to get tired" (*ibid.*, 143).

36 Waldemar George, "Appel du Bas-Empire. Georges de Chirico," in *Formes*, January 1930.

37 Giorgio de Chirico, "Guillaume Apollinaire," in *Ars Nova* 2 (1918): "When I recall his numismatic profile, which I printed on the Veronese sky of one of my Metaphysical paintings, I think of the grave melancholy of the Roman centurion."

38 See Salomon Reinach, *Répertoire de la statuaire grecque et romaine* (Paris: Ernest Leroux, 1897–1931), 6 vols. De Chirico's interest in Reinach is proof of how deep his classicist roots were even in his metaphysical period and harks back to his Florentine and Parisian years and was an interest he shared with Paul Guillaume, as previously noted from a letter from de Chirico to Guillaume of June 3, 1915, which ends with a maxim of Reinach (in *Lettere*, 63).

39 De Chirico, *Hebdomeros*, 61.

40 On the life of the group, *Les Italiens de Paris. De Chirico e gli altri a Parigi nel 1930*, exhibition catalogue edited by Maurizio Fagiolo dell'Arco and Claudia Gian Ferrari (Milan: Skira, 1998); Benzi, *Arte in Italia tra le due guerre*.

41 Georges Ribemont-Dessaignes, "G. de Chirico," in *Les feuilles libres* 43 (May–June 1926).

42 See notes 16 and 35.

43 Alberto Savinio, "Fini dell'arte," in *Valori Plastici* I, 6 (June–October 1919): 21.

44 On Waldemar George, see H. Romani, "Il pensiero neo-umanista di Waldemar George," in *Il futuro alle spalle. Italia-Francia: L'arte tra le due guerre*, exhibition catalogue edited by Federica

Pirani (Rome: De Luca, 1998), 109–113; on the political role of George, who clearly sympathized with facism at the end of the 1920s, see Matthew Affron, "Waldemar George: A Parisian Art Critic on Modernism and Fascism," in *Fascist Visions: Art and Ideology in France and Italy*, edited by Affron and Antliff, 171–205.

[45] See the catalogue of the Paris exhibition *22 Artistes Italiens Modernes* (Paris: Galerie Georges Bernheim, 1932).

[46] Waldemar George, catalogue presentation, in *Prima mostra di pittori italiani residenti a Parigi* (Milan: Galleria Milano, 1930).

[47] Alberto Savinio, "Prefazione," in *Tutta la vita* (Milan: Bompiani, 1945), 7–8.

[48] Giorgio d Chirico's letter to Alberto Savinio, April 24, 1926 (in *Lettere*, 360).

[49] Among the many studies on Rosenberg and the Gladiators, see Derouet, "La fureur guerrière malgré J.T. Soby est entrée au musée," in *Giorgio de Chirico. La fabrique des rêves*, exhibition catalogue edited by Munck.

[50] Cocteau, *Le Mystère laïc*.

[51] Waldemar George, *Giorgio de Chirico* (Paris: Chroniques du jour, 1928).

[52] Boris Ternovetz, *Giorgio de Chirico* (Milan: Hoepli, 1928). Ternovetz was a conservator at the Museum of Western Art in Moscow. On the influence of de Chirico in Russia—particularly on the work of Malevich—see Tatiana Goryacheva, "De Chirico and Russia: Contacts, Collections, Influence," in *Giorgio de Chirico. Metaphysical Visions*, exhibition catalogue edited by Gianni Mercurio, Tretyakov Gallery, Moscow (Crocetta del Montello: Antiga, 2017), 109–39.

[53] Roger Vitrac, *Georges de Chirico* (Paris: Gallimard, 1927).

Chap. 22
The Early 1930s: Between Renoir and Derain, a New Idea of Modern Classicism

[1] Waldemar George, *La grande peinture contemporaine à la collection Paul Guillaume* (Paris: Éditions des Arts à Paris, 1929), 44.

[2] Giorgio de Chirico, "Vox clamans in deserto," in *L'Ambrosiano*, in three parts: March 16, 23, and 30, 1938.

[3] George, *La grande peinture contemporaine à la collection Paul Guillaume*, 14–16.

[4] *Ibid.*, 135.

[5] *Ibid.*, 124.

[6] On the history of Renoir's work in the collection of Picasso, see *Picasso collectionneur*, exhibition catalogue edited by Hélène Seckel-Klein, Kunsthalle der Hypo-Kulturstiftung, Munich (Paris: Réunion des musées nationaux, 1998), 202–9.

[7] The *Avis* [Notice], published on the occasion of de Chirico's exhibition at the Galerie Le Centaure in Brussels, attacked the artist in the usual violent manner. It was signed by Breton, Louis Aragon, Camille Goemans, and Paul Nougé; Magritte's signature was missing, as he did not want to be associated with this act of aggression.

[8] George, *La grande peinture contemporaine à la collection Paul Guillaume*, 96.

[9] *La pittura metafisica*, exhibition catalogue edited by Briganti and Coen, 119–20.

Chap. 23
Between "Surrealism" and Realism

[1] De Chirico, *Piccolo trattato di tecnica pittorica*, 4.

[2] He first returned in 1931 on a number of occasions, while between 1932 and 1933 he stayed for a longer period of time in both Milan (where he lived in 9, Via Rugabella) and Florence, where he was a guest of the Bellini antique dealers. In Milan, in 1933, he executed a mural on the main wall of the Hall of Honor in the new Palazzo della Triennale, titled *La cultura italiana*. He returned to Paris in 1934.

[3] On this period of de Chirico's life, see Fagiolo Dell'Arco, *De Chirico: Gli anni Trenta*. See also Franco Ragazzi, "Giorgio de Chirico and the Exhibition of the 'Novecento Italiano,'" in *Metafisica* 7–8 (2008).

[4] De Chirico's interest in Velasquez began during a visit to his lover in Madrid in 1929, when he studied the painting of the Spanish artist at the Prado. See Katherine Robinson, "Giorgio de Chirico: lettere a Cornelia. Carteggio inedito (1929–1951)," in *Metafisica* 14–16 (2016): 140. Nothing was known of de Chirico's visit to Spain prior to the publication of this correspondence.

[5] On the iconography of the *Bagni misteriosi*, see Flavia Matitti, "'Ricerche di invenzione e di fantasia.' Una nuova pittura metafisica," in Fagiolo Dell'Arco, *De Chirico: Gli anni Trenta*, 149–70.

[6] Letter from de Chirico to Nino Bertoletti of October 14, 1934, in *Gli artisti di villa Strohl-Fern*, exhibition catalogue edited by Stefanelli Torossi, 143.

[7] Jean Cocteau, *Mythologie*, printed by Edmond

Desjobert (Paris: Éditions Les Quatres Chemins, 1934).

8 See the filmed interview of 1971 with Jean José Marchand, transcribed in *Metafisica* 11–13 (2014): 286–98.

9 Martha Davidson, "The New Chirico. A Classic Romantic," in *Art News*, October 30, 1936.

10 De Chirico describes the lithograph, *Accords*, from *Brahmsphantasie. Opus XII* of 1894, in his essay "Max Klinger" (in *Il Convegno*, October 1920): "Above a scaffolding built upon the sea and splashed with waves and foam upon which a pianist dressed in black sits, . . . Beneath them, a triton is struggling to hold up an enormous harp. . . . In order to render this paradoxically lyrical scene even more real, Klinger placed a wooden ladder next to the pianist, like that of a bathing cabin, the first steps of which descend into the water. The 'idea' of this ladder is full of extraordinary genius. Going back to my childhood memories, I remember how bathing cabin ladders such as this always troubled me and gave me a feeling of dismay. Those few rungs covered with algae and immersed in less than a metre of water seemed to me to descend countless leagues into the very heart of the ocean's gloom. I relived the same emotion when I saw this engraving by Klinger but the ladder has yet another meaning here: it unites the real scene with an unreal one, expressed through the same means and without being misty or confused. . . . It would seem that the pianist, abandoning his instrument, could descend into the water while the marine creatures could climb up and sit on the platform. It is a dream and reality at the same time; to the spectator it looks like a scene he has already seen without remembering when or where. The profundity and metaphysical sense in Klinger's vision can be compared in literature to Thomas de Quincey's account of a very strange dream he had. He narrates how he found himself in the hall of a brilliantly illuminated palace at a festival where many fine gentlemen and ladies were dancing; suddenly a mysterious voice shouted: *Consul Romanus!* and the Consul appeared with his legions."

Chap. 24
A Theatrical Art

1 De Chirico's set designs for this work (published on the cover of the *Rivista di Firenze* in May 1925) must have made an indelible impression on Savinio, who had still not yet begun to paint, given

their close correspondence with his postwar imagery.

2 Among de Chirico's many projects were: *Pulcinella*, 1931 (London, Lyceum Theatre, for l'Opéra Russe à Paris); *Ariadne et Bacchus*, 1931 (Paris, Théatre de l'Opera, music by Albert Roussel); *I Puritani*, 1933 (Maggio Musicale Fiorentino, music by Vincenzo Bellini); *La figlia di Jorio*, 1934 (Rome, Teatro Argentina; by Gabriele d'Annunzio, directed by Luigi Pirandello); four works for the Athens Festival that were never performed, 1939 (*Orestes, The Bacchae, The Minotaur, Oedipus*); *Anfione*, 1942 (Milan, Teatro alla Scala, script by Paul Valéry, music by Arthur Honegger and choreography by A. Miloss); *Don Giovanni*, 1944 (Milan, Teatro alla Scala, music by Richard Strauss, choreography by A. Miloss); *La lunga notte di Medea*, 1949 (Milan, Teatro Nuovo, by Corrado Alvaro); *Orfeo*, 1949 (Maggio Musicale Fiorentino, music by Monteverdi); *Ifigenia*, 1951 (Maggio Musicale Fiorentino, music by Ildebrando Pizzetti); *La leggenda di Giuseppe*, 1951 (Milan, Teatro alla Scala, music by Richard Strauss); *Don Chisciotte*, 1952 (Maggio Musicale Fiorentino, music by Vito Frazzi); *Mefistofele*, 1952 (Milan, Teatro alla Scala, music by Arrigo Boito); *La Coda Santa*, 1953 (Rome, Teatro dei Satiri, by D. Terra); *Apollon Musagète*, 1956 (Milan, Piccola Scala, music by Igor Stravinsky, choreography by Serge Lifar); *Otello*, 1964 (Teatro dell'Opera di Roma, music by Gioachino Rossini).

3 Giorgio de Chirico, "Discorso sullo spettacolo teatrale," in *L'Illustrazione Italiana* (October 25, 1942): 417. The text would later be republished, with Isabella Far's signature, in *Commedia dell'arte moderna* (Rome: Traguardi, 1945), English translation "Theater Performance," in *Metaphysical Art* 14–16 (2016): 130–34.

Chap. 25
De Chirico and the United States: The Metaphysics of the New World

1 De Chirico met Isabella Pakszwer in the fall of 1930 in Paris. The couple married on May 18, 1946, and stayed together for the rest of their lives. In his novel *Il Signor Dudron*, de Chirico gave Isabella the pseudonym "Far," "a name that has a heralding or prophetic quality about it. In French it sounds like the word phare." Giorgio de Chirico, *Il Signor Dudron*, published posthumously (Florence: Le Lettere, 1998); now in *Scritti/1*, 201.

[2] Levy, *Memoir of an Art Gallery*, republished in *Metafisica* 7–8 (2008): 707.

[3] De Chirico was interested in many aspects of British culture, from de Quincey to Shakespeare, and from George Frazer to Ruskin; in terms of British painting, he was an admirer of artists such as Holbein, Turner, and Constable, et al.

[4] On de Chirico and Britain, see Noel-Johnson's fundamental study *De Chirico and the United Kingdom (c. 1916–1978)*.

[5] On de Chirico in the United States, see *De Chirico and America*, exhibition catalogue edited by Braun. See also Robinson, "Giorgio de Chirico—Julien Levy: Shared Experience," in *Metafisica*: 326–56 and 672–78, and Id., "The Giorgio de Chirico—Jacques Seligmann & Co. Epistolary: Milan–Paris–New York 1938. A Missed Exhibition," in *Metaphysical Art* 9–10 (2011): 116–37 and 366–71.

[6] Julia May Boddewyn, "The First American Collectors of de Chirico," in *De Chirico and America*, exhibition catalogue edited by Braun, 46.

[7] Levy, *Memoir of an Art Gallery*.

[8] In February 1937, at the Decorators Picture Gallery in New York, he exhibited a dining room and living room constructed with furniture inspired by the sets of *The Puritans* in black and white on "apricot" red walls. These were decorated with five of his paintings, and incorporated a bar in the form of one of the cabins from the *Mysterious Baths*. The installation had been sponsored by Mrs. Ward Cheney, who financed the gallery, and of whom de Chirico had painted a portrait.

[9] Robinson, "The Giorgio de Chirico—Jacques Seligmann & Co. Epistolary," in *Metaphysical Art*: 120–21. The presence of Isa, who was not yet de Chirico's wife, also made it difficult for the couple to prolong their stay.

[10] Giorgio de Chirico, "J'ai été à New York," in *XX siècle*, March 1938, English translation, "I Have Been to New York," in *De Chirico and America*, exhibition catalogue edited by Braun, 136–38.

Chap. 26
Between 1938 and 1940: Omens of War

[1] Raffaele Carrieri, "Incontro con Giorgio de Chirico," in *L'Illustrazione italiana*, February 13, 1938.

[2] See Raffaello Giolli, "Ritorno di de Chirico," in *Domus* 123 (March 1938): 32–33.

[3] *Memoirs of Giorgio de Chirico*, 144–45.

[4] *Ibid.*, 149.

[5] *Ibid.*

Chap. 27
The War Years

[1] Libero De Libero, "La XXIII Biennale veneziana: cose dette e taciute," in *Documento*, July–August 1942.

[2] It should not be forgotten that de Chirico's wife was Jewish.

[3] Raffaele Carrieri, *Giorgio de Chirico* (Milan: Garzanti, 1942), n.p.

[4] Giorgio de Chirico, "Brevis pro plastica oratio," in *Aria d'Italia*, Winter 1940.

[5] See Giovanna Rasario, "Giorgio de Chirico *pendant* Bellini," in *Metafisica* 3–4 (2004): 294.

[6] Giorgio de Chirico, "Brevis pro plastica oratio," in *Aria d'Italia*.

[7] Even though de Chirico received help from molders and sculptors, from the numerous photos of works in progress in his atelier, one evinces that he personally took care of the realization and finishing.

[8] No updated study on this subject exists; see *De Chirico scultore*, edited by Giovanna Dalla Chiesa (Milan: Mondadori, 1988). It is noteworthy that in the same period—the 1960s—a number of the most important European painters, including Miró, Ernst, Dalí, and Magritte, dedicated themselves to transforming their bidimensional creations into bronze, even in large formats, helped by sculptors and molders, obtaining fine quality works showing great ability. Evidently, a certain demand existed on the international market at the time for iconic works. De Chirico, like Magritte and, at times, Dalí, used the Gi.Bi.Esse Foundry in Verona, but also Modern Art Foundry in Astoria, Queens, New York.

[9] *Memoirs of Giorgio de Chirico*, 156.

[10] *Ibid.*, 158.

[11] See Velso Mucci, "Galleria S. Bernardo," in *Cosmopolita* 15 (April 12, 1945): 6.

[12] See Arthur Schopenhauer, *The World as Will and Representation* (translation by E.F.J. Payne), New York 1969, III, 48, 230–33.

[13] *Ibid.*, III, 233–36: "The generation, in other words the dull multitude of any time, itself knows only concepts and sticks to them; it therefore accepts mannered works with ready and loud applause. After a few years, however, these

works become unpalatable, because the spirit of the times, in other words the prevailing concepts, in which alone those works could take root, has changed. Only the genuine works that are drawn directly from nature and life remain eternally youth and strong, like nature and life itself. For they belong to no age, but to mankind; and for this reason they are received with indifference by their own age to which they disdained to conform; and because they indirectly and negatively exposed the errors of the age, they were recognized tardily and reluctantly. On the other hand, they do not grow old, but even down to the latest times always make an ever new and fresh appeal to us. They are then no longer exposed to neglect and misunderstanding; for they now stand crowned and sanctioned by the approbation of the few minds capable of judging. These appear singly and sparingly in the course of centuries, and cast their votes, the slowly increasing number of which establishes the authority, the only judgment-seat that is meant when an appeal is made to posterity."

14 De Chirico had already painted a self-portrait in Eastern costume at the end of 1939 (exhibited in Florence in February 1940), but this was more reflective in regard to references to Delacroix and Orientalism that characterized his work during those years, rather than the "anachronism" of his subsequent self-portraits in costume. Naturally, one can still perceive the origins of the later works in such imagery (see the following note).

15 Raffaele Carrieri, *Giorgio de Chirico* (Milan: Garzanto, 1942), no. XLIII (Marmont collection); the *Portrait of Viscountess Maria Marmont* (no. XLVIII), also from 1940, features a period costume.

16 De Chirico, "Discorso sullo spettacolo teatrale," in *L'Illustrazione Italiana*: 131.

Chap. 28
Revisiting Metaphysical Works

1 See the de Chirico–Breton correspondence, in de Sanna, *Giorgio de Chirico—André Breton: Duel à mort*, 146–54.

2 Three paintings are presently known to date to the second half of the 1920s. These were indicated by Fagiolo dell'Arco (*Giorgio de Chirico: Parigi 1924–1929*, 479–80) as originally being, respectively, in the collections of René Berger (*Hector and Andromache*, 1924 [?], more likely 1926–29), Marcel Raval (*Souvenir of Italy*, 1925–26) and Pierre Roy (*The Pink Tower*, 1926 [?], more likely 1928–30).

However, Baldacci (*De Chirico 1888–1919*, 419–20), speaks of paintings executed *expressly* for these collectors: we know this to be untrue as Berger, in a letter held in the Tate Gallery Archives in London, indicates that he bought *Hector and Andromache* in Germany from a German collector, with the artist himself as an intermediator, during a stay when de Chirico was his guest (Berger lived in Berlin from December 1924 to 1930): see Rasario, "Le opere di Giorgio de Chirico nella Collezione Castelfranco. L'Affaire delle 'Muse Inquietanti'," in *Metafisica* 5–6 (2006): 277–351. De Chirico was in Berlin in 1930, so that is when the painting entered Berger's collection. The two had known each other since the early 1920s, when Berger was studying in Florence, and it was there that he began acquiring the artist's paintings. De Chirico had also been Berger's guest in Paris in November 1924, at his house at 32, rue Pergolèse. De Chirico painted a version that was decidedly "updated," not only of *The Troubadour* and *The Philosopher* (from *Le revenant [The Child's Brain]*) in 1924 for Éluard, but also of an Italian Piazza (ca. 1926–27, once owned by Savinio's dealer, Pomaret); *The Condottiero* (1925?, more likely 1926–29), bought by Berger along with *Hector and Andromache* in 1930 (Baldacci also indicates this as expressly made for Berger), is a painting that could be described as being halfway between a reinterpretation and a replica (no model exists, only a drawing on which it is based), and the technique is decidedly characteristic of that of the 1920s. I think *The Great Metaphysician* in Berlin, Staatliche Museen—Stiftung Preußischer Kulturbesitz, unrealistically dated 1916 and referred to by Fagiolo dell'Arco (*Giorgio de Chirico: Parigi 1924–1929*, 480) as 1926, may rather date to the late 1930s or early 1940s.

3 An initial, significant "reedition" of metaphysical paintings dates to de Chirico's stay in Paris in 1934–35 when, due to the crisis, he was having serious financial problems. In a letter of October 1934 he confided to his friend Nino Bertoletti: "I have a lot of problems here, due to the crisis, the collapse of the market, the death of Paul Guillaume (who was the only one who counted in these times), the arrival of my wife in Paris which cost me a lot without counting the arguments, the threat of scandals, fits of rage, gossip and slander etc. etc., really, reason to shoot oneself" (de Chirico letter to Nino Bertoletti, Paris, October 14, 1934, in *Gli artisti di villa Strohl-Fern*, exhibition catalogue edited by Stefanelli Torossi, 143).

4 In the monograph, with which he was directly involved, a number of paintings are reported with chronological differences of up to twenty years—

not only boldly aging the paintings but also dating them to more recent times.

5 An important early, albeit not yet precise, reconstruction can be found in Fagiolo dell'Arco, *De Chirico: Gli anni Trenta*. Fagiolo dell'Arco identifies around fifty works that he claims date from the period spanning the early 1930s and the mid-1940s; however, in my opinion not all of them date from those years (some are later, dating from the period following the Second World War).

6 Published in *Quadrante* 9 (1934). The work shows an unusual technical execution that could be attributed to the replication of older works and not to his current style.

7 The two works were displayed at the Siegel-Antheil Gallery in Hollywood as part of the exhibition *A Distinguished Showing of Surrealist and Neo-Romantic Works*, February 23–March 23, 1937 (organized with the collaboration of Julien Levy). Their dates can be deduced from both circumstantial evidence (provided by an analysis of *Egg in the Street*, which was painted on a French canvas) and a documentary source: a letter from the Jacques Bonjean gallery in Paris (that owned the painting) to Julien Levy of January 20, 1937 (the letter is located in the archives of the Philadelphia Museum of Art; I thank Giorgia Chierici for bringing this to my attention). The letter refers to *Egg in the Street* along with other paintings (*Plaster Head*, and another three works that have proved to be untraceable, and which were probably recent metaphysical replicas: *Mannequins on a Green Sky*, *Small Landscape—Italian Piazza*, and a "large Italian landscape") obtained from de Chirico himself through a recent exchange (in fact, the letter reports that de Chirico was thinking of cancelling the transaction). In addition to these two works (plus the three unidentified pieces) and that mentioned above (*Memories of Italy*), only four other metaphysical reconstructions are documented as having been executed during the 1930s (between 1938 and 1939), of which three relate to the Il Milione gallery, which was evidently involved in the trading of de Chirico's work (perhaps they were commissioned by the gallery). These are *Italian Piazza (with Ariadne)*, included in a 1938 calendar published by the Galleria Il Milione, and *Meditation* (published in *Emporium* [June 1939]: 534); the other two (*The Return of Hector* and *Hector and Andromache*, the first of which presents elements that are difficult to analyze) were exhibited at de Chirico's solo exhibition of metaphysical works at Galleria Il Milione (October 26–November 15, 1939).

8 For example, in Carrieri's 1942 monograph we find two Italian Piazzas dated 1915 (nn. IV and VI) and a *Hector and Andromache* dated 1915 (no. III), all of which were executed in the years immediately preceding 1942 (and all owned by the collector Rino Valdameri, along with other works published in the same volume). However, another *Hector and Andromache* (n. XIV, also then owned by Valdameri, and now in the Galleria Nazionale d'Arte Moderna in Rome) was dated to 1928, when in fact it can instead be dated with certainty to 1923–24. As we can see, de Chirico did not simply backdate his works, but also postdated them, subscribing in polemical fashion to the philosophy of "timeless painting" in a manner that contrasted with the approach of other protagonists of the Italian avant-garde. Another painting of the same period, *Turin Melancholy* (also dated 1915), passed from the Milione gallery into the Valdameri collection and, from 1944, belonged to the collection of Carlo Frua de Angeli; it was exhibited at the 1948 Venice Biennale as a work of 1915 (cat. 18, repr. 13).

9 Castelfranco, "La XXIV Biennale Internazionale d'Arte di Venezia," in *Bollettino d'Arte* XXXIII, 3: 281–82: "But let us read the official interpretation contained in the catalogue: according to it 'the metaphysics [of de Chirico] becomes clarified [in Carrà] with religious fullness'; 'the spatial nostalgia [of de Chirico] stimulates Carrà to the invention of compositional foundations . . . whose modules will not be the generic dimensions of temples, but the dry cubicula of Giotto.' And let everyone judge for themselves."

10 Michael R. Taylor, "A Conversation with Gerard Tempest," in *Giorgio de Chirico and the Myth of Ariadne*, exhibition catalogue edited by Taylor, 181. Taylor informs us as to the use of litharge (an oxide of lead), which the artist employed at that time to give transparency and luminosity to his paintings; in explaining its effects, he reveals that when executing the Italian Piazzas he did not use any of those technical expedients used in creating his "baroque" paintings, but simple tubes of color.

11 A series of Warhol's works inspired by de Chirico was presented in 1982 at the exhibition *Warhol versus de Chirico*, curated by Achille Bonito Oliva, Rome and Hamburg, 1983 (Milan: Electa, 1982). The two artists met in 1972 in New York.

12 See Gilles Deleuze, *Différence et repetition* (Paris: PUF, 1968). Deleuze's study is based on a reevaluation of Nietzsche's thought, which is an element shared with de Chirico.

Chap. 29
The Postwar Period and the Late Return to Classical Painting: Avant-Garde / Anti-Avant-Garde

[1] An interesting study regarding de Chirico's "postmodern" thought is found in Emily Braun, "Kitsch and the Avant-Garde: the case of de Chirico," in *Rethinking Art Between the Wars. New Perspectives in Art History*, edited by Hans Dam Christensen, Øystein Hjort, Niels Marup Jensen (Copenhagen: Museum Tusculanum Press, University of Copenhagen, 2001), 73–90.
[2] Giorgio de Chirico, "Pensieri e verità sulla pittura," in *Scena Illustrata* (May 1950): 12–13.
[3] Giuliano Briganti, "L'ultimo de Chirico," in *Cosmopolita* 21 (May 24, 1945): 6.
[4] Giorgio de Chirico, "Perché ho illustrato l'Apocalisse," in *Stile*, January 1941.
[5] See Fabio Benzi, "Correspondances," in *A Triple Alliance: Giorigio de Chirico, Francis Picabia, Andy Warhol*, edited by Gian Enzo Sperone (New York: Sperone Westwater, 2003).

Chap. 30
The 1950s and 1960s: Pictor classicus sum

[1] Giorgio de Chirico, "Le nature morte," in *L'Illustrazione Italiana* (May 24, 1942): 500, English translation "Still Life," in *Metaphysical Art* 14–16 (2016): 116–17.
[2] Romano Gazzera, Carlo Guarienti, Martin de Alzaga, Vieri Freccia, John Moxom, and Paolo Weiss. The initiative was repeated in 1952 and 1954, again being timed to coincide with the Biennale, but only as solo exhibitions of de Chirico's work.
[3] It seems that before implementing this "secession," de Chirico had been awarded a room at the 1950 Biennale in exchange for dropping his case regarding the fake painting. A circular letter sent by the president of the institution, Rodolfo Pallucchini, to the committee states that: "The artist has informed our lawyer that he would be willing to drop the case provided that the Biennale offer him a room at this year's Biennale" (letter of February 16, 1950, in Maria Cristina Bandera, *Il carteggio Longhi—Pallucchini. Le prime Biennali del dopoguerra (1948–1956)* [Milan: Charta, 1999], 112). The committee unanimously accepted this solution—except, of course, Roberto Longhi—and it was therefore decided to dedicate the room

to de Chirico. Ultimately, however, he refused it (ASAC, AV 25). This version of events raises certain doubts, for it is difficult to understand why, having obtained what he had asked for, de Chirico declined the invitation. It is much more likely that the idea of a reconciliation was devised by the two sides' legal teams, probably on the suggestion of the Biennale's lawyer, and supported by the artist's representative, but that de Chirico—for reasons of principle—rejected the tempting offer.
[4] See above, chap. 20.
[5] Giorgio de Chirico, "Fake de Chirico's," English translation in *Metafisica* 5–6 (2006): 590.
[6] See *Giorgio de Chirico. Betraying the Muse*, exhibition catalogue edited by Baldacci, 98. Another painting from the same series belonged to Breton, and is now in the Cleveland Museum of Art, having been authenticated by Soby.
[7] See Wieland Schmied, "Die Strategie der Fälscher," in Id., *De Chirico und sein Schatten* (Berlin: Prestel, 1989), 71; *Giorgio de Chirico. Betraying the Muse*, exhibition catalogue edited by Baldacci, 90–102. On de Chirico's assertion that Domínguez had created the forgeries, see the following note.
[8] André Breton, *La clé des champs* (Paris: Éditions du Sagittaire, 1953), 142. Breton reports that he had learned of this by the creator of the fakes. Given that this was Óscar Domínguez, a faithful surrealist and a friend of Breton's, this makes perfect sense. However, it is completely improbable that de Chirico would have asked one of Breton's friends to create forgeries that he would then have denounced as such. In fact, the artist immediately chronicled the course of events with precision: "In Paris, at the Galerie Allard located at number 20, rue des Capucines, an exhibition of paintings recently took place featuring works attributed to me, but which were almost all forgeries. I think this must have been the first time in the history of the world that an exhibition was mounted in which almost all of the works attributed to the artist were fake. The pride and honor for such a noble and idealistic event is owed to the so-called avant-garde circles of the 'Ville Lumière.' The owner of the aforementioned gallery—who I believe was duped, for otherwise he would not have acted in this way—sent me photographs of nineteen of the paintings exhibited and all nineteen paintings were forgeries. Here are some examples of these fakes, which are grotesque counterfeits of my works. The gallery owner asked me to authenticate the photographs by signing them on the back and returning them to him as soon as possible. I naturally replied that this was not an exhibition but a colossal fraud, and that I would take

legal action to put a stop to this obscene diffusion of forgeries of my works, made in Paris and distributed around the world—above all, in America" (Giorgio de Chirico, "Truffa a de Chirico," in *La Fiera Letteraria* I, 16 [July 25, 1946]; see also Giorgio de Chirico, "Una mostra di falsi de Chirico," in *Il Giornale d'Italia*, August 25, 1946). Immediately afterward, attempts were made to muddy the waters, as de Chirico himself pointed out, mentioning Domínguez's name for the first time: ". . . in the *Giornale della Sera* on the 1st of this month there appeared an ingenuous and poisonous article concerning the famous scandal of the fake paintings in Paris, accompanied by two photographs. This anonymous text sought to make the reader believe that the scandal was a consequence of my own mistakes, and that all of the paintings in that infamous exhibition were authentic. So here's how things stand. The photographs of the two paintings of Horses reproduced in the Roman newspaper belong to a batch of photographs that the gallery sent me in order that I might authenticate them. And at first, under the nauseating impression of that imposing quantity of fake Metaphysical pictures (more than a dozen), I also believed the paintings of Horses to be fakes, especially since they were very bad photographs of unfinished paintings, created during a period in which the greed of Parisian dealers was such that I was frequently not allowed to finish a picture. I declared that only the paintings of Horses were authentic. On the other hand, I continue more than ever to assert that the whole series of Metaphysical forgeries exhibited as part of that scandalous show comprises a set of fake, supremely fake, grotesquely fake, pictures, and I challenge anyone to prove otherwise. As to a certain Corbellini, a Paris-based Italian, emissary of the Galerie Allard, and the informer and inspirer of the article which appeared in the *Giornale della Sera*, I remember some lyrical and informative letters that several months ago, before the infamous exhibition, he wrote me from Paris. In one of these letters, which I have kept, after long speeches concerning the immorality and stupidity of Parisian avant-garde circles he states, among other things:—many fakes are circulating here; what to do? Some days ago in a fine exhibition to which I had lent three of your works, I made them remove a forgery that I had already had removed from a gallery on the rue de Seine. There is a certain Domínguez who tries to imitate you in a scandalous fashion and who has some success among those who slander you.—I have cited this verbatim, and the letter is signed Luigi Corbellini. So nothing has changed. The judicial inquiry will take place and the Parisian scandal of the forgeries remains what it was" (Giorgio de Chirico, "Una lettera di de Chirico," in *La Fiera Letteraria* I, 35 [December 5, 1946]: 6).

9 All of the documents relating to this episode belong to my own archive and were given to me by Luigi Bellini. A falling-out with Bellini must have occurred between October 8 and 12, 1946, the nature of which is unknown. See "Giorgio de Chirico letters to Julien Levy, 1938–48", in *Metaphysical Art* 9–10 (2011): 381.

10 Viscount Franco Marmont was an industrialist (he was head of the film company Ferrania) who owned several works by de Chirico dating from the late 1930s and early 1940s; he had also commissioned the artist to paint a portrait of his wife, Maria, in 1940.

11 See Wieland Schmied, Preface, in *Giorgio de Chirico. Betraying the Muse*, exhibition catalogue edited by Baldacci, II. Schmied recalls how museum directors would joke that if de Chirico declared a painting to be fake it could undoubtedly be considered authentic.

12 Typescript in Italian with handwritten corrections by Giorgio de Chirico, Fondazione Giorgio e Isa de Chirico Archives, Rome, English translation in *Metafisica* 5–6 (2006): 582–87.

Chap. 31
The Final Years: The New Metaphysical Phase and the "Eternal Return"

1 *Memoirs of Giorgio de Chirico*, 121.
2 Typescript published in *Metaphysical Art* 11–13 (2014): 317 (dated ca. 1963). The text was written on request of Bertrand Meyer (June 22, 1976), curator of the exhibition *Hommage to Jean Cocteau* (scheduled for November 1976, Institute Française du Royaume-Uni), who asked for a brief text in homage to Jean Cocteau. De Chirico sent the text on September 9, 1976. The exhibition took place the following year at the National Book League, London, rather than the Institute Française. Further venues included: Arts Center, Sunderland; National Library of Scotland, Edinburgh; Bluecoat Gallery, Liverpool; Holt Street Gallery, Birmingham. De Chirico's French text is published in English translation in *Jean Cocteau*, edited by B. Meyer (London: National Book League, 1977).
3 De Chirico's contracts with the gallerists Antonio and Ettore Russo of the La Barcaccia gallery are held in the private archive of Paolo Picozza, who

kindly allowed me to consult them. I also wish to thank Fabrizio Russo, who allowed me to consult the important documentary material in his possession. The exclusive contract was renewed in 1959, again in 1964 (the paintings to be delivered each month were at this point significantly lowered to a minimum of two) and again in 1966. The relationship was trustworthy, to the extent that with a notarial deed dated November 11, 1957, drafted by Diego Gandolfo of Rome, de Chirico entrusted Antonio Russo with "undertaking by all legal means to protect [his] paintings and works of art . . . thereby authorizing him to represent him in court, to appoint lawyers and solicitors, to proceed with the seizure of fake works or works that are deemed to be so, to claim damages, to request the appointment of experts, to proceed with appraisals and to pursue any other means of obtaining proof." De Chirico was clearly tired of tackling the proliferation of fakes himself and chose to entrust the task to the younger and more dynamic gallerist.

4 The contracts did not specify the kind of paintings to be produced, but at that time the strongest market was for his baroque works.

5 In breaking the contract, a disagreement appears to have taken place between the Russo brothers and de Chirico's wife, Isabella, due to the event of the artist's infatuation with a woman, that the gallery owners seem to have covered up. However, the fundamental point was that de Chirico intended substantially to change the kind of work he was producing.

6 Calvesi, "La nuova Metafisica," in *De Chirico. La nuova Metafisica*, exhibition catalogue edited by Calvesi and Ursino.

7 Isabella Far, *Giorgio de Chirico* (Milan: Fabbri, 1968).

8 *Giorgio de Chirico* (Milan: Galleria Alexandre Iolas, 1968).

9 *Giorgio de Chirico*, exhibition catalogue edited by Wieland Schmied, Milan and Hannover (Milan: Edizioni dell'Ente manifestazioni milanesi, 1970).

10 Calvesi, "La nuova Metafisica," in *De Chirico. La nuova Metafisica*, exhibition catalogue edited by Calvesi and Ursino, 16.

11 *Ibid.*, 17.

12 A comprehensive work on this period is Lorenzo Canova, *Il grande ritorno. Giorgio de Chirico e la Neometafisica* (Milan: La nave di Teseo, 2021).

13 Lorenzo Canova, "L'enigma chiaro. Giorgio de Chirico e il gioco felice della neometafisica," in *Giorgio de Chirico. Gioco e gioia della Neometafisica*, exhibition catalogue edited by Canova, Campobasso 2014–15 (Campobasso: Regia Edizioni, 2014), 28.

Illustrations

* All images of Giorgio de Chirico © Giorgio de Chirico, by SIAE, 2022.

The Torment of the Poet, late 1914, oil on canvas, 53×41 cm, Yale University Art Gallery, New Haven, p. 164.

The Seer, early 1915, oil on canvas, 89.6×70 cm, Museum of Modern Art, New York, p. 166.

The Duo, early 1915, oil on canvas, 81.5×59 cm, Museum of Modern Art, New York, p. 167.

Orestes and Electra (Ludovisi group, sculpture by Menelaos), Greek original I sec. A.D., Palazzo Altemps—Museo Nazionale Romano, Rome, p. 169.

The Two Sisters, first half of 1915, oil on canvas, 55×46 cm, Kunstsammlung Nordrhein-Westfalen, Düsseldorf, p. 171.

"Various stenographic methods compared" from a manual of 1897, p. 172.

The Span of Black Ladders, summer–autumn 1914, oil on canvas, 62×47.5 cm, private collection, p. 173.

The Double Dream of Spring, first half of 1915, oil on canvas, 56.2×54.3 cm, Museum of Modern Art, New York, p. 174.

The Purity of a Dream, first half of 1915, oil on canvas, 65×50 cm, private collection, p. 175.

The Poet and the Philosopher, first half of 1915, oil on canvas, 82×66 cm, private collection, p. 176.

Portrait of Carlo Cirelli, October 1915, oil on canvas, 77×64 cm, private collection, p. 180.

Portrait of Paul Guillaume, first half of 1915, oil on canvas, 79×57.2 cm, Musée de Grenoble, Grenoble, p. 181.

Still Life, autumn 1915, oil on canvas, 45×34.5 cm, private collection, p. 182.

The Playthings of the Prince, autumn 1915, oil on canvas, 55.5×25.9 cm, Museum of Modern Art, New York, p. 183.

The Amusements of a Young Girl, winter 1915, oil on canvas, 47.5×40.3 cm, Museum of Modern Art, New York, p. 185.

Ardengo Soffici *Bif§zf+18. Simultaneità. Chimismi lirici*, 1915, cover, p. 187.

Metaphysical Composition, early 1916, oil on canvas, 32.5×25 cm, private collection, p. 188.

The Nostalgia of the Engineer, first months of 1916, oil on canvas, 33.5×26.5 cm, Chrysler Museum of Art, Norfolk, p. 189.

The Faithful Servant, mid-1916, oil on canvas, 38.2×34.5 cm, Museum of Modern Art, New York, p. 190.

Greetings from a Distant Friend, mid-1916, oil on canvas, 48.2×36.5 cm, private collection, p. 191.

The Gentle Afternoon, mid-1916, oil on canvas, 65.3×58.3 cm, Peggy Guggenheim Collection, Venice, p. 192.

The Revolt of the Sage, mid-1916, oil on canvas, 67.3×59 cm, Estorick Collection of Modern Italian Art, London, p. 193.

The Troubadour, late 1917, oil on canvas, 91×57 cm, private collection, p. 219.

Hector and Andromache, late 1917, oil on canvas, 90×60 cm, private collection, p. 220.

The Great Metaphysician, late 1917, oil on canvas, 104.5×69.8, private collection, p. 221.

Metaphysical Muses, first half of 1918, oil on canvas, 54×34.5 cm, private collection, p. 225.

Metaphysical Interior with Matchbox, mid-1918, oil on canvas, 55×35 cm, private collection, p. 226.

Alcestis, June–July 1918, oil on canvas, 60×48 cm, Galleria Internazionale d'Arte Moderna—Ca' Pesaro (on loan from the Carraro Collection), Venice, p. 227.

Self-Portrait, July–November 1918, oil on canvas, 62×54 cm, private collection, p. 228.

Still Life with Waterfall and Landscape, July–November 1918, oil on canvas, 62.5×46 cm, private collection, p. 230.

Metaphysical Interior with Lighthouse, late 1918, oil on canvas, 48.5×37 cm, Museo d'Arte Contemporanea del Castello di Rivoli, Cerruti Collection, Rivoli, p. 231.

The Sacred Fish, early 1919, oil on canvas, 74.9×61.9 cm, private collection, p. 236.

Hermetic Melancholy, early 1919, oil on canvas, 62×50 cm, Musée d'Art Moderne de la Ville de Paris, Paris, p. 237.

Portrait of the Artist with his Mother, late spring 1919, oil on canvas, 79.7×60.4 cm, Centre National d'Art et de Culture Georges Pompidou, Paris, p. 238.

Portrait of a Man (detail from *Portrait of a Gentleman* by Lorenzo Lotto, Galleria Borghese, Rome), July 1919, measurements and whereabouts unknown, p. 239.

The Return of the Prodigal Son, July–November 1919, oil on canvas, 80×99 cm, private collection, p. 240.

The Virgin of Time, July–November 1919, oil on canvas, 83×60 cm, private collection (from *Valori Plastici*; the painting has been entirely repainted), p. 241.

Still Life with Pumpkins, July–November 1919, oil on canvas, 60×80 cm, private collection, p. 242.

Diana (Vestal Virgin), July–November 1919, oil on canvas, 70.5×50 cm, Palazzo Merulana, Cerasi Collection, Rome, p. 243.

Self-Portrait with Antique Bust and Paintbrush, November–December 1919, oil on canvas, 81×65 cm, private collection, p. 244.

The Folly of Horses, 1947, oil on canvas, 48×60 cm, published in the catalogue of the de Chirico exhibition held at Acquavella Gallery in New York in 1947, pp. 472–473.

Forgery of de Chirico's work, *The Folly of Horses*, 1947, oil on canvas, 48.3×60.3 cm, presumably exhibited at the de Chirico exhibition held at Acquavella Gallery in New York in 1947, p. 474.

Back of the previous painting with a sticker from the Acquavella Gallery in New York, p. 474.

Óscar Domínguez, *The Troubadour*, fake painting exhibited as a work by de Chirico at the Venice Biennale of 1948 (cat. no. 24), p. 475.

Óscar Domínguez, *Telephone and Revolver*, 1943, private collection, p. 476.

Return of Hebdomeros, 1973, oil on canvas, 60×80 cm, Musée d'Art Moderne de la Ville de Paris, Paris (Isabella Far Bequest), p. 480.

Ecstasy, ca. 1968, tempera on cardboard, 35×45 cm, private collection, p. 480.

Metaphysical Interior with Hand of David, 1968, oil on canvas, 79.5×59.5 cm, Fondazione Giorgio e Isa de Chirico, Rome, p. 481.

The Remorse of Orestes, 1969, oil on canvas, 90×70 cm, Fondazione Giorgio e Isa de Chirico, Rome, p. 482.

The Sadness of Spring, 1970, oil on canvas, 90×70 cm, Fondazione Giorgio e Isa de Chirico, Rome, p. 483.

Orpheus the Tired Troubadour, 1970, oil on canvas, 147×149 cm, Fondazione Giorgio e Isa de Chirico, Rome, p. 484.

The Meditator, 1971, oil on canvas, 90×70 cm, Fondazione Giorgio e Isa de Chirico, Rome, p. 485.

Figures over the City, 1970, pencil, charcoal and watercolor on cardboard, 360×505 mm, Fondazione Giorgio e Isa de Chirico, Rome, p. 486.

The Great Game (Italian Piazza), 1971, oil on canvas, 60×80 cm, private collection, p. 486.

Sun Temple, 1971, oil on canvas, cm 82×58, Musée d'Art Moderne de la Ville de Paris, Paris (Isabella Far Bequest), p. 487.

Thermopylae, 1971, oil on canvas, 55×65 cm, Fondazione Giorgio e Isa de Chirico, Rome, p. 488.

Mystery of Manhattan, 1973, oil on canvas, 80×60 cm, Fondazione Giorgio e Isa de Chirico, Rome, p. 488.

The Muses of the Opera, 1973, oil on canvas, 69×49.5 cm, Fondazione Giorgio e Isa de Chirico, Rome, p. 489.

The Venetian Decorators, 1973, oil on canvas, 54.5×65 cm, Fondazione Giorgio e Isa de Chirico, Rome, p. 490.

Metaphysical Interior with Profile of Statue, 1962, oil on canvas, 85×65 cm, Fondazione Giorgio e Isa de Chirico, Rome, p. 491.

The Return of Ulysses, 1968, oil on canvas, 60×80 cm, Fondazione Giorgio e Isa de Chirico, Rome, pp. 492–493.

Metaphysical Interior with Sun Turned Off, 1971, oil on canvas, 80×60 cm, Fondazione Giorgio e Isa de Chirico, Rome, p. 494.

Mysterious Spectacle, 1971, oil on canvas, 50×60 cm, La Galleria Nazionale, Rome, p. 495.

Battle on a Bridge, 1969, oil on canvas, 82.5×61 cm, Fondazione Giorgio e Isa de Chirico, Rome, p. 496.

Return to the Ancestral Castle, 1969, oil on canvas, 90×70 cm, Fondazione Giorgio e Isa de Chirico, Rome, p. 497.

The Mystery of a Hotel Room in Venice, 1974, oil on canvas, 91×72 cm, Fondazione Giorgio e Isa de Chirico, Rome, p. 498.

Head of Mysterious Animal, 1975, oil on canvas, 50×60 cm, Musée d'Art Moderne de la Ville de Paris, Paris (Isabella Far Bequest), p. 499.

Philip Guston, *Pantheon*, 1973, private collection, p. 500.

Index